ARTISTS

UNIVERSITY OF
GLOUCESTERSHIRE
at Cheltenham and Gloucester

NORMAL LOAN

420 3/2011

This edition published by John Murray 1976

Copyright 1945 by Pantheon Books, Inc.
Copyright renewed 1972
by Robert Goldwater and Marco Treves

Printed in Great Britain by Fletcher & Son Ltd, Norwich
0 7195 3312 0

FOREWORD

An anthology must balance inclusion and omission. Had we had the space, most of the selections which the reader will find here could have been longer, and the opinions of many other artists might have been added. But we believe that all we have chosen belongs to our theme, and sheds some light upon art and its making.

The writing of artists on art has, in many senses, been uneven. A large number of artists who, ideally, should have had the most to say, have left us no word of their opinions, whether through deliberate restraint or historical accident. The reader will soon discover that many of the great names are perforce missing: Giotto, Giorgione, El Greco, Rembrandt, Turner, to mention a few. We regret these lacunae; we could not repair them.

Historically, our collection begins with Cennino Cennini, and covers the period between the end of the Middle Ages and the Second World War. Professionally, it includes both painters and sculptors because the aesthetic, technical, and social questions they discuss are similar or related, and their opinions must be examined together. We have omitted the writing of architects because of necessity they deal in a different way with different problems.

Our subject is what the artist has written in the role of artist. His other writing has been excluded except in so far as it is an immediate reflection of his experience as an artist. Thus, in general, the reader will not find here the business letters of the artist (Titian, Rubens), or his ventures into other realms of theory (Piero della Francesca, Blake). The sculptor or painter in the role of critic (Delacroix, Fromentin), and the writer who has been an occasional draftsman (Victor Hugo, Thackeray), do not appear. We have hardly touched upon the tremendous fields of biography (Vasari, Van Mander), autobiography (Cellini), or anecdote; have avoided the half-truth of the epigram and the traditionally attributed saying, and confined ourselves as far as possible to written opinions. Where these limits have been overstepped, it was because the nature of the material seemed to make it imperative.

Whenever a choice has been possible, we have preferred to select the more personal, less formal statement; and have taken account of the published material in English to which the reader will have easy access. For example, these considerations have prompted us to omit Reynolds' *Discourses* entirely, and to reduce the possible citations from Leonardo, Vasari, Delacroix, and Van Gogh.

We have translated into English for the first time nearly one-half of the artists' writing quoted, and have reworked other selections for this book.

Our original intention was to bring the anthology down through the present generation of painters and sculptors. As the limitations of space grew more evident, it became regrettably clear that we would be forced to omit many contemporary artists altogether, and could include only insufficient selections from the few chosen by elimination; we therefore reluctantly decided upon their omission, and set the arbitrary limit of 1890 upon the birthdate of our artists. The younger men deserve another book.

In order to insure adequacy of reproduction the portraits and self-portraits have been limited to works done originally in a graphic medium, and to a few heads in sculpture. The full-page illustrations are all of specific works mentioned by the artists in the course of their discussions; here it seemed worthwhile to reproduce paintings without their color.

Each of the artists' likenesses has been placed at the head of his writing, without caption. Full details concerning all of these portraits, and of the other illustrations, have been given in the *List of Illustrations*.

The subtitles have been introduced into the text for reading facility; they are not always in the original. Instead of the usual subject-index, references to relevant passages have been inserted within the body of the book, in the hope that the reader will be led to fruitful comparison and contrast.

The task of the editors has been divided in the following way: The Italian and Spanish sections have been compiled and where necessary translated by Marco Treves, who has also translated Rubens on ancient statues and Poussin's *Observations*. Robert Goldwater has compiled and where necessary translated the French, German, English, and American sections, and has also been responsible for editing the entire book in its final form.

The publishers and the editors wish to acknowledge the kindness of all those who have allowed us to reprint material from other books, and permitted us to reproduce works of art in their collections.

In our task of compilation and editing we have been aided by many friends and colleagues; we wish to express our thanks to all of them, and to the staffs of the various libraries in New York City. Our appreciation is more especially extended to Lloyd Goodrich, Frits Lugt, Agnes Mongan, Andrew Ritchie, and James Stern for discussing portions of the material with us; to Margaret Miller for help on problems of editing; to Erwin Panofsky for his translation and arrangement of the Duerer passages; to Alfred H. Barr for his experienced counsel on matters of content and presentation; and to Louise Bourgeois for criticism from the point of view of the contemporary artist.

Our greatest debt is to Professor-Emeritus Walter Friedlaender, who has at all times let us help ourselves freely to the material in his well-stocked library of sources, and to any of his own great store of humanistic knowledge.

CONTENTS

THE SEVENTEENTH CENTURY

THE EIGHTEENTH CENTURY

REALISM AND IMPRESSIONISM

POST-IMPRESSIONISM AND SYMBOLISM

THE TWENTIETH CENTURY

LIST OF ILLUSTRATIONS

I

4

INTRODUCTION

Painting is a funny business.

TURNER

One repents having written succinct and lapidary phrases upon art.

BONNARD

I am anxious that the world should be inclined to look to painters for information on painting.

CONSTABLE

The contemporary artist, asked to write about his art, hesitates. The tradition of verbal shyness handed down to him by his craft has been reinforced by his own experience, and he will tell you that "explanations" rarely explain. His work, the best part of him, is there to speak for itself; those who do not understand its language will profit little from an approximate translation into the foreign tongue of words—even were this really possible. And besides the artist does not willingly enter into what, for him, must be a passionate discussion before a hostile, or at best objective, audience. He mixes pride with diffidence, and allows himself to be sure that in the long run the merit of his work will win its own recognition.

Without doubt many an artist of the past has felt the same way about addressing the public. His chief business has always been the making of his art. Nevertheless he has written and talked a great deal about it—about what painting and sculpture, painters and sculptors are and should be. Some of this writing and talking has been private, intended only for himself or his friends; some of it

has been professional, directed to other artists in so far as they were members of the same craft. A good deal of his discussion has, in spite of everything, been public, addressed to a variety of audiences: to his prospective patrons and buyers; to society in general; and sometimes to posterity; in explanation and defense of how artists work and behave, or of what he, as one among many, has been doing. As his audience has varied, so also has the artist changed the subject and tone of his writing. He has discussed business with his patron and his dealer; technique and aesthetics with his fellow artists and his pupils; the moral, material, and psychological difficulties of creation with himself. He has praised his own work to critics; sent letters to the editor in answer to journalistic attacks or professional intrigue; and tried to help and further work that he approved. He has spoken as an oracle expounding what "Art" should be and what his art is, and lately he has written manifestoes both before and after he carried out the principles they embodied.

Various as it is, all this writing is related to the artist's work. Though it may be neither a direct exposition of style, nor an explanation of subject, nor an analysis of aesthetic intention, yet it throws light upon his painting or his sculpture. And when such writing and conversation is gathered together (as it has been here), it helps to illuminate the work and personality of the individual artist, and many of the more general problems that meet us, his audience, as we confront the art of the past and present. Such artists' writing is more than a footnote in a factual history of art; it is a primary and important document in the history of taste, and in the formation of our own likes and judgments.

The collection and selection of the opinions gathered in this anthology has presented difficulties of several kinds. Like all source material, this particular sort of document has been preserved with little care and less uniformity of distribution. Gainsborough's letters, for example, were in large part destroyed because a later time judged his language, which was only the usual language of the eighteenth century, to be beyond the limits of good taste, and we

have no record of how much aesthetic discussion was destroyed with them. Corot's biographer, excellent and detailed as his work was, saw fit to reproduce only a few extracts from the painter's *Carnets;* perhaps these selections included all that was of interest, perhaps, however, what seemed banal and obvious to Moreau-Nélaton, who knew Corot, would seem important to us today. These are typical instances we happen to know of, but there are scores for which we have no evidence. If a Rembrandt or a Greco had written a theoretical treatise, it would perhaps be mentioned somewhere; but did they discuss art in letters which have been lost? Such are the historical accidents of our task, and they have resulted in large gaps and important omissions which there is no way of filling. (The most obvious is the total absence of any writing from the Dutch school of the seventeenth century. There are many others which there is no need to detail here, they will be apparent to the reader.)

There are other difficulties of a more positive nature, belonging to the very character of our subject. Artists' writing brings to mind Leonardo's *Notebooks,* Michelangelo's *Sonnets,* Reynolds' *Discourses,* Delacroix's *Journal,* Van Gogh's and Pissarro's *Letters.* Some of these have a public, some a private character, but each is the direct and intimate revelation of an artistic personality, the record of one approach to the artist's problem. Yet other artists, of equally decided personality and style, and whose lives we know rather completely, have written nothing and carried on little theoretical discussion. Now in some cases this may be fortuitous, due simply to a series of personal accidents, as with Degas who shielded his weak eyes. In others, however, it may be a positive expression of an approach and an attitude to artistic creation. We have, for example, no writing by Caravaggio; the only record of Bernini's opinions are reports of conversations with him, and nearly the same is true of Monet and Renoir. Caravaggio's realism probably scorned didactic theory as it was reproached its want of *disegno;* Bernini's impetuousness undoubtedly found long-winded writing difficult and the instruction of others boring; and the impressionists' attempt at the immediate transcription of visual "reality" lent itself little to theoretical analysis. Sometimes the lack of a particular kind of writing is even inherent in a whole period, as witness the dearth

of theoretical treatises in the nineteenth century. And it is entirely possible that the seventeenth century Dutch artist actually did little writing about art, rather than that a great deal of writing was later lost. Omissions of this kind are almost as significant as a quantity of material.

We can see that no general rule can be laid down on whether or not the good artist is also a writer. Some of the greatest painters and sculptors have expressed themselves in writing, some have not. In many instances, and at certain periods it is correct to say that the writing has been done by lesser personalities who codify the discoveries of masters whose chief interest is in creation rather than discussion. Yet it is as "romantic" a prejudice to be suspicious of the artist who writes as it is to believe that a great artistic personality can—by definition—express itself in any medium. The artist is just as rarely a universal genius as he is an alogical medium for the intuitive arrangement of lines and shapes and colors.

The subject of this book is the artist on art. Our concern is not with the artist as a writer, but with the painter and the sculptor as he deals with his own profession, discussing the problems and the aspirations he knows because he is a creative member of it: "I am anxious that the world should be inclined to look to painters for information on painting," said Constable. It is in this spirit, and with this alone as a guide that the material here has been assembled. No rules have been followed, nothing rigidly included or excluded provided it shed light upon the way in which the artist thinks about art. Clearly most of this material is aesthetic in character: It deals with the problems of subject and composition, of "landscape" as opposed to "history" painting, of color against line, the contemporary in preference to the historical, personal expression and objective statement. Much of it is set down in terms of the "beautiful" and the "ugly" as these generalized concepts have appeared at various times and to different personalities; a good deal of it is couched in terms of opinions upon older artists who represented continuing (though not constant) ideals to successive generations: Michel-

angelo and Titian; Duerer and Rubens; Rembrandt and Poussin; Ingres and Delacroix. Throughout the centuries artists have analyzed and criticized these men and their work, sometimes, like Reynolds, recommending that their qualities be combined; sometimes, like Blake, opposing them as good to evil. When such opinions have been presented, not as objective, professional criticism, but in relation to the artists' own creation they have been included here; often they are more revealing than the abstract words and conventional phrases of a generalized aesthetic.

But the artist is far from being an etherealized aesthetic machine, nor is art created in a vacuum, and there are many problems which though not in the realm of pure aesthetics are yet vital to the artist as an artist. There is, for example, the question of education; is art teachable at all, and if so how and when? Do schools encourage or discourage art; are academies indispensable or pernicious? A variety of characteristic opinions have been included here. The artist has been directly concerned with his relation to the public. He has discussed the utility of exhibitions and how they should be managed; he has favored juries and opposed them; he has tried to impress his views upon museums; and he has been anxious about the patronage of the arts. Such expressions have also been considered the proper material of this book. Finally the artist has often been concerned with himself as a creative mechanism, with the conditions and functioning of him who makes the work, rather than with the character and quality of his product. Surely reflections upon what an artist is belong in an anthology about art.

This writing of artists on art presents a wide variety. The style of each artist is as distinctive in his writing as it is in his painting or his sculpture. Yet as we proceed from period to period, a certain uniformity of change becomes evident, and it is possible to pick out a certain similarity of emphasis and form of writing among the painters and sculptors of a given time. Each of the seven centuries has its own character:

Cennino Cennini (with whom this collection begins), repre-

sents the Giottesque tradition and its combination of late medieval and early Renaissance characteristics. What is striking in his treatise is that his primary conscious concern is technical. He has written a craftsman's handbook of method which explains how things are to be done rather than why. Cennino, that is to say, takes his aesthetic for granted, and even where he states his aesthetic aim he does so with the air of one who is simply setting down an accepted axiom for the sake of greater clarity; there may be those who are ignorant of it, no one would seriously dispute it. This is far from saying that Cennino has no aesthetic—it is perhaps the very opposite; rather because there is no argument about the aim of art, its accepted end is implied in every one of his technical rules and moral precepts, which are simply the best methods of achieving the desired results, tested and approved by three generations of artists.

Cennino, then, is addressing himself exclusively to his fellow artists and future apprentices. During the fifteenth century this professional character of the artist's writing continues, but in conformity with the quality of Renaissance art and culture several new elements are introduced. The first is the concern with perspective and modeling as methods for the accurate representation of the natural world. Art is defined in general terms as a copy of nature, and the aesthetic standards and problems that such copying involves are more implied than actually discussed.

Second is the new assumption that each case need not be treated as a separate instance for which a rule of thumb has been found and a formula accepted, but that the rule discovered can, because it conforms to a law of nature, be made to cover all instances. This is of course the "scientific" attitude most familiar to us in the story of Uccello in love with the study of perspective, and the perspective rules codified by Alberti, but other artists extended this same attitude not alone to the question of proportions, where the most famous instance is Duerer, but to problems of color and modeling and types of subject-matter as well. Piero's discussion of the *Five Regular Bodies* is a case in point; it is not itself a treatise on aesthetics or art, but the very fact of Piero's writing on geometry is indicative of an attitude toward art and aesthetics.

The third new interest of the fifteenth century artist likewise

implies a "scientific" point of view: Under the influence of antique art and classic aesthetic theory he now writes about the abstract concept of "beauty." Alberti, for example, discusses how beauty must be added to a painting, and Filarete's treatise implies this end of art, while it is the assumed basis of Piero's work.

The classic treatment of art and science as twin aspects of the same "scientific" interest is of course to be found in Leonardo's *Notebooks*. In his final treatise on painting, had he put it into definitive form, Leonardo was evidently going to mix the formulae of a practical craftsman with the philosophic discussion of beauty and its relation to nature. It was to be at once a handbook and a system of aesthetics. Thus we may say that Leonardo as a personality—taking in the sum total of his work and his writing—reaches farther toward a full humanist conception of the world than does his writing on art alone, with its large measure of traditional treatment. There are of course many aspects of his ideas which belong more to the sixteenth than to the fifteenth century, for example his famous defense of painting against sculpture, yet Leonardo is far from attaining the complete freedom from the traditional concept of the artist as a craftsman that his younger contemporary Michelangelo achieves (of Raphael we can hardly judge). For Michelangelo, much under the influence of neoplatonic theory, only the end of art is worthy of discussion, the means are negligible; and one has the feeling that rules and formulae are to be replaced by genius, a change that was partly personal, partly due to the different tenor of his time.

The later sixteenth century continues this emphasis on theory. Technical counsels fall away, and are largely replaced by discussions of arrangement and composition and expression and fitness. The artist's relation to nature, which had been simple and direct in the fifteenth century, is now complicated by a new sense of art not being a copy of things seen in their most characteristic aspect, but an artificial ideal construction governed by its own laws and regulations. Moreover, a new method of argument and demonstration has crept in—that of reference to the ideal models established by the great masters of the beginning of the century, whose works have now been added to the antique as examples of perfection.

This is the vital idea behind the aesthetic of Vasari, and this discus-sion of art in terms of ideal examples runs through the seventeenth, eighteenth, and a good part of the nineteenth century. There is, however, this difference, that the sixteenth century, still close to its paradigms, is imbued with a sense of progress in the arts, whereas the common theme of later centuries is how art has fallen off from its former glorious days. Besides, as Vasari indicates, and as Cellini vividly brings home, the artist, in part at least, is now writing for a new public, the enlightened amateur, and his tone and his manner must be different than if he were addressing himself purely to professionals.

The seventeenth century continues these types of writing. The treatise of Lomazzo, for example, though written at the end of the sixteenth, becomes basic for the next century, and is widely trans-lated and profusely imitated. The century does, however, bring into prominence one important new kind of writing: the academy discourse. The beginnings of this type of address, like the academy itself, date back two centuries before, but like the academy, it be-comes dominant only in the seventeenth century, and it is in France, where the academy reached its fullest development, that the dis-course delivered to its assembled members has the greatest signifi-cance. It was heard by the artist's colleagues and the academy students. It had therefore to be unexceptionable, and so usually conformed to the established aesthetic doctrine, an eclectic teaching of antique and Renaissance models that had long since been ac-cepted. It is in fact doubtful if even under other circumstances there would have been any serious dissents, since the one basic difference of opinion in France was between *Rubenistes* and *Poussinistes*—one emphasizing color, the other line. (It is, however, significant that such critic-amateurs as Chantelou and De Piles took a leading part in these discussions; they had been carried over into the realm of philosophical aesthetics. For this reason, as well as for their very impersonal character, we give little of them here.)

Apart from business letters to patrons and amateurs, such as most of those of Rubens and Poussin, the one important exception to this kind of expression on the part of the artist is the record of the

opinions of Bernini, from whose hand (as mentioned above) we have no formal writing of any sort.

The eighteenth century carries on this tradition of formal discussion. But after 1750 it is only in England, where the academy was slower in developing, that it has any real freshness and contemporaneity. And even Reynolds' *Discourses,* influential as they were, do not have the vigor of his other writing. In both England and France the artist begins to express himself in a less didactic, more individual way, becomes reluctant to attach his art and his aesthetic to any universally acceptable truth and beauty, because he wishes to give more personal expression to his feelings. It is at this point that the personal letter—whether of a La Tour or a Gainsborough—begins to come into its own. But as a whole we have very little writing from the first seventy-five years of the eighteenth century, that is to say, before the advent of the neo-classic style.

Neo-classicism is now generally accepted as one of the styles in which the romantic attitude found expression. Certainly as far as the form and kind of writing which the artists of the two tendencies practiced, no distinction can be made. The personal quality that had already begun in the earlier part of the eighteenth century increases and intensifies. Characteristically the writing of the artists of this period, when it is not personal polemic, is private writing. Its typical forms are the letter and—new at this time—the journal. Of the latter, the tremendous work of Delacroix, forming with his letters and his criticism perhaps the most complete revelation of an artist's mind we have, is the heroic instance. But other artists of the period, both in France and out of it, set down their thoughts in this characteristic way; Chassériau, for example, and Thomas Cole. Even the great traditionalists like Ingres and his pupils, sure as they are of where the truth lies, and dogmatic as they are in its expression, do not write treatises in the renaissance-baroque manner. Ingres' opinions have come down to us from letters and conversations recorded by pupils, a vision of "beauty" in facets and fragments only later put together into a treatise. Nor is the neo-classic artist any different from the romantic in his conception of the artist as a genius who has nothing of the artisan. In this period both

the formal treatise and the technical handbook disappear, except where they are directed exclusively to the student and the beginning amateur. (Delacroix could only make the merest start upon a professional dictionary of painting; it was his friend Mme. Cavé who turned out popular books for the amateur painter.)

David's fusion of art and politics, and his use of art as a political instrument is as unique in writing as it is in painting—until the twentieth century. But other kinds of frankly polemical writing (as against philosophical argument) are by no means unknown at this time; writing which, though public, has the very personal character of the period. Here Blake is the classic instance, but not the only one, as witness Barry, David D'Angers, and Horatio Greenough, all carrying on a debate in order to change the state of the arts. Occasionally too, there appears a figure, like Blake again, or Girodet (perhaps even Delacroix had he not deliberately limited himself), who is almost equally at home in literature and painting. This is appropriate enough in a style which tends to do away with the nice distinctions between the arts in general.

Barry and Blake wrote to defend and explain their work to the public. In the next period first Courbet and then Whistler knew how to do the same, and to turn the disadvantages of hostility into the eventual advantage of notoriety. But as the century advanced and the progressive artist grew more isolated, it became harder to address the public, even in writing, and more by-play was needed to catch its attention. The characteristic writing of the period of impressionism is therefore private, and with one or two outstanding exceptions it is fragmentary in nature. Even the journal disappears and the typical form of the period is the letter from one artist to another, or to the patron who is also a friend (as Alfred Sensier or Antonin Proust). It is hard to escape the suspicion suggested above that this kind of art lent itself little to analysis on the part of the artist, who was an "eye" painting in accordance with his "temperament." Probably this fact, added to the older romantic legend of art as the product of an immediate inspiration, had much to do with the continuing mistrust (by both the members of the craft and the public), of the reasoning and reflective artist who writes about his art: "Artist, create, do not talk," Goethe had already said.

In this connection we can note that we have nothing directly from the pen of Renoir about *his own* art, all that we know of his opinions was taken down by others; while from Monet, an artist of equally long career and established style, we have almost as little. Pissarro is the great exception, but Pissarro was the least settled of all the impressionists, and he had the unique possibility of writing to a son who was also a painter.

Toward the end of the century this situation changes in several ways. With alterations in style, with the relation to nature once more open to question, verbal reasoning again becomes part of the artist's method of work. Programs for art, like those of Seurat and Signac, are formulated along with the works that embody them. (Cézanne too belongs here, but it so happens that he set down his program only during the last years of his life, the beginning of this century.) There is a new and close association between painters and literary men, particularly the poets and playwrights of "symbolism," and the painters look with less suspicion upon "literature" in art and consequently upon literature about art. A certain number of artist-critics, like Maurice Denis and Emile Bernard and Walter Sickert, also come into prominence at this time. And finally in the letters of van Gogh and the journals of Gauguin we have two extraordinary examples of an introspective record, evidence of a new tendency toward reflection given also by the journals of Redon and Ensor.

It is perhaps too soon to say just what forms of artists' writing will prove to have been the most frequently used by our contemporaries. The letter and the journal seem to have lost the importance they had in the nineteenth century, but much material like the letters of Gaudier-Brzeska and the correspondence of John Flannagan, only recently published, will yet come to light. But if introspection is losing ground, the public statement appears to be gaining. Manifestoes proclaiming the point of view of groups of artists such as the futurists, the suprematists, and the surrealists have been written in great abundance, directed at once to the artists' colleagues and the general public, defining an aesthetic program and an ideal. On the one hand abstract art has, paradoxically, produced a large body of exegesis upon the methods and ends of purely

visual expression; on the other surrealism has been at least as interested in literature as in the visual arts as carriers of subconscious communication. At the same time the artist (like everyone else) has become more and more conscious of his social and political position and, in his particular case, of its relation—passive or active —to his aesthetic point of view. Increasingly concerned with the gap between himself and the public he is trying to reach, he is also increasingly willing to use the interview and the magazine article as a method for providing a gloss for his work, and is less shy and superior about the value of such marginal comment upon the main body of his painting or his sculpture.

As the reader goes through the opinions in this book, comparing the pronouncements of one artist with the doubts of another, noting agreement here and difference there, he may wonder what relation all this reasoning and exposition has to the production of works of art. To what extent does the artist, whose primary means of expression is visual, say in words what he says in his painting and his sculpture? To what degree can the artist set forth verbally, expound discursively, an effect whose details are seized by the eye in simultaneous examination? How far can the artist formulate by introspection an impulse and an intention that came to him without logical development; how much can he explain of a final result whose attainment is in part beyond his control? To put the problem in other words, what is the angle of refraction with which the artist sees his own creation?

Of course in any absolute sense, the work can be explained no better by its creator than by anyone else. It goes without saying that a work of art is untranslatable; and it is also true that it is inexhaustible. One age does not see in it what another does, and what were the conscious concerns of the artist and his century are largely taken for granted by a later period. For example, the problem of pattern or arrangement or design, whose solution is to the modern eye the essential achievement of fifteenth century painting, is nowhere discussed by its contemporary theorists, while the details of

perspective, which many today consider incidental if not actually an obstacle, are described and analyzed at great length.

Such variations of visual consciousness are a characteristic not of the artist alone, but of his age. It is peculiar to the artist that he talks more particularly of the problems that occupy his mind as a creator, and that the relation of such conscious problems to the final result, far from being constant, is different for every period and for every individual. At one end of the scale we have the primitive artist who inherits his style and its meaning, as he inherits a role in his society, so that he largely takes his art for granted and has little conscious aesthetic. At the other there is the artist of the nineteenth and twentieth century, a Delacroix or a Picasso, who, working as an individual, familiar with the history of many styles, tries to carry in his own person the complete burden of consciousness of the entire form and subject of his work. At the same time—and perhaps in an attempt to throw off some of the load that has been imposed upon him, an impressionist, if he theorizes at all, confines himself largely to question of technique, and the surrealist claims to have relinquished all control over the process of creation. A Constable talks of his art as science, where we see romantic individualism; a Seurat analyzes the "simultaneous contrast of colors," where we appreciate his tight construction and visual logic; a Cennini discusses realism; and a Géricault would like to be able to paint more like Wilkie! Yet artists as various as Michelangelo and Matisse can describe almost completely the visual and emotional effect their work still has upon us. Some artists are consistent in their theoretical constructions, others will, as Delacroix says they should, contradict themselves as often as the dominating passion of their work changes. Thus the refracting medium through which the artist sees himself varies with the age and with the individual. Is there any more general answer to be given on why he says what he does about his own work and his own problems? The reader will draw his own conclusions from the artists' words that follow.

<div align="right">

ROBERT GOLDWATER

</div>

CENNINO CENNINI

FROM THE *BOOK OF THE ART*

A TUSCAN PAINTER who lived and worked at Padua, Cennino Cennini owes his fame not to his pictures, of which almost none survives, but to his *Book of the Art,* in which he expounds accurately and clearly the technique of art. As he tells us himself, he was a pupil of Agnolo Gaddi, son and pupil of Taddeo Gaddi, godson and pupil of Giotto. He is, therefore, a faithful recorder of the methods of the Giottesque tradition.

PAINTERS AND POETS HAVE ALWAYS HAD AN EQUAL RIGHT TO DARE WHATEVER THEY PLEASE

And this is an art known as Painting, which requires both imagination and work of the hand, because the painter has to invent things that are not to be seen, representing them under the guise of natural ones, and to shape them with his hand, making what does not exist appear to exist. And with reason she deserves to be seated in the second rank, beside the science of Poetry, and to be crowned with laurel. And the reason is this: that the poet, with his science, by a divine virtue of his that makes him worthy of it, is free to compose strange fables and to join together disparate forms, or not, as he pleases, according to his will. In like manner the painter is given liberty to compose a figure, standing or sitting, or half man and half horse, as he pleases, according to his imagination. [Compare Leonardo, p. 49.]

GIOTTO

Giotto turned the art of painting from Greek into Latin, and rendered it modern. He mastered our art more completely than anyone else ever did.

HOW SOME TAKE UP PAINTING FROM AN INNATE
REFINEMENT AND OTHERS FOR PROFIT

It is the impulse of their refined dispositions that induces some young men to engage in this art, for which they feel a natural love. Their intellects enjoy drawing merely because their own nature, of its own accord, attracts them to it, without any master's guidance, from an innate refinement. And prompted by this enjoyment, they next resolve to get a master; and they agree to stay with him, with love of obedience, submitting to serve him in order to attain perfection in the art.

There are others who take up painting from poverty and the necessity of earning a living, combining the desire for profit with a sincere love of our art. But above all these, they are to be commended who come to our art through a spontaneous love of it and an innate refinement.

WHICH ARE THE CHIEF VIRTUES THAT A MAN TAKING
UP PAINTING SHOULD BE EQUIPPED WITH

Therefore, you who love this accomplishment because of a refined disposition, which is the chief reason for your engaging in our art, begin by adorning yourselves with these vestments: love, fear of God, obedience, and perseverance. And put yourselves under the guidance of a master as early as possible. And leave the master as late as possible.

HOW YOU SHOULD ENDEAVOR TO COPY AND DRAW
AFTER AS FEW MASTERS AS POSSIBLE

When you have practiced drawing for a while as I have told you above, that is, on small panels, take pains and pleasure in constantly copying the best works that you can find done by the hand of great masters . . . And as you go on from day to day, it will be unnatural if you fail to pick up something of his style and of his mien. For if you set out to copy after one master today and after another one tomorrow, you will not acquire the style of either one or the other, and you will inevitably become fantastic, because each style will fatigue your mind . . . If

you imitate the forms of a single artist through constant practice, your intelligence would have to be crude indeed for you not to get some nourishment from them. Then you will find, if nature has granted you any imagination at all, that you will eventually acquire a style individual to yourself, and it cannot help being good; because your hand and your mind, being always accustomed to gathering flowers, would ill know how to pluck thorns.

HOW, BEYOND MASTERS, YOU SHOULD CONSTANTLY COPY
FROM NATURE WITH STEADY PRACTICE

Mind you, the most perfect steersman that you can have, and the best helm, lie in the triumphal gateway of copying from nature. And this outdoes all other models; and always rely on this with a stout heart, especially as you begin to gain some understanding of draftsmanship. Do not fail, as you go on, to draw something every day, for no matter how little it is it will be well worth while, and it will do you a world of good.

HOW YOU SHOULD REGULATE YOUR LIFE

Your life should always be arranged just as if you were studying theology, or philosophy, or other sciences, that is to say, eating and drinking moderately, at least twice a day, electing light and wholesome dishes and thin wines; saving and sparing your hand, preserving it from such strains as heaving stones, crowbars, and many other things which are bad for your hand, from giving them a chance to weary it. There is another cause which, if you indulge it, can make your hand so unsteady that it will waver more, and flutter far more, than leaves do in the wind, and this is indulging too much in the company of women.

ON THE NATURE OF ULTRAMARINE BLUE

Ultramarine blue is a noble, beautiful color, perfect beyond any other; one could not say anything about it, or do anything with it, that its quality would not still surpass. And, because of its excellence, I want to discuss it at length, and to show you in detail how it is made. And pay close attention to this, for you will gain great honor and profit from it. And let some of that color, combined

with gold, which will grace any work of our art, whether on wall or on panel, shine forth in every picture. [Compare Alberti, p. 37.]

THE PROPORTIONS WHICH A PERFECTLY FORMED MAN'S BODY SHOULD POSSESS

Take note that, before you go any further, I will give you the exact proportions of a man. Those of a woman I shall omit, as they are not exact multiples of one another. First, as I have said above, the face is divided into three parts, namely: the forehead, one; the nose, another; and from the nose to the chin, another. From the side of the nose through the whole length of the eye, one of these measures. From the end of the eye up to the ear, one of these measures. From one ear to the other, a face lengthwise, one face. From the chin under the jaw to the base of the throat, one of the three measures. The throat, one measure long. From the pit of the throat to the top of the shoulder, one face; and so for the other shoulder. From the shoulder to the elbow, one face. From the elbow to the joint of the hand, one face and one of the three measures. The whole hand, lengthwise, one face. From the pit of the throat to that of the chest, or stomach, one face. From the stomach to the navel, one face. From the navel to the thigh joint, one face. From the thigh to the knee, two faces. From the knee to the heel of the leg, two faces. From the heel to the sole of the foot, one of the three measures. The foot, one face long.

A man is as long as his arms crosswise. The arms, including the hands, reach to the middle of the thigh. The whole man is eight faces and two of the three measures in length. A man has one breast rib less than a woman, on the left side . . . The handsome man must be swarthy, the woman fair, etc. I will not tell you about the irrational animals, because I have never learned any of their measurements. Copy them and draw as much as you can from nature, and you will achieve a good style in this respect.

HOW TO PAINT A DRAPERY IN FRESCO

Now let us get right back to our fresco painting. And, on the wall, if you wish to paint a drapery, any color you please, you

should first draw it carefully with your *verdaccio* [green under-paint]; and do not have your drawing show too much, but moderately. Then, whether you want a white drapery or a red one, or yellow, or green, or whatever you want, get three little dishes. Take one of them, and put into it whatever color you choose, we will say red: take some *cinabrese* [a red pigment] and a little lime white; and let this be one color, well diluted with water. Make one of the other two colors light, putting a great deal of lime white into it. Now take some out of the first dish, and some of this light, and make an intermediate color; and you will have three of them. Now take some of the first one, that is, the dark one; and with a rather large and fairly pointed bristle brush go over the folds of your figure in the darkest areas; and do not go past the middle of the thickness of your figure. Then take the intermediate color; lay it in from one dark strip to the next one, and work them in together, and blend your folds into the accents of the darks. Then, just using these intermediate colors, shape up the dark parts where the relief of the figure is to come, but always following out the shape of the nude. Then take the third, lightest color, and just exactly as you have shaped up and laid in the course of the folds in the dark, so you do now in the relief, adjusting the folds ably, with good draftsmanship and judgment. When you have laid in two or three times with each color, never abandoning the sequence of the colors by yielding or invading the location of one color for another, except where they come into conjunction, blend them and work them well in together. Then in another dish take still another color, lighter than the lightest of these three; and shape up the tops of the folds, and put on lights. Then take some pure white in another dish, and shape up definitively all the areas of relief. Then go over the dark parts, and around some of the outlines, with straight *cinabrese;* and you will have your drapery, systematically carried out.

HOW BUILDINGS ARE TO BE PAINTED IN FRESCO AND IN SECCO

And everywhere in your buildings observe the following rule: the molding which you paint at the top of the buildings must slope downwards towards the background. The molding at the

middle of the building, halfway up the façade, must be quite even and level. The molding limiting the building at the bottom must appear to rise, contrary to the molding at the top, which slopes downwards.

HOW TO COPY A MOUNTAIN FROM NATURE

If you wish to acquire a good style for mountains, and to have them look natural, take some large stones, sharp-edged and not smooth, and copy them from nature, applying the lights and darks as the rule prescribes.

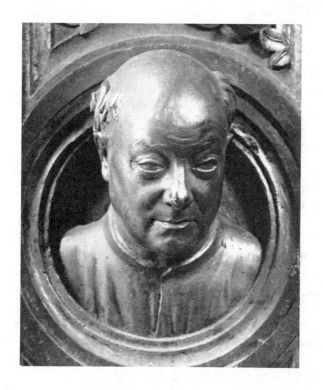

LORENZO GHIBERTI

FROM HIS *COMMENTARIES*

THE FAMOUS sculptor Ghiberti was also the first art historian of the Renaissance. His *Commentaries* treat of the history of ancient and modern art, and of theory and technique. Large sections are compiled or translated (not without errors) from Pliny, Vitruvius, Wittelo, and other classic and medieval authorities. Others are highly original and interesting. Probably Ghiberti wished to compose a complete treatise on art by uniting what he knew from his own experience with what he found in books, and was prevented by death from polishing and correcting.

The sculptor—and the painter also—should be trained in all these liberal arts:

Grammar	Perspective
Geometry	History
Philosophy	Anatomy
Medicine	Theory of Design
Astronomy	Arithmetic

THE REVIVAL OF PAINTING

And so in the days of Emperor Constantine and Pope Silvester the Christian faith gained the upper hand. Idolatry suffered so fierce a persecution that all the statues and paintings, of such nobility and antique beauty, were smashed and torn to pieces. And the volumes, treatises, drawings, and precepts which had been used for training men in these great, noble, and gentle arts also perished with the statues and pictures. And in order to do away with every ancient idolatrous custom, it was enacted that churches should be white throughout. At the same time very severe penalties were decreed for anyone who should make any statue or picture; and so the arts of sculpture and painting and all doctrine concerning them came to an end. Once art had ended, the churches stayed white for about six hundred years.

The art of painting started again very feebly among the Greeks, who produced some very rude works. But the Greeks of this age were as coarse and rude as the ancient Greeks were skilled. This was 382 Olympiads from the founding of Rome.

GIOTTO

The art of painting began to flourish again in a village called Vespignano, not far from the city of Florence. There a boy of wonderful talent was born, who one day was copying a sheep from the life. Cimabue the painter, passing by on the road to Bologna, saw him sitting on the ground and drawing the sheep

on a slab of stone. He was filled with admiration for the child who at an age so tender was working so well. And reflecting that he must have owed such skill to natural talent, he asked him his name. The boy replied: "My name is Giotto. My father's name is Bondone, and he lives near here, in yonder house." Cimabue, remarking the boy's agreeable personality, went with him to his father, whom he asked permission to take Giotto with him. The father was very poor and granted the painter's request.

Thus Giotto became a pupil of Cimabue, who then was painting in the Greek style and in that style had earned very great fame in Tuscany.

Giotto became great in the art of painting. He introduced the new art. He abandoned the rudeness of the Greeks. He attained the very first rank among Tuscan painters. And he executed some truly excellent works, especially in the city of Florence, and also in many other places. He had many pupils, all as skilled as the ancient Greeks. Giotto saw in art what others had not attained. He introduced natural art and refinement with it, never departing from the correct proportions. He was very skilled in every branch of art, inventing or discovering all this doctrine, which had remained buried for about six hundred years. When nature wants to grant something, she grants it without stint.

His works were plentiful in every kind of technique. He worked in fresco on walls; he worked in oil; he worked on wood. He executed in mosaic the *Ship* in St. Peter's in Rome, and he painted with his own hand the choir and the altarpiece in the same church.

THE DOORS OF PARADISE

I was commissioned [1425] to make the other door, that is, the third door of San Giovanni [the Florentine Baptistery], and I was given permission to execute it in whatever design I thought would look most perfect, most ornate, and richest. I set to work on panels, a braccio and a third square. The scenes have an abundance of figures. They are scenes from the Old Testament. I did my best to observe the correct proportions, and endeavored to imitate nature as much as possible, with all the details that I could

reproduce and with fine and rich compositions peopled with many figures. In one of the scenes I included about a hundred figures; in some scenes less, in others more. I executed this work with the most painstaking and loving care. The scenes are ten, all with buildings drawn with the same proportions as they would appear to the eye and so true that, if you stand far off, they appear to be in relief. Actually they are in very low relief. The figures in the foreground look larger and those in the distance smaller, just as they do in reality. And I have executed the whole work with the said proportions.

DISCOVERY OF ANCIENT STATUES

I have also observed in a temperate light works carved most perfectly and executed with the greatest art and diligence.

Among which, I saw in Rome in the 440th Olympiad a statue of an hermaphrodite the size of a thirteen-year-old girl, which was wrought with wonderful skill. It had been discovered at that time in a sewer about eight braccia below the ground. The sculpture lay at the level of the vault of the sewer and was covered with earth up to the surface of the street. While the area was being cleared—it was above St. Celsus—a sculptor stopped by, had the statue hauled out, and brought to Santa Cecilia in Trastevere, where he was working at the monument of a cardinal—he had removed some marble from it—the better to transport it to our city. As for the ancient statue, our tongues cannot express the skill, the art, the mastery, the perfection with which it was done. The figure was represented as lying upon spaded soil. On this soil a linen sheet was spread. The figure lay upon this sheet and was uncovered so as to exhibit both the virile and the feminine parts. The arms rested on the ground and were folded. The hands were joined. One of the legs was stretched and had caught the sheet with the big toe. In this act of pulling the sheet it showed wonderful art. The head was missing, but the rest was complete. This statue had very many refinements, which the eye could not perceive, but the hand could detect by touch.

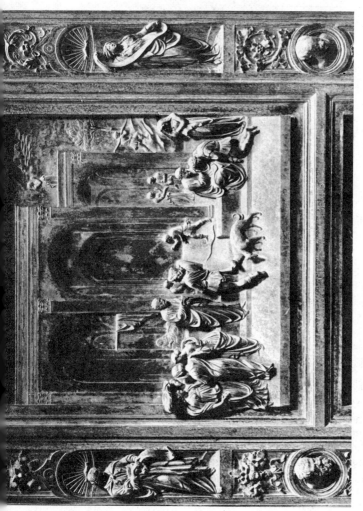

GHIBERTI: Scenes in the Lives of Jacob and Esau. Detail from the "Gates of Paradise," 1425-1452

LEON BATTISTA ALBERTI

ON PAINTING

ALBERTI WAS a typical humanist. Born in exile of a noble Florentine family, he was an enthusiast of beautiful art, clear thinking, graceful living, and ancient glory. As a poet, philosopher, painter, dramatist, and moralist he was little more than an elegant dilettante. Only in architecture (on which he also wrote a treatise) did he attain first rank. We quote, however, some passages from his *Treatise on Painting,* written in 1436, because it is a perspicuous expression of the Renaissance point of view, and because for centuries it had an enormous influence.

On such subjects as perspective, relief, the choice of the beautiful in nature, and the relative merits of painting and sculpture, it is to be compared with the treatises of Cennino Cennini, p. 21, and Leonardo, p. 45.

Leon Battista Alberti to Filippo di Ser Brunellesco, 1436.
I used both to marvel and regret that so many excellent and divine arts and sciences, which, as we see from extant works and from histories, flourished in antiquity among our most talented forefathers, had declined and almost entirely perished. Painters, sculptors, architects, musicians, geometers, rhetoricians, augurs, and similar most noble and marvelous intellects are now very scarce and hardly praiseworthy. Wherefore I concluded that—as I had heard many people say—nature, the maker of all things, had become old and tired, and just as she no longer produced giants, so she no longer produced such great and marvelous geniuses as in her youthful and more glorious days.

But when I returned from the long exile in which we, the Albertis, have grown old, to our native Florence, this most splendid of cities, I recognized that many artists, and especially you, Filippo, and that dearest friend of ours, Donato the sculptor, and those others, Nencio, and Luca, and Masaccio, have such talents for all sorts of laudable work as not to be rated lower than any of the ancients who were famous in these arts. Accordingly I perceived that the power to gain fame in any of the arts lies in our own industry and diligence no less than in the benignity of nature and the times. I am persuaded that if for those ancients, who had such an abundance of teachers to learn from and of masterpieces to imitate, it was not so difficult as it is now to acquire knowledge of the noble arts which today require so much toil, our own fame should be all the greater because we, without teachers and without examples, are discovering arts and sciences never seen or heard of before. Who can be so obtuse or envious as not to praise Pippo the architect on seeing here so great a structure [as the dome of the Cathedral] soaring above the skies, large enough to cover all the peoples of Tuscany with its shadow, and erected without help of scaffolding or large amount of timber; a mode of construction which our contemporaries did not believe possible, and the ancients, if I judge aright, were unacquainted with and unable to devise.

A DEFINITION OF PAINTING

And let the painters know that, whenever with their lines they draw contours, and with their colors they fill in the areas thus outlined, they have no other aim but to make the shapes of things seen appear on the surface of the picture not otherwise than if this surface were of transparent glass and the visual pyramid passed through it, the distance, the lighting, and the point of sight being properly fixed.

THE POWER OF PAINTING

Painting is possessed of a divine power, for not only, as is said of friendship, does it make the absent present, but it also, after many centuries, makes the dead almost alive, so that they are recognized with great admiration for the artist, and with great delight.

DIVISION OF PAINTING

Painting consists of Outline drawing, Composition, and Reception of light.

HOW TO PAINT ANIMALS AND MEN

As to the size of the limbs, some definite rule is to be followed. In determining these measures it is advisable first to draw in its place each of the animal's bones, next to add its muscles, and finally to clothe it all with its flesh. But here someone may object that, as I have said above, it is not the painter's business to represent what is not seen. True; but as in depicting a clothed man we first draw him naked and afterwards envelop him in drapery, so in painting a nude man we first draw his bones and muscles and afterwards so cover them with their flesh that it will not be difficult to understand where each muscle underneath lies.

VARIETY AMONG FIGURES

In any narrative piece variety is always agreeable, and a painting will always please most if the attitudes of the figures are very dissimilar. Accordingly, some of them should stand and show

their faces, their hands up and fingers raised, and their bodies resting on one foot. Others should turn their backs, their arms hanging down and their feet close together. And so let each have its own attitude and pose: some sitting, others kneeling, others lying down. And if the subject allows it let there be a few nude figures and others partly nude and partly draped, but always observe decency and modesty. Let the shameful parts and any others that happen to lack grace be covered with drapery, with foliage, or with the hand.

EXPRESSION OF EMOTIONS

A narrative picture will move the feelings of the beholders when the men painted therein manifest clearly their own emotions. It is a law of our nature—than which there is nothing more eager or more greedy for what is like itself—that we weep with the weeping, laugh with the laughing, and grieve with those who grieve. But these emotions are revealed by the movements of the body.

A narrative picture should include some figure announcing and explaining to us what is taking place there; either beckoning to us with its hand to come and see; or warning us with angry visage and menacing eyes to keep away; or pointing to some danger or some marvel; or inviting us to weep or laugh together with them.

ATTITUDES

It is fitting that a painting should exhibit gentle and agreeable attitudes, suited to the action represented. Let the movements and postures of maidens be graceful and simple, showing sweetness and quiet rather than strength—although Homer, whom Zeuxis followed, approved of robust forms even in women. Let the movements of young lads be limber and joyous, with a certain display of boldness and vigor. Let mature men have steadier movements, with handsome and athletic postures. Let old men have fatigued movements and attitudes and not only support themselves on both feet but hold on to something with their hands as well.

LIGHT AND SHADE

I certainly agree that abundance and variety of colors contribute greatly to the charm and beauty of the picture. But I would have artists be convinced that the supreme skill and art in painting consists in knowing how to use black and white. And every effort and diligence is to be employed in learning the correct use of these two pigments, because it is light and shade that make objects appear in relief. And so black and white give solidity to painted things.

In agreement with the learned and the unlearned, I shall praise those faces which seem to project out of the picture as though they were sculptured, and I shall censure those faces in which I see no art but that of outline.

USE OF A MIRROR

A mirror will greatly help you to judge of relief-effect. And I do not know why good paintings, when reflected in a mirror, are full of charm; and it is wonderful how any defect in a painting shows its ugliness in the looking glass. Therefore things drawn from nature are to be amended with a mirror.

BLACK AND WHITE

Remember never to make a surface so white that you could not make it yet far whiter. Though you were depicting snow-white clothes, you should stop far short of extreme whiteness. A painter has nothing better than white with which to render the brightest luster of a polished sword, and nothing more effective than black to render night's deepest darkness. And see the power of laying white beside black deftly; vases so done will look as if they were of silver, gold, and glass, and, though painted, will glitter. Therefore, every painter who uses black and white immoderately is much to be blamed.

COLOR HARMONIES

The picture will have charm when each color is very unlike the one next to it, . . . bright colors being always next to dark ones.

With such contrasts, the beauty of the colors will be more manifest and lovelier.

And among colors there are certain friendships, for some joined to others impart handsomeness and grace to them. When red is next to green or blue, they render each other more handsome and vivid. White not only next to gray or yellow, but next to almost any color, will add cheerfulness. Dark colors among light ones look handsome, and so light ones look pretty among dark ones.

GOLD

There are some who use a great deal of gold in their narrative pieces, holding that it adds magnificence. I have no praise for them. And though they were painting that Dido of Virgil's who had a gold quiver, golden hair bound with a gold ribbon, a purple robe with a golden clasp, golden reins on her horse, and everything of gold, yet I would not have them use gold at all, for the artist deserves more admiration and praise if he imitates the radiance of gold with other pigments. And moreover we see that gilded areas on a flat panel shine when they should be dark and look black when they should be bright.

However, I shall find no fault with ornaments in relief attached to a picture, such as carved columns, bases, capitals, and gables, though they be of very pure and massive gold.

BEAUTY

[The painter] will take pains not only to achieve a good likeness of every part, but to add beauty also. For beauty, in painting, is both welcome and demanded. Demetrius, an ancient painter, fell short of the highest praise because he took more pains to make his works like the models than to make them beautiful.

STUDY NATURE

Zeuxis, the foremost and ablest of painters, when painting a picture to be exhibited to the public in the temple of Lucina at Croton, did not trust madly in his own imagination, as every painter does nowadays; but, thinking he could not find in a single body all the beauties he was looking for, because nature does not

grant them all to one person, he accordingly chose from among all the youth of that town the five most beautiful girls, that he might copy from them whatever beauty is praised in women. He proved himself a wise painter. For when painters without any natural model to follow endeavor with their own imagination alone to attain the excellence of beauty, they are likely not to find that beauty they are seeking with so much toil, but to acquire instead certain bad habits, which afterwards, though they may desire it, they will never be able to relinquish. But he who has acquired the habit of taking from nature herself whatever he depicts will render his hand so practiced that thereafter anything he paints will always smack of nature . . .

We must always take from nature what we paint and always choose the most beautiful things.

COPY SCULPTURES RATHER THAN PAINTINGS

And if indeed you wish to copy the works of others because they are more patient in sitting than living things, I would rather have you copy an indifferent sculpture than an excellent painting. Because from paintings you will gain nothing further than ability to copy accurately, but from statues you can learn both to copy accurately and to understand and represent light and shade.

ANTONIO AVERLINO,
CALLED FILARETE

ON PAINTING

ANTONIO AVERLINO, who assumed the humanistic name of Filarete—in Greek, lover of virtue—was a distinguished sculptor and architect who made the bronze doors of St. Peter's in Rome and the Ospedale Maggiore in Milan.

Like the ancient Plato and the more recent Thomas More and Campanella, Filarete embodied his theories in the description of an imaginary city. His *Treatise of Architecture,* written between 1451 and 1464, is in the form of a dialogue between the artist and Francesco Sforza, Duke of Milan, whom he imagines to have charged him with the plans of a city called *Sforzinda.*

On perspective, compare, among others, Alberti, p. 34, and Piero, p. 44. On expression, compare Leonardo, p. 52.

IMPORTANCE OF PERSPECTIVE

I really believe Pippo di Ser Brunellesco invented this perspective, which formerly was not in use. The ancients, though they

39

were very subtle and acute, yet never used or understood this manner of perspective. Although they showed good discernment in their works, yet they did not set objects on the floor by these rules and methods.

You might object: "Perspective is deceitful, because it shows you something that does not exist." True; nonetheless in a drawing it is truthful because a drawing is not a true thing, either; on the contrary, it is a mere image of the thing that you portray or intend to show. So that perspective is truthful and perfectly suited for its purpose; and without it you cannot practice properly the art of painting or the art of sculpture.

You might also say: "You praised so highly the painters of antiquity and Giotto and many others who did not use these measurements and foreshortenings and so many things which you would have us know, and yet they were good masters and made handsome and laudable works." You speak true; but if they had known and used these ways and methods and measurements, they would have been far better. And if you want to convince yourself, look at those buildings of theirs: sometimes the figures are almost taller than the houses! And furthermore, they present to our view the upper and lower sides of an object at the same time!

You might reply: "Perhaps they knew perspective, but deliberately did not use it, to spare the trouble." This is not the case; because it is far less trouble when you know it, for you can draw every object according to measure, and you have always a guidance for whatever you want to depict, and you know where to place each object represented and you cannot go wrong.

So that I conclude by saying: if you want to be a good draftsman you must be acquainted with perspective and use it whenever you draw.

PROPRIETY OF EXPRESSION AND DRESS

Images of saints also should conform to their historical character. If you are doing a St. Anthony you must make him not timid, but spirited. And so is the case with St. George, as Donatello did him; which really is an excellent and perfect figure . . .

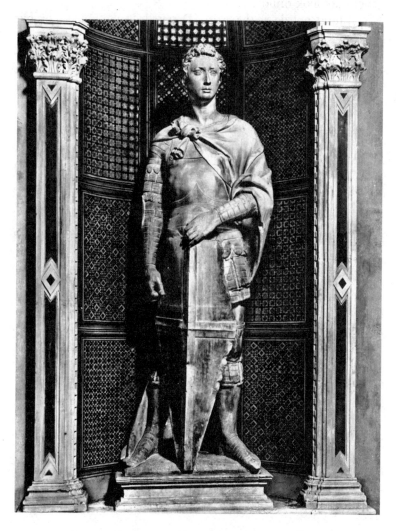

DONATELLO: St. George from Orsanmichele, 1415-1416

And likewise if you are doing a St. Michael slaying the devil, he should not look timid . . .

You must not do as the artist [Donatello] who made a bronze horse as a memorial to Gattamelata, which is so incongruous that he got little praise for it. For when you make the figure of a modern man, you must not dress it in the antique costume; but just as he is in the habit of going dressed, so you should represent him. [Compare Canova, p. 196.]

COLOR HARMONIES

Near green any color looks good: yellow, and red, and even blue will not look bad. White and black—you know how well they go together. Red does not agree so well with yellow; it agrees very well with blue, but better still with green. White agrees very well with red.

The knowledge of painting is a fine and worthy thing, and really an art for a gentleman.

PIERO DELLA FRANCESCA

ON PERSPECTIVE

WITH PIERO DELLA FRANCESCA, as with Leonardo, art and science were two aspects of the same Renaissance passion for clarity, precision, and understanding. Looking at Piero's paintings, one might guess that he was also a mathematician. Towards the end of his life he wrote one book on perspective and another, called *The Five Regular Bodies,* on geometry. Compare the opinions of Alberti, p. 34, and Leonardo, p. 50.

DIVISION OF PAINTING

Painting comprises three principal parts, which we say are Drawing, Commensuration, and Coloring. By Drawing we mean profiles and contours as they actually exist in the object. Commensuration [i.e., perspective] we call the same profiles and contours reduced proportionately and drawn in their places. By Coloring we mean colors as they show themselves in things, bright or dark according as light varies them.

43

THE IMPORTANCE OF PERSPECTIVE

Many painters censure perspective because they do not understand the purpose of the lines and angles that are constructed by it, and that enable us to represent with the right proportions the outline and shape of any object. Therefore I think I should explain how necessary this science is to painting.

I say that this word "perspective" signifies objects seen from afar and represented upon certain given planes in various scales depending on their distances. Without perspective it is impossible to foreshorten anything correctly. Now since painting is nothing but a representation of surfaces and solids foreshortened or enlarged, and placed upon the picture plane according as the real things viewed by the eye under various angles appear on the said plane; and since in every magnitude one part is always nearer to the eye than another, and the nearer part appears upon the assigned plane under a greater angle than the farther part; and since our intellects are unable by themselves to estimate these measures, that is, how large the nearer part should be and how large the farther; I conclude that perspective is necessary, inasmuch as it determines as a true science the apparent size of each magnitude, indicating by means of lines how much each must be shortened or lengthened.

Many ancient painters earned everlasting praise by cultivating perspective: Aristomenes of Thasos, Polycles, Apelles, Andramides, Nitheo, Zeuxis, and many others. To be sure, many painters without perspective have also been praised; but they were praised with false-judgments by men ignorant of the value of this art.

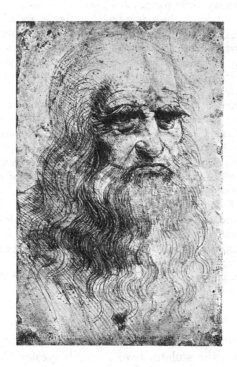

LEONARDO DA VINCI

EXTRACTS FROM HIS NOTEBOOKS

SOME PHILOSOPHERS have distinguished the practical from the speculative genius; Leonardo is one of the most perfect examples of the speculative kind. Possessed of an unquenchable thirst for knowledge, he investigated nature in all her aspects. For him art and science were two closely related activities, two means for describing the physical world. "The mind of the painter," he wrote, "should be like a mirror which is filled with as many images as there are things placed before him."

Leonardo undertook the composition of many treatises on the arts and the sciences, but he died before having published any of them. However, much of the material he had gathered has come down to us, either in the notebooks he used to carry in his pocket to jot down his thoughts "without

order," or in other manuscripts in which he or his disciples transcribed his notes.

The chief literary works planned and partly composed by Leonardo were: a treatise on anatomy, which was probably also to include embryology, physiology, and the study of expressions, attitudes, and the functions of the eye and ear; a treatise on mechanics, dealing with motion, weight, force, and percussion; a treatise on water; a treatise on painting; and a treatise on the flight of birds. He also left notes on geometry, bronze casting, ancient weapons, a bestiary, riddles, fables, etc.

Many of Leonardo's notebooks are now preserved in European libraries. But the number of those that perished, during the artist's lifetime or since, must be very large. Leonardo was left-handed, and all his notes were done in mirror-writing, backwards, from right to left.

Of the treatise on painting, besides the fragments scattered in the surviving manuscripts by Leonardo's hand, we have a version probably compiled at the beginning of the sixteenth century by one of his pupils. This is the *Codex Vaticanus Urbinas 1270,* published by H. Ludwig (Vienna, 1882). It contains many paragraphs undoubtedly by Leonardo but not found in his extant autographs. Leonardo, however, is not to be held responsible for the arrangement, which is the compiler's. An abridged version was published in Paris in 1651 and several times since.

In the following passages from Leonardo's treatise, both the autographs and the *Codex Urbinas* have been drawn upon.

THE DIFFERENCE BETWEEN PAINTING AND SCULPTURE

I do not find any other difference between painting and sculpture than that the sculptor's work entails greater physical effort and the painter's greater mental effort. The truth of this can be proved; for the sculptor, in carving his statue out of marble or other stone wherein it is potentially contained, has to take off the superfluous and excessive parts with the strength of his arms and the strokes of the hammer—a very mechanical exercise causing much perspiration, which, mingling with the grit, turns into mud. His face is pasted and smeared all over with marble powder, making him look like a baker, he is covered with minute chips as if emerging from a snowstorm, and his dwelling is dirty and filled with dust and chips of stone.

How different the painter's lot—we are speaking of first-rate painters and sculptors—for the painter sits in front of his work at perfect ease. He is well dressed and handles a light brush dipped

in delightful color. He is arrayed in the garments he fancies, and his home is clean and filled with delightful pictures, and he often enjoys the accompaniment of music or the company of men of letters, who read to him from various beautiful works to which he can listen with great pleasure without the interference of hammering and other noises.

Moreover, the sculptor in completing his work has to draw many outlines for each figure in the round so that the figure should look well from every aspect. And these contours are composed of protrusions and depressions flowing into one another, and can only be correctly drawn when viewed from a distance whence the concavities and projections can be seen silhouetted against the surrounding atmosphere. But this cannot be said to add to the difficulties of the sculptor, considering that he, as well as the painter, has an accurate knowledge of all the outlines of objects from every aspect and that this knowledge is always at the disposal of both the painter and the sculptor . . .

The sculptor says that if he takes off too much he cannot add on, like the painter. To this we reply that if he were proficient in his art he would, with his knowledge of the required measures, have taken off just enough and not too much. His taking away is due to ignorance, which makes him take off more or less than he should.

SCULPTURE IS LESS INTELLECTUAL THAN PAINTING

As practicing myself the art of sculpture no less than that of painting, and doing both the one and the other in the same degree, it seems to me that without suspicion of unfairness I may venture to give an opinion as to which of the two is the more intellectual and of the greater difficulty and perfection.

In the first place, sculpture is dependent on certain lights—namely, those from above—while a picture carries everywhere with it its own light and shade; light and shade therefore are essential to sculpture. In this respect the sculptor is aided by the nature of the relief, which produces these of its own accord, but the painter artificially creates them by his art in places where nature would normally do the like. The sculptor cannot render the difference

in the varying natures of the colors of objects; painting does not fail to do so in any particular. The lines of perspective of sculptors do not seem in any way true; those of painters may appear to extend a hundred miles beyond the work itself. The effects of aerial perspective are outside the scope of sculptors' work; they can represent neither transparent bodies, nor luminous bodies, nor angles of reflection, nor shining bodies such as mirrors and like things of glittering surface, nor mists, nor dull weather, nor an infinite number of things which I forbear to mention lest they should prove wearisome. [Compare Cellini, p. 87.]

PAINTING AND POETRY

Poetry is superior to painting in the presentation of words, and painting is superior to poetry in the presentation of facts. For this reason I judge painting to be superior to poetry . . .

If poetry treats of moral philosophy, painting has to do with natural philosophy; if the one describes the workings of the mind, the other considers what the mind effects by movements of the body; if the one dismays folk by hellish fictions, the other does the like by showing the same things in action. Suppose the poet sets himself to represent some image of beauty or terror, something vile and foul, or some monstrous thing, in contest with the painter, and suppose in his own way he makes a change of forms at his pleasure, will not the painter still satisfy the more? Have we not seen pictures which bear so close a resemblance to the actual thing that they have deceived both men and beasts?

HOW HE WHO DESPISES PAINTING HAS NO LOVE
FOR THE PHILOSOPHY OF NATURE

If you despise painting, which is the sole imitator of all the visible works of nature, it is certain that you will be despising a subtle invention with which philosophical and ingenious speculation takes as its theme all the various kinds of forms, airs and scenes, plants, animals, grasses and flowers, which are surrounded by light and shade. And this truly is a science and the true-born daughter of nature, since painting is the offspring of nature. But

in order to speak more correctly we may call it the grandchild of nature; for all visible things derive their existence from nature, and from these same things is born painting. So therefore we may justly speak of it as the grandchild of nature and as related to God Himself.

THE PAINTER HAS THE UNIVERSE IN HIS MIND AND HANDS

If the painter wishes to see enchanting beauties, he has the power to produce them. If he wishes to see monstrosities, whether terrifying, or ludicrous and laughable, or pitiful, he has the power and authority to create them. If he wishes to produce towns or deserts, if in the hot season he wants cool and shady places, or in the cold season warm places, he can make them. If he wants valleys, if from high mountaintops he wants to survey vast stretches of country, if beyond he wants to see the horizon on the sea, he has the power to create all this; and likewise, if from deep valleys he wants to see high mountains or from high mountains deep valleys and beaches. Indeed, whatever exists in the universe, whether in essence, in act, or in the imagination, the painter has first in his mind and then in his hands. His hands are of such excellence that they can present to our view simultaneously whatever well-proportioned harmonies real things exhibit piecemeal.

HOW TO STUDY

First study science, and then follow with practice based on science.

The painter who draws by practice and judgment of the eye without the use of reason is like the mirror that reproduces within itself all the objects which are set opposite to it without knowledge of the same.

The youth ought first to learn perspective, then the proportions of everything, then he should learn from the hand of a good master in order to accustom himself to good limbs; then from nature in order to confirm for himself the reasons for what he has learned; then for a time he should study the works of different masters; then make it a habit to practice and work at his art.

ON IMITATING PAINTERS

I tell painters never to imitate other painters' manners because, by so doing, they will be called grandsons, and not sons of nature, as far as art is concerned. For, as natural things are so plentiful, one must rather have recourse to nature herself than to the masters who have learned from nature. And I say this not to those who desire to gain riches by their art but to those who desire fame and honor. This we see was the case with the painters who came after the time of the Romans, for they continually imitated each other, and from age to age their art steadily declined.

After these came Giotto the Florentine, and he—reared in mountain solitudes, inhabited only by goats and suchlike beasts—turning straight from nature to his art, began to draw on the rocks the movements of the goats which he was tending, and so began to draw the figures of all the animals which were to be found in the country, in such a way that after much study he not only surpassed the masters of his own time but all those of many preceding centuries. After him art again declined, because all were imitating paintings already done; and so for centuries it continued to decline until such time as Tommaso the Florentine, nicknamed Masaccio, showed by the perfection of his work how those who took as their standard anything other than nature, the supreme guide of all the masters, were wearying themselves in vain. [Compare Vasari, p. 96.]

THE REQUISITES OF PAINTING

The first requisite of painting is that the bodies which it represents should appear in relief, and that the scenes which surround them with effects of distance should seem to enter into the plane in which the picture is produced by means of the three parts of perspective, namely, the diminution in the distinctness of the form of bodies, the diminution in their size, and the diminution in their color . . .

The second requisite of painting is that the actions should be appropriate and have a variety in the figures, so that the men may not all look as though they were brothers.

THE PAINTER MUST KNOW ANATOMY

It is a necessary thing for the painter, in order to be able to fashion the limbs correctly in the positions and actions which they can represent in the nude, to know the anatomy of the sinews, bones, muscles, and tendons in order to know, in the various different movements and impulses, which sinew or muscle is the cause of each movement, and to make only these prominent and thickened, and not the others all over the limb, as do many who, in order to appear great draftsmen, make their nudes wooden and without grace, so that it seems rather as if you were looking at a sack of nuts than a human form or at a bundle of radishes rather than the muscles of nudes.

PROPORTIONS OF THE HUMAN FIGURE

From the chin to the starting of the hair is a tenth part of the figure.

From the chin to the top of the head is an eighth part.

And from the chin to the nostrils is a third part of the face.

And the same from the nostrils to the eyebrows, and from the eyebrows to the starting of the hair.

If you set your legs so far apart as to take a fourteenth part from your height, and you open and raise your arms until you touch the line of the crown of the head with your middle fingers, you must know that the center of the circle formed by the extremities of the outstretched limbs will be the navel, and the space between the legs will form an equilateral triangle.

The span of a man's outstretched arms is equal to his height. [Compare Cennini, p. 24; and Duerer, p. 83.]

HOW TO COMPOSE GROUPS OF FIGURES IN HISTORICAL PICTURES

When you have thoroughly learned perspective and have fixed in your memory all the various parts and forms of things, you should often amuse yourself, when you take a walk for recreation, by watching and taking note of the attitudes and actions of men as they talk and dispute, or laugh or come to blows one with another—both their actions and those of the bystanders who either

intervene or stand looking on at these things; noting them down with rapid strokes in this way, in a little pocket book, which you ought always to carry with you.

HOW TO REPRESENT AN ANGRY FIGURE

An angry figure should be represented seizing someone by the hair and twisting his head down to the ground, with one knee on his ribs, and with the right arm and fist raised high up; let him have his hair disheveled, his eyebrows knit together, his teeth clenched, the two corners of the mouth arched, and the neck (which is all swollen and extended as he bends over the foe) full of furrows.

A GOOD PAINTER IS TO PAINT MAN AND HIS MIND

A good painter is to paint two main things, namely, man and the working of man's mind. The first is easy, the second difficult, for it is to be represented through the gestures and movements of the limbs. And these may best be learned from the dumb, who make them more clearly than any other sort of men.

MOTIONS OF FIGURES

Never set the heads of your figures straight above the shoulders, but turn them sideways to the right or to the left, even though they may be looking up, or down, or straight forward. Because it is necessary so to design their attitudes that they appear sprightly and awake, and not torpid and sleepy.

CHOICE OF BEAUTIFUL FACES

Methinks it is no small grace in a painter to be able to give a pleasing air to his figures, and whoever is not naturally possessed of this grace may acquire it by study, as opportunity offers, in the following manner. Be on the watch to take the best parts of many beautiful faces, of which the beauty is established rather by general repute than by your own judgment, for you may readily deceive yourself by selecting such faces as bear a resemblance to your own, since it would often seem that such similarities please us.

WHETHER IT IS BETTER TO DRAW IN COMPANY OR ALONE

I say and confirm that it is far better to draw in company than alone for many reasons: the first is that you will be ashamed to be seen among the draftsmen if you are unskillful, and this shame will cause you to study well. In the second place, a feeling of emulation will goad you to try to rank among those who are praised more than yourself, for praise will spur you; a third reason is that you will learn from the methods of such as are abler than you, and if you are abler than the others you will profit by eschewing their faults, and hearing yourself praised will increase your skill.

HOW TO MAKE AN IMAGINARY ANIMAL APPEAR NATURAL

You know that you cannot make any animal without it having its limbs such that each bears some resemblance to that of some one of the other animals. If, therefore, you wish to make one of your imaginary animals appear natural—let us suppose it to be a dragon—take for its head that of a mastiff or setter, for its eyes those of a cat, for its ears those of a porcupine, for its nose that of a greyhound, with eyebrows of a lion, the temples of an old cock, and the neck of a water tortoise.

HOW TO PORTRAY FACES, GIVING THEM CHARM OF LIGHT AND SHADE

Very great charm of light and shade is to be found in the faces of those who sit in the doors of dark houses. The eyes of the observer see the shaded part of such faces darkened by the shade of the house, and the illuminated part of them brightened by the luminosity of the atmosphere. From this intensification of light and shadow the faces gain relief, for the illuminated part has almost imperceptible shadows and the shaded part has almost imperceptible lights. This manner of treating and intensifying light and shadow adds much to the beauty of faces.

COLORS

The color of the object illuminated partakes of the color of that which illuminated it . . .

The medium that is between the eye and the object seen transforms the object into its own color. So the blueness of the atmosphere causes the distant mountains to seem blue; red glass causes everything that the eye sees through it to seem red.

The surface of every opaque body shares in the color of the surrounding objects.

SHADOWS

Since white is not a color but is capable of becoming the recipient of every color, when a white object is seen in the open air all its shadows are blue . . .

The shadows of verdure always approximate to blue, and so it is with every shadow of every other thing, and they tend to this color more entirely when they are farther distant from the eye, and less in proportion as they are nearer.

The shadow of flesh should be of burnt *terra verde*.

THE PAINTER SHOULD BE DESIROUS OF HEARING
EVERY MAN'S OPINION

Surely when a man is painting a picture he ought not to refuse to hear any man's opinion, for we know very well that though a man may not be a painter he may have a true conception of the form of another man, and can judge aright whether he is humpbacked or has one shoulder high or low, or whether he has a large mouth or nose or other defects.

THE MIRROR IS THE MASTER OF PAINTERS

When you wish to see whether the general effect of your picture corresponds with that of the object presented by nature, take a mirror and set it so that it reflects the actual thing, and then compare the reflection with your picture and consider carefully whether the subject of the two images is in conformity with both, studying especially the mirror. [Compare Alberti, p. 36.]

WHAT PAINTING IS THE MOST PRAISEWORTHY

That painting is the most praiseworthy which is most like the thing represented.

OF THE LIFE OF THE PAINTER IN HIS STUDIO

The painter or draftsman ought to be solitary, in order that the well-being of the body may not sap the vigor of the mind. [Compare Cennini, p. 23; contrast Whistler, p. 350.]

ADVICE TO THE PAINTER

O painter, take care lest the greed for gain prove a stronger incentive than renown in art, for to gain this renown is a far greater thing than is the renown of riches.

TO LUDOVICO SFORZA

In 1482, when Leonardo was thirty, he was sent by Lorenzo the Magnificent of Florence to Duke Ludovico il Moro of Milan, to present him with a silver lyre in the shape of a horse's skull. In the following letter the artist, desirous of finding employment with Ludovico, enumerates his manifold abilities. His application was successful.

[Ca. 1482]

Having now sufficiently seen and considered the proofs of all those who count themselves masters and inventors of instruments of war, and finding that their invention and use of the said instruments does not differ in any respect from those in common practice, I am emboldened without prejudice to anyone else to put myself in communication with Your Excellency, in order to acquaint you with my secrets, thereafter offering myself at your pleasure effectually to demonstrate at any convenient time all those matters which are in part briefly recorded below.

1. I have plans for bridges, very light and strong and suitable for carrying very easily, with which to pursue and at times defeat the enemy; and others solid and indestructible by fire or assault, easy and convenient to carry away and place in position. And plans for burning and destroying those of the enemy.

2. When a place is besieged I know how to cut off water from the trenches, and how to construct an infinite number of bridges, mantlets, scaling ladders, and other instruments which have to do with the same enterprise.

3. Also if a place cannot be reduced by the method of bombardment, either through the height of its glacis or the strength of its position, I have plans for destroying every fortress or other stronghold unless it has been founded upon rock.

4. I have also plans for making cannon, very convenient and easy of transport, with which to hurl small stones in the manner almost of hail, causing great terror to the enemy from their smoke, and great loss and confusion.

5. Also I have ways of arriving at a certain fixed spot by caverns and secret winding passages, made without any noise, even though it may be necessary to pass underneath trenches or a river.

6. Also I can make armored cars, safe and unassailable, which will enter the serried ranks of the enemy with their artillery, and there is no company of men at arms so great that they will not break it. And behind these the infantry will be able to follow quite unharmed and without any opposition.

7. Also, if need shall arise, I can make cannon, mortars, and light ordnance, of very beautiful and useful shapes, quite different from those in common use.

8. Where it is not possible to employ cannon, I can supply catapults, mangonels, *trabocchi* [old war engines: trébuchets], and other engines of wonderful efficacy not in general use. In short, as the variety of circumstances shall necessitate, I can supply an infinite number of different engines of attack and defense.

9. And if it should happen that the engagement is at sea, I have plans for constructing many engines most suitable either for attack or defense, and ships which can resist the fire of all the heaviest cannon, and powder and smoke.

10. In time of peace I believe that I can give you as complete satisfaction as anyone else in architecture in the construction of buildings both public and private, and in conducting water from one place to another.

Also I can execute sculpture in marble, bronze, or clay, and also painting, in which my work will stand comparison with that of anyone else, whoever he may be.

Moreover, I would undertake the work of the bronze horse, which shall perpetuate with immortal glory and eternal honor

the auspicious memory of the Prince your father and of the illustrious house of Sforza.

And if any of the aforesaid things should seem impossible or impracticable to anyone, I offer myself as ready to make trial of them in your park or in whatever place shall please Your Excellency, to whom I commend myself with all possible humility.

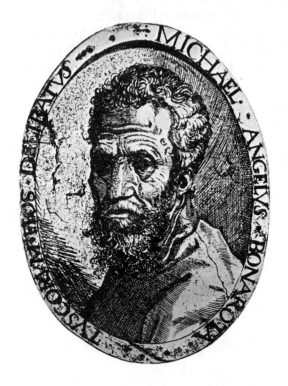

MICHELANGELO BUONARROTI

TO GIOVANNI DA PISTOIA

IN 1505, at the request of Pope Julius II, Michelangelo left Florence to work for the Pope in Rome (see p. 61). The years 1508 to 1512 he spent on the execution of the vault of the Sistine Chapel, frescoes which he executed almost singlehanded and for which he had the greatest difficulty in getting paid (see p. 62). Vasari relates that "he worked with great inconvenience to himself, having to labor with his face turned upwards, and impaired his eyesight so much in the progress of the work that he could neither read letters nor examine drawings for several months afterwards, except in the same attitude of looking upwards."

I've grown a goiter by dwelling in this den—
 As cats from stagnant streams in Lombardy,
 Or in what other land they hap to be—
 Which drives the belly close beneath the chin;
My beard turns up to heaven; my nape falls in,
 Fixed on my spine: my breast-bone visibly
 Grows like a harp: a rich embroidery
 Bedews my face from brush-drops thick and thin.
My loins into my paunch like levers grind:
 My buttock like a crupper bears my weight;
 My feet unguided wander to and fro;
In front my skin grows loose and long; behind,
 By bending it becomes more taut and strait;
 Crosswise I strain me like a Syrian bow:
 Whence false and quaint, I know,
 Must be the fruit of squinting brain and eye;
 For ill can aim the gun that bends awry.
 Come then, Giovanni, try
 To succor my dead pictures and my fame,
 Since foul I fare and painting is my shame.

ON BEAUTY

THE PURPOSE of Michelangelo's art was religious—the unfolding of the basic tenets of the Christian faith: creation, redemption, damnation, and salvation. The means was the representation of beauty. In the doctrines of Plato, Dante, and Ficino the artist found a metaphysical formulation of his mystical longing, of his unshakable faith, of his love of beauty, and of his artistic practice.

Beauty was given at my birth to serve
As my vocation's faithful exemplar,
The light and mirror of two sister arts:
Who otherwise believes in judgment errs.
She alone lifts the eye up to that height
For which I strive, to sculpture and to paint.
O rash and blind the judgment that diverts

To sense the Beauty which in secret moves
And raises each sound intellect to Heaven!
No eye infirm the interval may pass
From mortal to divine, nor thither rise
Where without grace to ascend the thought is vain.

Mine eyes that are enamored of things fair
And this my soul that for salvation cries
May never heavenward rise
Unless the sight of beauty lifts them there.
Down from the loftiest star
A splendor falls on earth,
And draws desire afar
To that which gave it birth.
So love and heavenly fire and counsel wise
The noble heart finds most in starlike eyes.

TO GIORGIO VASARI

MICHELANGELO SENT the following sonnet to his great admirer Vasari in
1554, ten years before his death. He accompanied it with a letter declaring:
"I would gladly rest my tired bones beside those of my father, but for the
fear that my departure should cause great injury to the building of St.
Peter's, which would be a great shame as well as a great sin."

The course of my long life has reached at last,
 In fragile bark o'er a tempestuous sea,
 The common harbor, where must rendered be
 Account of all the actions of the past.
The impassioned phantasy, that, vague and vast,
 Made art an idol and a king to me,
 Was an illusion, and but vanity
 Were the desires that lured me and harassed.
The dreams of love, that were so sweet of yore,
 What are they now, when two deaths may be mine,—
 One sure, and one forecasting its alarms?

Painting and sculpture satisfy no more
The soul now turning to the Love Divine,
That oped, to embrace us, on the cross its arms.

THE TRAGEDY OF THE SEPULCHER

IN 1505 Pope Julius II della Rovere summoned Michelangelo to Rome, entrusting him with the execution of his tomb, and dispatched him to Carrara to select the marble. But soon, at the instigation of Bramante, the Pontiff changed his mind and turned to other plans. Irritated by Michelangelo's insistence, he had him driven out of the palace by a groom. Angry, and perhaps frightened by his rivals, Michelangelo fled to Florence. In 1506, however, he met the Pope in Bologna, asked and obtained his forgiveness, and, after completing the bronze statue of the Pope (1506-1508) and the Sistine vault (1508-1512; see p. 62), resumed his work on the tomb.

After Julius' death (1513) Michelangelo was continually harassed on the one hand by the della Rovere family, who demanded the fulfillment of his contracts and the completion of the tomb, even accusing him of having diverted funds to his own use; and on the other by the Medici Popes—Leo X and Clement VII—who claimed the sculptor's time all for themselves, and employed him for other works at Florence. Michelangelo was forced to make successive agreements with the della Rovere, gradually reducing the size of the monument, and he turned parts of it over to assistants. Thus the funeral monument of Pope Julius was a source of bitterness, dispute, and difficulty which afflicted Michelangelo for the better part of his life.

TO SER GIOVAN FRANCESCO FATTUCCI [*Florence, January, 1524*]

You ask me in your letter how my affairs stand with regard to Pope Julius. I tell you that if I could claim damages and interest, according to my own estimate I should prove to be the creditor rather than the debtor.

When he sent for me to Florence—I believe it was in the second year of his pontificate—I had already undertaken to decorate one half of the Sala del Consiglio in Florence, that is to say, to paint it; and I was to have three hundred ducats for the work. As all Florence knows, I had already drawn the cartoon, so that the

money seemed half earned. Besides this, of the Twelve Apostles which I had been commissioned to carve for Santa Maria del Fiore, one had already been roughed out, as may still be seen; and I had already collected the greater part of the marble for the others. When Pope Julius took me away from here I received nothing in respect of one work or the other . . .

Afterwards, when Pope Julius first went to Bologna, I was obliged to go with the collar of penitence round my neck and beg his forgiveness: whereupon he commissioned me to execute a statue of himself in bronze, which was to be about seven braccia in height, seated. When he asked what the cost would be I said I believed I could cast it for a thousand ducats, but that it was not my trade, and that I did not wish to bind myself. He replied, "Go, and get to work: cast it as often as is necessary until you are successful, and we will give you enough money to satisfy you." To be brief, it had to be cast twice; and at the end of the two years I spent there I found myself four ducats and a half to the good . . .

Having hoisted the figure up to its position on the façade of San Petronio [Bologna], I then returned to Rome; but Pope Julius did not yet wish me to go on with the tomb, and set me to paint the vault of the Sistine Chapel, the price of the work being fixed at three thousand ducats. The first design consisted of figures of the Apostles within the lunettes, while certain portions were to be decorated after the usual manner.

As soon as I had begun this work I realized that it would be but a poor thing, and I told the Pope how, in my opinion, the placing of the Apostles there alone would have a very poor effect. He asked why, and I replied, "Because they also were poor." He then gave me fresh instructions, which left me free to do as I thought best, saying that he would satisfy me, and that I was to paint right down to the pictures below. When the vault was approaching completion the Pope returned to Bologna: wherefore I went to him there on two occasions for the money due to me, but it was to no purpose, and all my time was thrown away until he came back to Rome.

Your Lordship has sent to me saying I am to begin painting and to have no fear. My answer is that a man paints with his brains and not with his hands, and if he cannot have his brains clear he will come to grief. Therefore I shall be able to do nothing well until justice has been done me . . .

In the first year of Julius' pontificate, when he gave me the contract for making the tomb, I spent eight months at Carrara quarrying the blocks which I subsequently transported to the Piazza di San Pietro, where I had a workshop behind the church of Santa Caterina. Afterwards Pope Julius did not want to proceed with the tomb during his own life, and set me to painting . . .

When sundry barge-loads of marble which had been ordered from Carrara some time before arrived at Ripa, I could not get any money from the Pope because he had decided not to go on with the work. I had to pay the freightage, between a hundred and two hundred ducats, with money borrowed from Baldassare Balducci—from Messer Iacopo Gallo's bank, that is—for the purpose of discharging the said account . . .

I urged the Pope to allow the work to proceed as far as possible, and one morning when I went to discuss the matter with him he caused me to be turned out by one of his grooms. The Bishop of Lucca, who witnessed the act, said to the groom: "Do you not know who that is?" to which the groom replied: "Pardon me, Sir, but I have been ordered to act as I am doing."

I went home and wrote to the Pope as follows: "Most holy Father: this morning I was driven from the Palace by Your Holiness' orders: I give you to understand that from henceforth if you desire my services you must seek them elsewhere than in Rome." . . . I went out and took the post, departing in the direction of Florence.

As soon as the Pope received my letter he sent five-horsemen after me, who came up with me at Poggibonsi about the third hour of the night, and presented a letter to me from the Pope of the following tenor: "Immediately on receipt of this present thou

MICHELANGELO: Drawing for the Tomb of Pope Julius II, 1516 (?)

must return to Rome on pain of Our displeasure." The horsemen desired me to send a reply in order to show that they had delivered the letter; so 'I said that as soon as the Pope would carry out his obligations towards me I would return, otherwise he need never expect to see me again.

And afterwards, while I was living in Florence, Julius sent three Briefs to the Signoria concerning me. At last the Signoria sent for me and said: "We cannot go to war with Pope Julius on thine account: thou must go back. If thou wilt return to him We will give thee a letter making it clear that any injury done to thee will be treated as an injury done to Us." In order to please them I went back to the Pope; and it would take a long time to narrate all that happened afterwards . . .

All the disagreements that arose between Pope Julius and myself were due to the jealousy of Bramante and of Raffaello da Urbino; it was because of them that he did not proceed with the tomb during his own life, and they brought this about in order that I might thereby be ruined. Yet Raffaello was quite right to be jealous of me, for all he knew of art he learned from me.

TO BENEDETTO VARCHI

BENEDETTO VARCHI, well-known man of letters and historian, in 1546 sent a questionnaire to a number of artists of his acquaintance asking their views on the time-honored question of the pre-eminence of the arts. We have the answers of the painters Pontormo (see p. 85), Bronzino, and Vasari; the sculptors Cellini (see p. 87), Tribolo, and Francesco da Sangallo; and the inlayer Tasso. In 1549 Varchi sent his book, in which the same problems were discussed, to Michelangelo, whose reply follows. With his views compare also those of Leonardo, p. 46.

RELATIVE MERITS OF PAINTING AND SCULPTURE

[*Rome, 1549*]

So that it may be clear that I have received your little book, which duly reached me, I will make such a reply as I can to what you ask, although I am very ignorant on the subject. In my opinion painting should be considered excellent in proportion as it

approaches the effect of relief, while relief should be considered bad in proportion as it approaches the effect of painting.

I used to consider that sculpture was the lantern of painting and that between the two things there was the same difference as that between the sun and the moon. But now that I have read your book, in which, speaking as a philosopher, you say that things which have the same end are themselves the same, I have changed my opinion; and I now consider that painting and sculpture are one and the same thing, unless greater nobility be imparted by the necessity for a better judgment, greater difficulties of execution, stricter limitations and harder work. And if this be the case no painter ought to think less of sculpture than of painting and no sculptor less of painting than of sculpture. By sculpture I mean the sort that is executed by cutting away from the block: the sort that is executed by building up resembles painting.

This is enough, for as one and the other (that is to say, both painting and sculpture) proceed from the same faculty, it would be an easy matter to establish harmony between them and to let such disputes alone, for they occupy more time than the execution of the figures themselves. As to that man who wrote saying that painting was more noble than sculpture, as though he knew as much about it as he did of the other subjects on which he has written, why, my serving-maid would have written better!

An infinite number of things still remain unsaid which might be urged in favor of these arts, but, as I have already said, they would take up too much time and I have very little to spare, seeing that I am old and almost fitted to be numbered among the dead. For this reason I beg of you to excuse me.

CONVERSATIONS WITH VITTORIA COLONNA AS RECORDED BY FRANCISCO DE HOLLANDA

FRANCISCO DE HOLLANDA, a Portuguese miniaturist (1517-1584), lived for eight years in Italy, during which time he became acquainted with Michelangelo. He was present at some conversations between the sculptor, the Roman princess Vittoria Colonna, devoted friend of Michelangelo's old age, and some learned men, which he recorded in his *De Pintura Antigua*. There

is some question as to how far these quotations are historically accurate. It seems worth while, however, to quote a few passages that appear to express faithfully Michelangelo's sentiments as they are known to us from other sources.

GENIUS AND SOCIABILITY

There are many who maintain a thousand lies, and one is that eminent painters are strange, harsh, and unbearable in their manner, although they are really human and humane. And these fools, and not sensible persons, consider them fantastic and capricious and are loath to tolerate such characteristics in a painter. It is true that for such characteristics to exist the painter must exist; and him you will scarcely find outside of Italy, where things attain their perfection. But idle, unskilled persons are wrong to demand great ceremony from a busy, skillful man, since few persons excel in their work, and certainly none of those who bring such accusations. For excellent painters are not unsociable from pride, but either because they find few minds capable of the art of painting or in order not to corrupt themselves with the vain conversation of idle persons and degrade their thoughts from the intense and lofty imaginings in which they are continually rapt. And I assure Your Excellency that even his Holiness sometimes annoys and wearies me when he speaks to me and insistently inquires why I do not go to see him; and I sometimes think I serve him better by not answering his summons, against my own interest, and working for him in my house; and I tell him that I serve him better then as Michelangelo than by standing all day before him, as others do . . .

I assure you that at times my grave concern for my art makes me so free that, as I stand talking to the Pope, I thoughtlessly put this old felt hat on my head and speak to him very freely. And they have not killed me for that, rather he has given me a livelihood . . .

Why seek to embarrass [the artist] with vanities foreign to his quietness? Know you not that certain sciences require the whole man, leaving no part of him at leisure for your trifles? When he has as little to do as you have, then in good sooth he will observe

ractices and ceremonies, better than you do yourselves. You know this man and praise him in order to do yourselves honor, and are delighted if he be found worthy of the conversation of a pope or an emperor. And I would even venture to affirm that a man cannot attain excellence if he satisfy the ignorant and not those of his own craft, and if he be not "singular" or "distant," or whatever you like to call him. For as to those other meek and commonplace spirits, they may be found without the need of a candle in all the highways of the world.

FLEMISH AND ITALIAN PAINTING

Flemish painting will, generally speaking, please the devout better than any painting in Italy, which will never cause him to shed a tear, whereas that of Flanders will cause him to shed many; and that not through the vigor and goodness of the painting but owing to the goodness of the devout person. It will appeal to women, especially to the very old and the very young, and also to monks and nuns and to certain noblemen who have no sense of true harmony. In Flanders they paint with a view to external exactness or such things as may cheer you and of which you cannot speak ill, as for example saints and prophets. They paint stuffs and masonry, the green grass of the fields, the shadows of trees, and rivers and bridges, which they call landscapes, with many figures on this side and many figures on that. And all this, though it pleases some persons, is done without reason or art, without symmetry or proportion, without skillful choice or boldness, and, finally, without substance or vigor. Nevertheless there are countries where they paint worse than in Flanders. And I do not speak so ill of Flemish painting because it is all bad but because it attempts to do so many things well (each one of which would suffice for greatness) that it does none well . . .

And at its best nothing is more noble or devout [than true Italian painting], since with discreet persons nothing so calls forth and fosters devotion as the difficulty of a perfection which is bound up in union with God. For good painting is nothing but a copy of the perfections of God and a recollection of His painting; it is

a music and a melody which only intellect can understand, and that with great difficulty. And that is why painting of this kind is so rare that no man may attain it.

And further I say (and he who notes this will appreciate it): There is no clime or country lit by sun or moon outside the kingdom of Italy where one can paint well . . .

Therefore I declare that no nation or people (I except one or two Spaniards) can perfectly attain or imitate the Italian manner of painting (which is that of ancient Greece) in such a way that it will not immediately be seen to be foreign, however much they may strive and toil. And if by some great miracle one of them attains excellence in painting, then, even though his aim were not to imitate Italy, we say merely that he has painted as an Italian. Thus we give the name of Italian painting not necessarily to painting done in Italy but to all good and right painting; and because Italy produces more masterly and more noble works of splendid painting than any other region, we call good painting Italian, and if good painting be produced in Flanders or in Spain (which has most affinity with us) it will still be Italian painting. For this most noble science belongs to no country; it came down from heaven; yet from of old it has always remained in our Italy more than in any other kingdom on earth, and so I think it will be to the end.

In Italy great princes as such are not held in honor or renown; it is a painter that they call divine.

NATURE AND FANCY

I shall be glad to tell you why it is the custom to paint things that have never existed and how reasonable is this license and how it accords with the truth; for some critics, not understanding the matter, are wont to say that Horace, the lyric poet, wrote these lines in dispraise of painters:

> *Pictoribus atque poetis*
> *Quidlibet audendi semper fuit aequa potestas:*
> *Scimus, et hanc veniam petimusque damusque vicissim.*

And in this sentence he does in nowise blame painters but praises and favors them, since he says that poets and painters have license

to dare—that is, to dare do what they choose. And this insight and power they have always had; for whenever (as very rarely happens) a great painter makes a work which seems to be artificial and false, this falseness is truth; and greater truth in that place would be a lie. For he will not paint anything that cannot exist according to its nature; he will not paint a man's hand with ten fingers, nor paint a horse with the ears of a bull or a camel's hump . . . But if, in order to observe what is proper to a time and place, he exchange the parts or limbs (as in grotesque work which would otherwise be very false and insipid) and convert a griffin or a deer downwards into a dolphin or upwards into any shape he may choose, putting wings in place of arms, and cutting away the arms if wings are more suitable, this converted limb, of lion or horse or bird, will be most perfect according to its nature; and this may seem false but can really only be called ingenious or monstrous. And sometimes it is more in accordance with reason to paint a monstrosity (to vary and relax the senses and the object presented to men's eyes, since sometimes they desire to see what they have never seen and think cannot exist) rather than the ordinary figure, admirable though it be, of man or animals.

THE HUMAN FIGURE THE NOBLEST THEME

To copy each one of those things after its kind seems to me to be indeed to imitate the work of God; but that work of painting will be most noble and excellent which copies the noblest object and does so with most delicacy and skill. And who is so barbarous as not to understand that the foot of a man is nobler than his shoe, and his skin nobler than that of the sheep with which he is clothed, and not to be able to estimate the worth and degree of each thing accordingly?

THE DIFFICULTY OF EASE

And I would tell you, Francisco de Hollanda, a very great excellence of this art of ours, an excellence which you perhaps already know of and will I think consider supreme: that what one must most toil and labor with hard work and study to attain in a paint-

ing is that, after much labor spent on it, it should seem to have been done almost rapidly and with no labor at all, although in fact it was not so. And this needs most excellent skill and art.

SEBASTIANO DEL PIOMBO

TO MICHELANGELO

THE ARTISTS in Rome were divided into two hostile factions, that of Raphael and that of Michelangelo (see pp. 61 and 65). Sebastiano Luciani, usually known as Sebastiano del Piombo from the office of sealer of the apostolic briefs which he later obtained, was for twenty years a close friend of Michelangelo, who consented to be godfather to his son, and often helped him by correcting the design of his pictures.

The following letter refers to Sebastiano's *Resurrection of Lazarus* and Raphael's *Transfiguration,* which were painted in competition. The Monsignore mentioned is Cardinal Giulio de' Medici, the future Clement VII, who had commissioned both pictures. Michelangelo had given some assistance to Sebastiano.

I think Leonardo [Leonardo de' Borgherini, called Sellaio] has told you everything about how my things are going and about the slowness of my work, which is not finished yet. I have delayed it so long because I do not want Raphael to see my picture until he has finished his. This has been promised me by the Very Reverend Monsignore, who has many times been to my home . . .

I earnestly regret that you were not in Rome to see two paintings by the Prince of the Synagogue [Raphael] that have gone to France [the *Holy Family of Francis I* and the *St. Michael;* both Louvre]. I am certain that one could hardly conceive anything more contrary to your views than what you would have seen in those works. I will not say anything save that they look as if the figures had been exposed to smoke, or were of polished iron, all bright and black, and drawn as Leonardo will tell you. Imagine what they are like! They are indeed a fine pair of ornaments! Stuff fit for the French.

RAPHAEL SANZIO

TO COUNT BALDASSARE CASTIGLIONE

THIS LETTER to Count Castiglione (1478-1529), the famous author of the *Courtier* and Raphael's friend, appears to have been written in 1514, perhaps with some literary help from Pietro Aretino. The drawings mentioned probably were designs for one of the *Stanze* in the Vatican, while the story of Galatea is the subject of one of the frescoes in the Farnesina. The letter is remarkable for its use of the word "idea" in the Platonic sense; it is our first recorded appearance among Renaissance artists of the "idealistic" art doctrine.

[*Rome, 1514?*]

I have made drawings of various types based on Your Lordship's suggestions, and unless everybody is flattering me, I have

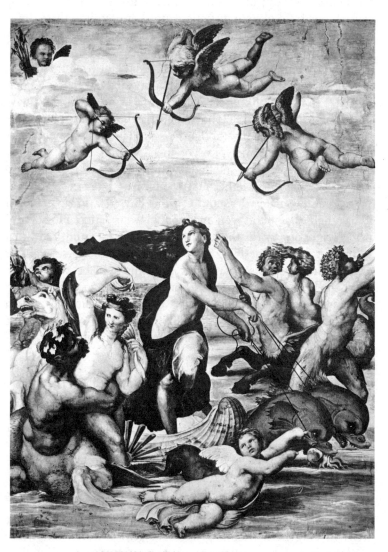

RAPHAEL: The Triumph of Galatea, 1514

satisfied everybody; but I do not satisfy my own judgment, because I am afraid of not satisfying yours. I am sending these drawings to you. Your Lordship may choose any of them, if you think any worthy of your choice.

The Holy Father, in honoring me, has laid a heavy burden upon my shoulders: the charge of the building of St. Peter's. I hope, indeed, I shall not sink under it; the more so, as the model I have made for it pleases His Holiness and has been praised by many persons of taste. But my thoughts rise still higher. I should like to revive the handsome forms of the buildings of the ancients. Nor do I know whether my flight will be a flight of Icarus. Vitruvius affords me much light, but not sufficient.

As for the Galatea, I should consider myself a great master if it had half the merits you mention in your letter. However, I perceive in your words the love that you bear me; and I add that in order to paint one fair one, I should need to see several fair ones, with the proviso that Your Lordship will be with me to select the best. But as there is a shortage both of good judges and of beautiful women, I am making use of a certain idea which comes into my mind. Whether this is possessed of any artistic excellence, I do not know. But I do strive to attain it.

ON ANCIENT ROMAN SCULPTURE

In 1515 Pope Leo X appointed Raphael Prefect of Antiquities. The following paragraph is an excerpt from a report on the plan of ancient Rome addressed to Leo in 1519. It was probably written by Raphael with the literary help of his friend Castiglione; in Raphael's letters to his family the style is rude and unpolished.

1519

Although literature, sculpture, painting, and almost all the other arts had long been declining and had grown worse and worse until the time of the last Emperors, yet architecture was still studied and practiced according to the good rules and the buildings were erected in the same style as before. Of the arts, she was the last to be lost.

Of this there are many evidences: among others, the Arch of Constantine, which is well designed and well built as far as architecture is concerned. But the sculptures of the same arch are very feeble and destitute of all art and good design. Those, however, that come from the spoils of Trajan and Antoninus Pius are extremely fine and done in a perfect style. A similar contrast may be observed in the Baths of Diocletian. The sculptures contemporary with the building and such relics of painting as are still to be seen are very bad in style and execution, and have nothing in common with those of the age of Trajan and Titus. And yet the architecture is noble and well conceived.

TITIAN VECELLIO

REMARKS ON PAINTING

THE VENETIANS did not write about their art as did the Florentines. Perhaps their dialect was less inviting to literary performance; perhaps their mode of painting was more sensuous and immediate, and less rational and scientific than the Florentine; perhaps it was based on a subtler science, not so easily expressed in words.

We quote here a few remarks attributed to Titian by the chronicler of Venetian art, Ridolfi.

Not everyone is fit to be a painter, and many deceive themselves, thus running against the difficulties of the art.

They who are compelled to paint by force, without being in the

necessary mood, can produce only ungainly works, because this profession requires an unruffled temper.

The painter, in his works, must always aim at what is suited to each subject, and represent each person with his true character and emotions, which practice will gratify the beholders amazingly.

It is not bright colors but good drawing that makes figures beautiful.

ALBRECHT DUERER

FROM HIS LETTERS AND TREATISES

DUERER IS often thought of as a typical representative of German art, as opposed to Italian. As a matter of fact, in both his writings and his paintings, he was a fervent propagandist of Italian theory and style. Duerer travelled twice to northern Italy (1494 and 1505-1507), and conceived such an admira-

tion for the "scientific" art south of the Alps that he determined to teach it to the less learned and more empirical painters of his native country.

Duerer, like Leonardo, planned a comprehensive treatise on painting, which he had no time to complete, but an outline of which was found among his papers. Two books by Duerer were published during his lifetime: *The Teaching of Measurements* (Nuremberg, 1525), and the *Fortifications of Towns, Castles, and Places* (1527). Shortly after his death appeared the celebrated *Four Books of Human Proportions* (1528), adorned with elegant illustrations which were widely used and admired all over Europe.

Other writings by the artist include his *Diary of His Journey to the Netherlands* and his *Correspondence,* with its humorous and often ribald letters to his most intimate friend, Wilibald Pirckheimer, the Nuremberg humanist and *bon vivant.*

In the following selections, the *Outline of a General Treatise on Painting* has, for typographical reasons, been rearranged in the translation.

TO WILIBALD PIRCKHEIMER *Venice, February 7, 1506*

Amongst the Italians I have many good friends who warn me not to eat and drink with their painters. Many of them are my enemies, and they copy my work in the churches and wherever they can find it; and then they revile it and say that it was not in the *antique* manner and therefore not good. But Giovanni Bellini has highly praised me before many nobles. He wanted to have something of mine, and himself came to me and asked me to paint him something and said he would pay well for it. And all men tell me what a God-fearing man he is, so that I am well-disposed toward him from the outset. He is very old, but is still the best painter of them all. And those works of art which so well pleased me eleven years ago please me no longer; if I had not seen it myself I should not have believed it of anyone else. You must know that there are many better painters here than Master Jacob (Jacopo de' Barbari) abroad, yet Anton Kolb would swear an oath that no better painter lives on earth than Jacob. Others sneer at him, saying: "if he were good he would stay here."

"OUTLINE OF A GENERAL TREATISE ON PAINTING"

[*Planned prior to 1512-1513*]

By the grace and help of God I have here set down all that I have learned in practice which is likely to be of use in painting, for the

service of all students who would gladly learn. That, perchance, by my help they may advance still further in the higher understanding of such art as he who seeks may well do, if he is inclined thereto; for my reason suffices not to lay the foundations of this great, far-reaching, infinite art of true painting.

Item. In order that you may thoroughly and rightly comprehend what is, or is called, an "artistic painter," I will inform you and recount to you. For the world often goes without an "artistic painter," in that for two or three hundred years none such appears; and this is in great part because those who might have become such were prevented from devoting themselves thereto. Observe then the three essential points following, which belong to the true artist in painting. These are the three main points in the whole book.

[I.] The First Division of the book is the Prologue, and it comprises three parts [A, B, and C].

[A.] The first part of the Prologue tells us how the lad should be taught, and how attention should be paid to the quality of his temperament. It falls into six parts:

First, that note should be taken of the birth of the child, in what sign it occurs; with some explanations. (Pray God for a lucky hour!)

Second, that his form and stature should be considered; with some explanations.

Third, how he ought to be nurtured in learning from the first; with some explanations.

Fourth, that the child should be observed, whether he learns best when kindly praised or when chidden; with some explanations.

Fifth, that the child should be kept eager to learn and not be made disgusted.

Sixth, if the child works too hard, whereby melancholy might super-abound in him, that he be drawn away therefrom by merry lute-play to the pleasuring of his blood.

[B.] The second part of the Prologue shows how the lad should be brought up in the fear of God and in reverence, that he may attain grace, whereby he may be much strengthened in intelligent art and attain to power. It falls into six parts:

First, that the lad be brought up in the fear of God and be taught to pray to God for the grace of fine perception and to honor God.

Second, that he be kept moderate in eating and drinking and also in sleeping.

Third, that he dwell in a pleasant house so that he be distracted by no manner of hindrance.

Fourth, that he be kept from women and not be allowed to live in their quarters; that he not see one naked or touch her; and that he guard himself from all impurity. Nothing weakens the understanding more than impurity. [Compare Leonardo, p. 55.]

Fifth, that he know how to read and write well, and be also instructed in Latin, so as to understand some works of writing.

Sixth, that such a one be able to pursue his studies for a long enough time at his own expense, and that his health be attended to with medicines when needful.

[C.] The third part of the Prologue teaches us of the great usefulness, joy, and delight which spring from painting. It falls into six parts:

First, it is a useful art; for it is of godly sort and is employed for holy edification.

Second, it is useful; for if a man devote himself to art, much evil is avoided that happens otherwise if one is idle.

Third, it is useful; for no one, unless he practices it, believes that it is so rich in joys in itself; it has great joys indeed.

Fourth, it is useful because a man gains great and lasting memory thereby if he applies it aright.

Fifth, it is useful because God is thereby honored when it is seen that he has bestowed such genius upon one of his

creatures in whom such art dwells. All wise men will hold
you dear for the sake of your art.

Sixth, the sixth use is that if you were poor you may by such
art come unto great wealth and riches.

[II.] The Second Division of the books treats of painting itself;
it also is threefold.

[A.] The first part speaks of the freedom of painting; in six ways.

[B.] The second part speaks of the proportions of men and build-
ings and what is needful for painting; in six ways.

[C.] The third part speaks of all that which is seen when repre-
sented in one view [i.e., in perspective]; to do this [is
taught] in six ways.

[III.] The Third Division of the book is the Conclusion; it also
has three parts.

[A.] The first tells in what place such an artist should dwell to
practice his art; in six ways.

[B.] The second part tells how such a wonderful artist should
charge highly for his art, and that no money is too much for
it; moreover it is divine and rightful; in six ways.

[C.] The third part speaks of praise and thanksgiving unto God
who has thus bestowed His grace upon him [i.e, the artist],
and unto other for His sake [?].

FROM THE INTRODUCTION TO THE "BOOK ON HUMAN PROPORTIONS"

[*As planned in 1512-1513*]

Item. The sight of a fine human figure is above all things pleas-
ing to us, wherefore I will first construct the right proportions of a
man. Thereafter, as God gives me time, I will write of and carry
out other matters. I am well assured that the envious will not keep
their venom to themselves; but nothing shall in any wise hinder

me, for even the great men have had to undergo the like. We see human figures of many kinds arising from the four temperaments, yet if we have to make a figure, and if it is left to our discretion, we ought to make it as beautiful as we can according to the task, as it is fitting. No little art, however, is needed to make many various kinds of figures of men. Deformity will continually of its own accord entwine itself into our work. No single man can be taken as a model for a perfect figure, for no man lives on earth who is endowed with the whole of beauty; he might still be much more beautiful. There lives also no man upon earth who could give a final judgment upon what the most beautiful shape of a man may be; God only knows that. How beauty is to be judged is a matter of deliberation. One must bring into it every single thing according to circumstances, for in some things we consider that as beautiful which elsewhere would lack beauty. "Good" and "better" in respect of beauty are not easy to discern, for it would be quite possible to make two different figures, neither of them conforming to the other, one stouter and the other thinner, and yet we scarce might be able to judge which of the two may excel in beauty. What beauty is, I know not, though it adheres to many things. When we wish to bring it into our work we find it very hard. We must gather it together from far and wide, and especially in the case of the human figure throughout all its limbs from before and behind. One may often search through two or three hundred men without finding amongst them more than one or two points of beauty which can be made use of. You, therefore, if you desire to compose a fine figure, must take the head from some, the chest, arm, leg, hand, and foot from others; and, likewise, search through all members of every kind. For from many beautiful things something good may be gathered, even as honey is gathered from many flowers. There is a right mean between too much and too little; strive to hit upon this in all your works. In calling something "beautiful" I shall here apply the same standard as is applied to what is "right." For as what all the world prizes as right we hold to be right, so what all the world esteems beautiful that will we also hold for beautiful and strive to produce.

A good figure cannot be made without industry and care; it should therefore be well considered before one sets to work with it; for it will not succeed fortuitously. For, inasmuch as the lines of its form cannot be traced by compass or rule but must be drawn by hand from point to point, it is easy to go wrong in them. And in devising such figures great attention should be paid to human proportions, and all their kinds should be investigated. I hold that the more nearly and accurately a figure is made to resemble man, so much the better will the work be. If the best parts, chosen from many well-formed men, are fitly united in one figure, it will be worthy of praise. But some are of another opinion and discuss how men *ought* to be. I will not argue with them about that; but I hold nature for master in such matters and the fancy of man for delusion. The Creator fashioned men once and for all as they *must* be, and I hold that the perfection of form and beauty is contained in the sum of all men. That man will I rather follow who can extract this aright, than one who wants to establish some newly thought-up proportion, in which human beings have had no share. For the human figure must, once and for all, remain different from those of other creatures, let them [the painters] fashion them otherwise just as they please. If I, however, were here to be attacked upon this point—namely, that I myself had set up strange proportions for figures—about that I will not argue with anyone. Nevertheless, they are not unhuman; I set them so much apart from each other in order that anyone can render account of it to himself and take care whenever he thinks that I do too much or too little in defiance of the natural shape—to avoid this and to follow nature.

It is evident that the German painters are not a little skillful with their hand and in the use of colors, though they have as yet been wanting in the art of measurement, also in perspective, and other like matters. It is therefore to be hoped that, if they learn these

also and thus acquire skill and knowledge together, they will in time allow no other nation to take the prize before them . . .

Without proportion no figure can ever be perfect, even though it be made with all possible diligence . . . If, on the contrary, it has its right measurements, it cannot be condemned by anyone, even though it is executed quite simply.

JACOPO CARRUCCI DA PONTORMO

TO BENEDETTO VARCHI

THE RELATIONSHIP of a mannerist artist like Pontormo to the painters of the early Renaissance, like Leonardo, might be compared to the relationship of Matisse to the impressionists. Interest had shifted from the technical problems of rendering the effects of nature to compositional problems and values.

We quote a page from Pontormo's reply to Varchi's inquiry about the comparative excellence of the arts (see page 65). Pontormo seized the opportunity to write a eulogy on painting.

THE PAINTER'S AUDACITY *[Ca. 1547]*

He is overbold, indeed, wishing to imitate with pigments all the things produced by nature, so that they will look real, and

even to improve them so that his pictures may be rich and full of varied details. He will paint, for instance, wherever they fit his purpose, glares, nights with fires or other lights, the air, clouds, landscapes with towns in the distance or close by, buildings with many varied systems of perspective, animals of many sorts and many colors, and a multitude of other things. Sometimes a scene painted by him will include things that nature never produced. Furthermore, as I said above, he will improve the things he depicts, and with his art he will give them grace, arrange them, and group them where they will look best. Furthermore, there are the various modes of working—fresco, oil, tempera, glue—all of which require great practice in handling so many different pigments, to know their various results when mixed in various ways, to render lights, darks, shadows, high-lights, reflections, and many other effects beyond number. But what I said above about the painter being overbold is proved by his presumption to surpass nature in trying to infuse spirit into a figure and make it look alive while painting it on a flat surface. For had he but considered that when God created man He made him in relief, it being thus easier to make him alive, the painter would not have chosen so difficult a subject, fitter for divine and miraculous powers.

BENVENUTO CELLINI

ON DRAWING, PAINTING, AND SCULPTURE

IN ADDITION to his famous *Autobiography*, Cellini also wrote two treatises on art, published at the end of his life in 1568, rhymes, and letters. He of course treated the problem of the relative value of the arts that had concerned Leonardo (p. 46) and Michelangelo (p. 65). He was among those of whom Benedetto Varchi inquired concerning this problem; see p. 65.

TO BENEDETTO VARCHI *January 28, 1547*

I say that the art of sculpture is eight times as great as any other art based on drawing, because a statue has eight views and they must all be equally good . . .

And in order to show you better the greatness of this art, I may

point out that Michelangelo today is the greatest of all known painters, both ancient and modern, only because he copies every figure that he paints from very carefully studied models in sculpture. Nor do I know anyone who comes nearer to such artistic truth than the talented Bronzino. I see all the others wallow in cornflowers and in a juxtaposition of varied colors fit for deceiving peasants.

I say, reverting to the great art of sculpture, that we see by experience that if you want to make but a column, or even a vase, which are very simple things, and you draw them on a sheet of paper with as much proportion and grace as may be shown in a drawing, and then from such drawing you execute the column or vase in sculpture, you will find that the work in relief will turn out to be far less graceful than the drawing; nay, it will appear quite ill-made and clumsy. But if you make a vase or column in the round and then, either by measuring or by free hand, reproduce it in a drawing, you will find that it will appear exceedingly graceful.

Sculpture is the mother of all the arts involving drawing. If a man is an able sculptor and has a good style in this art he will easily be a good perspectivist and architect, and also a better painter than a man unconversant with sculpture. A painting is nothing better than the image of a tree, man, or other object reflected in a fountain. The difference between painting and sculpture is as great as between a shadow and the object casting it.

RELIEF IS THE FATHER OF PAINTING

A true drawing is nothing but the shadow of a relief. Thus relief turns out to be the father of all drawing, and that wonderful and beautiful thing that we call "painting" is a drawing colored with the colors that nature displays. For there are two kinds of painting: the one that imitates all the colors that nature herself shows us; the other that is called *chiaro e scuro* [monochrome], which was revived at Rome in our time by two young and able draftsmen named Polidoro and Maturino.

DRAWING

Reverting to our subject—the value of drawing—I shall tell you that I have seen others do and myself have done a great deal of study in order to get a perfect grasp of the effects of foreshortening. We would take a well-formed young man, and then, in a whitewashed room, we would make him sit or stand in various attitudes so that we could have a view of the most difficult foreshortenings. Then, placing a lamp behind him in a properly studied position, neither too high nor too low, nor too far from him, we would adroitly pose him so as to show us the most beautiful and natural postures. And, while he kept still, we looked at the shadow cast by him on the wall and drew its outline quickly. Then we easily added a few lines that were not visible in the shadow, for some details are always concealed in the thickness of the arm at the elbow, near the shoulders, both under and over, and on the head, and in various points of the torso, legs, and hands.

PAINTING AND SCULPTURE

A painting is nothing more than one of the eight principal views required of a statue. And this is so because when a worthy artist wants to model a figure—either nude, or draped, or otherwise (but I shall speak only of nudes, because one always first models one's figures in the nude and then one clothes them)—he will take some clay or wax and begin to fashion his graceful figure. I say "graceful" because beginning from the front view, before making up his mind, he often raises, lowers, pulls forwards and backwards, bends and straightens every limb of the said figure. And once he is satisfied with the front view, he will turn his figure sideways—which is another of the four principal views—and more often than not he will find that his figure looks far less graceful, so that he will be forced to undo that first fine aspect he had decided upon, in order to make it agree with this new aspect . . .

These views are not only eight, but more than forty, because even if the figure be rotated no more than an inch, there will be some muscle showing too much or not enough, so that each single piece of sculpture presents the greatest variety of aspects imagi-

nable. And thus the artist finds himself compelled to do away with that gracefulness that he had achieved in the first view in order to harmonize it with all the others. This difficulty is so great that no figure has ever been known to look right from every direction.

FROM HIS *AUTOBIOGRAPHY*

CELLINI'S FAME lies at least as much in his *Autobiography* as in his goldsmithing and his sculpture. Goethe translated it into German, and Horace Walpole called it more entertaining than any novel.

The *Autobiography* was dictated by Benvenuto to his studio boy between 1558 and 1566. It was not published, however, until the eighteenth century. One of its more dramatic episodes, typically full of Cellini's self-importance, is the account of the casting of the bronze *Perseus,* which adorns the Loggia dei Lanzi in Florence.

THE CASTING OF THE PERSEUS

And so I took heart, and with all the resources of my body and my purse—though I had little enough money left—I set about procuring several loads of pine from the pine woods of Serristori, near Monte Lupo. While I was waiting for these, I covered my *Perseus* with the clay I had got ready several months before, in order that it might be well seasoned. When I had made its "tunic" of clay—for so it is called in our art—and had most carefully armed and girt it with iron, I began to draw off the wax by a slow fire through the various vent-holes I had made. (The more of these you have, the better will your molds fill.) When this was done, I built up round the mold of my *Perseus* a funnel-shaped furnace of bricks, arranged one above the other so as to leave numerous openings for the fire to breathe through. Then very gradually I laid the wood on, and kept up the fire for two days and two nights on end. After I had drawn off all the wax, and the mold had been properly baked, I set to work at once to dig a hole to sink the thing in, attending to all the strictest rules of the great art. This done, I raised the mold with the utmost care by means of windlasses and strong ropes to an upright position, and suspended it a cubit above the level of the furnace, being careful that it

CELLINI: Wax Model of the Perseus, 1545-1554

hung exactly over the middle of the pit. Then gently, gently, I let it down to the bottom of the furnace, sparing no pains to settle it securely there. This difficult job over, I set about propping it up with the earth I had dug out of the hole; and as I built up the earth, I made vent-holes, that is, little pipes of terra cotta such as are used for drains and things of that kind. Then I saw that it was quite firm, and that this way of banking it up and putting conduits in their proper places was likely to be successful. It was evident also that my workmen understood my mode of working, which was very different from that of any of the other masters in my profession. Sure, therefore, that I could trust them, I gave my attention to the furnace, which I had filled up with pigs of copper and pieces of bronze, laid one on top of the other, according to the rules of the craft—that is, not pressing closely one on the other, but arranged so that the flames could make their way freely about them; for in this manner the metal is more quickly affected by the heat and liquefied. Then in great excitement I ordered them to light the furnace. They piled on the pine logs; and between the unctuous pine resin and the well-contrived draft of the furnace, the fire burned so splendidly that I had to feed it now on one side and now on the other. The effort was almost intolerable, yet I forced myself to keep it up.

On top of all this the shop took fire, and we feared lest the roof should fall upon us. Then, too, from the garden the rain and the wind blew in with such chill gusts as to cool the furnace. All this fighting for so many hours with adverse circumstances, forcing myself to a labor such as even my robust health could not stand, ended in a one-day fever of an indescribable severity. There was nothing for it but to fling myself on my bed, and I did so very ill-content . . .

When I had mastered all this confusion and trouble, I shouted now to this man, now to that, bidding them fetch and carry for me; and the solidified metal beginning to melt just then, the whole band was so excited to obedience that each man did the work of three. Then I had them fetch half a pig of pewter, weighing about sixty pounds, and this I threw right in the middle of the solid metal in the furnace. And what with the wood I had put in be-

neath, and all the stirring with iron rods and bars, in a little while the mass grew liquid. When I saw I had raised the dead, in despite of all those ignorant skeptics, such vigor came back to me that the remembrance of my fever and the fear of death passed away from me utterly. Then suddenly we heard a great noise and saw a brilliant flash of fire, just as if a thunderbolt had rushed into being in our very midst. Every man of us was dazed by this prodigious and terrifying event, and I still more than the rest. Only when the great rumble and the flashing flame had passed did we dare look each other in the face. Then I saw that the lid of the furnace had blown open, so that the bronze was running over. In the same instant I had every mouth of the mold open and the plugs closed.

But perceiving that the metal did not run as freely as it should, I came to the conclusion that the intense heat had consumed the alloy. So I bade them fetch every pewter dish and porringer and plate I had in the house, nearly two hundred in all; and part of them I threw, one after another, into the channels, and put the rest into the furnace. Then they saw that my bronze was really melted and filling up my mold, and gave me the readiest and most cheerful help and obedience. Now I was here, now I was there, giving orders or putting my own hand to the work, while I cried, "O God, who in Thy limitless strength didst rise from the dead, and glorious didst ascend to Heaven . . . !" In an instant my mold filled up; and I knelt down and thanked God with all my heart; then turned to a plate of salad lying on a bench there, and with a splendid appetite ate and drank, and all my gang of men along with me. After that, as the day was but two hours off, I betook myself to bed, sound of body and in good heart; and, as if I had never known an ache in my life, sank gently to my rest.

GIORGIO VASARI

FROM HIS *LIVES*

VASARI IS much more famous for his *Lives of the Most Eminent Painters, Sculptors, and Architects* than for his painting. An ardent admirer of Michelangelo, he worked in the mannerist style. In spite of his efforts to praise everyone, he betrays that point of view. He is, besides, typical of the Renaissance in his faith in the continual progress of art and in his pride in its culmination in his own era. Contrast, for example, Albani, p. 128, Rubens, p. 148, or Ingres, p. 218.

The first edition of the *Lives* appeared in 1550; the second, revised and enlarged, in 1568.

DESIGN

Design cannot have a good origin if it has not come from continual practice in copying natural objects, and from study of pictures by excellent masters and of ancient statues in relief, as has been said many times. But above all, the best thing is to draw men and women from the nude and thus fix in the memory by constant exercise the muscles of the torso, back, legs, arms, and knees, with the bones underneath. [Compare Pacheco, p. 143, and Carducho, p. 139.]

FRESCOES

Of all the methods that painters employ, painting on the wall is the most masterly and beautiful, because it consists in doing in a single day that which, in other methods, may be retouched day after day, over the work already done.

CHIAROSCURO

All pictures, then, whether in oil, fresco, or tempera, ought to be so harmonized that the principal figures in each scene will be painted in the brightest colors. Do not paint the figures in the foreground so dark that those standing behind will be lighter. On the contrary, as the figures diminish in size towards the background, they must grow proportionally darker in the color of the flesh and the draperies. And especially let there be great care taken always in putting the most attractive, the most charming, and the most beautiful colors on the principal figures, and above all on those that are complete and not cut off by others, because these are always the most conspicuous and are more looked at than others which serve as the background to the coloring of the former. A sallow color makes another which is placed beside it appear the more lively, and melancholy and pallid colors make those near them very cheerful and almost of a certain flaming beauty. Nor ought one to clothe the nude with heavy colors that would make too sharp a division between the flesh and the draperies when the said draperies pass across the nude figures, but let the colors of the lights of the drapery be delicate and similar to the

tints of the flesh, either yellowish or reddish, violet or purple, making the depths either green or blue or purple or yellow.

THE STYLE OF GIOTTO

The original Byzantine style was entirely abandoned, at first through the efforts of Cimabue and then by the help of Giotto. From it arose a new style which I like to call Giotto's, because it was introduced by him and his pupils, and was afterwards universally admired and imitated. In this the profile surrounding the whole figure is abandoned, as well as the lusterless eyes, the tiptoed feet, the attenuated hands, the absence of shadow, and all the other Byzantine absurdities, which were replaced by graceful heads and beautiful coloring.

Giotto in particular improved the attitudes of the figures and began to give a measure of vivacity to the heads and folds to the draperies, which made a closer approach to nature than is seen in the work of his predecessors, while he partially discovered the art of foreshortening figures. He also was the first to express emotions, so that fear, hope, rage, and love may be partly recognized.

THE FIFTEENTH AND SIXTEENTH CENTURIES

Those masters whose Lives we have written in the second part made substantial additions to the arts of architecture, painting, and sculpture, improving on those of the first part in rule, order, proportion, design, and style . . .

But although the artists of the second period made great additions to the arts in all these particulars, yet they did not attain to the final stages of perfection, for they lacked a freedom which, while outside the rules, was guided by them, and which was not incompatible with order and correctness. This demanded a prolific invention and the beauty of the smallest details. In proportion they lacked good judgment, which, without measuring the figures, invests them with a grace beyond measure in the dimensions chosen. They did not attain to the zenith of design, because, although they made their arms round and their legs straight, they were not skilled in the muscles and lacked that graceful and sweet ease which is partly seen, partly felt, in matters of flesh and living

things, but they were crude and stunted, their eyes being difficult and their style hard . . .

That finish and assurance which they lacked they could not readily attain by study, which has a tendency to render the style dry when it becomes an end in itself. The others were able to attain it after they had seen some of the finest works mentioned by Pliny dug out of the earth: the *Laocoön,* the *Hercules,* the great torso of *Belvedere,* the *Venus,* the *Cleopatra,* the *Apollo,* and endless others, which are copied in their softness and in their hardness from the best living examples, with actions which do not distort them, but give them motion and display the utmost grace. This removed a certain dryness and crudeness caused by overmuch study, observable in Piero della Francesca, Lazzaro Vasari, Alesso Baldovinetti, Andrea del Castagno, Pesello, Ercole Ferrarese, Giovanni Bellini, Cosimo Rosselli, the abbot of S. Clemente, Domenico del Ghirlandaio, Sandro Botticelli, Andrea Mantegna, Filippo and Luca Signorelli.

All these endeavored to attain the impossible by their labors, especially in foreshortening and unpleasant objects, but the effort of producing them was too apparent in the result. Thus, although most were well designed and flawless, vigor was invariably absent from them, and they lacked a soft blending of color, first observable in Francia of Bologna and Pietro Perugino. The people, when they beheld the new and living beauty, ran madly to see it, thinking that it would never be possible to improve upon it.

But the works of Leonardo da Vinci clearly proved how much they erred, for he began the third style, which I will call the modern, notable for boldness of design, the subtlest imitation of nature in trifling details, good rule, better order, correct proportion, perfect design, and divine grace, prolific and diving to the depths of art, endowing his figures with motion and breath.

Somewhat later followed Giorgione da Castelfranco, who gave tone to his pictures and endowed his things with tremendous life by means of the well-managed depth of the shadows. No less skillful in imparting to his works force, relief, sweetness, and grace was Fra Bartolommeo of S. Marco; but the most graceful of all was Raphael of Urbino, who, studying the labors of both the an-

cient and the modern masters, selected the best from each, and out of his garner enriched the art of painting with that absolute perfection which the figures of Apelles and Zeuxis anciently possessed, and even more, if I may say so. Nature herself was vanquished by his colors, and his invention was facile and appropriate, as anyone may judge who has seen his works, which are like writings, showing us the sites and the buildings, and the ways and habits of native and foreign peoples just as he desired . . .

Andrea del Sarto followed him in this manner, but with a softer and less bold coloring, and it may be said that he was a rare artist because his works are faultless. It is impossible to describe the delicate vivacity which characterizes the works of ˙Antonio da Correggio. He depicted hair in a manner unknown before, for it had previously been made hard and dry, while his was soft and downy, the separate hairs polished so that they seemed of gold and more beautiful than natural ones, which were surpassed by his coloring. Francesco Mazzuoli Parmigiano did the like, surpassing him in many respects in grace, ornament, and fine style, as many of his paintings show, the faces laughing, the eyes speaking, the very pulses seeming to beat, just as his brush pleased . . .

How many are there among the dead whose colors have endowed their figures with such life as is imparted by Il Rosso, Fra Sebastiano, Giulio Romano, Perino del Vaga, not to speak of the many celebrated living men? But the important fact is that art has been brought to such perfection today, design, invention, and coloring coming easily to those who possess them, that where the first masters took six years to paint one picture our masters today would take only one year to paint six, as I am firmly convinced both from observation and experience; and many more are now completed than the masters of former days produced.

MICHELANGELO

But the man who bears the palm of all ages, transcending and eclipsing all the rest, is the divine Michelangelo Buonarroti, who is supreme not in one art only but in all three at once. He surpasses not only all those who have, as it were, surpassed nature, but the most famous ancients also, who undoubtedly surpassed her . . .

The purpose of this remarkable man was none other than to paint the most perfect and well-proportioned composition of the human body in the most various attitudes and to show the emotions and passions of the soul, displaying his superiority to all artists in his great style, his nudes, and his knowledge of the difficulty of design. He has thus facilitated art in its principal object, the human body, and in seeking this end alone he has neglected charming coloring, fancies, new ideas with details and elegances, which many other painters do not entirely neglect, perhaps not without reason. Thus some, perhaps not so grounded in design, have tried varied and new inventions with divers tints, light and dark colors, hoping to win a place among the first masters. But Michelangelo, firmly founded in the profundity of art, has shown the true road to perfection to all who have sufficient knowledge . . .

But if we so greatly admire those who devoted their lives to their work, when induced by extraordinary rewards and great happiness, what must we say of the men who produced such precious fruit not only without reward but in miserable poverty? [Compare Ridolfi, p. 129.] It is believed that if there were just rewards in our age we should become undoubtedly greater and better than the ancients ever were. But the necessity of fighting against famine rather than for fame crushes men of genius and prevents them from becoming known, which is a shame and disgrace to those who could improve their condition and will not.

BARTOLOMMEO AMMANNATI

NUDES, MORALS, AND ART

AMMANNATI WAS a well-known Florentine sculptor and architect, author, among many other works, of the marble *Neptune* in the Piazza della Signoria and of the bridge of Santa Trinita, now destroyed. In these two letters of repentance for having produced so many nude statues, he was expressing a trend general in the second half of the sixteenth century. His petition to the Grand Duke was, however, not granted, and Ammannati's marbles still display their bare limbs to the Tuscan sun.

On the propriety of the nude, compare the views of Pietro da Cortona, p. 132, and David d'Angers, p. 220.

TO THE ACADEMY OF DESIGN AT FLORENCE

Florence, August 22, 1582

Beware, for God's sake, as you value your salvation, lest you incur and fall into that error that I have incurred in my works when I made many of my figures entirely nude and undraped, following rather the usage—nay, the abuse—than the reason of the artists, my predecessors, who did likewise and failed to consider that it is far more creditable to appear modest and decent than to appear vain and lascivious, no matter how fine and excellent our works may be.

Being unable otherwise to mend and correct this not trivial error and fault of mine—for it is impossible to withdraw my statues or to apprise all who see them how much I regret having made them—I have resolved to confess publicly, write down, and make known to all, so far as it is in my power, how gravely I have sinned and how sorely I grieve and repent—also for the purpose of warning my fellow-artists not to incur such baleful vice.

For, rather than offend public morals and still more God (blessed be He) by setting bad examples, we ought to desire the death both of our bodies and of our names.

Therefore, my dearest brethren of the Florentine Academy, may you heed this warning that I give you with all the affection of my heart: never to make anywhere any work of yours indecent or lewd—I am referring to entirely nude figures—nor anything else that may move any man or woman, of any age, to wicked thoughts, seeing that, unfortunately, our corrupt nature of its own accord, even without outside incentives, is all too ready to waver . . .

I know indeed—what many of you know—that there is no less difficulty and no less display of skill in carving a statue with beautiful drapery, gracefully arranged, than in making it entirely nude and undraped. The example of eminent and practiced artists proves that it is so. Is the *Moses* in San Pietro in Vinculis at Rome not praised as the handsomest figure that Michelangelo ever made? Yet it is completely clothed.

From my youth I have devoted my years and my activity to the service of Your Highness' Most Serene House. Being now almost eighty, and not very far from that voice with which God calls everybody to Himself, I am compelled by my conscience to ask of Your Highness something which I hope I shall obtain without difficulty . . .

Recently Your Highness ordered that those statues which I made thirty years ago on the commission of the Most Serene Grand Duke Your Father, at Pratolino, should be transferred to the Pitti Garden—as has been done. I am filled with remorse that the labor of my hands should remain there as an incitement to many indecent thoughts to any who see it.

Therefore I beseech you with all reverence that—as the greatest gift and reward that I may receive for my services—you shall do me the grace, first, of not seeking any other artist's help in altering them, and, secondly, of allowing me to clothe them artistically and decently, entitling them with names of virtues, so that they may never be the occasion of wicked thoughts to anybody. And these alterations are all the more expedient as they will give the Most Serene Grand Duchess, the ladies of her retinue, and the other gentlewomen coming to visit her an opportunity of seeing in every section and corner of Your Highness' Residence only things that will edify in a Christian way a Most Christian Princess, as she is. And I shall be everlastingly obliged to Your Highness.

JACOPO ROBUSTI, CALLED TINTORETTO

REMARKS ON PAINTING

WE HAVE no writings from the hand of Tintoretto. We quote, however, some remarks recorded by Ridolfi in his life of the painter. They have all the appearance of authenticity, and they reflect the mannerist point of view, with its interest in design, drawing, and chiaroscuro. On the walls of his

studio Tintoretto wrote: "The drawing of Michelangelo and the colors of Titian," and resolved to combine the excellences of both.

The study of painting is toilsome, and the further one advances into it, the more difficulties appear, and the sea grows larger and larger.

Young students should never depart from the path of the foremost masters, if they want to profit, and particularly from Michelangelo and Titian, the one wonderful in drawing, the other in color.

Nature is always the same, and therefore the muscles of the figures are not to be varied at whim.

In passing judgment on paintings, you should consider whether the first impression gratifies the eye and whether the artist has observed the rules, for as to the rest everyone makes some mistakes.

He who exhibits his works in public should wait many days before going to see them, until all the shafts of criticism have been shot and people have grown accustomed to the sight.

Black and white [are the most beautiful colors], because black gives force to the figures by making the shadows deeper, and white by making the high-lights stand out.

Only skilled artists should draw from living bodies, because in most cases these lack grace and good shape.

These drawings [by Luca Cambiaso] are enough to ruin a young student who has not yet mastered the foundations of the art; but a skilled artist, well conversant with his craft, can draw some fruit from them, because they are filled with much learning.

Beautiful colors are for sale in the shops of Rialto, but good drawing can only be fetched from the casket of the artist's talent with patient study and sleepless nights, and it is understood and practiced by few.

PAOLO CALIARI,
CALLED VERONESE

AN EXAMINATION BY THE INQUISITION

AFTER THE Council of Trent the Inquisition exercised a more rigorous supervision of everything relating to morals and religion, including painting.

In 1573 Veronese was summoned before the Tribunal of the Holy Office and charged with introducing fanciful and disrespectful details in one of his famous *Suppers*. The record of his examination is preserved in the Archives at Venice; it reveals as well something of the painter's views on the rights of fancy. Paolo does not appear to have been much perturbed or overawed in the presence of the Inquisitors. Probably he had been assured of high-placed protection; the Republic would look after a famous artist.

The alterations Veronese was ordered to make in his picture were only partially carried out: the "bleeding nose" was deleted, but the dog remains, with the dwarf, the parrot, and the German halberdiers. The title was changed to *Supper in the House of Levi*. The picture now hangs in the Academy in Venice.

Saturday, the 18th of July, 1573

Mr. Paolo Caliari Veronese, living in the parish of San Samuel, was summoned to the Holy Office, before the Sacred Tribunal, and was asked his name and surname.

He answered as above.

He was asked his profession.

A: I paint and make pictures.

Q: Do you know the reason why you have been summoned?

A: No, my lords.

Q: Can you imagine it?

A: I surely can.

Q: Tell us what you imagine.

A: For the reason told me by the Reverend Father, that is, by the Prior of SS. Giovanni e Paolo, whose name I know not, who told me that he had been here, and that your most illustrious lordships had directed him to make me substitute a figure of the Magdalen in the place of a dog. And I replied that I would willingly do this or anything else for my own credit and the advantage of the picture, but that I did not feel that a figure of the Magdalen would look good there, for many reasons which I am ready to state whenever I have an opportunity.

Q: What picture are you referring to?

A: A picture of the last supper that Jesus Christ took with His Apostles in the house of Simon.

Q: Where is this picture?

A: In the refectory of the Friars of SS. Giovanni e Paolo . . .

Q: In this Supper of our Lord did you paint any attendants?

A: Yes, my lords.

Q: Tell us how many attendants and what each is doing.

A: First, there is the master of the house, Simon. Next, below this figure, I painted a butler, whom I supposed to have come for his amusement, to see how matters were getting on at the table.

Veronese: Supper in the House of Levi, April, 1573

There are also many others, whom, as it is long since I hung up the picture, I do not recollect.

Q: Have you painted other suppers besides this?

A: Yes, my lords.

Q: How many have you painted, and where?

A: I did one at Verona for the Reverend Monks of San Nazaro, which is in their refectory.

He said: I did one in the refectory of the Reverend Fathers of St. George, here in Venice.

He was told: That is not a supper. You are asked about our Lord's supper.

A: I did one in the refectory of the Servites at Venice, and one in the refectory of St. Sebastian, here in Venice. And I did one at Padua for the Fathers of the Magdalen. And I do not remember having done any others.

Q: In this supper that you painted in SS. Giovanni e Paolo, what is the meaning of the figure of the man with the bleeding nose?

A: I did him for a servant, whose nose, owing to some accident, may have been bleeding.

Q: What is the meaning of those armed men, dressed in the German fashion, each with a halberd in his hand?

A: Here I need to say a few words.

Q: Say them.

A: We painters take the same liberties as poets and madmen take. And I painted those two halberdiers, the one drinking and the other eating near the staircase, who are placed there that they might perform some duty, because it seemed fitting to me that the master of the house, who was great and rich, according to what I have been told, should have such servants.

Q: That fellow dressed as a jester, with a parrot on his fist, for what purpose did you paint it on that canvas?

A: For ornament, as is often done.

Q: Who is sitting at our Lord's table?

A: The twelve Apostles.

Q: What is St. Peter doing, who is the first?

A: He is carving the lamb, to pass it on to the other end of the table.

Q: What is the next one doing?

A: He holds a plate for receiving what St. Peter will give him.

Q: Tell us what the next after this is doing.

A: He has a toothpick, with which he is cleaning his teeth.

Q: Who do you really believe were present at that Supper?

A: I believe Christ and His Apostles were present, but if in a picture there remains unfilled space, I adorn it with figures, according to my inventions.

Q: Did anyone commission you to paint in that picture Germans, jesters, and such things?

A: No, my lords. But I was commissioned to adorn the picture as I judged best, and it is large, and had room for many figures, as it seemed to me.

He was asked about the ornaments that he, the painter, is in the habit of introducing into his murals and pictures, whether he is in the habit of making them suited and appropriate to the subject and to the principal figures, or does he really paint them at his own pleasure, following the vagaries of his fancy, without any discretion or judgment.

A: I do my paintings with such consideration as is suitable, and as my mind can comprehend.

He was asked whether he thought it suitable that in our Lord's Last Supper one should paint jesters, drunkards, Germans, dwarfs, and similar scurrilities.

A: No, my lords.

Q: Are you not aware that in Germany and other places infected with heresy there is the custom of using strange and scurrilous pictures and similar inventions for mocking, abusing, and ridiculing the things of the Holy Catholic Church, in order to teach the false doctrine to the illiterate and ignorant?

A: Yes, my lords. That is wicked. But I shall repeat what I said before, that I am obliged to follow what my predecessors did.

Q: What did your predecessors do? Did they ever do anything like that?

A: Michelangelo, at Rome, in the Pontifical Chapel. He painted

our Lord Jesus Christ, His Most Holy Mother, St. John, St. Peter, and the Court of Heaven, all of them naked, from the Virgin Mary down, with little reverence.

Q: Do you not know that in painting the Last Judgment, in which no garments or such things are supposed to be, there was no need of painting clothes, and in those figures there is nothing that is not spiritual, and there are no jesters, dogs, weapons, or such like buffooneries? And do you presume, on account of this or of any other example, that you have done right in painting that picture in the way it is? And do you intend to defend yourself pleading that the picture is quite right and proper?

A: Most illustrious lords, no. I do not intend to defend it, but I thought I was doing right. And I did not consider so many things, thinking I was doing nothing very irregular, the more so since the figures of the jesters are outside the place where our Lord is.

After which, their lordships decreed that the above-mentioned Mr. Paolo should be required and obliged to correct and amend the picture in question at his own expense within three months, to be reckoned from the day of the sentence, under such penalties as the Sacred Tribunal might impose.

GIOVAN BATTISTA ARMENINI

THE TRUE PRECEPTS OF PAINTING

OF ARMENINI, first painter, then priest, only one painting remains, an *Assumption* in his native Faenza. He is known chiefly for his treatise *On the True Precepts of Painting* (Ravenna, 1587), in which he explains accurately and typically, the technique of his art, and shows his acquaintance with the practices of the various Italian schools. [On the decline of models, see Rubens, p. 149.]

NATURAL MODELS NOT SUFFICIENT

Painters gain great benefit from traveling over various countries as they do, because they thus see many dissimilar paintings, and the unusual styles of fanciful and novel works, so that their minds

gain assurance and are enriched with much noble material concerning both the nude and a vast variety of subjects.

Nor will it serve to object that natural models are in every case sufficient, that they are to be found everywhere, and that a painter who shows that he can imitate them well may be regarded as skilled enough. This will not be so easily conceded, for it is well known among us artists, and may be observed everywhere, that the use of living models unassisted by a vigorous and antique manner brings only contempt to the painter who relies upon them for all his works. From specimens of ancient sculpture repeatedly examined by us, we have observed that nature, declining continually, has from old age grown so clumsy and bungling that it is now very difficult—even by inspecting large numbers of persons —to find a body or limb of such quality that it may be approved of without corrections by a competent artist.

HOW TO ACQUIRE A GOOD MANNER OF PAINTING

There are two very sure ways for learning the said manner: the one is to copy assiduously the works of several good artists; the other, to apply oneself to only one of the very first order. If you follow the former method, a very general and universal rule is to copy always the finest works, the most learned, and those nearest to good antique sculpture. By continual study you shall accustom yourself to their forms and master them so thoroughly that you will be able to put to use one or two of their compositional motifs in each of your works . . .

We must conclude, therefore, that besides seeking the best and most perfect things of nature, you must supplement them with a good manner, and go with it as far as you deem sufficient, because, once you have combined a good manner with a good living model, you can make a composition of excellent beauty.

THE UTILITY OF MODELS IN THE ROUND

It is an ancient and very laudable custom of the best painters that, when charged with noble and important works, once they have devised the invention they set to work to make many figures in the round and sometimes even whole groups with the best pro-

portions and most correct measurements they can. Most painters make them in the same sizes and forms in which they intend to reproduce them in their finished drawings on paper, and in truth not without much labor, industry, and time, for they are obliged to engage in a kind of work which is foreign to their profession, except so far as these figures are concerned. They do so both in order to study the foreshortenings and cast shadows, about which they may be doubtful, and also to verify several other points involved in many-figured compositions.

HOW TO MIX COLORS

You take your saucers or little dishes and begin your mixtures. First, you put white in three or four of these saucers, and black in as many others, but in smaller quantities. Next, you take the jar of the pure color—whether yellow, vermilion, blue, green, or whatever you want—and put some in the said saucers or dishes, mixing it with the white so as to produce at least three mixtures, one lighter than the other, by putting in one dish or saucer less pure color than in another. A similar procedure is to be followed in mixing the same pure color with the black or other suitable dark color that you have put in the saucers. You follow the same system so as to obtain mixtures, one darker than the other. By this method, from each pure color you may obtain four to six, and as many mixtures as you wish, which should match those of the well-finished drawing. [Compare Cennini, p. 25.]

PORTRAITS

As for the painting of portraits, we shall not waste time in showing you the methods, for any indifferently gifted artist can master them sufficiently, provided he has some practice in coloring and keeps in mind the true hues; whereas proficient painters who consider the difficult points of our art are unwilling to apply their minds to portraits, because, being thoroughly schooled in the art, they know well those things which the majority are ignorant of and which common and low talents avoid with all their power. Assuredly, other study, other industry, other intelligence, and other labor are required to paint one or more life-size nudes, in color,

with all their muscles and other details in the right places and, further, so delineated and shaded that they will stand out from the surface on which they are painted! Again and again experience has proved that the more deeply versed an artist is in drawing, the less he is able to paint portraits.

GIOVANNI PAOLO LOMAZZO

ON THE ART OF PAINTING

LOMAZZO, A PUPIL of Gaudenzio Ferrari, painted many pictures for the churches of Milan in the mannerist style. At the age of thirty-three, forced by blindness to abandon the practice of his art, he devoted himself to expounding its theory. He wrote a *Treatise on the Art of Painting* (Milan, 1584), which was quickly translated into French and English (see p. 117), from which the following pages are taken; a book of *Rhymes* (1587); and the *Idea of the Temple of Painting* (1590).

A DEFINITION OF PAINTING

Painting is an art which, with proportionate lines and lifelike colors, and by observing perspective light, so imitates the appearance of corporeal things as to represent upon flat surfaces not only the thickness and roundness of bodies, but their motions, and even shows visibly to our eyes many feelings and emotions of the mind.

A PRECEPT OF MICHELANGELO

Michelangelo is reported to have once given the following advice to the painter Marco da Siena, his pupil: that he should always make his figures pyramidal, serpentlike, and multiplied by one, two, and three. In this precept, in my opinion, the whole secret of painting consists. For the greatest charm and grace that a figure may have is to seem to move, which painters call the "fury" of the figure. And there is no form more fit to express this motion than that of the flame of fire.

CORRESPONDENCE OF LIGHT AND DARK COLORS

It is necessary for the painter to be perfectly acquainted and familiar with the aptitude that each color may have to shadow or illuminate any other, so that if he is painting drapery, whatever its color, all the light and dark portions of it will harmonize and agree, and no yellow cloth will show red shadows nor any white cloth violet or red ones, which would not agree at all.

It has been rightly remarked that white agrees only with black, nor may it be shadowed with any other color, for among colors white and black are the two extremes.

Naples yellow and orpiment cannot be better shadowed than with ocher. But German yellow, being darker, requires a darker ocher.

Azures and smalts shadow the pale blues made of them and white mixed together. Verdigris likewise shadows the mixture of itself and white. Terre verte, iron purple, salt purple, and indigo shadow their own mixtures with white, and so do vermilion and brown of Spain.

Lake mixed with brown of Spain shadows red lead and also the mixture of lake and white.

Brown of Spain shadows burnt orpiment . . .

In the second degree true ocher, which shadows light yellow, may be shadowed in turn with burnt ocher or burnt lake.

Burnt and dark ocher are shadowed with umber mixed with burnt ocher, or else with brown of Spain or lake.

Azures and smalts are shadowed with indigo and also with a mixture of black and lake; verdigris with black and also with indigo; terre verte with umber; iron purple and salt purple with black; vermilion with lake and also with burnt ocher, or with itself mixed with black.

In the third degree, black and lake shadow true yellow, but somber yellow is shadowed with black, and so are umber and burnt ocher. Lake shadows all mixtures of itself with white or with vermilion.

Lastly, umber shadows all colors lighter than itself.

Contrapposto

We are to consider that these movements must be varied somewhat from one another, according to the quality of the bodies. A standing figure which rests its weight upon one foot must have all the members on the side on which it is resting higher than those on the other. Furthermore, all the aforesaid movements, as well as any others, must always be so represented that the body will assume a serpentlike line to which our bodies have a natural tendency . . .

Whatever the action a figure is engaged in, its body must always appear so twisted that if the right arm is extended forward or makes any other gesture designed by the artist, the left side of the body shall recede and the left arm be subordinate to the right. Likewise the left leg shall come forward and the right leg recede. . . . Figures will never look graceful unless they have this serpentine arrangement, as Michelangelo used to call it, and unless the face is turned either in the direction required by the emotion it is meant to express or else towards the action of the hands.

FEDERICO ZUCCARI

FROM THE *IDEA*

ZUCCARI's *Idea of the Painters, Sculptors, and Architects* (Turin, 1607) is an important, though somewhat heavy and diffuse, treatise on the philosophy of art. Federico distinguishes three kinds of design: natural, artificial, and fantastic. His remarks on fantastic design are typical of the mannerist fondness for the marvelous and the grotesque. His refutation of the theories of Duerer and Leonardo illustrates the contrast between the scientific and naturalistic spirit of the Renaissance, and the freedom from the rules of nature claimed by the mannerists.

FANTASTIC DESIGN *1607*

The third kind of design is that representing whatever the human mind, fancy, or whim may invent in any art. Though less perfect than the two preceding kinds, it is necessary and delightful nevertheless and affords great help, improvement, and perfection to all the painter's works as well as to those of the other arts and the practical sciences. It devises new inventions and caprices with all sorts of subjects for pictorial, sculptural, and architectural panels and ornaments to be executed in stucco, stone, marble, bronze, iron, gold, silver, wood, ebony, ivory, and other natural or artificial materials, or simulated with colors, and for ornaments pertaining to any other art whatsoever, such as fountains, gardens, loggias, halls, temples, palaces, theaters, stage scenery, decorations for festivals, war engines, and anything else, such as grotesques, harpies, festoons, scrolls, almanacs, spheres, mathematical forms, a thousand kinds of contrivances, machines, mills, ciphers, clocks, chimeras, and what not. All these things enrich our art and are very ornamental.

A REFUTATION OF DUERER AND LEONARDO

I say—and I know I am saying the truth—that the art of painting does not draw her principles from the mathematical sciences. Nor is there any need to have recourse to them in order to learn

this art's rules and methods, nor even in order to be able to discuss them theoretically. Painting is the daughter not of Science, but of Nature and Design. Nature points out her forms to her, and Design teaches her to work. So that the painter, by using, in addition to the first elements and lessons received from his predecessors and from Nature herself, his own natural judgment, a well-directed diligence, and the observation of the beautiful and the good, can become proficient without further aid and without resorting to mathematics.

I shall add—as is true—that in every creature that Nature produces there is proportion and measure, as the Sage asserts. Nonetheless, if an artist were to undertake to examine everything existing and to acquaint himself with its structure speculatively by mathematical theory, and then proceed to paint accordingly, not only would he embark on intolerable drudgery, but he would waste his time fruitlessly . . .

Rules serve no purpose, but only do harm, because, apart from the fact that bodies are foreshortened and always rounded, these rules are useless and unsuited to our tasks. The artist's mind should be not only clear, but free. His fancy should not be trammeled and restrained by a mechanical slavery to such rules. In this truly most noble profession judgment and practice should serve as rules and formulas.

My beloved brother and predecessor, in showing me the basic rules and measurements of the human figure, told me that perfect and graceful proportions should be of so many faces in length, and no more. "But you must," he added, "become so familiar with these rules and measurements that when working you will have the compasses and the square in your eye, and judgment and practice in your hand." So that these mathematical rules and methods are not and cannot be of any service or value. Nor should we use them in our work, for, instead of increasing the artist's practice, spirit, and vivacity, they will take them from him entirely, by mortifying his intellect, dulling his judgment, and depriving his art of all grace, spirit, and flavor.

Therefore, I believe that Duerer took all that trouble, which

was not small, as a joke and pastime for entertaining such minds as are more inclined to speculation than to work.

Of as small fruit and substance is that other treatise, illustrated with drawings and written backwards, left us by that other artist [Leonardo], adept in our profession, to be sure, but oversophistical, who laid down mathematical precepts for drawing the movements and attitudes of figures by means of perpendicular lines, the square, and the compasses.

LAMBERT LOMBARD

TO GIORGIO VASARI

LOMBARD WAS a Flemish painter and architect, protected by the Cardinal de la Marck, Prince-Bishop of Liége. He went to Rome in 1537 and on his return painted many pictures in Liége, his native town. He displays here a sense of the history of art very appropriate in writing to Vasari.

EARLY ITALIAN ART *Liége, April 27, 1565*

From your books I understand that your spirit is as kind and courteous as it is gifted in the arts, so that I feel encouraged to open my mind to you, as one painter to another, without ornaments of speech, and to confess my great desire of obtaining a favor from your courtesy. I should be content to have a painting by Margaritone, and also one by Gaddi and one by Giotto, in order to compare them with certain glazed windows in ancient monasteries here and with certain bronze bas-reliefs. These works bear figures on tiptoe for the most part. Nonetheless they have aroused my interest more than certain modern works of the last hundred years. Works two, three, or four centuries old please me better than those of today, as far as their style is concerned, in spite of their being done more according to tradition than with real art and imitation of life.

I recollect having seen in Italy some figures painted around 1400, very disagreeable to the eye, for they were neither thin nor fat nor had they any good style. It seems to me—forgive me if I

am mistaken—that the works of the artists living between the times of Giotto and Donatello prove to be clumsy. Of this kind there are many in our country and throughout Germany, dating from the period between that time and Master Roger and John of Bruges. The latter opened the eyes of the painters, who took to imitating his manner and, concerning themselves with nothing further, left our churches full of pictures that are unlike good and lifelike ones and have no quality except beautiful colors.

SCHONGAUER AND DUERER

Then there arose in Germany one Martin Schongauer, a copperengraver, who did not depart from the style of Roger his master, yet failed to attain Roger's excellence in coloring. He was less practiced in handling the brush than in engraving his prints, which at that time seemed miraculous and today still enjoy a good reputation among our artists, because, though somewhat dry, they are not without elegance.

From this Martin Schongauer all famous German artists derive. The first is that unequaled and diligent Albrecht Duerer, his pupil. He followed the manner of his master, but treated his ample draperies in a manner far more conformable to life, although not absolutely true to it, and introduced a more vigorous and less dry mode of drawing, assisted by geometry, optics, rules, and proportions of figures.

NICHOLAS HILLIARD

A TREATISE CONCERNING THE ARTE OF LIMNING

In 1598 Richard Haydocke published a translation of Lomazzo's *Treatise* (see p. 111). Looking for someone to write on the art of limning, he thought of Nicholas Hilliard, limner and goldsmith to Queen Elizabeth, because, as he said: "His perfection in ingenious illuminating or limning, the perfection of painting, is so extraordinaire that when I devised with myselfe the best argument to set it forth, I found none better than to per-

suade him to do it himself . . ." It is generally assumed that Hilliard's consent resulted in the treatise from which we quote.

Compare Leonardo upon the painter as a gentleman, p. 46.

PAINTING IS FOR GENTLEMEN

Amongst ye antient Romans in time past forbad that any should be taught the arte of painting saue gentelmen only. I coniecture they did it upon judgment of this ground, as thinking that noe man vsing the same to get his liuing by, if he was a needy artificer, could haue the patience or leasure to performe any exact true & rare peece of worke, but men ingeniously borne, and of sufficient means not subject to [those?] comon cares of the world for food and garment, moued with emulation and desier therof, would doe theier vtermost best, not respecting the profitt or the lenght of time . . .

Now therfor I wish it weare so that none should medle with limning but gentelmen alone, for that it is a kind of gentill painting of lesse subiection than any other; for one may leaue when hee will, his coullers nor his work taketh any harme by it. Morouer it is secreet, a man may vsse it and scarsly be perseaued of his owne folke; it is sweet and cleanly to vsse, and it is a thing apart from all other painting or drawing, and tendeth not to comon mens vsse, either for furnishing of howsses or any patternes for tapistries, or building, or any other worke whatsoeuer, and yet it excelleth all other painting whatsoeuer in sondry points, in giuing the true lustur to pearle and precious stone, and worketh the metals gold or siluer with themselfes, which so enricheth and innobleth the worke that it seemeth to be the thinge itselfe, euen the worke of God and not of man . . .

Neuertheless, if a man be so indued by nature and liue in time of trouble, and vnder a sauage gouerment wherin arts be not esteemed, and himselfe but of small meanes, woe be vnto him as vnto an vntimly birth; for of mine owne knowledge it hath mad poure men poorer, as among others many, the most rare English drawer of story works in black and white, John Bossam, for one of his skill worthy to haue bene Sergant Painter to any King or Emperour . . . Being very poore, and belyke wanting to buy faier

cullors, wrought therfore for the most part in whit and black, and growing yet poorer by charge of childeren &c. gaue painting cleane ouer, . . . and became a reading minister, only unfortunat becasse he was English borne, for euen the strangers would other-wisse haue set him vpp.

PAINTING IMITATETH LIFE

Now knowe that all painting imitateth nature or the life in euerythinge, it resembleth so fare forth as the painters memory or skill can serue him to expresse, in all or any maner of story worke, embleme, empresse, or other deuice whatsoeuer; but of all things the perfection is to imitate the face of mankind, or the hardest part of it, and which carieth most prayesse and comendations, and which indeed one should not atempt vntill he weare metly good in story worke, soe neare and so weel after the life as that not only the party in all liknes for fauor and complection is or may be very well resembled, but euen his best graces and countenance notabelly expressed, for ther is no person but hath variety of looks and countenance, as well ilbecoming as pleassing or delighting.

LYNE WITHOUT SHADOWE SHOWETH ALL

Forget not therfore that the principal parte of painting or draw-ing after the life consisteth in the truth of the lyne . . . As drawe but that lyne about the shadowe [of a man against a wall] with a coall, and when the shadowe is gone it will resembel better then before, and may, if it be a faire face, haue sweet countenance euen in the lyne, for the line only giueth the countenance, but both lyne and coulor giueth the liuely liknes, and shadows showe the round-nes and the effect or defect of the light wherin the picture was drawne.

This makes me to remember the wourds also and reasoning of her Majestie when first I came in her Highnes presence to drawe, whoe after showing me how shee notied great difference of shadowing in the works and diuersity of drawers of sundry nations, and that the Italians who had the name to be cunningest and to drawe best, shadowed not, requiring of me the reason of it, seeing that best to showe onesselfe nedeth no shadow of place

HILLIARD (?): Elizabeth, Queen of England

but rather the oppen light; to which I graunted, and afirmed that shadowes in pictures weare indeed caused by the shadow of the place or coming in of the light as only one waye into the place at some small or high windowe, which many workmen couet to worke in for ease to their sight, and to giue vnto them a grosser lyne and a more aparant lyne to be deserned, and maketh the work imborse well, and shewe very wel afar of, which to liming work nedeth not, because it is to be weewed of nesesity in hand neare vnto the eye. Heer her Majestie conseued the reason, and therfor chosse her place to sit in for that porposse in the open ally of a goodly garden, where no tree was neere, nor anye shadowe at all, saue that as the heauen is lighter then the earthe soe must that littel shadowe that was from the earthe.

ERROR OF PRAYSING MUCH SHADOWES

This matter only of the light let me perfect, that noe wisse man longer remaine in error of praysing much shadowes in pictures after the life, especially small pictures which ar to be wiued in hand: great pictures placed high ore farr of requier hard shadowes or become the better then nearer in story worke better then pictures of the life, for beauty and good fauor is like cleare truth, which is not shamed with the light, nor neede to bee obscured, so a picture a littel shadowed maye be bourne withall for the rounding of it, but so greatly smutted or darkened as some vsse disgrace it, and is like truth ill towld. If a very weel fauored woman stand in place wher is great shadowe, yet showeth she louly, not because of the shadow, but becausse of her sweet fauor consisting in the lyne or proportion, euen that littel which the light scarsly sheweth greatly pleaseth, mouing the desier to see more, ergo more would see more; but if she be not very fayre together with her good proportion, as if to palle, too red, or frekled etc., then shadowe to shewe her in doeth her a fauore.

ANNIBALE CARRACCI

TO HIS COUSIN LUDOVICO

THE BROTHERS Agostino and Annibale Carracci and their cousin Ludovico were the founders of the Academic School of Bologna and of the reaction against mannerism towards the end of the sixteenth century. According to their admirers, they avoided both Caravaggio's undiscriminating realism and the mannerists' unnatural idealism. Actually, their style was based on an eclectic imitation of nature and the earlier sixteenth-century painters. Annibale was the most gifted of the three.

IN PRAISE OF CORREGGIO *Parma, April 18, 1580*

I am writing the present letter to greet you and to let you know that I arrived at Parma yesterday . . . I could not refrain from going at once to see the great dome, which you have so often commended to me. Yet I was astonished to behold such a vast and

complex composition—every detail of it so admirably conceived and so well foreshortened from below, with such rigor and yet always with such good taste, such grace, and a coloring that is real flesh. Great God! Neither Tibaldi, nor Niccolino, nor, I was going to say, Raphael himself has anything in common with Correggio. I do not claim to be a great connoisseur, but this morning I went to see the altarpiece with the St. Jerome and the St. Catherine, and the Madonna going to Egypt with the Bowl, and, by God! I would not barter either of these for the St. Cecilia. Can one describe the grace of that St. Catherine, who so gracefully rests her head upon the foot of that charming little Christ? Is she not lovelier than the St. Mary Magdalen? Is not that fine old man of a St. Jerome both grander and tenderer—which is what matters—than the St. Paul, which formerly seemed a miracle to me, but now seems wooden, so hard and sharp it is? Come now! One cannot say so much, but it deserves more. Let your Parmigianino himself be patient, for I realize that he has tried to imitate all the grace of that great man, and yet lags very far behind, for Correggio's *putti* breathe, live, and laugh with such grace and truth that they compel you to laugh and rejoice with them. [See illustration, p. 193.]

CORREGGIO AND TITIAN *Parma, April 28, 1580*

When Agostino comes he will be welcome and we shall stay at peace and shall apply ourselves to the study of these fine works, but, for God's sake! without squabbles and without so many subtleties and so much talking. Let us devote ourselves to becoming masters of this fine manner. This shall be our concern, so that someday we may mortify that gang of spiteful rascals that are always baiting us as though we had committed murder.

The opportunities [for work] desired by Agostino are not to be found, and this seems to be a town unbelievably destitute of good taste and with no interest in painting and no opportunities. Here, except for eating, drinking, and making love, people think of nothing.

I promised to send you some report on my impressions, as we again agreed before I left, but I confess that I find it impossible, so distracted am I. I am going mad and weeping inwardly at the

mere thought of poor Antonio [Correggio]'s misfortune. Such a great man—if indeed he was a man at all and not an angel incarnate—doomed to languish in this town where he could not be appreciated nor extolled to the stars and to die here miserably. He will be always my favorite, and so will Titian. Until I have been to see Titian's works in Venice I shall not die contented. These are real paintings, let anyone say what he will. Now I acknowledge it, and I confess that you were perfectly right. I am unable and unwilling to juggle with words. I like this straightforwardness and this purity that is not reality and yet is lifelike and natural, not artificial or forced. Every man has his own views, and these are mine. I am unable to express them in words, but I know how I am to work and that is enough.

I have been to the [Church of Santa Maria della] Steccata and to the Zoccoli [Church of the Annunziata] and have noticed that which you used to tell me of, and I confess it is true [of Parmigianino and Correggio]. But still I maintain that, to my taste, Parmigianino may not be compared to Correggio, because Correggio's ideas and conceptions were his own: one sees that he has drawn them out of his own head and invented them by himself, only verifying them with the living model. All the other painters rely on something that is not their own: some on lay figures, others on statues, others on prints. Other painters picture men as they might be: he, as they are. I am unable to explain myself or to make myself understood, but I know what I mean. Agostino will be able to make sketches of these pictures and to discourse of them in his own fashion.

GUIDO RENI

TO MONSIGNOR MASSANI

THE FRAGMENTARY letter from which we quote was addressed to the Steward
of the Household of Pope Urban VIII. In it the artist, a pupil of the Car-
racci, refers to his painting *St. Michael Fighting the Devil,* in the church
of Santa Maria della Concezione, in Rome. [Compare Raphael, p. 74, on
the "idea."]

I should have liked to have an angelic brush and heavenly forms
for delineating the Archangel, and to see him in Paradise. But I
was unable to ascend so high, and I sought him on earth in vain.
So, I had to look to the idea of beauty conceived in my mind. The
idea of ugliness, too, is to be found, but I omit explaining its use

in the image of the Devil, because I shun him with my very thoughts and I do not care to remember him.

GUIDO'S MODELS

Asked once by a pupil from what exemplars he drew the noble forms and fair faces, so divine in their features and expressions, he showed him a few very common plaster heads cast from antique statues—the *Niobe,* the Medici *Venus,* and others—and replied: These are my teachers, and you will be able to extract from them the same lineaments as I do, if you have enough talent.

FRANCESCO ALBANI

FROM HIS TREATISE ON PAINTING

ALBANI, A BOLOGNESE painter and pupil of the Carracci, left fragments of a treatise on painting in which he gives vent to the academist's prejudice against still life, half-length portraits, and the realism of Caravaggio. The

distinctions between the real and the probable and the comparisons of painting and poetry are drawn from the *Poetics* of Aristotle and show that Albani, though not very well educated himself, associated with learned men. He speaks of himself in the third person.

THE FOLLOWERS OF CARAVAGGIO

He never could suffer those who followed Caravaggio, perceiving that this manner is the precipice and total ruin of the most noble and accomplished art of painting, because, although the mere imitation of nature is partly commendable, it was destined nonetheless to engender all those evils that have ensued in the past forty years. One sees, indeed, imitations of the real, but not of the probable, nor does one achieve representations of characters or liveliness of movements. And since the painter—like the poet —should first conceive a thought, our art is now totally depraved, for these fellows illustrate no thoughts, nor do they even introduce any thoughts in what they represent.

But why more? They present to our view a half-length figure and pass it off as a complete picture, thereby freeing themselves from the obligation of painting the thighs, the legs, and the floor on which it stands—for it is only from the waist up—and dispensing with perspective, with thoughts, with expressions, and— what I should have mentioned before—with inventions.

Albani never could suffer this manner of painting, entirely contrary to that of Raphael of Urbino; and, as he always liked to tread in Raphael's footsteps, he determined to follow him also in his style of composition.

THE STYLES OF RAPHAEL AND TITIAN

Had Raphael lived beyond his thirty-seventh year and reached the age of fifty, which is the perfect age, he would have turned his hand to a more tender refinement and, guided by his art and intellect, would have approached closer to nature. Nature was the very principal object and aim of Titian and Correggio. It was better for them that they did not meddle with statues. Statues, no matter how beautiful, are a dangerous model for a painter; being white and usually exposed to the intense light of courtyards,

a painter making drawings or studies of them should be very wary, because in them the shapes of the folds of the draperies are all very clearly defined, and if he reproduces them in his painting as they appear to him, exhibiting all their grooves and ridges even in the shadowed portions, he will mar his picture and deprive it of force and unity. That is why Titian, in painting the darks, used to leave in the grooves of the draperies an impasto blended in accordance with nature. If a draftsman accustomed to draw from the works of Raphael—who studied much and imitated in part antique statues—turns to drawing from Titian, he will be disappointed because he will not be able to decipher anything in the dark parts, whereas he can perfectly understand the works of Raphael of Urbino. [Compare Rubens, p. 148.]

THOSE WHO PAINT WITH BOLD BRUSH STROKES

To those who admire no painting but that which is done with ease and who require nothing further, I say: Oh, poor works, then, of Correggio, Titian, Raphael, and others, which do not exhibit these brush strokes! Look at Correggio: he is all smoothness, and no brush strokes can be distinguished in him any more than in nature. If someone has the courage to show me the face of a man and to indicate to me the bold brush strokes on it one by one, I pledge myself to give him a doubloon for each. But nature is made of real flesh and is all blended, and no outlines are to be found there, although the head must always be bounded by the background, whether it be the air or dark architecture.

THE UNLEARNED PAINTERS OF STILL LIFE

Today we see the triumph of the insensate, or, to make myself clearer, of those who are able to portray only still and dead things and with these gain fame among the vulgar. I sometimes reflect on the wonders we read about those painters [Parrhasius] who deceived the birds with well-pictured grapes, and I say: It is one matter to deceive birds and another to deceive persons of judgmen⁺ acquainted with sentient beings and with the passions of the mind, which are far more difficult to represent than the features of the body. Grapes, figs, and melons are far easier than such

passions. By his works one can tell whether a man has nursed from his youth a desire to become a painter in the hope of equaling— nay, surpassing—Raphael, has believed that he could achieve this in a few years, has neglected the study of books, has not listened to the voice of the learned, has assumed that he could take his degrees merely by looking at paintings or tapestries, neglecting to acquaint himself with perspective and failing to alternate the practice of drawing with the perusal of books of all sorts. Books are the true means of acquiring talent, for if one does not read one remains ignorant, and ignorance can never produce true painters.

CARLO RIDOLFI

THE PAINTER'S PROFESSION

RIDOLFI, A VENETIAN painter, imitator of Paolo Veronese, is chiefly known for his lives of the painters of his city, entitled *The Wonders of Art* (1648). Compare Vasari, p. 99.

There is no profession—among those that the Most High, in order to manifest His Divine Omnipotence, has infused into the minds of men—in which you may expect less happiness and contentment than in painting. For a painter, before he can attain even a moderate degree of perfection, has to submit to so many drudgeries and toils, that they exceed human credibility. Nor, after so much sweating, may he expect even a little applause unless some wind of favorable fortune turns up to blow him into the harbor. Wherefore it often happens that his life ends in misery and want. But what causes us even greater astonishment is that, when the artist who was so unlucky during his lifetime has passed away and can no longer enjoy the fruit of his labors, then his works begin to be praised and coveted by men.

ANDREA SACCHI

TO FRANCESCO ALBANI

SACCHI WAS a pupil of Albani. Pieter van Laer, known as Bamboccio (1592-1642), whose style Sacchi here criticizes, was a Dutch painter who lived in Rome for many years and gained a reputation by painting scenes of rustic revelries and low-class brawls.

Rome, October 28, 1651

I am persuaded that you will appreciate my informing you that among the things now in decline at Rome is painting. The painters of this city, seeing what a lofty thing true beauty in nature is and how difficult it is to apprehend it and to represent it decorously with a fitting nobleness of detail and proper expression, have arrogated to themselves a certain freedom of conscience: they represent anything whatsoever, and badly; they copy reality, and paint indecent and unseemly attitudes with no regard for grace and decorum. They will picture a vagabond searching for lice, another drinking soup out of a bowl, a woman urinating and holding a braying donkey by the halter, a Bacchus vomiting, and a dog licking. Pshaw! This crowd of painters is patronized by certain dilettanti who buy their works to dispose of them at a small profit and then order new ones at six or eight crowns apiece. Such, then, is the unhappy state of painting. There are six real painters in Europe at most; but they have all these Bamboccianti against them like pygmies setting up for giants.

PIETRO BERRETTINI DA CORTONA

NUDITY, RELIGION, AND ART

THE FOLLOWING excerpts are drawn from a *Treatise on Painting and Sculpture* (Florence, 1652), composed by the artist, who was painter and architect, in collaboration with the Jesuit Father G. D. Ottonelli. They are there-

Follower of HONTHORST: Girl Hunting for Lice, 1615-1620

fore typical of the official baroque point of view and are to be compared with the earlier views of Ammannati (p. 100) and the later ones of David d'Angers (p. 220).

THE NUDE

Images of the nude are not *per se* obscene, for in many men's judgment many such images have been painted without obscenity. But, for my part, I think this happens rarely and in practice does not ordinarily succeed, because more often than not the painter of nude images designs them with some immodesty. Nor would a painter deserve praise who, in order to show off his skill, pictured and exhibited—I do not say the illicit familiarity of Mars and Venus—but the lawful embraces of a married couple in the nude, for not all that we are allowed to do in private are we allowed to represent in public.

STICK TO RELIGIOUS SUBJECTS

I exhort every artist to restrict himself to the production of sacred works alone, whenever the subject is left to his choice. Whenever he cannot, either by a refusal or by persuasion, gain exemption from profane work, let him execute it diligently and according to the rules of our art, but let him make known, if not by outward signs to men, at least by his inward feeling to God, that only on compulsion does he submit to such profane employ.

The painter must so paint each of his works that it will look well designed, judiciously composed, gracefully colored, and be such as will incite to devout feelings if it is sacred and to noble thoughts if it is not. Thus he will please the painters with the design, the learned with the composition, the simple with the colors, the religious with the devoutness, and men of honor with the magnanimity.

GIAN LORENZO BERNINI

CONVERSATIONS REPORTED BY THE SIEUR DE CHANTELOU

In 1665 Louis XIV invited Bernini to come to Paris to execute the east façade of the Louvre. He crossed the Alps in April and was received with great honors. But he was used to great freedom in Rome, even when working for the Pope, and he misunderstood and resented the complicated protocol of the French court and his apparently menial position. Owing to this strangeness, and to the jealousy of the French artists who knew how to use it, he was not permitted to accomplish his purpose, and after five months he returned to Italy. The only works he completed in France were a bust of the King and the canopy of the altar of the church of the Val-de-Grâce.

Bernini spoke no French, so Paul Fréart, Sieur de Chantelou, *maître d'hôtel* to Louis XIV, who was fluent in Italian and had a lively interest in the arts (he had long been a friend of Poussin; see p. 150), was charged by the King with accompanying him as guide and interpreter. Chantelou has left us an accurate day-by-day account of Bernini's stay in Paris, his contact with the court, and his opinions on art.

PORTRAITS IN MARBLE *June 6, 1665*

Speaking of sculpture and the difficulty of succeeding in it— particularly in marble portraits—and of achieving good likenesses, he said something remarkable, which he has since been re- peating on every occasion: "If a man whitened his hair, beard, eyebrows, and—were it possible—his eyeballs and lips, and pre- sented himself in this state to those very persons that see him every day, he would hardly be recognized by them. . . . Hence you can understand how difficult it is to make a portrait, which is all of one color, resemble the sitter."

He made another and still more extraordinary remark: "Some- times in order to imitate the original one must put into a marble portrait something that is not in the original."

This sounds like a paradox, but he explained it thus:

"In order to represent the livid hue that some people have around their eyes we must carve out the place in the marble corresponding to these livid patches so as to render their effect and to make up, so to speak, by this artifice the deficiency of sculpture, which cannot reproduce the colors of things. And yet," he added, "the original has not the cavities which we make in the imitation."

BAROCCIO AND MICHELANGELO *June 8, 1665*

"When a painting by Baroccio, who used bright colors and gave agreeable looks to his figures, is seen for the first time, even by a connoisseur, it will please him perhaps better than a painting by Michelangelo, which at first glance looks so rude and unpleasant that it makes you turn your eyes away from it. Nevertheless, while you are turning away and leaving the room, Michelangelo's paint- ing seems to detain you and call you back, and after having

examined it for a while you are forced to say: Ah! and yet it is
fine! At length it charms you insensibly and so deeply that you
are loath to depart. And every time you behold it again it will
look finer and finer. The reverse happens with a work of Baroccio's
or with any painting having no other merit but those of coloring
and natural agreeableness. Such works will lose a bit of their
beauty every time you see them again."

ON POUSSIN *July 25, 1665*

He examined the first *Bacchanal,* which contains those masks
scattered about the ground, for a quarter of an hour, at least. He
found the composition admirable, then he said: "Indeed, this man
was a great painter of history and a great painter of mythology."

HOW TO CORRECT ONE'S WORKS *August 14, 1665*

"There are two devices which can help the sculptor to judge of
his work: one is not to see it for a while; the other—whenever he
has not leisure for the former—is to look at his work through
spectacles which will change its color and magnify or diminish it,
so as to disguise it somehow to his eye, and make it look as though
it were the work of another, removing by this means the delusions
caused by *amour-propre.*"

MICHELANGELO *August 21, 1665*

"Michelangelo would never make portraits. He was a great man,
a great sculptor and architect. Nevertheless, he had more art than
grace, and consequently failed to equal the ancients, for—surgeon-
like—he applied himself chiefly to anatomy."

A LECTURE AT THE ACADEMY *September 5, 1665*

Standing in the middle of the room, surrounded by all the
members of the Academy, he said that in his opinion the Academy
should possess the plaster casts of all the finest antique statues, bas-
reliefs, and busts, for the instruction of the students, so that they
could learn to draw in those antique styles and from the outset fa-
miliarize their minds with beauty, which would be of service to
them throughout their lives. If one makes them draw from nature

at the beginning, one ruins them. Nature is nearly always feeble and puny, so that if their imaginations are filled only with natural forms they never will be able to produce anything beautiful and grand, for these qualities are not to be found in nature. Those who make use of living models must already be very proficient, in order to recognize their defects and correct them, which young, untrained students are unable to do . . .

He told us that, when still very young, he would often draw from the antique, and that, when he was working at his first figure, every time he was in doubt about something he would go to consult the *Antinoüs* as an oracle. He added that day by day he noticed in this statue new beauties which had hitherto escaped him and which he never would have noticed had he not handled the chisel. For this reason he always advised his pupils and other young artists not to give themselves to modeling or to drawing unless they applied themselves at the same time to carving or painting, thus intermingling production and imitation, or, if we may so express it, action and contemplation, a method from which a great and marvelous progress will result.

In the meanwhile Mr. LeBrun arrived. The Cavaliere greeted him politely and went on saying that three things are required for success in sculpture and painting: to see beauty early and accustom oneself to it, to work much, and to get good advice. [Compare Chardin, p. 169.]

LOMBARD AND FRENCH ARTISTS *September 6, 1665*

The Cavaliere added that an art school in France requires other teachings than an art school in Lombardy. The French have spirit, but a bad and minute manner. The Lombards, on the contrary, lean somewhat towards the sluggish and heavy side, but have grandeur. The Lombards need awakening and the French need to be taught grandeur.

MODELS *October 11, 1665*

He said that most of our models are not handsome. So he had sent to Civitavecchia and Ancona for Levantines to serve him as models and had found them satisfactory He had some general

advice for all who draw from nature. They should be on their guard and examine the model carefully. They should make the legs longer rather than shorter, for if you add a little bit to the length of the legs you increase the figure's beauty, but if you shorten them a little bit you render it heavy and clumsy. Compared to what is to be seen in nature ordinarily, men's shoulders should be made broader rather than narrower, and men's heads smaller rather than larger. The shoulders of women, on the contrary, must be made a little narrower than real ones, for God gave to men breadth of shoulders for strength and work, and to women breadth of hips for bearing us in their wombs. Feet must be made small rather than big, in accordance with the handsomest models and antique statues.

CONTRAPPOSTO

In connection with the student's drawing that he had just seen, he said that during his studies he had discovered that one of the most important points for a student to bear in mind concerning the posture of a figure is that it should have a natural stance. Seldom does a man, unless he is very old, rest his weight on more than one leg. The artist must be careful to reproduce this posture accurately and make the shoulder on the side of the leg bearing the weight of the body lower than the other. If one of the arms is raised, it should always be the one on the side opposite the leg bearing the body. If this maxim is disregarded, the figure will lack grace and violence will be done to nature. Observing good antique statues, he had found that they all conform to this rule.

VICENTE CARDUCHO

DIALOGUES ON PAINTING

THE BROTHERS Bartolommeo and Vincenzo Carducci were two Florentine painters who sought their fortunes in Spain, where their name was adapted to the Spanish spelling, as was then the custom.

Vincenzo, who was a pupil of his elder brother, painted many works scattered through the churches and convents of Spain. His style is fluent and brilliant. His *Dialogues on Painting* was published in 1633.

On portrait painting, compare Armenini, p. 110; and Palomino, p. 164.

GREAT PAINTERS PAINT NO PORTRAITS

A painter ignorant of theory, but well practiced, sets to work to copy from the life a head, which, as is ordinarily the case, is

wholly or partly disproportionate and ugly. He will copy it very accurately, but it is inevitable that the portrait should exhibit all the imperfections of the original. This would not happen if the painter were learned, because with his reason and the learned habits of his mind he would correct and amend the features of his model. And doubtless this is the reason why the great and eminent painters were not portraitists, because a portraitist has to submit to an exact imitation of his model, whether handsome or ugly, without using his reason or his learning, and a man whose mind and eyes are accustomed to good proportions and shapes cannot do so without doing violence to his whole mental attitude.

USE OF LIVING MODELS

Living models are to be studied, but not copied. They are to be used thus: after having reasoned and speculated on their good and bad essential and accidental qualities and having made an art and science out of them, they will serve only as a stimulus to recollection and a means of awakening our forgotten knowledge, because what has faded from our memories may be traced back with their aid. It will be expedient sometimes to keep them before us, not for the purpose of copying them, but in order to examine them carefully so that they may serve to animate the spirits of our imagination, awakening and resuscitating ideas which, owing to the frailty of our memorative power, lay asleep and dead. Living models will be of great service to a learned artist, for he will not run against the dangers besetting the unlearned.

AGAINST AN OVERRIGOROUS ADHERENCE TO
THE RULES OF PERSPECTIVE

From such rigor very conspicuous defects would ensue, because figures and scenes would appear distorted and unintelligible, owing to the foreshortenings that would result.

If painters do not adhere to the rigorous methods of perspective, it is not that they are unacquainted with them, but that they choose the most adequate means for their ends, which are the representation of a story and the propriety and agreeableness required to instruct and delight the spectators.

THE ARTIST'S WORK MIRRORS HIS TEMPERAMENT

In most cases differences [of style] will be caused by the variety of men's temperaments. As each artist has a proclivity to imitate or reproduce his own likeness—and as a painting is the offspring of the mind which conceived it and of the senses and tendencies of the body, which is the instrumental power of man—he will imitate himself as much as he can, impelled by the tendencies of his temperament and natural constitution. And so you will see that if a painter is choleric he will show fury in his works; if he is phlegmatic, meekness; if devout, religion; if lecherous, sensuality; if he is small, his figures will be dwarfish; if he is jovial they will be ruddy and merry; and they will be melancholy if he is saturnine; if he is niggardly and narrow-minded, his painting will show meanness and timidity. All these effects will result indubitably, for he will let himself be carried away by his temperament and will imitate himself in his works—his moral character in his manner of painting, and his physical aspect in the proportions of the figures. [Compare La Tour, p. 171.]

ONLY DEATH ESTABLISHES THE ARTIST'S REPUTATION

According to an opinion now prevalent and widely spread among gentlemen, paintings shall not be valued highly nor enjoy any renown while the artists who did them are living, as though the fatal scythe of death were the *me fecit* establishing the value of the artist. Or, at any rate, the artist must live very far away so that only an echo of his name may arrive here, as though the sight of the person canceled the excellence of his works. [Compare David, p. 206.]

FRANCISCO PACHECO

THE ART OF PAINTING

FRANCISCO PACHECO DEL RIO lived and worked largely in Seville. His works are correct but cold. Velasquez was his pupil and in 1618 married his daughter Juana. In 1649 Pacheco published *The Art of Painting, Its Antiquity and Greatness,* from which the following excerpts are drawn.

On nudes, compare Pietro da Cortona, p. 132, and Ammanati, p. 100.

HOW TO PAINT A LANDSCAPE

The order observed in painting a landscape—once the canvas has been prepared—is as follows: First, one draws it, dividing it into three or four distances or planes. In the foremost, where one places the figure or saint, one draws the largest trees and rocks, proportionate to the scale of the figure. In the second, smaller trees and houses are drawn; in the third yet smaller, and in the fourth, where the mountain ridges meet the sky, one ends with the greatest diminution of all.

The drawing is followed by the blocking out or laying in of colors, which some painters are in the habit of doing in black and white, although I deem it better to execute it directly in color in order that the smalt may result brighter. If you temper the necessary quantity of pigment—or even more—with linseed or walnut oil and add enough white, you will produce a bright tint. It must not be dark; on the contrary, it must be rather on the light side because time will darken it. From this principal tint mixed with white you will produce two other light ones, one lighter than the other, so that there will be a clear differentiation among them.

Then, with carmine and white, you shall make a pinkish tint, lighter than the blue ones. If you are representing a sunset or sunrise, you may, with white and ocher, make a lighter tint than those we have described.

Once these tints have been prepared, they shall be distributed thus: On the horizon adjoining the mountains the tint made of ocher and white. From thence upwards you will lay next to it the pinkish tint, more or less in the same quantity. After this, the blue tints will follow, ending at the top with the darkest. You must bear in mind that all tints must be blended with one another and finished with great smoothness . . .

Once the sky, which is the upper half of the canvas, is done, you proceed to paint the ground, beginning with the mountains bordering on the sky. They will be painted with the lightest smalt-and-white tints, which will be somewhat darker than the horizon, because the ground is always darker than the sky, especially if

the sun is on that side. These mountains will have their lights and darks, because it is the custom to put in the lower part—after finishing—some towns and small trees.

After this, you proceed to put down the larger houses, towns, and trees, painting them in a delicate blue, so that they will harmonize better with this distance. This blue must be mixed with white, and in order to differentiate some of the objects you will put into them a dash of light yellow, which takes on a greenish tinge in that part, and if houses are being represented here, you shall put in a little black or red earth so that they shall be differentiated from those above and be suited to this part of the picture.

As you get nearer the foreground, the trees and houses shall be painted larger, and if desired they may rise above the horizon. These trees may be painted with a green color made with blue ashes or green-blue. Some of them may be darker, so as to be distinguished from the others, and you may add some light spots with *ancorca* [a dark yellow obtained from weld] and *genuli* [a light lead-yellow] in order to lend them brightness . . . If in this part there are any figures, they must be in the correct proportions, just as a figure beside a tree or a house would appear in reality. They must not be too sharply outlined, nor the trees too minutely stippled, and the colors must not be so dark as those of the foreground, yet darker than those of the farther distances.

The foreground, where the figure is placed, is the first part to be drawn and the last to be blocked out in painting and finished, because it is the largest in size and the principal in importance, and you conclude your work with it. The trees painted in it are to extend from the ground up to the top of the sky, because, being the part that is viewed first, they dominate all the other distances. They may be blocked out or underpainted with black and umber, and with a little verdigris or ancorca in their lights, without bringing out the shapes of the leaves, because if this were done they would stand out too much. In this part it is customary to use a practical method in putting in the details, mingling a few dry leaves among the green ones. But it will be much better if they look like the natural leaves of some known species of tree, and the same applies to the trunk, for this part of the picture is the

most important, and it is here that the figure is placed. And it is very praiseworthy to make the grass on the ground look natural, for this section is the nearest to the observer.

THE STRANGE OPINIONS OF EL GRECO

I was greatly surprised—forgive me this anecdote, which I am not relating out of envy—when, having asked Dominico Greco in the year 1611: "Which is the more difficult, drawing or coloring?" he answered: "Coloring."

Yet this was not so amazing as it was to hear him speak with so little esteem of Michelangelo, who is the father of painting, and say that he was a good man but did not know how to paint. However, those who are acquainted with this man will not think it strange that he should have departed from the common sentiment of the rest of the artists, for he was as odd in everything as he was in painting.

As for me, as in drawing the nude I should certainly follow Michelangelo as the principal authority in this department, so in the other details of historical scenes, in the grace and composition of the figures, in the splendor of the costumes, in fitness and propriety, I should follow Raphael of Urbino.

HOW TO PAINT WOMEN

I seem to hear someone saying: "My scrupulous painter, you set us the example of the ancients, who used to strip women in order to depict them to perfection, and you oblige us to paint them well. What way out do you suggest?"

I should reply: "My learned sir, here is what I should do: from the life, I should take the faces and hands with all the required variety and beauty—from virtuous women whom I might see without danger. And for the rest of the bodies I should make use of good paintings, prints, drawings, plaster casts, ancient and modern statues, and the excellent outlines of Albrecht Duerer. And so while choosing the most graceful and perfect parts I should avoid the danger."

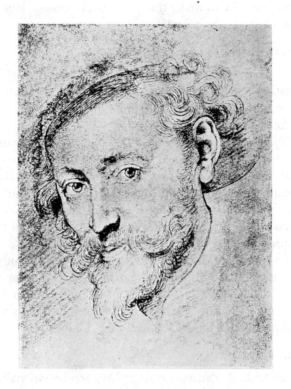

PETER PAUL RUBENS

TWO LETTERS

ALMOST THE entire bulk of Rubens' tremendous correspondence deals with business matters. The letter concerning the death of Adam Elsheimer, a young German painter from whom Rubens had learned much when they met in Rome, is perhaps unique in its direct and personal interest. On the other hand, Rubens corresponded frequently with English friends and patrons, to whom he sold not only his own works (both from his atelier and from his own brush), but antiques out of his large personal collection. The Whitehall Palace project which he mentions was executed in 1631-1635, largely by assistants from Rubens' designs.

TO JEAN FABER *Antwerp, January, 1611*

I have received, one after the other, two letters from Your Lordship, very different in tone and spirit. Because where the first was gay and amusing, the second—that of December 18th—contained frightful news: that of the death of our friend Adam [Elsheimer]; it caused me much sorrow. Our entire corporation [of painters] should put on mourning for the hour in which it lost such a man, a man whom it will not be easy to replace and who, in my opinion, has never had an equal for "subject" painting and for landscapes. He disappears in full force, and *adhuc sua messis in erba erat,* so that one could still have hoped for from him *res nunquam videndae; in summa ostenderunt terris hunc tantum fata.* As for me, I do not remember ever having been as cruelly stricken as at the moment when I learned this news, and I will never again have any sympathy for those who brought him to such a miserable end. I pray God to forgive him his sin of laziness, which deprived the world of a host of masterpieces, gave rise to all his troubles, and drove him to despair—he who, with his own hands, could have created such an immense fortune and commanded universal respect.

But enough of recrimination. I am sorry that we have no painting by him in this country, and I hope that the picture of which Your Lordship spoke, *The Flight into Egypt,* will fall into the hands of one of my compatriots, who will bring it here. I am, however, afraid that the high price of thirty *écus* will prevent the realization of this wish. In any case, I would advise his widow— if she does not wish to sell the picture quickly in Rome—to send it to Flanders, where there are so many art collectors. I cannot promise that her price will be met, but I will gladly do all I can, in memory of our friend.

TO WILLIAM TRUMBULL *Antwerp, September 13, 1621*

I am quite willing that the picture painted for My Lord Ambassador Carleton be returned to me and that I should paint another hunting piece less terrible than that of the lions, making rebate as is reasonable for the amount already paid, and the new picture

to be entirely by my own hand without admixture of the work of anyone else, which on the word of a gentleman I will carry out.

I am very sorry that there should have been any dissatisfaction on the part of Mr. Carleton, but he would never give me to understand clearly, though I often entreated him to do so, whether this picture was to be entirely original or merely touched by my own hand. I wish for an opportunity to put him in a good humor with me, although it should cost me some trouble to oblige him . . .

I have almost completed a large picture, entirely by my hand and, in my opinion, one of the best, representing a lion hunt. The figures are as large as life. It is an order of My Lord Ambassador Digby, to be presented, I am given to understand, to the Marquis of Hamilton. But, as you truly say, such subjects have more grace and vehemence in a large than in a small picture. I should very much like the picture for the gallery of H.R.H. the Prince of Wales to be of larger proportions, because the size of the picture gives us painters much more courage to represent our ideas adequately and with an appearance of reality . . .

As to His Majesty and H.R.H. the Prince of Wales, I shall always be very pleased to receive the honor of their commands, and with respect to the Hall in the New Palace [Whitehall], I confess myself to be, by a natural instinct, better fitted to execute works of the largest size than little curiosities. Everyone according to his gifts. My endowments are such that my courage has always been equal to any enterprise, however vast in size or diversified in subject.

ON THE IMITATION OF STATUES

FEW PEOPLE admiring Rubens' gorgeous figures, so fresh and ruddy in their complexion, so plump and florid in their forms, which suggest the Flemish type of beauty, would imagine that many of them are patterned after antique marbles. Yet his *Chilled Venus* reproduces the attitude of the *Crouching Venus* of Doedalsas; his *Mercury* is imitated from the Vatican *Meleager;* his *Nymph* with the horn of plenty from an antique Nereid; and so on. Rubens' views of the use of the antique are set forth in the following essay, written in Latin. [On the decline of art, see Armenini, p. 109.]

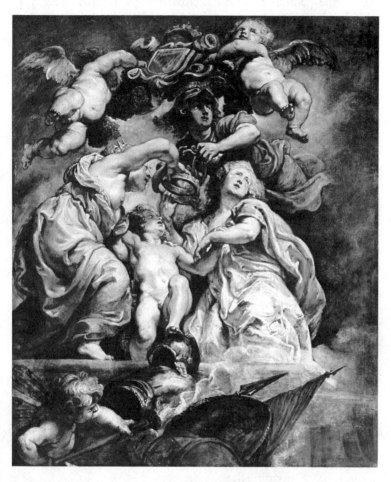

RUBENS: Allegory of the United Realm of England and Scotland, about 1631

COPY WITH DISCRIMINATION

To some painters it is very useful [to copy antique statues], to others so harmful as to destroy their art. I conclude, nonetheless, that in order to achieve the highest perfection it is necessary to be acquainted—nay, imbued—with them. But they are to be made use of judiciously and avoiding any suggestion of the stone. Many unskilled and even some skilled painters do not distinguish the material from the form, the stone from the figure, the inescapable characteristics of marble from the achievements of art.

One good maxim is that the best statues are very useful, but inferior ones are useless and even harmful. Beginners derive from them a certain harshness and stiffness, a sharpness of contour, and an affectation of anatomy, so that, while seemingly making progress, they do so to the outrage of nature, for with their colors they represent merely marble instead of flesh.

Even the best statues, however, through no fault of the sculptor, show many peculiarities which the painter must notice, and indeed avoid. Shadows especially are different from what one sees in nature; flesh, skin, and cartilage by their translucency, in many cases, soften the abruptness of the edges of black patches and shadows, which the stone of statues, on the contrary, by its opacity inexorably makes doubly abrupt. Add that living bodies have certain dimples, changing shape at every movement, and, owing to the flexibility of the skin, now contracted and now expanded, which sculptors ordinarily omit, though the best ones occasionally reproduce them, but which painters must necessarily render, though with moderation. In the high-lights, also, statues are quite unlike anything human, for they have a stony luster and a harsh brightness which give the surface a more pronounced relief than is right, or, at any rate, dazzles the eyes.

THE DECLINE OF ART

The painter who with wise discernment can separate all these characteristics shall cling to statues closely. For what else can our degenerate race do in this age of error? Our lowly disposition keeps us close to the ground, and we have declined from that

heroic genius and judgment of the ancients; whether it be that we are blinded by the fog of our fathers, or that we have fallen on evil by the will of the gods and since then have been unable to rise again, or that we are irretrievably enfeebled because the world is growing old, or else that in antiquity natural objects, being nearer to their origin and perfection, spontaneously presented undivided those beauties which now, disfigured by alterations resulting from the debasement of our aging centuries, they no longer retain; for now perfection is dispersed among many individuals and succeeded by defects. Thus, even man's stature is proved by the statements of many writers to have gradually decreased, for, of what sacred and profane authors relate about the age of Heroes, Giants, and Cyclopes, much is fabulous, to be sure, but something is indubitably true.

The chief cause of the difference between the ancients and the men of our age is our laziness and life without exercise: always eating, drinking, and no care to exercise our bodies. Therefore, our lower bellies, ever filled by a ceaseless voracity, bulge out overloaded, our legs are nerveless, and our arms show the signs of idleness. In antiquity, on the contrary, all men exercised their bodies every day in the palaestra and the gymnasium—to say the truth, even too strenuously—till they perspired and were thoroughly fatigued.

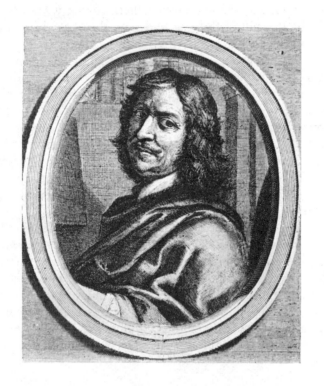

NICOLAS POUSSIN

TO PAUL FRÉART DE CHANTELOU

THE OFFICIAL court post of Poussin's friend, admirer, and patron, the Sieur de Chantelou, was *maître d'hôtel* to His Majesty, Louis XIV. An amateur of the arts (see p. 133), his fine collection centered around the works of his friend.

The *Correspondance* of Poussin with Chantelou consists of several hundred letters, but with rare exceptions almost none of it deals with Poussin's artistic convictions. If Poussin's explanation of the "modes" is confused, it is because he was himself not very clear about them: as Anthony Blunt has shown, they were taken almost directly from a book of musical theory published in Venice in 1585. Nevertheless, they formed the basis of much of Poussin's art and laid out the method by which he varied his style to fit

his subject-matter. Elsewhere Poussin defined painting thus: "It is an imitation of anything that is to be seen under the sun, done with lines and colors upon a surface. Its end is delectation."

Rome, April 7, 1647

I admit that it is very true that all the letters you are pleased to favor me with bring me both profit and pleasure. Your last, of March fifteenth, had the same effect on me as the previous ones, and something more too, because you tell me without sham or pretense what they [in Paris] thought of the last picture [the *Baptism*] I sent you. I am not at all troubled by their criticism and fault finding. I have long been used to it, because no one has ever spared me; on the contrary, I have often been the victim not merely of reproof, but also of slander. In truth this has brought me not a little profit, for it has prevented a vanity that might have blinded me and has made me proceed cautiously in my work—a practice I wish to adhere to all my life. Well, even if those who find fault with me cannot teach me to do better they will be the cause of my finding the means myself . . .

I am not unaware that as soon as one alters one's usual manner just a bit, the run of painters says one has changed one's style; for painting has unhappily been reduced to engraving [i.e., copying what has already been done], or, better, has been lowered to its grave (if, after the Greeks, any has ever seen it alive). On this subject I could tell you many things that are true, and yet known to no one, so that I must not mention them. I only ask you to receive kindly, as is your wont, the pictures that I send, though each one is drawn and colored differently; I assure you that I will do my utmost to satisfy art, you, and myself.

THE MODES *Rome, November 24, 1647*

Our good ancient Greeks, inventors of all beautiful things, discovered certain "modes" by means of which they produced marvelous effects.

The word "mode" really means the system, or the measure and form which we use in making something. It constrains us not to pass the limits, it compels us to employ a certain evenness and

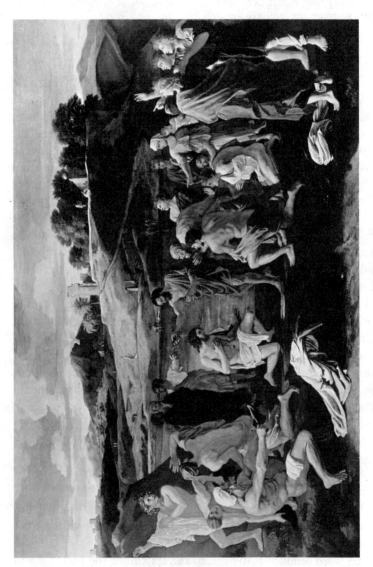

Poussin: The Sacrament of Baptism, 1645-1647

moderation in all things, and therefore is nothing but a certain manner or order that has been determined upon, and which reinforces the process by which the essence of the thing is preserved. The modes of the ancients were compositions of several things put together, and there resulted from the variety of these things a difference of mode, so that it was understandable that each one retained its own peculiar character. Thus the modes had the power of inducing different emotions in the heart of the spectator. Because of this the ancient sages attributed to each the quality of the effects that they saw it produce, and for this reason they called the Dorian mode stable, serious, and severe, and employed it for subjects that were serious, severe, and full of wisdom.

And passing to gay and amusing things, for these they used the Phrygian mode so that they might benefit from finer modulations and a sharper appearance than in any other mode. These two manners, and no others, were praised by Plato and Aristotle, who judged any others to be useless. They thought this latter mode [Phrygian] vehement, violent, very harsh, and capable of astonishing people. Before a year is out I hope to paint a subject in this Phrygian mode. Horrible subjects are suitable to this manner.

They thought also that the Lydian mode was proper for sad things because it has neither the simplicity of the Dorian nor the severity of the Phrygian.

The Hypolydian possesses a certain suavity and softness which fills the soul of the spectator with joy. It is proper for subjects of divine glory, and Paradise.

The ancients invented the Ionic mode, with which they represented bacchanalian dances and feasts in order to achieve a jocund effect.

Were it not that it would be composing a book rather than writing a letter I would inform you of many other things that must be considered in painting so that you might know fully how I study to serve you well. For, though you are very intelligent in all things, I am afraid that the company of madmen and dunces who surround you will by contagion corrupt your judgment.

OBSERVATIONS ON PAINTING

WITH THE help of Plato, Aristotle, Horace, Quintilian, Lomazzo, and Castel-vetro's commentary on Aristotle's *Poetics,* the *peintre philosophe,* as Poussin was called, began a treatise on painting dense with doctrine. Death prevented him from completing it. What remains are the following twelve observations, found among Poussin's papers, and published by his biographer Bellori.

1. THE EXAMPLE OF GOOD MASTERS

Although after the exposition of the theory of painting some instructions concerning its practice are added, nonetheless, until the precepts are authenticated by the inspection of pictures, they do not leave in the reader's mind that ability to work which should be the effect of productive science. On the contrary, leading the young student by long and circuitous paths, they seldom bring him to his journey's end unless the effective guide of good examples points out to him shorter methods and less involved rules.

2. A DEFINITION OF PAINTING

Painting is nothing but an imitation of human actions, which alone are, properly speaking, imitable. Other actions are imitable not *per se,* but accidentally, and not as principal but as accessory parts. With this qualification one may also imitate not only the actions of beasts, but anything natural.

3. HOW ART SURPASSES NATURE

Art is not a different thing from nature, nor can it pass beyond nature's boundaries. For that light of knowledge which by natural gift is scattered here and there and appears in different men in different times and places is collected into one body by art. This light is never to be found in its entirety or even in a large part in a single man.

4. HOW THE IMPOSSIBLE CONSTITUTES THE PERFECTION OF PAINTING AND POETRY

Aristotle, by the example of Zeuxis, intends to show us that the poet is permitted to describe impossible things, provided they be

better than possible ones. Thus, by nature, it is impossible that a woman should unite in herself all the beauties possessed by the image of Helen, which was perfectly beautiful and therefore better than is possible. See Castelvetro.

5. RULES OF.DESIGN AND COLOR

A painting will be elegant when the extreme distances are connected to the foregrounds by means of the middle distances in such a way that they will contrast neither too feebly nor with too much harshness of lines and colors. Here one may speak of the friendships and enmities of colors and their rules.

6. ACTION

There are two instruments for influencing the minds of an audience: action and speech. Action is by itself so potent and effective that Demosthenes assigned to it the primacy among rhetorical devices; Marcus Tullius called it the language of the body, and Quintilian attributed to it such vigor and force that he deemed thoughts, proofs, and emotions ineffective without it. In like manner, if in a painting there is no action its lines and colors are ineffective.

7. SOME CHARACTERISTICS OF THE GRAND MANNER

The grand manner consists of four things: subject-matter or theme, thought, structure, and style.

The first thing that, as the foundation of all others, is required, is that the subject-matter shall be grand, as are battles, heroic actions, and divine things. But assuming that the subject on which the painter is laboring is grand, his next consideration is to keep away from minutiae to the best of his abilities lest he offend against the dignity of historical painting by passing over with a hasty brush things magnificent and grand, and lingering amid vulgar and slight ones. Wherefore the painter is required to exercise not only art in giving form to his matter, but judgment in appraising it, and he must choose a subject that will naturally admit of every ornament and perfection. Those who elect mean subjects take refuge in them because of the weakness of their talents. But good painters

shall spurn mean and lowly subjects refractory to any artifice that might be tried upon them.

As for the thought, it is but an offspring of the mind laboring on things. Such was Homer's and Phidias' thought in the Olympian Jupiter: that with a nod he shook the universe. The design of a scene, therefore, shall be such as will best bring out the thought embodied in the scene.

The structure or arrangement of the parts shall be not far-fetched, not strained, not laborious, but lifelike and natural.

The style is the personal manner and method of painting and drawing, and arises from each artist's particular genius in the application and use of the ideas. This style, manner, or taste he owes to his nature and innate gifts.

8. THE IDEA OF BEAUTY

The idea of beauty does not descend into matter unless this is prepared as carefully as possible. This preparation consists of three things: arrangement, measure, and aspect or form. Arrangement means the relative position of the parts; measure refers to their size; and form consists of lines and colors. Arrangement and relative position of the parts and making every limb of the body hold its natural place are not sufficient unless measure is added, which gives to each limb its correct size, proportionate to that of the whole body, and unless form joins in, so that the lines will be drawn with grace and with a harmonious juxtaposition of light and shadow.

From all the foregoing it can clearly be seen that beauty is altogether independent of the matter of the body, which never receives it unless it is predisposed with these incorporeal preparations. And here we may conclude that painting is nothing but an image of incorporeal things, despite the fact that it exhibits bodies, for it represents only the arrangements, proportions, and forms of things, and is more intent on the idea of beauty than on any other. Wherefore some have maintained that beauty alone is the mark and, as it were, the goal of all good painters, and that painting is the wooer of beauty and the queen of the arts.

9. NOVELTY

Novelty in painting consists mainly not in a subject never treated before, but in good and new groupings and expressions. By these means a subject that is common and old can become singular and new. Here it is fitting to speak of the *Communion of St. Jerome* by Domenichino, in which the emotions and gestures are unlike those of the picture on the same subject by Agostino Carracci.

10. HOW THE DEFICIENCIES OF THE SUBJECT ARE TO BE SUPPLIED

If a painter wishes to excite wonder in the minds of the beholders, even though the subject he is working at is not by itself capable of producing it, he shall not introduce novel, strange, and un-reasonable details, but shall accustom his talents to make his works amazing by the excellence of their manner, so that it may be said: *Materiam superabat opus.*

11. FORM

The form of each thing is distinguished by the thing's function or purpose. Some things produce laughter, others terror; these are their forms.

12. COLOR

Colors in painting are as allurements for persuading the eyes, as the sweetness of meter is in poetry.

CHARLES LEBRUN

FROM HIS *CONFERENCE UPON EXPRESSION*

The *Académie Royale,* as guardian of the true tradition in the arts, held monthly lectures which, though chiefly directed towards its students, were attended by all its members. The *Premier Peintre du Roi*, Charles LeBrun, naturally took a leading part in these, since he was in duty bound to direct students along the right road.

The teaching of the *Académie* was always rigid, but in the study of "expression" it was particularly dogmatic, because gesture, attitude, and physiognomy had been an especial concern of Poussin's (who could do no wrong), and because such an interest corresponded to the psychology of the day. (In his definitions of the passions, as in his original title, LeBrun borrowed directly from Descartes' *Traité des Passions*.) With these analyses before

him, the student did not need to run the risk of consulting nature: he had only to follow the prescription.

The text, first published in 1667, was extremely popular; we quote from an English translation of 1701.

EXPRESSION

At our last Assembly you were pleas'd to approve the Design which I then took to Entertain you upon Expression. It is necessary then in the first place, to know wherein it Consists.

Expression, in my Opinion, is a Lively and Natural Resemblance of the Things which we have to Represent: It is a necessary Ingredient in all the parts of Painting, and without it no Picture can be perfect; it is that which describes the true Characters of Things; it is by that, the different Natures of Bodies are distinguished; that the Figures seem to have Motion, and that every thing therein Counterfeited appears to be Real.

It is as well in the Colouring as in the Design; it ought also to be observed in the Representation of Landskip, and in the Composition of the Figures.

This, Gentlemen, is what I have endeavoured to make you observe in my past Discourses; I shall now Essay to make appear to you, that Expression is also a part which marks the Motions of the Soul, and renders visible the Effects of Passion.

ADMIRATION

As we have said, that Admiration is the first and most temperate of all the Passions, wherein the Heart feels the least disturbance, so the Face receives very little Alteration thereby; and if any, it will be only in the raising of the Eye-brows, the Ends thereof being yet parallel, the Eye will be a little more open than ordinary, and the Ball even between the Lids and without Motion, being fixed on the Object which causes the Admiration. The Mouth will be open, but will appear without Alteration any more than the other part of the Face. This Passion produces only a Suspension of Motion, to give time to the Soul to deliberate what she has to do, and to consider attentively the Object before her; if that be rare and extraordinary, out of this first and simple Motion of Admiration is engendred Esteem.

HORROR

But if, instead of Scorn, the Object raises Horrour, the Eyebrow will be still more frowning than in the preceding Action; the Eye-ball instead of being in the middle of the Eye, will be drawn down to the under Lid; the Mouth will be open, but closer in the middle than at the corners, which ought to be drawn back, and by this Action makes Wrinkles in the Cheeks; the Colour of the Visage will be pale; and the Lips and Eyes something livid; this Action has some resemblance to Terrour.

SIMPLE LOVE

The Motions of this Passion, when it is simple, are very soft and simple, for the Forehead will be smooth, the Eye-balls shall be turned. The Head inclined towards the Object of the Passion, the Eyes may be moderately open, the White very lively and shining, and the Eyeball being gently turned towards the Object, will appear a little sparkling and elevated; the Nose receives no Alteration, nor any of the parts of the Face; which being only filled with Spirits, that warm and enliven it, render the Complexion more fresh and lively, and particularly the Cheeks and Lips; the Mouth must be a little open, the Corners a little turn'd up, the Lips will appear moist, and this moistness may be caused by Vapours arising from the Heart.

LAUGHTER

If to Joy succeed Laughter, this Motion is expressed by the Eyebrow raised about the middle, and drawn down next the Nose, the Eies almost shut; the Mouth shall appear open, and shew the Teeth; the corners of the Mouth being drawn back and raised up, will make a wrinkle in the Cheeks, which will appear puffed up, and almost hiding the Eyes; the Face will be Red, the Nostrils open; and the Eyes may seem Wet, or drop some Tears, which being very different from those of Sorrow, make no alteration in the Face; but very much when excited by Grief.

ANTOINE COYPEL

FROM A DISCOURSE TO THE ROYAL ACADEMY OF PAINTING AND SCULPTURE

AN ARTIST in a family of artists, and a respected academician who painted "history" pictures in the approved "grand manner," Coypel, for the instruction of his son, had written a poem on the *Aesthetics of the Painter*. At the request of the aesthetician Roger de Piles and other friends, Coypel elaborated upon this aphoristic epistle of 186 lines with a long commentary. This was delivered as a discourse to the Academy and then published in 1721, the year before Coypel's death.

WHAT THE PAINTER MUST KNOW *Paris, 1720*

With how much diverse knowledge must not the painter's mind be fitted out? Not only should he have a generous acquaintance with the humanities; he should also be somewhat of a rhetorician, that he may use the same rules as the orator so that, like him, he may be able to teach, to please, and to touch the heart. These are the three ends which more than any others lend power to painting, which should be sought with the greatest care, and which are the most often neglected.

The painter in the grand manner must be a poet; I do not say that he must write poetry, for one may do that without being a poet; but I say that not only must he be filled with the same spirit that animates poetry, but he must of necessity know its rules, which are the same as those of painting . . . Painting must do for the eyes what poetry does for the ears.

Can the painter in the grand manner be ignorant of sacred, profane, or fabulous history? Does he not need geography, geometry, and perspective? He cannot cultivate architecture too much, and in order to understand nature he must be a physicist. Can he be sure of correctly representing things whose cause and effect he does not know? Unless he has some knowledge of that part of moral law which teaches us of the passions, how can he draw the visible images of these movements of the soul? . . .

Through the study of proportions and anatomy he must know the external man; and with the help of philosophy he must delve into his soul. How can he paint his characters unless he has some knowledge of the rules of physiognomy? . . .

Were we to list all the knowledge needed by the painter we should never finish. But all this knowledge will be useless unless he can control it by the order and economy of his whole work, by the beauty and elevation of his thoughts, by a majestic and noble manner of treating his subjects, by worthily filling out the truth of history, by depicting nations, customs, and traditions; by a noble and living expression, and an agreeable and facile execution; and by spreading a smiling abundance and an agreeable variety with a just insight into what will please or displease, bore or fascinate.

DRAWING

The grand manner of drawing is something other than correctness. One can be exact and regular, and still draw in a very petty way. Such is the case with Lucas [van Leyden], Albrecht Duerer, and many others. One can also draw in the grand manner without being very correct, as is evident in most of the works of Correggio. This nobility of drawing, which belongs to the genius of the painter, is not easy to define. It consists, however, in bringing out the large forms and the large masses, and in avoiding everything dry, hard, and cut. Angles in the contours make for the small, the dry, and the mean. An undulating form, one that resembles a flame, animates the contours, and lends them nobility, elegance, and truth. This is what is called the sense of contour, and to attain it Correggio cannot be too much imitated. Everything opposed to this is barbarism and illusion, directly contrary to nature and the taste of the greatest masters: Consult Michelangelo, Leonardo da Vinci, Raphael, and the Carracci. They contain the antidote to Lucas, Albrecht, and mediocrity in general. [Compare Blake, p. 266.]

SEBASTIANO CONCA

PRECEPTS FOR YOUNG PAINTERS

CONCA, A PAINTER of the Neapolitan baroque school, was a pupil of Solimena and was influenced by Maratti. A skillful decorator, he left many paintings in the churches of Rome and was knighted by Clement IX. He taught at the Academy of St. Luke, whence his interest in how the young artist should proceed.

1. He who devotes himself to the practice of the fine arts must not allot so much time to the exclusive study of drawing as to be prevented from applying himself early enough to painting and coloring.

2. However praiseworthy may be studious diligence, one must not set so high a value upon it as to lose originality and inspiration and that fire, that assurance that is the evidence that an artist is master of his art.

4. The study of the antique is useful for learning with what eyes the ancient masters looked at nature and judiciously chose from her.

7. The forms of the ancient Greek visages lead us to sublime and ideal beauty, to be sure, but we must not imitate them exclusively and thus risk forgoing that variety of expressions in which nature is rich.

11. Do not let your desire to please lead you so far in search of the new as to lose sight of the true. Nature is very ancient and still pleases. Novelty may at best strike the fancy of one age, but the good artist must work for eternity, so far as the fragility of things human allows it.

13. Beware of becoming a copyist; you will always remain inferior to your model.

21. Do not bother to be quick. Improvisers do not work for posterity. The public will ask not whether you have completed your work in three days, but whether it is beautiful.

33. The young artist shall relax reading poetry.

ANTONIO PALOMINO

FROM HIS TREATISE ON PAINTING

Acisclo Antonio Palomino de Castro y Velasco was a painter of religious pictures. He was a friend of the more famous artists Carreño de Miranda and Claudio Coello. It was Coello who procured for him the position of court painter to King Charles II of Spain. Palomino's treatise *El Museo Pictorico y Escala Optica* was published in 1715. [Compare Armenini, p. 110, on portraits.]

PORTRAIT PAINTING

I warn you that this is very important. Before undertaking to draw the portrait, you must make your model stand in the most graceful posture that is natural to him and that you desire to pose him in. Thus standing you must draw him, for that is the way to catch his expression. If the portrait is full length you will keep the canvas unnailed and pinned down only with a few drawing-pins. When the drawing is done, take it off and roll up the lower part, nailing the rest at that height at which you can paint sitting.

Now make your model sit down, and sit down yourself. So it is done even in the presence of the King, if His Majesty orders it. If he does not, beg him to allow you to, in order to be comfortable during your work. Begin the underpainting, fixing first the contours and the proportions of the whole and the parts. Then lay in the colors patiently, paying great attention to those of nature, without tormenting them much or defining them too precisely for the time being. I remark that it is advisable—especially while you are doing the eyes—that the sitter should look at you. For thus the portrait will look in every direction and at everyone who looks at it. This is a feature highly praised by those who do not understand it and do not know how it is done.

COLOR HARMONIES

The gradation and matching of the colors also contributes a great deal to beauty. For not every color harmonizes with every other. A green next to a blue is an execrable combination, but if between the two a rosy hue is inserted, it will reconcile them. Blue and purple also are bad neighbors, but if a yellow separates them they will agree. And above all, good taste is what mellows everything. For by lightening or darkening a color more than another or by changing the lights of one of them you can remedy many discordances which will often result by the assemblage of colors, especially in many-figured scenes.

ANTOINE WATTEAU

TO MONSIEUR DE JULLIENNE

JEAN DE JULLIENNE was one of that small (modern) circle of wealthy friends and patrons which included Pierre Crozat (*Trésorier de France*), the Comte de Caylus, and Pierre-Jean Mariette, who discovered and supported Watteau. Jullienne met Watteau when they were both young men of twenty-one. He was the owner of a textile factory, collector, amateur painter, engraver, and musician. After Watteau's early death Jullienne compiled an engraved record of his more than five hundred paintings and drawings. Here Watteau records the admiration for Rubens so evident in his works.

Monsieur l'Abbé de Noirterre has been pleased to send the canvas by P. Rubens with heads of two angels and on the cloud below

the figure of a woman sunk in contemplation. I assure you that nothing could make me happier, were I not persuaded that it is out of friendship for you and for Monsieur your nephew that M. de Noirterre separated himself from so rare a picture. From the moment I received it I have not been able to rest quiet, and my eyes do not tire of returning to the stand where I have placed it as upon an altar. One could not easily persuade oneself that P. Rubens had ever done anything more perfect than this painting. You will be good enough, Monsieur, to transmit my sincere thanks to Monsieur l'Abbé de Noirterre until I myself can address them to him. I will take the occasion of the messenger from Orléans to write him and send him the painting of the *Rest on the Flight* that I destine for him in gratitude.

JEAN-BAPTISTE SIMEON CHARDIN

TO THE JURY OF THE ACADEMY

THIS MORALIZING speech to the admission jury of the official Salon is recorded by the philosopher and critic Diderot—editor of the great *Encyclopédie,* court savant to Catherine of Russia, and defender of Chardin's younger contemporary Greuze—in his review of the Salon of 1765. These are probably not Chardin's exact words; yet they give us the spirit of the modest artist who, to the amazement of his more ambitious and conventional colleagues of the rococo, calmly painted still lifes for his own pleasure.

For other views on academic training see Girodet, p. 212, Géricault, p. 223, and Greenough, p. 284.

ART IS LONG

Messieurs, messieurs, not quite so fast! Seek out the worst of all the pictures here, and think that two thousand unfortunates have broken their brushes between their teeth, in despair at ever doing anything as bad. You call Parocel [a now forgotten painter] a dauber, and he is—if you compare him to [Joseph] Vernet; but this same Parocel is a rare man—compared to the multitude who abandoned the career they entered with him. [François] Lemoine used to say that one needed thirty years of practice to know how to keep the qualities of a sketch, and Lemoine knew whereof he talked. If you will hear me out, you will perhaps learn to be indulgent. When we are seven or eight years old, a pencil is put into our hands. We begin to draw from the cast eyes, mouths, noses, ears, and afterwards feet and hands. Our backs have long been bent over our boards, when we are put before a Hercules or an antique torso, and you have not been a witness to the tears that the *Satyr,* the *Gladiator,* the *Venus de' Medici,* the *Antaeus* have caused to flow. Had these Greek masterpieces been delivered to the vengeance of the pupils, you can be sure that they would no longer arouse the envy of their masters.

After having withered for days and nights before immobile and inanimate nature, we are presented with living nature, and suddenly all the preceding years seem wasted: we were no more at a loss the first time we held a pencil. The eye must be taught to look at nature; and how many have never seen and will never see it! It is the agony of our lives. We have been kept thus far five or six years before the model when we are delivered over to our genius, if we have any. Talent does not declare itself in an instant. It is not at the first attempt that one has the honesty to admit one's inabilities. How many attempts, now happy, now unhappy!

Precious years have flown before disgust, lassitude, and boredom overcome the student. He is nineteen or twenty when, letting fall his palette, he remains without resources, without a trade, and without a character, because it is impossible to be both young and virtuous when one has naked nature constantly before one's eyes.

What shall he do, what shall he become? He must throw himself into one of those low conditions whose doors are open to misery, or die of hunger. He chooses the first alternative, with the exception of some few who come here every two years to expose themselves to the beast; the others, and perhaps the least unhappy, wear a plastron on their chests in some fencing school, or a musket on their shoulders in some regiment, or a costume on the boards The story I have told you here is the story of Belcourt, of Lekain, of Brizard, become bad comedians out of despair at being mediocre painters . . . He who has not felt the difficulties of his art does nothing that counts; he who, like my son, has felt them too soon, does nothing at all; and you can be sure that most of the high conditions of society would be empty if one were admitted only after an examination as severe as the one we must pass.

Adieu, messieurs; be lenient. messieurs, lenient!

MAURICE-QUENTIN DE LA TOUR

TO THE MARQUIS DE MARIGNY

IN 1751, at the age of twenty-four, the Marquis de Marigny, brother of Mme. de Pompadour, became *Directeur des Bâtiments,* with power over all artistic work, and held this post until 1773. His aesthetic education, accomplished largely by Cochin and Soufflot, directed him towards an aversion to what he officially called the *"chicorée moderne"* of the rococo and a support of the grand manner; but his private taste went to Boucher, Natoire, and Greuze.

When La Tour wrote the Count this letter, he had been doing pastel portraits in Paris for some thirty years and had been at the top of his profession for twenty—getting good prices, being a favorite of the court, and allowing himself a favorite's attitude and manner.

NATURE, VISION, AND MANNER

Aux Galléries du Louvre, August 1, 1763

Since I have my pen in hand, Monsieur le Marquis, I am submitting for your judgment some of my thoughts concerning the variations to be noted in organs such as that of sight. It is

maintained that painters see the same object differently, for example, in respect to color, and that due to this variation in their organs one can immediately recognize their works, even from a distance. But it seems to me that, if they were exact in their imitation of nature, from a distance one should recognize their work only by the degree of perfection that each attained, and from close up by their manner of painting. This theory seems to me fatal to the progress of art. It encourages laziness by letting us continue in a routine manner far removed from nature; for nature has no manner but varies her productions so greatly that one never sees two people built and colored the same way.

It would be easy to demonstrate the falsity of this opinion by having several artists paint an inanimate, easily preserved object, such as a piece of porcelain, in a north or south light, in fine weather at a given hour, in the foreground of a picture. Each painter whose eye caused him to see the porcelain as tending towards red, or any other tone, would, if he had a feeling for truth, use his colors so accurately that those whose eyes saw the porcelain a little blue, yellow, violet, gray, or green, not being able to see any difference between the tones of the original and those of the copy, would be convinced that the painter sees as they do and that their eyes are made in the same way as his. If the copies did not stand up under comparison, one could not then blame the organs, but habit and the manner that had been adopted, or a lack of intelligence and talent.

PASTELS AND PERFECTION

Upon the death in 1766 of his brother Charles, with whom he had lived, de la Tour traveled to Holland. There, among many others, he did a pastel portrait of Belle de Zuylen, to whom, upon his return, he wrote this letter. The artist and his sitter—later the author of *Calliste* and the first beloved of Benjamin Constant—were on very good terms. In one of her own letters she describes how La Tour's "mania is to want to include [in the picture] all that I say, all that I think, and all that I feel."

Aux Galléries du Louvre, April 14, 1770

Always interested in perfection of any sort, and consequently in the happiness of the human race, I lose myself like an atom in

the space of the universe. I should be disgusted with this passion for perfection, since it makes me spoil so many works. It is not from vanity that I regret their loss but because nature is thus deprived of any mark of gratitude for the remarkable talents she has been pleased to dispense. Poets and musicians can come back to their best works when their efforts at improvement have put out the spark which had given a sublime effect; but in my pastels all is lost when, for an instant, I let myself drop into a different mood; the unity has been broken. The painter in oils can recover his mood with a little bread dough and some alcohol.

TO THE COMTE D'ANGIVILLER

Louis XVI ascended the throne in 1774, and since May of that year the *Directeur des Bâtiments* had been the Comte d'Angiviller, who, in accordance with the reformist tendencies of the times, did all in his power to reconstitute the glory of "history" painting and to combat the *petite manière* of the rococo.

The four prizes La Tour proposed here were accepted by the Academy in February and March. Besides these, La Tour gave his home town of Saint-Quentin funds for the relief of aged artisans, established an endowment for the aid of indigent mothers in childbirth, and founded a free school of drawing.

FOUR STUDENT PRIZES

Aux Galléries du Louvre, February 1, [1776]

I was mortified by not having been advised of what day Your Lordship was holding audience in order to come and pay my respects, and it so upset me that I took the liberty of writing you many things that in my apathy I then threw into the fire. I cannot make my intentions known until my plans for the public good have been arranged, since I have wished to go on living only to achieve them. Because of your taste for the arts, you will be interested in one of these projects, if the King, who has just established several prizes of one hundred *louis* for the pupils in the engineering school, will be pleased to permit the foundation of four prizes [in the fine arts], and if it will please Your Lordship

to give his approval. These prizes would be for perspective, anatomy, and accurate drawing both from the best ancient and modern statues and from the hands and feet of models. The fourth prize would be for truthfulness of color, asking the pupils to paint the light and shadow of a fine head three times. I think this kind of study is indispensable in avoiding mannerisms. The flesh tones are never uniform, but are constantly changing, and no student can help but understand his deficiencies when he compares the model with ten or twelve heads painted from it. It is the most useful lesson possible for learning to read nature, and such well-considered studies will give the student a facility in coloring all other objects more truthfully. Please excuse my scrawl.

ETIENNE FALCONET

REFLECTIONS ON SCULPTURE

FALCONET's literary and aesthetic interests were many: He was a friend of Diderot, who secured him the commission for his statue of Peter the Great. For four years during his stay in Russia (he left in 1778) he was in some sort aesthetic counsellor to the Empress Catherine, being supplanted only by the learned Grimm. He exchanged many letters with Diderot, translated part of Pliny, and wrote *Observations on the Statue of Marcus Aurelius* and the *Reflections on Sculpture*.

THE AIM OF SCULPTURE *[After 1765]*

The worthiest aim of sculpture—viewed from its moral aspect —is to perpetuate the memory of illustrious men and to give models of virtue which will be the more efficacious in that they can no longer be the objects of envy . . . When sculpture treats subjects that are simply decorative and pleasant, it has another, and an

apparently less useful aim; but even then it is no less capable of leading the heart towards good or evil. Thus a sculptor, like a writer, merits praise or blame as the subjects he treats are decent or licentious.

ART AND NATURE

In envisaging the imitation of the surface of the human body, sculpture must not limit itself to [creating] cold resemblance such as the body of man might have had before it received the breath of life . . . Nature alive, breathing, and passionate—this is what the sculptor must express in stone or marble . . .

Sculpture is above all the enemy of those artificial attitudes which nature abhors, and which many artists have needlessly employed merely to show their skill in handling their medium . . .

The grandest, the noblest, and the most striking product of the sculptor's genius should only express relationships possible in nature—its effects, its fantasies, its singularities: in other words, the beautiful—the beautiful we call *ideal*—must, in sculpture as in painting, be a summation of the real beauty of nature.

AGAINST THE BAROQUE

The liberty that the sculptor has to make the marble, so to speak, grow, should not go so far as to load the external forms of his figures with excessive detail counter to the action or the movement represented. Against its background of air, trees, or architecture, the work must stand out clearly and unequivocally from as far away as the eye can distinguish it . . .

If through an error of judgment—of which, fortunately, there are but few instances—a sculptor were to mistake the irrational impetuousness which carried off Borromini and Meissonnier for the divine enthusiasm of genius, let him be convinced that such wrongly directed efforts, far from beautifying the objects they portray, remove them from the truth and only serve to represent the disorders of the imagination. Though the two above-mentioned artists were not sculptors, they can be cited as dangerous examples, because the spirit that guides the architect guides the painter and the sculptor too.

PIERRE-PAUL PRUD'HON

TO JEAN-BAPTISTE FAUCONNIER

PRUD'HON HAD come from the Dijon Academy to study in Paris in 1780. He lodged in the Rue de Bac in the same house as the Fauconnier family, who became his fast friends. They were well-to-do bourgeois, interested in the theories of Rousseau, the American war, and the reforms of Louis XVI, and they earned a living selling lace and embroidery to the aristocracy and the court. When Prud'hon went to Italy in November, 1784, after winning the Dijon Academy *Prix de Rome,* he kept up his contact with them. All this was before Prud'hon became the "French Correggio."

LEONARDO *Rome, 1785*

I have just come from seeing the admirable tapestries done from the cartoons of the famous Raphael; in my opinion they are

without doubt the most beautiful things he did, the most deeply felt and the most expressive. But one who far surpassed him in precision, pithiness, and force of execution, and in harmony of chiaroscuro and perspective, etc., is the inimitable Leonardo da Vinci, the father, the prince, and the first of all painters, after whom one can also see a single tapestry done from his famous *Last Supper* painted in Milan in a Dominican refectory. This is the world's outstanding picture, the masterpiece of painting . . . Yet few people pay any attention not simply to this picture, but to Leonardo generally: either his merits are too far beyond their intelligence, or he is so perfect that it never occurs to them even to try to follow a style which seems impossible to approach. To a sublime genius this rare man joined a just reason and a profound imagination, qualities rarely found in the same mind, since the first seems to belong to a sanguine, and the second to a cold and reflective nature. . . . For myself, I can see only perfection in him; he is my master and my hero.

ART SHOULD MOVE THE SPECTATOR *Rome, 1787*

Show by the way in which you do your picture that Rome is not made to be seen by the blind, or by the minor masters; boldness of expression, a drawing sure and broad in its main areas. Join to this a strong and quiet effect of the whole, so that the movement of your figures will stand out even more. None of those bright reflections that tire the eye and prevent the observer from quietly enjoying the object before him . . .

To explain what I mean, let me say that in general there is too much concern with how a picture is made, and not enough with what puts life and soul into the subject represented. We worry about the brilliance of the color scheme, the magic effect of light and shade and a little meanly about the drawing. There is even some concern with the emotions contained in the subject. But no one remembers the principal aim of those sublime masters who wished to make an impression on the soul, who mark strongly each figure's character and, by combining it with the proper emotion, produce an effect of life and truth that strikes and moves the spectator . . . What is more, in place of the charm of color,

and the fine contrast of tones which are but superficial and give the effect of a lie instead of the truth, a soft and quiet, though vigorous, atmosphere should suffuse the picture, pleasing the spectator without blinding him, and letting his soul enjoy all that affects it.

WILLIAM HOGARTH

FROM HIS *MEMOIRS*

THE MANUSCRIPT from which these paragraphs are taken was found among Hogarth's papers; it was published after the artist's death by John Ireland in his *Hogarth Illustrated*. These excerpts explain how, after serving as an engraver, Hogarth took up the style of painting for which he is famous. The mixture of motives is more typical of the accidents of art than later ages like to think.

WHY I GAVE UP CONVERSATION PIECES

I then married [1729], and commenced painter of small conversation pieces, from twelve to fifteen inches high. This having novelty, succeeded for a few years. But though it gave somewhat more scope to the fancy [than engraving], was still but a less kind of drudgery; and as I could not bring myself to act like some of my brethren, and make it a sort of manufactory, to be carried on by the help of back-ground and drapery painters; it was not sufficiently profitable to pay the expenses my family required.

I therefore turned my thoughts to a still more novel mode, viz., painting and engraving modern moral subjects, a field not broken up in any country and any age. The reasons which induced me to adopt this mode of designing were, that I thought both writers and painters had, in the historical style, totally overlooked that intermediate species of subject which may be placed between the sublime and the grotesque.

I TREAT MY SUBJECT AS A STAGE

I therefore wished to compose pictures on canvas similar to representations on the stage; and farther hope, that they will be tried by the same test, and criticized by the same criterion. Let it be observed, that I mean to speak only of those scenes where the human species are actors and these, I think have not often been delineated in a way of which they are worthy and capable. In these compositions those subjects that will both entertain and improve the mind bid fair to be of the greatest public utility and must, therefore, be entitled to rank in the highest class. If the execution is difficult (though that is but a secondary merit), the author has a claim to a higher degree of praise. If this be admitted, *comedy* in painting, as well as in writing, ought to be allotted the first place, as most capable of all these perfections, though the *sublime,* as it has been called, has been opposed to it. Ocular demonstration would carry more conviction to the mind of a sensible man, than all he would find in a thousand volumes; and this has been attempted in the prints I have composed . . .

This I found was most likely to answer my purpose, provided

I could strike the passions, and by small sums from many, by the sale of prints which I could engrave from my own pictures, thus secure my property to myself.

THE ANALYSIS OF BEAUTY: WRITTEN WITH A VIEW OF FIXING THE FLUCTUATING IDEAS OF TASTE

IN PRESENTING his theory that beauty is ultimately contained in the "precise serpentine line" Hogarth reveals attitudes that run through his painting as well as his writing: his opposition to academism; his knowledge that his art ran counter to official opinion (hence his appeal to the public over the heads of artists and connoisseurs); his support of English art against the collecting of Continental "masterpieces"; his love for the exact as opposed to the *je ne sais quoi* theorists; and, like Locke and Hume, his basis in common sense and individual experience. We quote from the introduction, which is more personal than his theoretical aesthetics.

Compare Hilliard, p. 118, on the difficulties of the English artist.

ART ACCESSIBLE TO ALL [*1753*]

I would fain have . . . my readers be assured that, however they may have been awed and overborn by pompous terms of art, hard names, and the parade of seemingly magnificent collections of pictures and statues; they are in a much fairer way, ladies, as well as gentlemen, of gaining a perfect knowledge of the elegant and beautiful in artificial as well as natural forms, by considering them in a systematical, but at the same time a familiar way, than those who have been prepossessed by dogmatic rules, taken from the performance of art only: nay I will venture to say, sooner, and more rationally, than even a tolerable painter, who has imbibed the same prejudices . . .

The reason why gentlemen, who have been inquisitive after knowledge in pictures, have their eyes less qualified for our purpose, than others, is because their thoughts have been entirely and continually employed and encumbered with considering and retaining the various *manners* in which pictures are painted, the histories, names, and characters of the masters, together with many

other little circumstances belonging to the mechanical part of the art; and little or no time has been given for perfecting the ideas they ought to have in their minds, of the objects themselves in nature: for by having thus espoused and adopted their first notions from nothing but *imitations,* and becoming too often as bigotted to their faults, as their beauties, they at length, in a manner, totally neglect, or at least disregard the works of nature, merely because they do not tally with what their minds are so strongly pre-possessed with . . .

It is also evident that the painter's eye may not be a bit better fitted to receive these new impressions, who is in like manner too much captivated with the works of art; for he also is apt to pursue the shadow, and drop the substance. This mistake happens chiefly to those who go to Rome for the accomplishment of their studies; as they naturally will, without the utmost care, take the infectious turn of the connoisseur, instead of the painter: and in proportion as they turn by those means bad proficients in their own arts, they become the more considerable in that of a connoisseur. As a con-firmation of this seeming paradox, it has ever been observed at all auctions of pictures, that the very worst painters sit as the most profound judges, and are trusted only, I suppose, on account of their *disinterestedness* . . .

But it is time now to have done with the introduction; and I shall proceed to consider the fundamental principles, which are generally allowed to give elegance and beauty, when duly blended together, to compositions of all kinds whatever; and point out to my readers the particular force of each, in those compositions in nature and art, which seem most to *please and entertain the eye,* and vie that grace and beauty which is the subject of this inquiry. The principles I mean are FITNESS, VARIETY, UNIFORMITY, SIMPLICITY, INTRICACY, and QUANTITY;—*all which co-operate in the production* of beauty, mutually correcting and re-straining each other occasionally.

SIR JOSHUA REYNOLDS

A LETTER TO *THE IDLER*
(THE GRAND STYLE OF PAINTING)

SHORTLY AFTER his return from Italy in October, 1752, Reynolds made the acquaintance of the outstanding literary figure of his day, and for over thirty years Samuel Johnson was his good and intimate friend. "He may be said to have formed my mind and to have brushed off from it a deal of rubbish," was Sir Joshua's later verdict.

It was apparently upon Johnson's request that Reynolds, in 1759, wrote three letters for Johnson's paper: The first dealt with the "ridiculous presumption of connoisseurs who endeavored to judge pictures according to rules they had drawn up." In the later editions of *The Idler* this second letter was called *The Grand Style of Painting,* and the third *The True Idea of Beauty.* As was Johnson's custom, they were published without the name of the author, as they were in 1761 when they were separately issued as a small pamphlet.

These early letters already sum up the influential doctrine of the eclectic grand manner that Sir Joshua, as first president of the Royal Academy, was later to preach at length in his *Discourses*—and was himself to practice so little.

On the grand style, compare Coypel, p. 162.

IMITATION VS. IMAGINATION

The Idler, No. 79; Saturday, October 20, 1759

Your acceptance of a former letter on Painting [in *The Idler,* No. 76], gives me encouragement to offer a few more sketches on the same subject.

Amongst the Painters and the writers on Painting, there is one maxim universally admitted and continually inculcated. Imitate Nature, is the invariable rule; but I know none who have explained in what manner this rule is to be understood; the consequence of which is, that every one takes it in the most obvious sense,—that objects are represented naturally, when they have such relief that they seem real. It may appear strange, perhaps, to hear this sense of the rule disputed; but it must be considered,

that if the excellency of a Painter consisted only in this kind of imitation, Painting must lose its rank, and be no longer considered as a liberal art, and sister to Poetry: this imitation being merely mechanical, in which the slowest intellect is always sure to succeed best; for the Painter of genius cannot stoop to drudgery, in which the understanding has no part; and what pretence has the Art to claim kindred with Poetry, but by its power over the imagination? To this power the Painter of genius directs his aim; in this sense he studies Nature, and often arrives at his end, even by being unnatural, in the confined sense of the word.

The grand style of Painting requires this minute attention to be carefully avoided, and must be kept as separate from it as the style of Poetry from that of History. Poetical ornaments destroy that air of truth and plainness which ought to characterise History; but the very being of Poetry consists in departing from this plain narration, and adopting every ornament that will warm the imagination. To desire to see the excellencies of each style united, to mingle the Dutch with the Italian School, is to join contrarieties which cannot subsist together, and which destroy the efficacy of each other. The Italian attends only to the invariable, the great and general ideas which are fixed and inherent in universal Nature; the Dutch, on the contrary, to literal truth and a minute exactness in the detail, as I may say, of Nature, modified by accident. The attention to these petty peculiarities is the very sense of this naturalness so much admired in the Dutch pictures, which, if we suppose it to be a beauty, is certainly of a lower order, that ought to give place to a beauty of a superior kind, since one cannot be obtained but by departing from the other.

If my opinion were asked concerning the works of Michel Angelo, whether they would receive any advantage from possessing this mechanical merit, I should not scruple to say, they would lose, in a great measure, the effect which they now have on every mind susceptible of great and noble ideas. His works may be said to be all genius and soul; and why should they be loaded with heavy matter, which can only counteract his purpose by retarding the progress of the imagination?

ENTHUSIASM

If this opinion should be thought one of the wild extravagancies of enthusiasm, I shall only say, that those who censure it are not conversant in the works of the great Masters. It is very difficult to determine the exact degree of enthusiasm that the arts of Painting and Poetry may admit. There may perhaps be too great an indulgence, as well as too great a restraint of imagination; and if the one produces incoherent monsters, the other produces what is full as bad, lifeless insipidity. An intimate knowledge of the passions and good sense, but not common sense, must at last determine its limits. It has been thought, and I believe with reason, that Michel Angelo sometimes transgressed those limits; and I think I have seen figures by him, of which it was very difficult to determine, whether they were in the highest degree sublime or extremely ridiculous. Such faults may be said to be the ebullition of genius; but at least he had this merit, that he never was insipid; and whatever passion his works may excite, they will always escape contempt.

What I have had under consideration is the sublimest style, particularly that of Michel Angelo, the Homer of Painting. Other kinds may admit of this naturalness, which of the lowest kind is the chief merit; but in Painting, as in Poetry, the highest style has the least of common nature.

One may safely recommend a little more enthusiasm to the modern Painters; too much is certainly not the vice of the present age. The Italians seem to have been continually declining in this respect from the time of Michel Angelo to that of Carlo Maratti, and from thence to the very bathos of insipidity to which they are now sunk; so that there is no need of remarking, that where I mentioned the Italian Painters in opposition to the Dutch, I mean not the moderns, but the heads of the old Roman and Bolognian Schools; nor did I mean to include in my idea of an Italian Painter, the Venetian School, which may be said to be the Dutch part of the Italian Genius.

NOTES ON DU FRESNOY'S
THE ART OF PAINTING

THE REV. WILLIAM MASON, a well-known poet of the period and author of a life of Gray, had met Reynolds in 1755 and became one of his closest friends. Mason had translated Du Fresnoy's poem (1641-1665) into English verse (it had already been translated by Dryden), and Reynolds, to oblige his friend, and because the poem had been "one of the first books on the theory of painting to attract him" in his youth, agreed to annotate it. He knew the poem well, since the early *Discourses* to the Academy (1770-1775) are "permeated with the ideas suggested by it." After his return from the trip to Flanders and Holland, Reynolds first wrote his notes of that journey, and then proceeded to his notes on Du Fresnoy; they were published in 1783.

SOME LOFTY THEME LET JUDGMENT FIRST SUPPLY,
SUPREMELY FRAUGHT WITH GRACE AND MAJESTY [*1781-1782*]

It is a matter of great judgment to know what subjects are or are not fit for painting. It is true that they ought to be such as the verses here direct, full of grace and majesty; but it is not every such subject that will answer to the painter. The painter's theme is generally supplied by the Poet or Historian: but as the Painter speaks to the eye, a story in which fine feeling and curious sentiment is predominant, rather than palpable situation, gross interest, and distinct passion is not suited to his purpose.

It should be likewise a story generally known; for the Painter, representing one point of time only, cannot inform the spectator what preceded the event, however necessary in order to judge of the propriety and truth of the expression and character of the Actors. It may be remarked that action is the principal requisite in a subject for History-painting; and that there are many subjects which, though very interesting to the reader, would make no figure in representation: such are those subjects which consist in any long *series* of action, the *parts* of which have very much *dependency* each on the other; or where any remarkable point or turn of verbal expression makes a part of the excellence of the story: or where

it has its effect from *allusion to circumstances not actually present*.

SEE RAFFAELLE THERE HIS FORMS CELESTIAL TRACE,
UNRIVALL'D SOVEREIGN OF THE REALMS OF GRACE

The pre-eminence which Fresnoy has given to those three great painters, Raffaelle, Michel Angelo, and Julio Romano, sufficiently points out to us what ought to be the chief object of our pursuit. Though two of them were either totally ignorant of, or never practised any of those graces of the art which proceed from the management of colours, or the disposition of light and shadow, and the other (Raffaelle) was far from being eminently skillful in these particulars, yet they all justly deserve that high rank in which Fresnoy has placed them: Michel Angelo, for the grandeur and sublimity of his characters, as well as for his profound knowledge of design; Raffaelle for the judicious arrangement of his materials, for the grace, the dignity, and the expression of his characters; and Julio Romano, for possessing the true poetical genius of painting, perhaps, in a higher degree than any other painter whatever.

In heroic subjects it will not, I hope, appear too great a refinement of criticism to say, that the want of naturalness or deception of the art, which give to an inferior style its whole value, is no material disadvantage: the Hours, for instance, as represented by Julio Romano, giving provender to the horses of the sun, would not strike the imagination more forcibly from their being coloured with the pencil of Rubens, though he would have represented them more naturally: but might he not possibly, by that very act, have brought them down from the celestial state to the rank of mere terrestrial animals? In these things, however, I admit there will always be a degree of uncertainty. Who knows that Julio Romano, if he had possessed the art and practice of colouring like Rubens, would not have given to it some taste of poetical grandeur not yet attained to? The same familiar naturalness would be equally an imperfection in characters which are to be represented as demi-gods, or something above humanity.

Though it would be far from an addition to the merit of those

two great painters to have made their works deceptions, yet there can be no reason why they might not, in some degree, and with a judicious caution and selection, have availed themselves of many excellencies which are found in the Venetian, Flemish, and even Dutch schools, and which have been inculcated in this poem. There are some of them which are not in absolute contradiction to any style; the happy disposition, for instance, of light and shade; the preservation of breadth in the masses of colours; the union of these with their grounds; and the harmony arising from a due mixture of hot and cold hues, with many other excellencies, not inseparably connected with that individuality which produces deception, would surely not counteract the effect of the grand style: they would only contribute to the ease of the spectator, by making the vehicle pleasing by which ideas are conveyed to the mind, which otherwise might be perplexed and bewildered with a confused assemblage of objects; they would add a certain degree of grace and sweetness to strength and grandeur. Though the merit of those two great painters are of such transcendency as to make us overlook their deficiency, yet a subdued attention to these inferior excellencies must be added to complete the idea of a perfect painter.

THOMAS GAINSBOROUGH

PICTURES ARE NOT MADE TO SMELL OF

From about 1752 on Gainsborough, his schooling in London finished, had practiced portraiture in Ipswich with moderate success. In 1759, the year after this letter was written, he moved to fashionable Bath, where his popularity was almost immediate, and where he built the reputation that made possible his final removal to London to rival the great Sir Joshua.

This letter was probably addressed to a certain Mr. Edgar of Colchester, attorney-at-law, and member of a family "known to have employed the painter in those early days."

Ipswich, March 13, 1758

You please me much by saying that no other fault is to be found in your picture than the roughness of the surface; for that

part being of use in giving force to the effect at a proper distance, and what a judge of painting knows an original from a copy by; in short being the touch of the pencil which is harder to preserve than smoothness, I am much better pleased that they should spy out things of that kind than to see an eye half an inch out of its place or a nose out of drawing when view'd at a proper distance. I don't think it would be more ridiculous for a person to put his nose close to the canvas and say the colours smell offensive than to say how rough the paint lies; for one is just as material as the other with regard to hurting the effect and drawing of a picture. For Sir Godfrey Kneller used to tell them that pictures were not made to smell of . . . [A variation of this statement is also attributed to Rembrandt.]

TO WILLIAM JACKSON

The intimate friendship between Gainsborough and Jackson began in Bath in 1767 and ended only with the death of the painter in London more than twenty years later. Jackson, conductor, composer, and friend of artists including Sir Joshua, was himself an amateur painter; and Gainsborough was passionately fond of music. Most of the twelve letters preserved contain gossip and banter in Gainsborough's "brilliant but eccentric" style; fortunately, these were not, like others, "too licentious to be published."

On the comparative values of pure "Landskip" and "History" compare Cole, p. 280.

Bath, June 4, [1768]

I'm sick of Portraits and wish very much to take my viol-da gamba and walk off to some sweet village, where I can paint landskips and enjoy the fag-end of life in quietness and ease. But these fine ladies [his daughters] and their tea-drinkings, husband-huntings, etc., etc., etc., will job me out of the last ten years, and I fear miss getting husbands too. But we can say nothing to these things you know Jackson, we must jog on and be content with the jingling of the bells, only d— it, I hate a dust, and kicking up a dust, and being confined in harness while others ride in the waggon, under cover, stretching their legs in the straw at ease, and gazing at green trees and blue skies without half my *Taste*. That's d—d hard. My

comfort is I have five viols-da gamba, three jayes and two Barack Normans.

LANDSKIP AND HISTORY *Bath, Aug. 23, [1767]*

Will it—(damn this pen)—will it serve as any apology for not answering your last obliging letter to inform you that I did not receive it of near a month after it arrived, shut up in a music-book at Mr. Palmer's. I admire your notions of most things, and do agree with you that there might be exceeding pretty pictures painted of the kind you mention. But are you sure you don't mean instead of the flight into Egypt, my flight out of Bath! Do you consider, my dear maggotty sir, what a deal of work history pictures require to what little dirty subjects of coal horses and jackasses and such figures as I fill up with; no, you don't consider anything about that part of the story; you design faster than any man or any thousand men could execute. There is but one flight I should like to paint, and that's yours *out* of Exeter, for while your numerous and polite acquaintance encourage you to talk so cleverly, we shall have but few productions, real and substantial productions. But to be serious (as I know you love to be), do you really think that a regular composition in the Landskip way should ever be filled with History, or any figures but such as fill a place (I won't say stop a gap) or create a little business for the eye to be drawn from the trees in order to return to them with more glee. I did not know that you admired those tragic-comic pictures, because some have thought that a regular History Picture may have too much background, and the composition be hurt by not considering what ought to be principal. But I talk now like old squaretoes. There is no rule of that kind, say you.

> But then, says I,
> Damme you lie!

SIR THOMAS LAWRENCE

TO JOSEPH FARINGTON

SIR THOMAS LAWRENCE, at the Prince Regent's expense, set out from London on September 29, 1818, for Aix-la-Chapelle. He had been chosen by the Congress of the Allied Nations to paint the sovereigns of Europe. He had begun the task when the Congress met in London in 1814, and now he was to finish it. From Aix he proceeded to Vienna, where, among many less important figures, he portrayed the Emperor, Prince Schwarzenberg, and Metternich. Thence he went on to Italy, always employed at his task as official portrait painter, and arrived in Rome—from where these letters were written—on May 10, 1819. He was at the height of his fame, and perhaps the most generally acclaimed artist in the whole of Europe. Farington was the Royal Academy's chief politician and intriguer. [On Correggio, compare Carracci, p. 122.]

MICHELANGELO AND RAPHAEL *Rome, 1819*

It often happens that first impressions are the truest—we change, and change, and then return to them again. I try to bring my mind in all the humility of truth, when estimating to myself the powers of Michael Angelo and Raphaele, and again and again, the former "bears down upon it," to borrow a strong expression, "with the compacted force of lightning." The diffusion of truth and elegance, and often grandeur, cannot support itself against the compression of the sublime. There is something in that lofty abstraction; in those deities of intellect that people the Sistine Chapel, that converts the noblest personages of Raphaele's drama into the audience of Michael Angelo, before whom you know that, equally with yourself, they would stand silent and awe-struck. Raphaele never produced figures equal to the Adam and Eve of Michael Angelo—the latter is miserably given in Gavin Hamilton's print—all its fine proportions lost,—though it is Milton's Eve, it is more the mother of mankind, and yet nothing is coarse or masculine, but all is elegant, as line of the finest flower. You seem to forsake humanity in surrendering Raphaele, but God gave the command

to increase and multiply before the fall, and Michael Angelo's is the race that would then have been.

BOLOGNESE ART *Rome, February 19, 1820*

The Bolognese school is in my opinion, far superior to the Florentine [mannerist], which, with a few exceptions is all learned distortion, apathy, and falsehood. By apathy, I mean total absence of the passions and feelings—and by falsehood, actions improper to the sense and incident, and, in some, impossible to the human frame—Michael Angelo, its great founder, as a painter must be still excepted—my opinion of him remains unaltered. It was, besides, your great friend's [Reynolds'] faith, and I must always, from deep impression, fairly and frequently tried, believe it to be the true one. But the Bolognese, and all their school, yield to the Lombard, to the great man [Correggio] whose works I have been contemplating at Parma.

I got there early on Wednesday, and spent the whole day in the Academy, the Cathedral, and other places, where his works and those of Parmegianino are to be seen. The next morning I went again, twice, to look at the Cupola from those small arches, . . . and four times I went on long visits to the St. Jerome, his finest work. How beautiful, how devoid of everything like the handicraft of art it is—the largeness, and yet ingenuity of its effect—the purity of its colour—the truth, yet refinement and elegance of the action, particularly of the hands, (in which he peculiarly excels;) and then, a lesson to all high-minded slovens, the patient vigilance with which the whole is linked together, by touches, in some instances small almost as miniature, but like the sparkling of water . . .

I am going now to see the splendors of Venetian art. I know what will be the impression on my senses and my mind, which ought not to resist the noble daring of their inventions, and various combinations of rich colour; but that reverence for the perfection of nature and of truth (by which I mean the best of each, and which I see in Raphaelle, Corregio, Titian, and Sir Joshua Reynolds,) cannot be shaken by the luxuriant falsehood, even when united with the genius of Paolo Veronese and Tintoretto; and

CORREGGIO: Detail of the Cupola of Parma Cathedral, about 1530

though Rubens, (perhaps a greater genius) is not forgotten by me, I shall still bend to these four, with the acknowledged benefactor of the first as the head of all.

How fine was our Sir Joshua! How we know him now, when we see the sources of his greatness, and remember how often he surpassed their usual labours; and in his own country, and in Europe, against prejudice and ignorance, how firmly and alone he stood.

ANTONIO CANOVA

DIALOGUES WITH NAPOLEON

NAPOLEON CALLED Canova to Paris twice: in 1802 to make a bust of the Emperor, and in 1810 to do a portrait and a statue of the newly-wed Empress Marie Louise. Canova had in addition carried out several other works for the Bonaparte family, notably the statue of Pauline Bonaparte Borghese. The equestrian statue of Napoleon discussed here had been ordered by the King of Naples; uncompleted in 1815, a figure of Charles III of Naples by another sculptor was substituted for the Napoleon on the horse Canova had modeled. [Compare Filarete, p. 42.]

[*Paris, October 11,*

We began to talk . . . of the custom of clothing statues. Whereupon I protested that God Himself would be unable to do something fine if He tried to portray His Majesty dressed like that, in his French breeches and boots. "The language of the sculptor," I resumed, "requires the sublime and either the nude or that style of drapery that is proper to our art. We, like the poets, have our own language. If a poet introduced into a tragedy phrases and idioms used habitually by the lower classes in the public streets, he would rightly be reprimanded by everybody. In like manner, we sculptors cannot clothe our statues in modern costumes without deserving a similar reproach." And here I adduced the example, among others, of the *Laocoön,* which represents a priest on the point of sacrificing, and nonetheless is almost entirely naked . . .

At this point we mentioned the equestrian statue that I was modeling and he asked how it was clothed. I told him: "In the heroic style."—"Why not nude also on horseback?" I remarked that it was not fitting that he should be represented in the nude while commanding his army. The heroic costume had been used by ancients and moderns alike. The kings his predecessors had been portrayed in this attire, as he could convince himself from the statue of Joseph II at Vienna. I described to him my idea of representing him in the act of riding at the head of his troops and commanding them to follow.

TO QUATREMÈRE DE QUINCY

ANTOINE CHRYSOSTOME QUATREMÈRE DE QUINCY (1755-1849) was a French archaeologist and writer on art who had been a deputy to the Legislative Assembly and was later to become secretary of the *Académie des Beaux-Arts.* His neoclassic aesthetic was sympathetic to Canova, and they exchanged many letters.

November 29, 1806

It takes something more than pilfering here and there a few details of the antique and lumping them together without judg-

ment, to deserve the name of a great artist. It needs sweating day and night over the Greek models, imbibing their style, turning it into one's own blood, always keeping an eye upon beautiful nature and reading there the same maxims . . .

Someday my statue of the Emperor will arrive at Paris, and it will be criticized mercilessly. I know it. It has certainly its faults, and above all it has the misfortune of being modern and by an Italian. But here those critics might be asked to show me who else could do better, and then I shall own myself beaten . . .

And then they will give attention to a thousand truly contemptible niceties, such as it would be quite easy to point out in the finest antiques. You inform me that the group of *Hercules and Lichas* and that of *Theseus and the Centaur* are regarded by them as too restless and mannered. But let us yield to the truth, what would my censors say if I had designed the group of the *Wrestlers* at Florence, the *Laocoön*, the so-called *Arria and Paetus*, the *Farnese Bull*, the *Faun with the Hermaphrodite*, now shipped to England, the group with figures poking their eyes out, or the other one in which they bite their arms, etc.? I mean only designed. What would they say if I were the author of the *Borghese Warrior*, and, still worse, of the *Massimi Discobolus*, believed to be by Myron? But these are ancient; and that is enough to make our censors drop their pens and extol as true beauties what in a modern artist would be regarded as real faults. Let any who tax me with having made the backs too deep look at the *Farnese Hercules*. Let them look at the *Belvedere Torso*, which, leaning so much forward, should jut its spine outward and yet keeps it so deeply grooved. My figures are bent backwards, if you did not notice it. Draw the consequence. Let any who want to see flesh look at the *Medici Venus*, at the copies of Praxiteles' *Satyr* and of the *Cupid*, at the *Torso*, at the group of *Ajax and Patroclus*, and at so many other fragments. These are the masterpieces of ancient art, and they all will display very fleshy details to those people who would like only a conventional treatment, which was used by the ancients only in statues to be seen at a distance or in inaccurate copies.

ON MICHELANGELO

Count Leopoldo Cicognara (1767-1834), art critic and liberal politician, had written a *History of Sculpture* (1813-1818), his best known work. In discussing the Count's views on Michelangelo, Canova exhibits the neoclassic point of view. Compare the opinions of Rodin, p. 327, Maillol, p. 406, and Epstein, p. 463.

Rome, February 25, 1815

In speaking of the half-drunken Bacchus with the little Satyr you applaud it as a work of masterly excellence. I avow that this is the most widespread opinion, yet I would dare disagree and say that to me it seems a work unworthy of so great a man, on account of its want of style, of good forms, and above all of *ensemble.* These defects, to my mind, are certainly not compensated by the posture of the subject, who is represented as drunk; for the ancients constantly used to give style, good forms, and *ensemble* to all their Bacchuses, even if drunk, by making some Satyr or Silenus support them.

I am unable to understand, moreover, what it is that you call Michelangelo's "anatomical science." It seems to me that he deliberately elected contorted and convulsed movements—especially of the arms, which are bent z-wise—in order to have an opportunity to express and carve the most prominent parts and muscles, emphasizing them more violently than is natural . . . But the study of these forms was always subordinated to Buonarroti's particular genius and feeling. He always made use of the antique, but only to transform it into his own style of modeling and to impress upon his works that swollen and unnatural character that was his personal element . . .

But let these doubts be confided to the ear of a bosom friend, to whom I take the liberty to reveal them because I consider him as my other self.

THOUGHTS ON ART

You are searching in nature for some beautiful part of the body and you cannot find it? Do not lose heart. Undress some more

persons and you will find it. In nature there is everything, pro-
vided you know how to look for it.

Sculpture is but a language among the various languages where-
by the eloquence of the arts expresses nature. It is a heroic language
just as the tragic style is the heroic one among the languages of
poetry. And as the terrible is the first element of the language
of tragedy, so the nude is the first element of the language of
statuary. And as in a tragic epopee the terrible should be expressed
by the sublimest diction, so in a sculptural epopee the nude should
be represented with the choicest and handsomest forms. In the
arts as in literature a sublime execution is the only conventional
part. Whereas in the invention and disposition one should always
imitate nature closely, in the elocution—that is, in the execution
—it has been agreed to depart from the vulgar path of usage and
to devise a great and sublime eloquence composed of the most
beautiful features existing in nature and in the imagination.

I am unwilling to engage in portraiture. I prefer to practice my
art on a larger scale. When you have produced a portrait, using all
your artistic knowledge, what is your reward? The sitter's mistress
comes along and tells him: "But you are handsomer; I hardly
recognized you in it." Then the unfortunate sculptor is pulled to
pieces and some other artist of the lowest sort triumphs.

Resemblance, I think, is produced by the larger and more general
parts and by bringing out only the more important features.

I have read that the ancients, when they had produced a sound,
used to modulate it, heightening and lowering its pitch without
departing from the rules of harmony. So must the artist do in
working at the nude. He must fill it with modulations, but always
within the limits of a correct outline.

To this rule we may add another, drawn from the observation
of nature and from numerical proportions, that is, to design every
part according to a ternary scale. I mean that every part, however
small, should always be composed of three others, one larger,
another smaller, and the third very small. These, in various in-
discernible ways, should combine to make up but one part.

GIUSEPPE BOSSI

ON CHROMATIC HARMONY

BOSSI, A MILANESE neoclassic painter mentioned by Stendhal, wrote verses in his native dialect and several dissertations on art: *Discourse on the Political Utility of the Arts of Design* (1805); *Four Books on Leonardo's "Supper"* (1810); and *Researches on Natural and Artificial Chromatic Harmony* (1821). Bossi's interest in the use of the six principal colors and the agreeable effect of the juxtaposition of complementary colors is to be compared to the later practice and theories of impressionists and neoimpressionists (see p. 376).

GENERAL PRECEPTS OF CHROMATIC HARMONY

We are to imitate moderately illuminated natural objects.

The second precept excludes from beautiful imitations the predominance of a single color and advises the use of many contrasting colors with a great variety of gradations of light and shadow.

Never use the six principal colors in their full intensity, except very parsimoniously; diversify the gradations of color by many modifications and admixtures of shadow and light; and, finally, never imitate with art certain natural appearances which produce strange and unbalanced oscillations in our organ of sight.

In colored imitations endeavor as far as possible to lay opposite colors next to one another and allied colors far from one another.

EXCEPTIONS

For fierce and forceful subjects, violent shadows and lights with an exuberance of shadow and a predominance of primary colors are best suited. For gentle, sad, and melancholy subjects, a great moderateness and balance of light and shade are suitable, with a sacrifice of the primary colors and a predominance of the derived. For gay subjects, bright lights, soft shadows, and a mingling of many primary and derived colors. And so every subject and every figure is to be painted with colors suited to its respective character, having regard for the nature of the colors and their gradations, and the play of light and shade.

CONCLUSION

Painters, lovers of painting, and any who have a taste for these studies and who visit the galleries will observe with pleasure how our principles are verified and our precepts sanctioned by those very works which are most universally liked for the harmony of their coloring. If the observer will confine himself to the examination of combinations of colors, he will gain a clear understanding of the art by which sometimes the old masters obviated the unpleasant quality of a hue by placing its opposite beside it, a practice in which some artists, allured by the grace with which these combinations flatter our sight, delighted beyond measure . . . He will see how aptly the Venetian school contrasted rosy flesh with draperies of a splendid green. He will see how the Florentines spread light with too much uniformity, how the Lombards concentrated it in too small areas, and how the school of Bologna used a too wide diversity in gradation and hue between the shadows and the lights.

FRANCISCO GOYA

ANNOUNCEMENT OF THE *CAPRICHOS*

THE SERIES of the *Caprichos,* one of Goya's most famous works, consists of eighty etchings satirizing Spanish life and manners, ridiculing the vices, prejudices, follies, and guiles of women, lawyers, physicians, priests, and monks. Some pictures contain thinly veiled portraits; others, fantastic allegories. Their general character was explained by Goya in the inscription of the 43rd *Capricho:* "The dream of reason produces monsters," and in his added comment, "Imagination deserted by reason produces impossible monsters. United with reason, imagination is the mother of the arts and the source of their wonders."

Goya also explained and justified his intentions in the following announcement—perhaps composed with the help of his friend Ceán-Bermúdez—which appeared in the *Diario de Madrid.* But though thus heralded, the

Caprichos were offered for sale for only a few days, and then withdrawn. Only twenty-seven sets were sold. Doubtless their outspoken satire aroused protests; the artist was denounced to the Inquisition. But Goya had powerful protectors and not only was not molested but was allowed to make a present of the plates to the King, who in return granted a yearly pension of twelve thousand *reales* to the artist's son, Francisco Xavier.

Wednesday, February 6, 1799

A series of prints of whimsical subjects, invented and etched by Don Francisco Goya.

The artist, persuaded that the censure of human errors and vices —though it seems to belong properly to oratory and poetry— may also be the object of painting, has chosen as appropriate subjects for his work, among the multitude of extravagances and follies which are common throughout civilized society, and among vulgar prejudices and frauds rooted in custom, ignorance, or interest, those which he has believed to be aptest to provide an occasion for ridicule and at the same time to exercise his imagination.

Since the greater part of the objects represented in this work are imaginary, it will not be rash to hope that its defects will obtain, perhaps, ample indulgence among the intelligent.

Considering that the artist has not followed the example of others, nor has found it possible to copy nature, although the imitation of nature is as difficult as it is admirable when it is achieved, one must allow that he will still deserve some esteem who, departing from her entirely, has been obliged to exhibit to the eye forms and attitudes which hitherto have existed only in the human mind bedimmed and confused by want of enlightenment or excited by the violence of unbridled passions.

It were to presume an excessive ignorance of the fine arts if we warned the public that in none of the compositions constituting this series has the artist proposed to ridicule the particular defects of this or that individual; which in truth would be an excessive restriction on the limits of talent and a misunderstanding of the means used by the arts of imitation to produce perfect works.

Painting, like poetry, selects in the universe whatever she deems

most appropriate to her ends. She assembles in a single fantastic personage circumstances and features which nature distributes among many individuals. From this combination, ingeniously composed, results that happy imitation by virtue of which the artist earns the title of inventor and not of servile copyist.

On sale at No. 1 Calle del Desengaño, the perfume and liquor store, at the price of 320 *reales* for each set of 80 prints.

JACQUES-LOUIS DAVID
TO THE REVOLUTIONARY CONVENTION

AT THE time of the French Revolution, David, by virtue of his neoclassic reaction against the excesses of the rococo, and the patriotic subject-matter of his pictures, had already established himself as the artistic voice of the

movement of reform. A member of the *Convention* and virtual dictator of the arts in its Committee on Public Education, David proposed to perpetuate his reforms by substituting for the old Royal Academy a "national jury of the arts," made up of artists and expert laymen. On juries, compare Delacroix, p. 234.

ART AND THE STATE [*November, 1793*]

In decreeing that those artistic monuments awarded by competition and worthy public recompense shall be judged by a jury named by the people's Representatives, you have paid homage to the unity and indivisibility of the Republic, and you have asked your Committee on Public Education to prepare a list of candidates. Your Committee has, therefore, considered the arts in the light of all those factors by which they should help to spread the progress of the human spirit, and to propagate and transmit to posterity the striking examples of the efforts of a tremendous people who, guided by reason and philosophy, are bringing back to earth the reign of liberty, equality, and law. The arts must therefore contribute forcefully to the education of the public. Too long have tyrants, fearful even of the image of virtue, kept thought itself in chains, encouraged license, and stamped out genius; the arts are the imitation of nature in her most beautiful and perfect form; a feeling natural to man attracts him to the same end . . . Then will those marks of heroism and civic virtue offered the eyes of the people electrify its soul, and plant the seeds of glory and devotion to the fatherland.

JURIES

Your Committee has decided that, during a period when art, like virtue, must be reborn, to leave the judgment of the productions of genius to artists alone would be to leave them in the rut of habit, in which they crawled before the despotism they flattered. It belongs to those stout souls to whom the study of nature has lent a feeling for truth and grandeur to give a new impulse to the arts and bring them back to the principles of true beauty. Thus he who is gifted with a fine sensibility, though without culture, and the philosopher, the poet, and scholar, each in those different things which make up the art of judging the artist, pupil of nature,

are the judges most capable of representing the tastes and insights of entire people in the task of awarding Republican artists with the palms of glory.

ART AND THE ANTIQUE

THESE THREE statements to his pupils, all made by David between 1796 and 1800, represent his formulation of an increasingly cold neoclassical ideal. The first referred to what he was trying to do in his *Battle of the Sabines* (see immediately below); the second to those pictures sent back by Napoleon from his Italian campaign and borne in triumph through the streets of Paris on the 9th Thermidor, year VI, the anniversary of the fall of Robespierre; and the third to his *Leonidas at Thermopylae*.

[*1796*]

I want to work in a pure Greek style. I feed my eyes on antique statues, I even have the intention of imitating some of them. The Greeks had no scruples about copying a composition, a gesture, a type that had already been accepted and used. They put all their attention and all their art on perfecting an idea that had been already conceived. They thought, and they were right, that in the arts the way in which an idea is rendered, and the manner in which it is expressed, is much more important than the idea itself. To give a body and a perfect form to one's thought, this—and only this—is to be an artist.

[*1798*]

Understand, my dear friend, that there is no natural love for the arts in France, but an artificial taste. In spite of the great enthusiasm that has recently been shown, you can be sure that the masterpieces that have been brought here from Italy will soon be considered only curiosities. The location of a work of art and the distance one must go in order to admire it help singularly to bring out its true value; those pictures, in particular, which adorned churches will lose a great deal of their charm and their effect when they are no longer in the spot for which they were made. The study of these masterpieces (now in the Louvre) will perhaps help to form scholars—Winckelmanns—but artists, no!

[*1800*]

I want to try to avoid the theatrical gestures and expressions which modern artists have entitled "expressive painting." In imitation of the artists of antiquity, who never failed to choose the moment before or after the climax of their subject, I am going to paint Leonidas and his soldiers calm before the battle, promising themselves immortality.

THE EXHIBITION OF THE *SABINE WOMEN*

As a RESULT of his ardent support of Robespierre, David had been imprisoned in 1794. Freed by the Directorate in 1795, he immediately began to execute in paint his promise "to be guided henceforth by principles and not by men." The *Battle of the Sabine Women*, done in emulation of Poussin, was a call to union and the cessation of party strife. Upon its completion in 1799 the Citizen David exhibited it publicly at the National Palace of Science and Art, and he defended this unusual procedure by the printed argument from which we quote.

[*1799*]

The practice by which a painter exhibits his works to the gaze of his fellow-citizens in return for individual remuneration is not new . . .

In our own day this practice is found in England, where it is called an exhibition. The pictures of the *Death of General Wolfe* and of Lord Chatham, painted by our contemporary West, have earned him immense sums. But the exhibition has long been in existence there, having been introduced during the last century by Van Dyck, whose public came in crowds to admire his work, and he thus made a considerable fortune.

Is not that idea as just as it is wise which gives the arts the means of independent existence and self-support and the enjoyment of the proud independence proper to genius and for lack of which its spark is soon extinguished? On the other hand, what more worthy means of drawing an honorable return from the fruits of one's labor than to submit it to the public's judgment and expect no other reward than the reception the public is pleased to give?

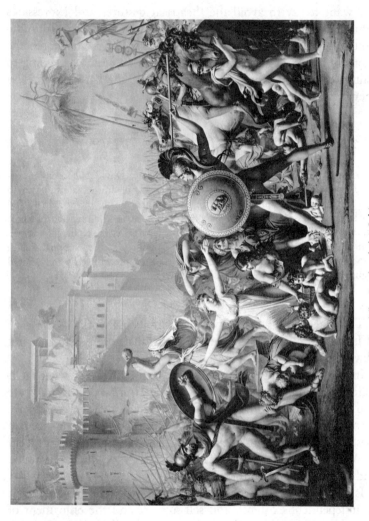

DAVID: The Battle of the Sabines, 1799

If the work is poor, the public taste will soon do it justice. And the author, reaping neither glory nor fortune, will learn by hard experience how to correct his mistakes and capture the attention of the spectator with happier ideas . . .

How sweet it would be, and how happy it would make me, if in setting the example of a public exhibition I could bring it into general practice; if this practice could give artistic talent the means of escaping poverty, and if in consequence of this first advantage I could help the arts towards their true destiny, which is to serve morality and elevate men's souls! . . . Who will deny that until now the French people has been a stranger to the arts, and has lived in their midst without participating in them? Any fine piece of painting or sculpture was immediately bought by a rich man, often very cheaply; and, jealous of his exclusive ownership, he allowed it to be seen by only a few friends, and barred it from the rest of society. At least, by adopting a system of public exhibitions, the people will, for a small sum, partake of the wealth of genius; it will educate itself in the arts, to which it is not as indifferent as one pretends to believe; its horizons will spread, its taste will grow, and though it may not be experienced enough to decide upon delicate or difficult points, its judgment, arising from feeling and dictated by nature, will often flatter and even teach the artist who can understand it.

TO BARON GROS

WHEN NAPOLEON fell in 1815, David, rather than ask for a pardon from the restored Bourbons, went into exile. Until his death in 1825 he lived in Brussels, trying to direct the course of painting in Paris. There Gros, who had succeeded to David's atelier, received constant and vehement exhortations to abandon the realist-romantic art which was his natural style and return to the true tradition he was in honor bound to continue. The resulting conflict of conscience and talent was a contributing factor in Gros's suicide in 1836.

HISTORY PAINTING *Brussels, 1820*

Rarely does one do good things to order, at least that has always been the effect that this way of working has had on me.

This procedure was only good for second-rate painters. It is what caused Raphael and so many other first-raters to commit anachronisms they never should have allowed themselves, such as introducing modern popes into scenes depicting much earlier events.

. . . Time passes, and you have not yet done what is called true history painting. While you still have talent and strength, does it become you always to put it off? Hurry, hurry my dear friend, thumb over your Plutarch and choose a subject familiar to everyone—it counts a great deal. Send me your sketch, and I will let you know my opinion.

[*1821*]

I am happy that you are being taken from your gold-braided uniforms and your boots. You have shown what you can do with this kind of picture; you have no equal. Now give yourself to what really constitutes history painting; you are on the road, do not leave it. All other sorts of painting will disappear, only this is safe from men's passions.

ANNE-LOUIS GIRODET-TRIOSON

TO MONSIEUR TRIOSON

WHEN ANNE-LOUIS GIRODET DE ROUSSY wrote this criticism of academic methods to his adoptive father he was thirty-four—rather old for an academy student. He had been David's favorite pupil in Paris and, having won the *Prix de Rome* in 1789, been a *pensionnaire* at the French Academy for some two years. Girodet's sensuous, protoromantic painting was only a part of his activity: as poet, collector, wit, and amateur-at-large, he devoted the last years of his life entirely to writing. He translated Greek and Latin poets and composed rather conventional treatises, of the *ut pictura poesis* variety, on the arts.

For Géricault's opinion of this Roman boardinghouse system, see p. 223.

It is not that our director bothers us, because we, or I at least, hardly see him except in the street or on the stairs. When I first came, though, he tried to get me to go and draw at the Academy. I asked him to excuse me, and when he insisted I insisted too, answering that such an occupation was not at all to my taste, and that I urgently requested him to allow me to direct my own course of study, which he did, and did completely. What I do not like is the way we are all forced to live together, and so forced to follow approximately the same studies. It would be better if the Academy of France in Rome did not exist—that is to say, if there were no royal sheepfold in which twelve sheep are kept and made to get up, work, and go to bed at the same time. Each scholar should be sent abroad with a thousand *écus* a year for two years, and be free to go to Rome, Bologna, Florence, Venice, to the mountains, Flanders, Switzerland, wherever he pleases, on condition that he give evidence of his studies. If he has nothing to send home—unless because of illness—his fellowship would be withdrawn. This would be the only way of getting men of genius and original work.

TO BERNARDIN DE SAINT-PIERRE

IN WRITING to the disciple of Rousseau and the author of *Paul et Virginie,* Girodet, the friend and illustrator of Chateaubriand, was addressing himself to a kindred spirit. He was defending his *Paradise of Ossian,* which Napoleon had ordered in 1801 for his palace at Malmaison. It is reported that Napoleon had Ossian read to him during the crossing of the Mediterranean to the Battle of the Pyramids.

[Ca. 1802]

I have not yet despaired of reconciling M. de Saint-Pierre with my picture inspired by the poems attributed or denied to Ossian. In spite of all the criticisms leveled against it, some of which were justified, this painting has given me the most confidence in my small talents, because it is altogether, in all its parts, my own creation, and neither its drawing, color, chiaroscuro, nor conception was at all inspired by a model. I was even obliged to invent the

costumes, and since I could not rely on any ancient work I had to be guided by analogies . . . The subject also had the advantage of rendering homage to the spirits of our warriors and to the genius protecting France . . .

It is generally agreed that the figures I have shown are not those of any French, Greek, or Roman beauties: I could not find their general type either among the ancients or the moderns; it is therefore a creation. The grayish color which pervades these semi-transparent beings could not be imitated from nature, who provides no models of this kind; nor is it taken from any work of art, since I knew none that could give me a suggestion; it is a pure inspiration, and is therefore a creation. The final effect—on the one hand the coloring, on the other the distribution of light and shade —is also mine, . . . and therefore again a kind of creation.

JEAN-AUGUSTE-DOMINIQUE INGRES

FROM HIS NOTES AND THOUGHTS ON ART

THE OPINIONS of Ingres, from which these extracts are drawn, were first put together in 1870, three years after the painter's death, by his friend the Vicomte Henri Delaborde. Delaborde drew them from Ingres' letters to his friends and pupils, from official reports which Ingres (as director of the French Academy in Rome) had occasionally to write, and from conversations and atelier criticisms which had been set down almost on the spot and so could be regarded as authentic transcriptions of the master's ideas. Delaborde arranged the paragraphs and sentences he thus culled in a systematic order, and with rare exceptions he did not note their dates. He made no attempt to follow the evolution of the painter's ideas from early maturity to old age, although we know from other sources (Amaury-Duval) and

Ingres' own painting that a considerable change did occur. Owing in large measure to this fact, the undoubtedly dogmatic character of Ingres' original pronouncements was further frozen into legend.

For a continuation of Ingres' classicist ideas see Flandrin, p. 241, and John Sloan, p. 401; for a contrast see Delacroix, p. 228. For opinions on Ingres, see his pupil Chassériau, p. 238; Théodore Rousseau, p. 289; and Redon, p. 359.

HIS OPINION OF HIMSELF *1813*

When one knows one's craft well, when one has learned well how to imitate nature, the chief consideration for a good painter is to *think out* the whole of his picture, to have it in his head as a whole, so to speak, so that he may then execute it with warmth and as if the entire thing were done at the same time. Then, I believe, everything seems to be felt together. Therein lies the characteristic quality of the great master, and there is the thing that one must acquire by dint of reflecting day and night on one's art, when once one has reached the point of producing. The enormous number of ancient works produced by a single man proves that there comes a moment when an artist of genius has a feeling as if he were being swept along by his own means, when, every day, he does things which he thought he could not do.

It seems to me that I am that man. I am making advances every day; never was work so easy for me, and yet my pictures are by no means scanted: the exact opposite is the truth. I am finishing more than I used to do, but much more rapidly. My nature is such that it is impossible for me ever to do my work in any other than the most conscientious fashion. To do it quickly in order to earn money, that is *quite impossible for me.*

SONS OF HOMER *1821*

It must not be thought that the exclusive love which I have for this painter [Raphael] causes me to ape him: that would be a difficult thing, or rather, an impossible thing. I think I shall know how to be original even when imitating. Look: who is there, among the great men, who has not imitated? Nothing is made with nothing, and the way good inventions are made is to famil-

iarize yourself with those of others. The men who cultivate letters and the arts are all sons of Homer.

ART AND THE BEAUTIFUL

There are not two arts, there is only one: it is the one which has as its foundation the beautiful, which is eternal and natural. Those who seek elsewhere deceive themselves, and in the most fatal manner. What do those so-called artists mean when they preach the discovery of the "new"? Is there anything new? Everything has been done, everything has been discovered. Our task is not to invent but to continue, and we have enough to do if, following the examples of the masters, we utilize those innumerable types which nature constantly offers to us, if we interpret them with wholehearted sincerity and ennoble them through that pure and firm style without which no work has beauty. What an absurdity it is to believe that the natural disposition and faculties can be compromised by the study—by the imitation, even—of the classic works! The original type, man, still remains: we have only to consult it in order to know whether the classics have been right or wrong and whether, when we use the same means as they, we lie or tell the truth.

TASTE

It is rarely other than the lower type of the arts, whether in painting or in poetry or in music, which naturally pleases the multitude. The more sublime efforts of art have no effect at all upon uncultivated minds. Fine and delicate taste is the fruit of education and experience. All that we receive at birth is the faculty for creating such taste in ourselves and for cultivating it, just as we are born with a disposition for receiving the laws of society and for conforming to their usages. It is up to this point, and no further, that one may say that taste is natural to us.

DRAWING

Drawing is the probity of art.

To draw does not mean simply to reproduce contours; drawing does not consist merely of line: drawing is also expression, the

inner form, the plane, modeling. See what remains after that. Drawing includes three and a half quarters of the content of painting. If I were asked to put up a sign over my door I should inscribe it: *School for Drawing,* and I am sure that I should bring forth painters.

Drawing contains everything, except the hue.

One must keep right on drawing; draw with your eyes when you cannot draw with a pencil. As long as you do not hold a balance between your seeing of things and your execution, you will do nothing that is really good. [Compare Delacroix, p. 230.]

SCULPTURAL PAINTING

The beautiful forms are those with flat planes and with rounds. The beautiful forms are those which have firmness and fullness, those in which the details do not compromise the aspect of the great masses.

What is necessary is to give health to the form.

. The completion of the form is achieved by finish. There are people who, in drawing, are satisfied by feeling; with feeling once expressed, the thing suffices them. Raphael and Leonardo da Vinci are there to prove that feeling and precision can be allied.

The great painters, like Raphael and Michelangelo, have insisted on line in finishing. They have reiterated it with a fine brush, and thus they have reanimated the contour; they have imprinted vitality and rage upon their drawing.

From the material standpoint we do not proceed like the sculptors, but we should produce sculptural painting.

[Compare the opinions of Michelangelo, p. 65, and Blake, p. 266.]

EXPRESSION

Expression in painting demands a very great science of drawing; for expression cannot be good if it has not been formulated with absolute exactitude. To seize it only approximately is to miss it and to represent only those false people whose study it is to counterfeit sentiments which they do not experience. The extreme precision we need is to be arrived at only through the surest talent

for drawing. Thus the painters of expression, among the moderns, turn out to be the greatest draftsmen. Look at Raphael!

COLOR

Color adds adornment to painting; but it is only the tiring-woman [court lady charged with dressing a queen], for she does not go beyond rendering more amiable the veritable perfections of art.

It is unexampled that a great draftsman has not had the color quality exactly suited to the character of his drawing. In the eyes of many persons, Raphael did not use color; he did not use color like Rubens and Van Dyck: *parbleu,* I should say not! He would take good care not to do such a thing.

Rubens and Van Dyck may please the eye, but they deceive it; they are of a bad school of color, the school of the lie. Titian: there is true color, there is nature without exaggeration, without forced brilliance! He is exact.

STUDY THE ANTIQUE

To claim that we can get along without study of the antique and the classics is either madness or laziness. Yes, anti-classic art, if one may even call it an art, is nothing but an art of the lazy. It is the doctrine of those who want to produce without having worked, who want to know without having learned; it is an art as lacking in faith as in discipline, wandering blindly because of its having no light in the darkness, and demanding that mere chance lead it through places where one can advance only by means of courage, experience, and reflection.

ART, NATURE, AND FASHION

Let me hear no more of that absurd maxim: "We need the new, we need to follow our century, everything changes, everything is changed." Sophistry—all of that! Does nature change, do the light and air change, have the passions of the human heart changed since the time of Homer? "We must follow our century": but suppose my century is wrong. Because my neighbor does evil, am I therefore obliged to do it also? Because virtue, as also beauty, can be

misunderstood by you, have I in turn got to misunderstand it? Shall I be compelled to imitate *you*! [Compare Couture, p. 244.]

RAPHAEL AND REMBRANDT

The Flemish and Dutch schools have their own type of merit, as I well recognize. I can flatter myself that I appreciate that merit as much as anybody else; but, for goodness' sake, let us have no confusion. Let us not admire Rembrandt and the others through thick and thin; let us not compare them, either the men or their art, to the divine Raphael and the Italian school: that would be blaspheming. [See also Delacroix, p. 229.]

EXHIBITIONS AND COMMISSIONS

To remedy the present overflow of mediocrities, which is the cause of our no longer having any school, to remedy that banality which is a public misfortune, which sickens taste and overwhelms the Administration by absorbing its resources without producing any result, the thing that should be done is to renounce exhibitions; there should be a courageous declaration that monumental painting alone will be encouraged. It should be decreed that we decorate our great public buildings and our churches, the walls of which are thirsty for painting. Those decorations would be entrusted to the higher type of artists, who would employ the mediocre artists as their aides, and the latter would, in this way, cease to oppress art and would become useful. The young artists would be proud to aid their masters. Everyone who now uses a brush could be utilized. [Compare Géricault's opinions, p. 223.]

Exhibitions have become part of our habit of life, it is quite true; therefore it is impossible to suppress them; but they must not be encouraged. They ruin art, for it becomes a trade which the artist no longer respects. The exhibition has now become no more than a bazaar where mediocrity spreads itself out with impudence. The exhibitions are useless and dangerous. Aside from the question of humanity, they ought to be abolished.

We must follow the same procedure as we had last year, and open the doors of the exhibition to all. Humanity and art itself are interested in that solution of the problem, for it is the most

liberal of all. Society has not the right to condemn the artist and his family to die of hunger because the productions of that artist are not to the taste of this or that person. [Compare the opinions of David d'Angers, p. 222.]

PIERRE JEAN DAVID D'ANGERS

TO HUMBERT DE SUPERVILLE

DAVID D'ANGERS, sculptor of Thomas Jefferson and of the pediment of the Panthéon in Paris, was a less romantic artist than his better known contemporaries Rude and Barye. His aim was to make his art "national," to place it in the service of democracy by carving the portraits of famous men as a constant call to virtue.

Humbert de Superville was director of the newly founded Print Room and the Collection of Casts in his native Leyden. As an artist, he was best known for his vigorous experiments in lithography.

On the purpose of sculpture, compare Falconet, p. 174.

MODERN DRESS AND THE NUDE *1832*

You are right, sir; only when sculpture creates worthy symbols is it worthy of respect. The Egyptian colossi are the symbols of a myth and religion. Later, the Greeks represented a chosen individual; though her artists were naturalists, theirs was still a noble calling. We modern sculptors spend our time cutting full-length portraits of an individual, not as his Creator made him, but ridiculously disguised in a frock coat invented by the stupid brain of some tailor. It is really excellent thus to preserve the vagaries of fashion for all time!

But what can one do! The features of the geniuses and benefactors of mankind must be recorded. It is useful to remind those whom they came to console and to improve of the all too rare saintly men who set an example in the peaceful honors they attained.

As for clothes, one will never be able to persuade mankind not to change a style, no matter how beautiful it may be. Humanity's

changeable character and industry's necessity are insurmountable obstacles.

I do not know why we take such pleasure in the representation of animals, and why we should not rather wish to copy the most beautiful creature God has made. The nude is indecent only when it shows unchaste acts. Sculpture should be pure and virginal, that is its essence and its character; but that depends upon the morality of the artist.

TO CHARLES BLANC

CHARLES BLANC, who was later to found the *Gazette des Beaux-Arts,* was at this time already a recognized critic and historian. In his *Grammaire des Arts du Dessin* there are numerous references and illustrations from the works of David d'Angers.

Compare Théodore Rousseau's letter to Charles Blanc, p. 289.

ART, DESPOTISM, AND DEMOCRACY *Marseille, 1839*

Do you remember, my dear friend, our long conversations on the future of humanity, and on the means of making man better, and so happier? Naturally, the arts found a place in this exchange of thoughts and outpouring of hearts . . .

You know we often asked ourselves if, as some people assured us, artists would be less happy under a democratic government than under a monarchy . . .

But would it, in fact, be possible that the artist could be happy only under a regime which begins by asking him to relinquish his dignity, and which grants the man of genius favors only in a courtier's livery? Is not the private satisfaction that proud hearts draw from a feeling of the inviolability of their personal dignity an essential part of happiness? I am even easily persuaded that this satisfaction not only forms a portion of happiness but a portion of genius . . .

[It is said that] artists would have less work. What an error! Liberty possesses an immense expansive force. Despotism feels the need of corrupting men to dominate them, and destroying their souls to enslave them, and at the same time has an enthusiasm for noble things and respects great men. A democratic government,

on the contrary, needs to exalt men's souls, and to keep continually before the people the image of those virtues which uphold it in the knowledge of its greatness.

TO ADOLPHE CHAMBOLLE

CHAMBOLLE WAS editor of the magazine *Le Siècle,* which published considerable material on art.

This opinion of the harmful effect of juries, surprising because of its early date and because it comes from a conservative artist, fits in with David d'Angers' democratic opinions. It is to be compared with Ingres' similar point of view on the subject, p. 219.

AGAINST JURIES *Paris, 1840*

In your number of last Wednesday, you gave the names of the members of the jury of admission for the Salon, and you only mentioned Mm. Ingres, Delaroche, and Vernet as having taken no part in the decisions. I owe it to the truth to state that for several years I have had no part in the deliberations of the jury. Mm. Horace Vernet and Delaroche withdrew because they wanted the jury to be extremely rigid in its admissions. They hoped that only very remarkable works would be admitted. As for myself, I concede to no jury of artists the right to admit or to refuse the work of their colleagues. I want artists as well as authors to have their liberty of press, and so prevent their falling victim to the passions, and the fashion, of the moment. I recognize but one judge for the artist—the public, which can and should pass sentence upon cliques and coteries. I repeat that we must have the same rights as in literature. Would it not be absurd to make up a jury of writers, no matter how distinguished they might be, to decide which books are worth printing? It is easy to foresee the abuses such a system would engender, with judges simply the natural and unwitting victims of their own human weakness. Many years ago I published my ideas on exhibitions free from all censorship except that required by morality. Some people objected that the number of works would be too great, and that their mediocrity would discourage the public. In the first instance, one would have to limit

any single painter to one canvas; concerning the second, tl
no cause for alarm. Freedom of exhibition would make the
more severe; and one can be very sure that a man who has to live
by his profession would not often submit himself to the public's
sarcasm. I even believe that this system would have the tremendous
advantage of getting rid of the superfluity of artists who today
dispute their infrequent commissions.

THÉODORE GÉRICAULT

THE ACADEMY OF FRANCE IN ROME

GÉRICAULT had only just arrived in the Eternal City, where he viewed the
French Academy from the outside, yet perhaps not impartially, since he was
never *Prix de Rome*. His natural restlessness, heightened by the memory of
an unhappy love affair, from which he had fled France, endured exile only a
little over a year; late in 1817 he was back in Paris. The letter is to an un-
known correspondent.

Compare Girodet's opinion of the Academy in Rome, p. 212.

Rome, November 23, 1816

Italy is an admirable country to know, but one need not spend
as much time there as is usually urged. One year seems to me
sufficient, and the five years granted to the students at the Academy
are more harmful than beneficial, because it prolongs their studies
at a time when they would be better off doing their own work.
They thus become accustomed to living on government money,
and they spend the best years of their lives in tranquillity and
security. They come out having lost their energy and no longer
knowing how to make any effort. And they end, as mediocre men,
lives whose beginnings had given much cause for hope.

This is burying the arts instead of helping them grow, and the
institution of the Academy at Rome could, in principle, only have
been what it is today. Many go, and few return. The real and
proper encouragement for all these clever young men would be
pictures to carry out for their country, frescoes, monuments to

decorate, prizes and money payments; but not five years of good family cooking that fattens up their bodies and destroys their souls . . .

I am confiding these thoughts to you, M—, assuring you of their correctness, and asking you to tell them to no one.

TO HORACE VERNET

GÉRICAULT HAD shown his big romantic masterpiece, *The Raft of the Medusa*, in the Salon of 1819. When it did not receive the acclaim he had counted on, and was not bought by the state, Géricault, disappointed, decided to show it in a traveling exhibition in England (see David, p. 207). In the spring of 1820, accompanied by the lithographer Charlet, he took his picture to London, returning to Paris in 1822. Horace Vernet, two years older than Géricault and of a well-known family of artists, was one of the leading painters of oriental and military subjects.

On the virtues and defects of national characters in art, see also Holman Hunt, p. 339; Whistler, p. 351; and Wadsworth, p. 459.

MERITS OF ENGLISH ART *London, May 1, [1821]*

I was saying the other day to my father that your talent needed but one thing—to be steeped in the English school—and I repeat it to you, because I know that you admire the little you have seen of their work. The Exposition which has just opened has more than ever convinced me that only here are color and effect known and felt. You can have no idea of the fine portraits shown this year, and the many landscapes and genre pictures; there are animals painted by Ward and by Landseer, only eighteen years old, and even the masters have produced nothing better of this sort. One must not be ashamed of returning to tradition; the beautiful in the arts can be achieved only by comparisons. Each school has its own character. If one could succeed in uniting all of their qualities would one not have reached perfection? But that requires incessant effort and great love. Here they complain that their drawing is poor, and they envy the French school its much greater facility: why don't we complain of our own defects? What is *the silly pride* that closes our eyes; can we honor our country by refusing to recognize quality wherever it may be and repeating

madly that we are the best? Will we always be our own judges; someday will not our works scattered among the galleries testify to our vanity and presumption? . . .

How I should like to be able to show our cleverest painters several portraits, which are such close resemblances to nature, whose easy poses leave nothing to be desired, and of which one can really say that all they lack is the power of speech. How useful, too, it would be to see Wilky's [sic] touching expressions. In a little picture, whose subject is of the simplest, he knows how to turn them to admirable advantage. The scene takes place at the Pensioners' Hospital; he supposes that at the news of a victory the veterans gather to read the *Bulletin* and rejoice. With much feeling he has varied all his characters! I will talk to you only of one figure, which seemed to me the most perfect, and whose pose and expression draw tears, however one may try to hold them back. It is the wife of a soldier, who, thinking only of her husband, scans the list of the dead with a worried and haggard eye. Your imagination will convey to you all that her discomposed visage expresses. There is neither crepe nor mourning; on the contrary, wine flows on all the tables, and the sky is not rent with lights of sinister omen. He achieves nevertheless a pathos as convincing as nature herself. I am not afraid that you will tax me with Anglomania. You know our good qualities as well as I do, and you know what we lack.

ON SCHOOLS AND COMPETITIONS

THESE PARAGRAPHS form part of the fragments of a book found among Géricault's effects at his death. Other portions of the manuscript deal with the state of the arts in France and combat the theories of the classicist painters.

Compare Greenough's opinions on artistic education, p. 284; and those of Flandrin, p. 242; and Bouguereau, p. 287.

OPPORTUNITY SPELLS MEDIOCRITY

The government has erected public schools of drawing, which are maintained at great expense and to which any youth is ad-

mitted. Frequent competitions seem to stimulate constant rivalry, and at first glance this institution seems to be the surest method of encouraging the arts. Neither Athens nor Rome offered their citizens greater opportunity of studying the arts or the sciences than do the many schools of all kinds in France. But since their establishment I have noticed with disappointment that they have produced an entirely different effect than had been expected, and that instead of being useful they have become a real hindrance, because, though they have given birth to thousands of mediocre talents, they cannot pride themselves upon having formed any of our most distinguished painters, since these men have in a way been themselves the founders of the schools, or at least have been the first to spread the principles of taste.

David, the most distinguished of our artists, owed the achievements that have attracted the attention of the entire world solely to his own genius . . .

Supposing that all the young people admitted to our schools were endowed with all the qualities needed to make a painter, isn't it dangerous to have them study together for years, copying the same models and treading approximately the same path? After that, how can one hope to have them still keep any originality? Haven't they in spite of themselves exchanged any particular qualities they may have had, and sunk the individual manner of conceiving nature's beauties that each one of them possessed in a single, uniform style?

The nuances that can survive this sort of confusion are imperceptible; and each year we see with disgust ten or twelve compositions, carried out in about the same way, painted from one end to the other with a disheartening perfection, and showing no trace of originality.

OBSTACLES INCITE GENIUS

If obstacles discourage the mediocre talent, they are, on the contrary, the necessary food of genius; they ripen and exalt it, where the easy road would leave it cold. Everything that opposes the triumphant progress of genius irritates it, and induces that fever of exaltation that overthrows and conquers all to produce its

masterpieces . . . Unfortunately, the Academy does better: it snuffs out those who have some sparks of the sacred fire, it smothers them by not giving them time to develop naturally, and in wishing to produce precocious fruits robs itself of those which a slower ripening would have made tasty.

EUGÈNE DELACROIX

EXTRACTS FROM HIS *JOURNAL*

THE *Journal* of Eugène Delacroix was begun on Tuesday, September 3, 1822, when the painter was twenty-four, and in the year which saw his first large document of romanticism (*Dante and Virgil*) exhibited at the official Salon. Before his death the *Journal* was to run to a total of three

volumes, even though Delacroix allowed it to lapse for twenty years (1825-1846), during the time when all his energy and attention were taken up with his painting.

In writing his *Journal* Delacroix's primary purpose was to clarify his own ideas and record his thoughts for his own better understanding. "It seems to me," he notes in 1854, "that these worthless trifles, written on the fly, are all that remain of my life as it passes. My lack of memory makes them necessary to me." Yet the idea of eventual publication was never entirely absent from Delacroix's mind. (We must not forget that when he was still painting as an amateur he had thought of writing as his future profession.) And in later life he had a large part of the *Journal* copied "with his authorization and under his direction."

Delacroix's other writing is of two kinds: his letters, of which four volumes have been preserved for us; and some twelve long articles of professional criticism and theory that appeared in contemporary magazines. Together with the *Journal* they constitute the most complete revelation of an artist's mind since the days of Michelangelo and Leonardo. And it is the *Journal* that deals most directly and vividly with his ideas on art.

The immediate contrast to the romantic (?) ideas expressed in the *Journal* is to be found in Ingres' *Notes and Thoughts,* p. 214. For opinions on Delacroix himself, see, among others, Couture, p. 244; Rossetti, p. 336; Rousseau, p. 289; Signac, p. 377; and Redon, p. 359.

MICHELANGELO *1824*

This morning I saw several fragments of figures by Michelangelo, drawn by [his friend] Drolling. God! what a man! What beauty! A strange thing, and a very beautiful one, would be joining Michelangelo's style [see below, p. 235] to that of Velasquez. That idea came to me right after seeing the drawing. It is gentle, and it is full. The forms have that softness which, so it seems, only a heavy loading of the paint can give, and at the same time the contours are vigorous. The engravings after Michelangelo give no idea of this. Therein lies the sublimity of the execution. Ingres has something of that. The spaces within his contours are smooth and but slightly cluttered up with details. How that would facilitate labor, especially in small pictures!

BEAUTY NOT THE ONLY AIM OF ART *1847*

All those young men of the school of Ingres have something pedantic about them. It seems that there is already a very great

merit on their part in having joined the party of serious painting: that is one of the words of the *party*. I told Demay that a whole lot of men of talent had done nothing worth while, with that mass of fixed opinions that they impose on themselves, or that the prejudice of the moment imposes on you. That is the case, for example, with that famous idea of *beauty,* which is, as everybody says, the goal of the arts. If it is their only goal, what becomes of the men like Rubens, Rembrandt, and all the northern natures generally, who prefer other qualities? Demand purity, in a word beauty, from Puget—good-by to his verve! This is an idea to develop. In general the men of the north tend less in this direction. The Italian prefers ornament. One gets a confirmation of this in music. [Compare Ingres, p. 216; and Flandrin, p. 241.]

PAINTING AND POETRY . *September 19, 1847*

I see in painters prose writers and poets. Rhyme, measure, and the turning of verses, which is indispensable and which gives them so much vigor, are analogous to the hidden symmetry, to the equilibrium at once wise and inspired, which governs the meeting or separation of lines and spaces, the echoes of color, etc. This thesis is easy to demonstrate, only one has need of more active organs and a greater sensibility to distinguish error, discord, false relationship among lines and colors, than one needs to perceive that a rhyme is inexact or that a hemistich is clumsily (or badly) hung. But the beauty of verse does not consist of exactitude in obeying rules, when even the most ignorant eyes see at once any lack of attention to them. It resides in a thousand secret harmonies and conventions which make up the power of poetry and which go straight to the imagination; in just the same way the happy choice of forms and the right understanding of their relationship act on the imagination in the art of painting. David's picture of *Leonidas at Thermopylae* is masculine and vigorous prose, I admit. [Compare David, p. 207.]

PERFECTION IS NOT ART *1850*

I have told myself a hundred times that painting—that is to say, the material thing called painting—was no more than the

pretext, the bridge between the mind of the painter and that of the spectator. Cold exactitude is not art; ingenius artifice, when it *pleases* or when it *expresses,* is art itself. The so-called conscientiousness of the majority of painters is only perfection applied to the *art of boring.* People like that, if they could do it, would work with the same minute attention on the back of their canvas. It would be interesting to write a treatise on all the falsehoods which can add up to truth. [Compare Degas, p. 308.]

COLOR AND LIGHT *1850*

The two conceptions of painting which Mme. Cavé was telling me about, that of color as *color* and of light as *light,* have got to be reconciled in a single operation. If you make the light dominate too much, the breadth of the planes leads to the absence of half-tints, and consequently to discoloration; the opposite abuse is harmful above all in big compositions destined to be seen from a distance, like ceilings, etc. In the latter form of painting, Paul Veronese goes beyond Rubens through the simplicity of his local color and his breadth in handling the light . . . Paul Veronese had greatly to strengthen his local color in order that it should not appear discolored when illumined by the very broad light he threw on it. [Compare Allston, p. 275.]

COLOR IS THE PROBITY OF ART *Monday, February 23, 1852*

Painters who are not colorists produce illumination and not painting. All painting worthy of the name, unless one is talking about a black-and-white, must include the idea of color as one of its necessary supports, in the same way that it includes chiaroscuro and proportion and perspective. Proportion applies to sculpture as to painting; perspective determines the contour; chiaroscuro gives relief through the disposition of lights and shadows in their relationship with the background; color gives the appearance of life, etc. [Compare above, Ingres, p. 216.]

The sculptor does not begin his work with a contour; with his material, he builds up an appearance of the object which, rough at first, immediately presents the chief characteristic of sculpture —actual relief and solidity. The colorists, the men who unite all

the phases of painting, have to establish, at once and from the beginning, everything that is proper and essential to their art. They have to mass things in with color, even as the sculptor does with clay, marble, or stone; their sketch, like that of the sculptor, must also render proportion, perspective, effect, and color.

COURBET's *Bathers* *Friday, April 15, 1853*

I went to see the paintings by Courbet. I was astonished at the vigor and the relief in his principal picture [the *Bathers*]; but what a picture! What a subject! The commonness and the use-lessness of the thought are abominable; and if only his idea, common and useless as it is, were clear! What are those two figures doing? A fat bourgeoise is seen from the back, completely nude save for a carelessly painted bit of cloth, covering the lower part of her buttocks; she comes out of a little strip of water which does not seem deep enough for even a foot-bath. She makes a gesture which expresses nothing, and another woman, whom one may suppose to be her maid, is seated on the ground, taking off her shoes and stockings. One sees stockings that have just been taken off, one of them only halfway, I think. Between these two figures there is an exchange of thoughts which one cannot understand. The landscape is of an extraordinary vigor, but Courbet has done no more than enlarge a study exhibited there, near his large canvas; the conclusion is that the figures were put in afterwards and with-out connection with their surroundings. This brings up the ques-tion of harmony between the accessories and the principal object, a thing lacking in the majority of great painters. It is not the biggest defect in Courbet . . .

Oh, Rossini! Oh, Mozart! Oh, geniuses inspired in all the arts, who draw from things only such elements of them as are to be shown to the mind! What would you say before these pictures? Oh, *Semiramis*! Oh, entry of the priests to crown Ninias! [See below, pp. 236 and 295.]

ART IS NOT IMITATION *1853*

When we were in the forest yesterday and I was praising to Jenny [his servant] the forest painting of Diaz, she said, with her

COURBET: The Bathers, 1853

great good sense, "The closer the imitation the colder it is," and that is the truth! Continual caution in showing only what is shown in nature will always make the painter colder than the nature which he thinks he is imitating; moreover, nature is far from being always interesting from the standpoint of effect and of ensemble. If each detail offers a perfection which I shall call inimitable, these details collectively, on the other hand, rarely present an effect equivalent to the one which results, in the work of the great artist, from the feeling for the ensemble and the composition. That is what made me say just now that if the use of the model gave to the picture something striking, it could do so only in the case of very intelligent men: in other words, the only ones who can really benefit by consulting the model are those who can produce their effect without a model.

How do things stand, now, if the subject contains a large element of pathos? . . . Consider such an interesting subject as the scene taking place around the bed of a dying woman, for example; seize and render that ensemble by photography, if that is possible: it will be falsified in a thousand ways. The reason is that, according to the degree of your imagination, the subject will appear to you more or less beautiful, you will be more or less the poet in that scene in which you are an actor; you see only what is interesting, whereas the instrument puts in everything. [Compare Cole, p. 282.]

RUBENS *1853*

Glory to that Homer of painting [Rubens], to that father of warmth and enthusiasm in the art where he blots out everything —not, if you like, through the perfection which he has brought to one part or another, but through that secret force and that life of the soul which he has attained everywhere. How strange! the picture which perhaps gave me the strongest sensation, the *Raising of the Cross* [in Antwerp], is not the one most brilliant because of the qualities peculiar to him and in which he is incomparable. It is neither through color nor through the delicacy nor the frankness of the execution that this picture triumphs over the others, but, curiously enough, through Italian qualities which, in the work of the Italians, do not delight me to the same degree; I

think it is appropriate for me to take note here of the quite analogous way I have felt before Gros's battle pictures, and before the *Medusa* [of Géricault, for which Delacroix is supposed to have posed], especially when I saw it half finished. The essential thing about these works is their reaching of the sublime, which comes in part from the size of the figures. The same qualities in small dimension would, I am sure, produce quite a different effect on me.

ART COMMISSIONS *1854*

The commissions [on art of the city of Paris, on which Delacroix served]: At the last session I was struck by the way that matters have to be submitted to specialists. Memorandum on this subject: everything that commissions do is incomplete and, more especially, incoherent; at that session the artists voted together; they had reason on their side; the others understand only in a confused fashion; they have no clear ideas.

That is not to say that, if I had governmental power, I would turn over questions of art, for example, to commissions of artists. The commissions would be purely consultative, and the able man who would preside over them would follow his own ideas entirely, after having listened to them. When they are gathered at a meeting and are thinking of their profession alone, each one promptly goes back to his narrow point of view; when opposed by completely incompetent people, the sure and general advantages are clearly visible to their eyes, and they will succeed in making them visible to others. [See above, David, p. 205; and Ingres, p. 219.]

PRESERVING INSPIRATION *1854*

The original idea, the sketch, which is so to speak the egg or embryo of the idea, is usually far from being complete; it contains everything, which is simply a mixing together of all parts. Just the thing that makes of this sketch the essential expression of the idea is not the suppression of details, but their complete subordination to the big lines which are, before all else, to create the impression. The greatest difficulty therefore is that of returning in the picture to that effacing of the details which, however, make up

the composition, the web and the woof of the picture. [Compare Corot, p. 240.]

MICHELANGELO VS. RUBENS *1854*

Titian—there is a man whose qualities can be savored by people who are getting old; I confess that I did not appreciate him at all in the time when I had such admiration for Michelangelo [see above, p. 228] and Lord Byron. It is not, in my opinion, either by the depth of his expression or by a great understanding of the subject that he touches you, but by his simplicity and by the absence of affectation. The painter qualities are carried to the highest point in his work: what he does is done—through and through; when he paints eyes, they see, they are lit with the fire of life. Life and reason are everywhere. Rubens is quite different and has a quite different turn of the imagination, but he really paints men. Neither of these artists loses his sense of proportion save when he imitates Michelangelo and tries to take on a grandiose quality that is only swollen pretense and that usually drowns out his real qualities.

The claim . . . for Michelangelo is that he has painted man above all, and I say that all he has painted is muscles and poses, in which even science, contrary to general opinion, is by no means the dominant factor. The least of the ancients has infinitely more knowledge than there is in the whole work of Michelangelo. He did not know a single one of the feelings of man, not one of his passions. When he was making an arm or a leg, it seems as if he were thinking only of that arm or leg and was not giving the slightest consideration to the way it relates with the action of the figure to which it belongs, much less to the action of the picture as a whole.

You are forced to admit that certain passages treated in this way, things that resulted from the artist's exclusive absorption in them, are of a character in which the only passion is their own. Therein lies his great merit; he brings a sense of the grand and the terrible into even an isolated limb.

COURBET'S *Atelier* *August 3, 1855*

I went to the [International] Exposition; I noticed that fountain which spouts gigantic artificial flowers.

The sight of all those machines makes me feel very bad. I don't like that stuff which, all alone and left to itself, seems to be producing things worthy of admiration.

After leaving, I went to see Courbet's exhibition [see below, p. 294]; he has reduced the admission to ten cents. I stay there alone for nearly an hour and discover that the picture of his which they refused [The *Atélier*] is a masterpiece; I simply could not tear myself away from the sight of it.

THÉODORE CHASSÉRIAU

TO HIS BROTHER FRÉDÉRIC

ALTHOUGH HE was only twenty-one years old when he wrote this letter from Rome, Chassériau had already had two successes in the Salon of 1839: *Susanna and the Elders* and the *Venus Anadyomene*. He had been Ingres' pupil before 1834, when the master left Paris to become Director of the Academy of France at Rome, and, young as he was, he now met the older man as one who has freed himself from his teacher. He was to go on to combine some of the qualities of Ingres and Delacroix into his own personal style.

The Abbé Lacordaire, whose portrait Chassériau painted at this time, was the famous preacher, pupil of Lamennais, and collaborator of Montalembert; a product of the religious revival that centered in the church of St. Sulpice.

ROME AND M. INGRES *Rome, September 9, 1840*

I look upon Rome as that spot on earth where there is the largest number of sublime things, as a city which forces one to think a great deal, but also as a tomb.

I have found the Coliseum to be the only Christian thing in Rome; St. Peter's does not seem at all religious, and, although in ruins, the pagan monuments are so common that it is antiquity which is always present to the imagination. Since we can have no sympathy in our hearts with Jupiter, Pluto, Vesta, and a host of other gods and goddesses, we see no contemporary life in Rome; when our eyes are always turned towards the past, our work runs the risk of remaining in a pleasant beatitude which puts us to sleep! . . .

I have done some studies of the *campagna* which is so celebrated and so beautiful. It is a unique thing, very fine and pure in design, very rich in color, and of a great sadness and gravity that is sublime when painted grandly—because I do not want to use the ugly word "historical," so cold and academic, and above all so meaningless . . .

After a fairly long conversation with M. Ingres, I saw that in many respects we could never agree. He has outlived his prime, and he does not understand the ideas and changes that have taken place in the arts in our time; he is completely ignorant of all the recent poets. It is all very well for him; he will remain as a memory and a repetition of certain periods of the art of the past, having created nothing for the future.

But my hopes and my ideas are in no way similar. This is why I will be back in France by the end of December, and to begin my campaign I will bring with me my portrait of the Abbé Lacordaire.

JEAN-BAPTISTE-CAMILLE COROT

SELECTIONS FROM HIS NOTEBOOKS

MOREAU-NÉLATON, friend and biographer of Corot and other artists, has given us only extracts from the *carnets* in which Corot jotted down the record of his day-to-day existence. Mixed in with notes on practical affairs were these views on his painting method and the relation of his art to nature. They date from his earliest trip to Rome in the twenties to the time when a softer, somewhat sentimental style was beginning to bring him popularity and, later, fame.

Compare the opinions of Rousseau, p. 290, and Sisley, p. 309.

DRAWING METHODS *[Rome, ca. 1828]*

 I have learned from experience that it is useful to begin by drawing one's picture clearly on a virgin canvas, first having noted the

desired effect on a white or gray paper, and then to do the picture section by section, as immediately finished as one can, so that when it has all been covered there is very little left to retouch. I have noticed that whatever is finished at one sitting is fresher, better drawn, and profits from many lucky accidents, while when one retouches this initial harmonious glow is lost. [Compare Delacroix, p. 234.] I think that this method is particularly good for foliage, which needs a good deal of freedom. Drapery and, in general, all things that are fairly regular need much exactness. I see, too, how meticulously one must follow nature, and not be satisfied with a hasty sketch. How often, looking at my drawings, have I been sorry that I hadn't had the energy to spend half an hour more on them. Until now, in the manner in which I have done them they annoy me and only give me a vague idea. If they but rub together a bit in traveling, I no longer recognize them. Nothing should be left to indecision.

FORM, VALUE, COLOR

The first two things to study are form and values. For me, these are the bases of what is serious in art. Color and finish put charm into one's work.

In preparing a study or a picture, it seems to me very important to begin by an indication of the darkest values (assuming that the canvas is white), and to continue in order to the lightest value. From the darkest to the lightest I would establish twenty shades. Thus your study or picture is set up in orderly fashion. This order should not cramp either the linearist or the colorist. Always [keep in mind] the mass, the ensemble which has struck you. Never lose sight of that first impression by which you were moved. Begin by determining your composition. Then the values—the relation of the forms to the values. These are the bases. Then the color, and finally the finish . . . It is logical to begin with the sky.

[France, ca. 1850]

I am never in a hurry to reach details. First and above all I am interested in the large masses and the general character of a picture;

when these are well established, then I try for subtleties of form and color. I rework the picture constantly and freely, and without any systematic method.

FEELING [*France, ca. 1856*]

Be guided by feeling alone. We are only simple mortals, subject to error; so listen to the advice of others, but follow only what you understand and can unite in your own feeling. Be firm, be meek, but follow your own convictions. It is better to be nothing than an echo of other painters. The wise man has said: When one follows another, one is always behind. Beauty in art is truth bathed in an impression received from nature. I am struck upon seeing a certain place. While I strive for a conscientious imitation, I yet never for an instant lose the emotion that has taken hold of me. Reality is one part of art; feeling completes it . . . Before any site and any object, abandon yourself to your first impression. If you have really been touched, you will convey to others the sincerity of your emotion.

HIPPOLYTE FLANDRIN

IN DEFENSE OF THE FRENCH ACADEMY AT ROME

ON NOVEMBER 15, 1863, the *Surintendant des Beaux-Arts* under Napoleon III had published the official proposals for reforming the system of the Academy in Paris and the French Academy at Rome. The most striking changes were reducing the importance of the annual competition for the *Prix de Rome* and shortening the Italian sojourn of the Roman *pensionnaires* from five years to two. Flandrin, pupil of Ingres, and himself a former director of the Academy of France at Rome, rose up in arms against this attack upon tradition and wrote the draft of a reply. He had just come once again to the Eternal City; four months later he was dead of smallpox. His answer was published posthumously.

Contrast the opinions of Girodet, p. 212, and Géricault, p. 223, on the Academy in Rome, and of Greenough, p. 284, on official academies in general.

[*Rome, November-December, 1863*]

You talk of liberty, of liberty of teaching. I say to you that there is an age to learn and an age to judge and choose. It is only at this latter age that there can be any question of liberty, this liberty which so concerns you. I hold that in a school of fine arts, as in any other, it is the government's duty to teach only uncontested truths, or at least those that rest upon the finest examples accepted for centuries. You can be sure that once out of school the pupils will create the truth of their own time from this noble tradition: truth that will have good title to its name, because it will be the product of a true liberty, while the teaching of the pros and cons in the same place and, so to speak, from the same mouths can only produce doubt and discouragement . . .

Alas, it is the force of circumstance that makes us so weak and miserable compared to the old masters. But what would things be like if we abandoned their tracks? So long as truth does not reign more generally over the human spirit, this luminous trace is our only hope. This is, then, hardly the time to suppress the schools, because I call suppression that teaching of pros and cons, that teaching of doubt that penetrates the pores and kills whatever it touches.

No, it is not doubt that teaches; it is affirmation, and this is why I have wished to have no part in a teaching without principle and without faith. Since I have the good fortune to believe, I do not want to say, "This is, perhaps, beautiful," but I wish to say, "This is beautiful," without having any court, superior or not, come and blow first hot, then cold, and so destroy my work. I believe firmly that the absolute independence of the professor is the first condition of success, because it engenders confidence in the pupils, and this alone can give the authority and the title of master

THOMAS COUTURE

CONVERSATIONS ON ART METHOD

WHEN IT first appeared in Paris as a privately printed volume known as *Entretiens d'Atelier*, Couture's book, like its companion volume *Paysage*, went almost unnoticed. The artist had not exhibited for many years and had been almost forgotten. But when an American edition was published in the year of Couture's death (1879), it had an immediate and widespread popularity. In his introduction Couture proposes his book as a royal road to learning: "I have made a tour of painting as many make a tour of the world. I shall relate to you my voyages, my discoveries. They are not numerous and I believe very simple. You will not have the difficulties which I had, but will learn easily what it is necessary to know."

ORIGINALITY

Do not listen to those who say to you, these rules are useless, and even hurtful to those who have originality.

There are not two ways of painting; there is but one, which has always been employed by those who understand the art.

Knowing how to paint and to use one's colors rightly has not any connection with originality.

This originality consists in properly expressing your own impressions. Take for example the most personal and original: Raphael, Rubens, Rembrandt, Watteau; these four great names are sufficient to make you understand.

RAPHAEL

Raphael expresses beauty in its sweetest form; he embellishes youth in such a way that it captivates us. Everything in his pictures is represented in the springtime of life; men, women, flowers; all are young; elegance, gracefulness, purity, simplicity of lines. This beautiful flesh, firm and round on the slender forms, the reserved bearing, this reminder of the flower which is opening but not yet fully blown; the green turf enameled with marguerites, the shrubs ornamented with small leaves, showing themselves against the pure morning sky; all is born, all breathes, but has

not yet lived. All is perfect with this truly divine painter; here is life without its wear; this is what I wish you to feel, and what gives to the works of Raphael an angelic aspect.

You see, he does more than copy; he chooses first, he develops afterwards, then he throws aside all that is not in the domain of youthful beauty; this is what makes his style and originality.

FRENCH ART

What is the mission of the artist? Ought he to consider his art from the point of view of art only, or ought he, respecting the rules that I consider eternal, make his art bend to the taste and the customs of his country?

Yes, the artist ought to submit himself to the taste and the customs of his country, for his mission is to please and to charm; but, you say, if the taste of the public is false, ought he not to combat it; if he is more enlightened than it is, ought he not to advance his age? . . . Great words, these; they have often been repeated, but it was only for the benefit of very doubtful talent. [Compare Boudin, p. 301.]

The public takes no interest in these professional disputes; the people want beautiful and great things; they wish you to speak to their hearts and to represent what they love and admire.

The public has never been ungrateful; it has always applauded, not only beautiful works, but even simple attempts, when made in the right spirit.

Let us return to our French traditions. Poussin and Le Sueur have the religious ideal; David, Gros, Prud'hon, Girodet, Guérin, Géricault, have the philosophic ideal. [Compare Holman Hunt, p. 339.]

ANTON RAPHAEL MENGS

FROM HIS WRITINGS

THE NAME of Mengs is always associated with that of his friend Winckelmann, the great archaeologist. But though his art leans towards an academic neoclassicism, Mengs (a pupil of Conca; see p. 163) was little influenced

by Winckelmann's ideas; the basis of his extensive writings on art is to be found in the traditional theories that go back to Bellori. Born in Bohemia, Mengs was an infant prodigy, studied in Rome, was court painter at Dresden and Madrid, and worked in Rome during five different sojourns.

RULES FOR COMPOSITION

A group is an assemblage of many figures closely related to one another. It should be composed of an odd number, such as 3, 5, 7, etc. Of even numbers those that are the exact double of odd ones are the more tolerable, but the multiples of 4 can never be used with grace! In the former class are 6, 10, etc.; in the latter, 4, 8, etc.

Every group must form a pyramid and at the same time be as rounded as possible in its relief.

The masses must be set thickest towards the center of the group. One must contrive to put the small parts towards the edges so that the group may look less compact and more agreeable.

Beware of showing too much background; that is, of making only one row of figures. Arrange them in depth as well as in breadth, because this will give an agreeable air to the picture by the variety in the scale of the figures, and by the play and accidental effects of light and shade which will always result from such an arrangement.

Never let two limbs—two arms or two legs—of the same figure appear in an identical foreshortening. Let no limb be repeated, and if you show the outer side of the right hand you must show the inner side of the left.

Always contrive to exhibit the most beautiful parts, which are generally the joints—the shoulders, neck, elbows, wrists, hips, knees, ankles—and the back and the breast. These parts are beautiful for various reasons: the extremities and joints because they enable you to display expression and science, and the back and breast because they are big and allow the introduction of a large mass of an almost uniform and very agreeable color, as is the color of flesh.

GOOD TASTE

The painter, wishing to hit upon the best taste, should learn it from the following four masters: from the antique a taste for

beauty; from Raphael a taste for significance and expression; from Correggio a taste for agreeableness and harmony; from Titian a taste for truth and color.

PHILIPP OTTO RUNGE

TO HIS BROTHER DANIEL

Runge, who was born in Hamburg and studied in Copenhagen, was less than twenty-four when he went to the Dresden Academy. The two years that followed—from June, 1801, to November, 1803—were the decisive years of his life: he met Ludwig Tieck, who taught him the basic ideas of the mystic Jakob Boehme; he first was influenced by, and then opposed, the neoclassic revival of Goethe and the *Weimarer Kunstfreunde;* and he formulated the fundamental concepts of his own romantic painting, including

the famous *Tageszeiten,* and the color theories from which Goethe borrowed. This letter was written during this period to the brother, who was Runge's closest confidant.

On the symbolic importance of landscape, see Cole, p. 280.

THE FUTURE BELONGS TO LANDSCAPE PAINTING

Dresden, February, 1802

Works of art all through the ages show us in the clearest fashion how mankind has changed, how a stage that has once appeared never reappears; then how could we have had the unhappy notion of wanting to revive the art of long ago? We see reflected in Egyptian art the iron hardness and crudity of mankind. The Greeks infused their works of art with all the emotions of their religion. Michelangelo was the high point of composition, and his *Last Judgment* marks the boundary of history painting; Raphael already had produced much that was not pure historical composition, as for example his *Sistine Madonna* in Dresden, which is obviously only an immediate sensation expressed through familiar forms.

After him nothing truly historical was done, all fine compositions leaning towards landscape (e.g., Guido Reni's *Aurora*), though there was yet no landscape painter who put real meaning into his landscapes, who put allegories and clear and beautiful thoughts into his pictures. Who does not see angels on the clouds at sunset? Who in his soul does not have intimations of the clearest thoughts? Can't I hold the fleeting moon as well as any fleeting form that awakens thoughts in me, and won't this be just as much a work of art? And what artist feeling these things in himself, awakened to nature through what we see in ourselves, in our love, and in the heavens, will not find the right subjects to bring forth these sensations; how, indeed, could he want for a subject? Such feeling must precede the subject, and set problems are therefore ridiculous.

How then can we think of re-creating a past art? The Greeks brought beauty of form and figure to its highest point at a time when their gods were crumbling; the Romans of the Renaissance achieved the best in historical compositions, just when Catholicism

crumbled; now in our time something once again is gone from Catholicism, and as their abstractions crumble everything becomes lighter and more airy, tends towards landscape, and, seeking something certain amid all the uncertainty, doesn't know how to begin. They attach themselves once more to history painting; if you wish, isn't it possible to reach a high point too, one that will perhaps be more beautiful than those that have preceded it? I will portray my life in a series of works of art; when the sun sinks, and the moon gilds the clouds, I will capture the fleeting spirits. We will not live to see this art's golden age, but we will devote our lives to calling it forth in truth and in fact. No base thoughts shall enter our hearts. He who with an ardent love holds fast to the beautiful and the good—he always achieves something fine. We must become children, if we wish to attain the best.

FRANZ PFORR

TO JEAN DAVID PASSAVANT

THIS LETTER was written six months before the founding in Vienna, on July 10, 1809, of the *Lukasbund* by Pforr (aged twenty-one), Overbeck (aged twenty), and other young German artists. The *Lukasbund* was a communal society (prototype of others later in the century) which, in reaction against the pseudo-classicists of the Academy, proposed for itself the task of regenerating German art on a religious basis. Its members had a decided preference for the German and Italian primitives over later periods. In 1810 Pforr and Overbeck went to live in Rome; Pforr died near Naples in October, 1811. [Compare Holman Hunt, p. 337.]

J. D. Passavant abandoned his father's bank to study painting with David in Paris, but he hardly practiced his art. He was more important as one of the first modern art historians, author of a book on Raphael, and *Inspektor* at the *Staedelinstitut* in Frankfort.

THE VIRTUE OF THE PRIMITIVES *Vienna, January 6, 1809*

I am far from believing that that city which possessed no artists would be an unhappy one, but I nevertheless believe that few men can have as strong an influence upon morality and virtue. Nor can

I say that the opinion of the multitude is altogether wrong—art has greatly declined. When we consider the ends for which it is now used, we can only deplore that its decay is so very general. Formerly the artist tried to charm the spectator into devotion by representing pious objects, and to induce him to emulate the noble actions he depicted; and now? A nude Venus with her Adonis, a Diana in her bath—towards what good end can such representations point? Then, too, why do we seek subjects so distant from our interests, why not instead those that concern us? In the old Israelite stories we can find more material than anywhere else . . . Don't we find subjects in the Middle Ages that are worth immortalizing, and who sets them down for us? Everyone pursues an ideal set up by a few men who had an exaggerated preference for the art of the Greeks and Romans . . . I must confess that even the finest antique figure never seems to me to be more than a finely ornamented piece of stone, in which one looks in vain for that heart and soul which the artists of the fifteenth and the beginning of the sixteenth century knew so well how to render . . .

The old masters tried to create something that was good, but the newer ones invent works that only seem to be good. It follows from this that a true picture produces little effect upon us at first glance, and that the more we look at it the more it attracts us; while false work has just the opposite result—it surprises and dazzles; at first glance all our attention is drawn to the main figure, which is well composed, and we don't notice the rest. But then we begin to examine it in somewhat colder blood, and we are compelled to see all its unnatural features, and the fact that the main group alone has been really executed and given almost all the light . . . [Compare Bernini, p. 134.]

The primitives are reproached for the hardness and exactitude of their contours, but this is a fault I would gladly master. Which is easier, to draw a body with a contour no wider than a hair, or with one the width of two fingers that merges into the background? I think the answer is obvious. But our eyes are spoiled, so that whatever doesn't have these qualities we object to as being hard and sharp. And I ask of you—look at nature. Can one surpass its precision? I doubt it.

FRIEDRICH OVERBECK

ART IN THE SERVICE OF THE LORD

WHEN OVERBECK and Franz Pforr left Vienna in 1809 (see above, p. 248), they went to Rome. There, in September, 1810, they took over the Convent of S. Isidoro to continue their purpose of regenerating art by restoring its religious inspiration. After the death of Pforr, Overbeck became the leader of the Nazarenes, as the group soon came to be called. They admired the Quattrocento, dispensed with living models, and practiced an art that was cold and meticulous in line. Chief among the other German and Italian adherents was Peter Cornelius.

On the religious purpose of art, compare the more scholastic statement of Eric Gill, p. 455.

Art is to me what the harp was to David. I use it on every occa-
sion to utter psalms in praise of the Lord. These "Sacraments"
are the melodies of the seven psalms which I have drawn from
the strings of my instrument. Only if I, the least of His servants,
have suceeded in finding grace in His eyes by singing of His
charity and His truth, such as He always asserted it on earth in
His Church—only then shall I beg Him to bless my humble song,
that it may break forth like the voice of an organ to awaken, warm,
and comfort great numbers of hearts of my brethren, and to dispel
the prejudices of those who are outside the Holy Church, to rectify
their opinions according to our doctrine, and to show them all
the grace and beauty of this Church destined to announce on earth
the Kingdom of Heaven, for to God alone are our praises due for
ever and ever.

JAMES BARRY

TO EDMUND BURKE

IN 1763 Burke brought Barry from Dublin to London, and from that time
on remained his patron. He helped Barry go to Italy to study in 1766, and
Barry wrote him regular reports of progress. It was in Rome that Barry
first reacted against the theories of Montesquieu and Winckelmann, accord-

ing to whom climate was the principal determining factor in a people's production of great art; here was the germ of Barry's 1774 *Inquiry into the Real and Imaginary Obstructions to the Acquisition of the Arts in England,* in which he concluded that the main causes for England's lack of a "grand" style were moral and religious.

THE DECLINE OF ART *Rome, Feb. 13, 1767*

People now, to be painters, copy and imitate every thing, Barocci, Murillo, Bernini, Carlo Maratti, Cortona, Mengs, and others of less note; in whom art is little more than a painted and varnished shadow, the substance being quite lost and evaporated by the multiplicity of mediums and reflections through which it has passed from one imitator to another. They go on, as I said, still grafting upon this perishing stock, that is of the species of a mule, which was never intended to succeed beyond the first transfusion; whilst invention and genius, which strengthens and comes to maturity only by the labouring and perpetual exercise of it, is lying either an uncultivated waste, or else choked up by what they transplant from this noxious soil. This is clearly the ignis fatuus, which has so long misled the artists, and that to which is principally owing the long decay of art; as certainly even less labour, more properly directed, would be attended with more success.

But that I am afraid of being tiresome, I would mention to you some curious systems of Abbate Wincleman, the pope's antiquary, and of others here, with which we have been harassed eternally about the *no* genius of the ultra-montanes for the fine arts. I first heard something of this doctrine in England. Experience has shewn me that it can only come from a baffled artist, who might intend it as an apology for his own bad success. And it is besides not an unserviceable notion to the business of the antiquarian, which is the last and general resource of these disappointed people. You are all mad in England after Magilphs, as several accounts confirm to us. I intend you an entire long letter, though I don't know whether you will have the patience to read it, upon these and other matters; as yet I cannot think of it, as I am rather busy amongst the antique figures and bustos all the day, and at nights paint after nature at the academy.

AGAINST THE BAROQUE *Bologna, September 8, 1770*

The greatest part of the works of Tintoret are considerably made up of this leaven, and the world has been taught to believe that it is the effect of true genius—that it is *Maestroso,* and such cant, as at once gives the lie to all our notions of sound art. From this absurd principle differently modified, may be traced out many of the seemingly different manners and corruptions of the Venetians, Romans, Florentines, Bolognese, &c. The greatest part of Tintoret's pictures are executed in this beastly manner: and yet his large work of the crucifixion at St. Roch, and his resurrection of Christ at the Doge's palace ought to be excepted out of this censure, as they really prove that he was capable of better things; however, you will say that this is so much the worse, as it vindicates the capacity at the expense of the morals, and shews that man to have been wanting in love and respect for his art; who could consent to the putting such indigested stuff in public and honourable places; while his accepting payment for them leaves us but a poor idea of his honesty. [Compare Blake, p. 266.]

TO HIS GRACE THE DUKE OF RICHMOND

THROUGHOUT HIS life Barry worked to "revive" true art in England. His first great practical proposal (1772) was the decoration of St. Paul's with historical pictures to be executed by a number of leading artists; his second, to decorate the great room of the Society for the Encouragement of the Arts, Manufacture, and Commerce in the Adelphi. When this latter plan was rejected by the artists themselves Barry carried it out alone, exhibiting his pictures in 1783. His sense of neglect of his efforts in this direction was at the basis of his violent letter of 1799 to the Dilettanti Society, which resulted in his dismissal from the Royal Academy.

MONUMENTAL ART IN ENGLAND *[London], October 14, 1773*

We [Reynolds, West, Angelica Kauffmann, Barry, etc.] had some disputes before we could agree about the size of our figures [for the decoration of St. Paul's], but the result was, that no figure should exceed seven and a half feet, or be less than seven in height.

I neglected adding this piece of intelligence to what I had before the honour of writing to Your Grace, as I had some suspicions that it was not all got over, and the event shews that they were not ill founded, Sir Joshua Reynolds, who had undertaken the management of this business, informed us last Monday, the day after his return from Plympton, where he was chosen mayor, that the archbishop of Canterbury and bishop of London had never given any consent to it, and that all thoughts about it must consequently drop. As there are but few artists interested in leading the arts into such a channel as this would be, it is no wonder to me that there are so few who regret the obstacles thrown in the way of it: but if it could be supposed that these difficulties do really originate from the tender consciences of those two bishops, it is weak and inconsistent beyond all description. When St. Paul's was built, they carried on the necessary ornaments of it as far as their finances suffered them . . . ; and Westminster Abbey is even more than abundantly filled up with carved images, and representations of dead men.

Mengs and other natives of foreign countries, where art and the human mind have been long since in a vitiated, sickly, and dying state, are employed without scruple in pictures for the churches of our Universities; and it is well known that there are but few sacred places in England where art has not long since been so far introduced as to make it impossible for us, with any appearance of consistency, to wallow in the filth and grossness of ancient arguments and ideas. You know, my Lord, that when the people on this side of the Alps, about two hundred and sixty years ago, were freeing themselves from the fetters of the Roman pontiff, the arts, which (unfortunately for this country at present) were the glory and ornament of Italy at that time, were wrapt up in the same bundle with papal encroachments; they were confounded with what they were but accidentally connected with, and every argument was tortured to criminate them: so that however justly we may be disposed to set a value upon the love of freedom and independent spirit of our forefathers, yet it would be very unwise and unbecoming us, after so much literature and Greek elegance

have been poured into the country, to bind ourselves down to the ignorant, passionate, and weak decisions of a people, when they were but just emerging from barbarity.

HENRY FUSELI

APHORISMS ON ART

FUSELI BELONGS with Blake as one of the versatile and eccentric figures of early romanticism. He was born in Zurich, where he first studied literature, then took holy orders in 1761 at the same time as Lavater, whose studies of physiognomy later had much influence on him. Coming to London in 1763, Fuseli first frequented literary circles (and was courted by Mary Wollstonecraft). In 1765 he published a translation of Winckelmann's *Reflections on the Painting and Sculpture of the Greeks,* which ten years later Barry answered (see p. 251). Reynolds, whom Fuseli met in 1767, encouraged him to take up painting seriously.

In 1789 Fuseli brought out a translation of Lavater's *Aphorisms on Man* (*Physiognomische Fragmente*) and promised a corresponding "aphorisms on art" before the end of the year, a promise not fulfilled because the printer's establishment burned down. As later published, and as we give them here the aphorisms were accompanied by corollaries because, as Fuseli said, "an aphorism may be discussed, but ought not to contain its own explanation."

For opinions on Fuseli, see Blake, p. 259, and Allston, p. 274.

1. Life is rapid, art is slow, occasion coy, practice fallacious and judgment partial.

16. Taste is the legitimate offspring of nature, educated by propriety: fashion is the bastard of vanity, dressed by art.

42. Beauty alone, fades to insipidity; and like possession cloys.

43. Grace is beauty in motion, or rather grace regulates the air, the attitudes and movements of beauty.

107. Disproportion of parts is the element of hugeness,—proportion, of grandeur; all Oriental, all Gothic styles of Architecture, are huge; the Grecian alone, is grand.

125. Love for what is called deception in painting, marks either the infancy or decrepitude of a nation's taste.

134. Indiscriminate pursuit of perfection infallibly leads to mediocrity. [Compare Reynolds, p. 187.]

Coroll. Take the design of Rome, Venetian motion and shade, Lombardy's tone of colour, add the terrible manner of Angelo, Titian's truth of nature, and the supreme purity of Corregio's style; mix them up with the decorum and solidity of Tibaldi, with the learned invention of Primaticcio, and a few grains of Parmegiano's grace: and what do you think will be the result of this chaotic prescription, such elemental strife? Excellence, perhaps, equal to one or all of the names that compose these ingredients? You are deceived, if you fancy that a multitude of dissimilar threads can compose a uniform texture—that dissemination of spots will make masses, or a little of many things produce a whole. If Nature stamped you with a character, you will either annihilate it by indiscriminate imitation of heterogeneous excellence, or debase it to mediocrity and add one to the ciphers of art. Yet such is the prescription of Agostino Carracci, and such in general must be the dictates of academics.

147. Antient art was the tyrant of Egypt, the mistress of Greece, and the servant of Rome.

148. The superiority of the Greeks seems not so much the result of climate and society, as of the simplicity of their end and the uniformity of their means . . . Apollonius and the sculptor of the small Hesperian Hercules in bronze are distinguished only by the degree of execution; whilst M. Angelo and Bernini had no one principle in common but that of making groups and figures.

149. Art among a religious race produces reliques; among a military one, trophies; among a commercial one, articles of trade.

150. Modern art, reared by superstition in Italy, taught to dance in France, plumped up to unwieldiness in Flanders, reduced to "chronicle small beer" in Holland, became a rich old woman by "suckling fools" in England.

151. Tintoretto attempted to fill the line of Michael Angelo with colour, without tracing its principle . . .

Andrea Mantegna was in Italy what Albert Duerer was at Nuremberg; Nature seems not to have existed in any shape of health in his time: though a servile copyist of the antique, he never once adverted from the monuments he copied to the originals that inspired them.

The forms of Albert Duerer are blasphemies on Nature, the thwarted growth of starveling labour and dry sterility—formed to inherit his hell of paradise. To extend the asperity of this verdict beyond the forms of Albert Duerer, would be equally unjust and ungrateful to the father of German art, on whom invention often flashed, whom melancholy marked for her own, whose influence even on Italian art was such that he produced a temporary revolution in the style of the Tuscan school.

194. The forms of virtue are erect, the forms of pleasure undulate: Minerva's drapery descends in long uninterrupted lines; a thousand amorous curves embrace the limbs of Flora.

196. Raffael's drapery is the assistant of character; in Michael Angelo it envelopes grandeur; it is in Rubens the ponderous robe of pomp.

216. The women of Michael Angelo are the sex.

217. The women of Raffaelle are either his own mistress, or mothers.

218. The women of Correggio are seraglio beauties.

219. The women of Titiano are the plump, fair, marrowy Venetian race.

220. The women of Parmegiano are coquettes.

WILLIAM BLAKE

TO RICHARD PHILLIPS

MYSTIC, SEER, and poet, as well as painter, William Blake is one of the most extraordinary characters in the history of art. He was neglected during his own lifetime, and long thereafter; when his art was rediscovered it was at first thought to be without precedent, and its affinities with older artists to be the product of a kind of mystical kinship. Blake himself knew differently, and he gave just appreciation not only to Michelangelo but to the other artists of his own period (especially Barry and Fuseli), in whom the struggle of romanticism against the weight of Reynolds' "classical" tradition and public demand helped to produce similar eccentricities of character.

Richard Phillips, a bookseller with whom Blake had a long acquaintance, was the editor of the *Monthly Magazine,* and it was as such that Blake wrote

to him. This letter was rediscovered by Swinburne and published in his
Critical Essay of 1868.

For another opinion on Fuseli, see Allston, p. 274.

IN DEFENSE OF FUSELI [*London*], *June, 1806*

My indignation was exceedingly moved at reading a criticism
in *Bell's Weekly Messenger* (25th May) on the picture of Count
Ugolino, by Mr. Fuseli, in the Royal Academy Exhibition; and
your Magazine being as extensive in its circulation as that Paper,
and as it also must from its nature be more permanent, I take the
advantageous opportunity to counteract the widely diffused malice
which has for many years, under the pretence of admiration of
the arts, been assiduously sown and planted among the English
public against true art, such as it existed in the days of Michael
Angelo and Raphael. Under pretence of fair criticism and candour,
the most wretched taste ever produced has been upheld for many,
very many years; but now, I say, now its end is come. Such an
artist as Fuseli is invulnerable, he needs not my defence; but I
should be ashamed not to set my hand and shoulder, and whole
strength, against those wretches who, under pretence of criticism,
use the dagger and the poison.

My criticism on this picture is as follows: Mr. Fuseli's Count
Ugolino is the father of sons of feeling and dignity, who would
not sit looking in their parent's face in the moment of his agony,
but would rather retire and die in secret, while they suffer him to
indulge his passionate and innocent grief, his innocent and vener-
able madness and insanity and fury, and whatever paltry, cold-
hearted critics cannot because they dare not, look upon. Fuseli's
Count Ugolino is a man of wonder and admiration, of resentment
against man and devil, and of humiliation before God; prayer
and parental affection fill the figure from head to foot. The child
in his arms, whether boy or girl signifies not (but the critic must be
a fool who has not read Dante, and who does not know a boy
from a girl), I say, the child is as beautifully drawn as it is col-
oured—in both, inimitable! and the effect of the whole is truly
sublime, on account of that very colouring which our critic calls
black and heavy. The German flute colour, which was used by

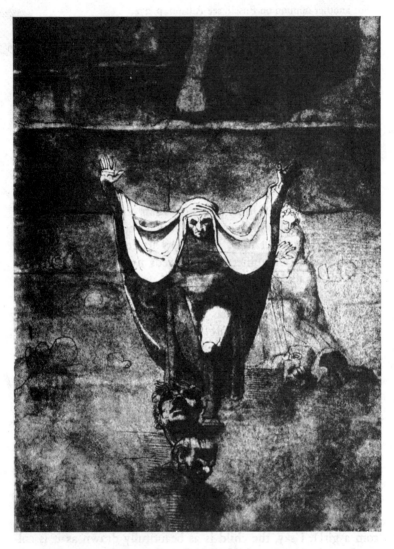

FUSELI: Sketch of Dante and Ugolino, 1774

the Flemings (they call it burnt bone), has possessed the eye of certain connoisseurs, that they cannot see appropriate colouring, and are blind to the gloom of a real terror.

The taste of English amateurs has been too much formed upon pictures imported from Flanders and Holland; consequently our countrymen are easily brow-beat on the subject of painting; and hence it is so common to hear a man say: "I am no judge of 'pictures.'" But O Englishmen! know that every man ought to be a judge of pictures, and every man is so who has not been connoisseured out of his senses. [Compare Hogarth, p. 180.]

corrupted by art historian jargon

ANNOTATIONS TO SIR JOSHUA REYNOLDS' *DISCOURSES*

As REYNOLDS annotated Du Fresnoy (see above, p. 185), so Blake annotated Reynolds. He wrote these annotations, as he wrote his poems about Reynolds, with a great deal of resentment for personal injuries. For though Reynolds had died in 1792, Blake held him responsible for the direction of English art and taste, and so for the neglect he himself suffered.

His point of view is that of the passionate "imaginative" artist opposed to Reynolds' "classicism." Where Reynolds wrote, "there is a rule, obtained out of general nature, to contradict which is to fall into deformity," Blake commented, "What is General Nature? Is there Such a Thing?" Where Reynolds said art could not express passions, Blake replied, "Passion and Expression is Beauty Itself."

SIR JOSHUA AND HIS GANG OF KNAVES [*Ca. 1808*]

Having spent the Vigour of my Youth & Genius under the Opression of Sir Joshua & his Gang of Cunning Hired Knaves Without Employment & as much as could possibly be Without Bread, the Reader must Expect to Read in all my Remarks on these Books Nothing but Indignation & Resentment. While Sir Joshua was rolling in Riches, Barry was Poor & Unemploy'd except by his own Energy; Mortimer was call'd a Madman, & only Portrait Painting applauded & rewarded by the Rich & Great. Reynolds & Gainsborough Blotted & Blurred one against the other

—& Divided all the English World between them. Fuseli, Indignant, almost hid himself. I am hid.

The Arts & Sciences are the Destruction of Tyrannies or Bad Governments. Why should A Good Government endeavour to Depress what is its Chief & only support?

The Foundation of Empire is Art & Science. Remove them or Degrade them, & the Empire is No More. Empire follows Art & Not Vice Versa as Englishmen suppose . . .

Reynolds' opinion was that Genius may be taught & that all Pretense to Inspiration is a Lie & a Deceit, to say the least of it. For if it is a Deceit, the whole Bible is Madness. This Opinion originates with the Greeks' calling the Muses Daughters of Memory.

BARRY

Who will Dare to Say that Polite Art is Encouraged or Either Wished or Tolerated in a Nation where The Society for the Encouragement of Art Suffer'd Barry to Give them his Labour for Nothing, A Society Composed of the Flower of the English Nobility & Gentry?—Suffering an Artist to Starve while he Supported Really what They, under Pretence of Encouraging, were Endeavouring to Depress.—Barry told me that while he Did that Work, he Lived on Bread & Apples.

O Society for Encouragement of Art! O King & Nobility of England! Where have you hid Fuseli's Milton? Is Satan troubled at his Exposure?

Invention depends Altogether upon Execution or Organization; as that is right or wrong so is the Invention perfect or imperfect. Whoever is set to Undermine the Execution of Art is set to destroy Art. Michael Angelo's Art depends on Michael Angelo's Execution Altogether.

Knowledge of Ideal Beauty is Not to be Acquired. It is Born with us. Innate Ideas are in Every Man, Born with him; they are truly Himself. The Man who says that we have No Innate Ideas must be a Fool & Knave, Having No Con-Science or Innate Science.

What does this mean, *"Would have been" one of the first Painters of his Age?* Albert Duerer *Is,* Not would have been. Besides, let them look at Gothic Figures & Gothic Buildings & not talk of Dark Ages or of any Age. Ages are all Equal. But Genius is Always Above The Age. [Compare Coypel, p. 162.]

RUBENS

To My Eye Rubens' Colouring is most Contemptible. His Shadows are of a Filthy Brown somewhat of the Colour of Excrement; these are fill'd with tints & masses of yellow & red. His lights are all the Colours of the Rainbow, laid on Indiscriminately & broken one into another. Altogether his Colouring is Contrary to The Colouring of Real Art & Science.

Opposed to Rubens' Colouring Sir Joshua has placed Poussin, but he ought to put All Men of Genius who ever Painted. Rubens & the Venetians are Opposite in every thing to True Art & they Meant to be so; they were hired for this Purpose.

What has reasoning to do with Art or Painting?

The difference between a bad Artist and a Good One Is: The Bad Artist Seems to copy a Great deal. The Good One Really does Copy a Great deal. *Copy the imagination ?*

To Generalize is to be an Idiot. To Particularize is Alone Distinction of Merit.

ON REYNOLDS' SELF-PORTRAIT

THE PARTICULAR object of Blake's ridicule in these poems is the self-portrait Reynolds sent to the Uffizi in 1775, in accordance with the rules, upon his election to the Florentine Academy. On art vs. reason, compare Ensor, p. 387

FLORENTINE INGRATITUDE

SIR JOSHUA sent his own Portrait to
The birth Place of Michael Angelo,
And in the hand of the simpering fool

He put a dirty paper scroll,
And on the paper, to be polite,
Did "Sketches by Michael Angelo" write.

The Florentines said " 'Tis a Dutch English bore,
Michael Angelo's Name writ on Rembrandt's door."
The Florentines call it an English Fetch,
For Michael Angelo did never sketch.
Every line of his has Meaning
And needs neither suckling or Weaning
'Tis the trading English Venetian cant
To speak Michael Angelo & Act Rembrandt.
It will set his Dutch friends all in a roar
To write "Mich. Ang." on Rembrandt's Door.

Giotto's Circle or Apelles' Line
Were no the Work of Sketches drunk with Wine,
Nor of the City Clark's warm hearted Fashion,
Nor of Sir Isaac Newton's Calculation,
Nor of the City Clark's Idle Facilities
Which sprang from Sir Isaac Newton's great Abilities

These Verses were written by a very Envious Man,
Who, whatever likeness he may have to Michael Angelo,
Never can have any to Sir Jehoshuan.

All Pictures that's Painted with Sense & with Thought
Are Painted by Madmen as sure as a Groat;
For the Greater the Fool in the Pencil more blest,
And when they are drunk they always paint best.
They never can Rafael it, Fuseli it, nor Blake it;
If they can't see an outline, pray how can they make it?
When Men will draw outlines begin you to jaw them;
Madmen see outlines & therefore they draw them.

REYNOLDS: Self-Portrait, 1775

PREFACE TO THE CATALOGUE OF HIS EXHIBITION OF 1809

FROM MAY to September, 1809, Blake held an exhibition of his works at the house of his brother James on Broad Street. He had advertised it with the motto "Fit audience find tho' few." The catalogue was included in the half-crown admission. This exhibition was Blake's "one great effort to secure recognition as a representative of imaginative art," and it ended in comparative failure.

1809

The eye that can prefer the Colouring of Titian and Rubens to that of Michael Angelo and Rafael, ought to be modest and to doubt its own powers. Connoisseurs talk as if Rafael and Michael Angelo had never seen the colouring of Titian or Correggio: They ought to know that Correggio was born two years before Michael Angelo, and Titian but four years after. Both Rafael and Michael Angelo knew the Venetian, and contemned and rejected all he did with the utmost disdain, as that which is fabricated for the purpose to destroy art.

Mr. B. appeals to the Public, from the judgment of those narrow blinking eyes, that have too long governed art in a dark corner. The eyes of stupid cunning never will be pleased with the work any more than with the look of self-devoting genius. The quarrel of the Florentine with the Venetian is not because he does not understand Drawing, but because he does not understand Colouring. How should he, he who does not know how to draw a hand or a foot, know how to colour it?

Colouring does not depend on where the Colours are put, but on where the lights and darks are put, and all depends on Form or Outline. On where that is put; where that is wrong, the Colouring never can be right; and it is always wrong in Titian and Correggio, Rubens and Rembrandt. Till we get rid of Titian and Correggio, Rubens and Rembrandt, We shall never equal Rafael and Albert Duerer, Michael Angelo, and Julio Romano.

JOHN CONSTABLE

TO THE REV. JOHN FISHER

JUST WHEN Constable met the Rev. John Fisher, nephew and chaplain of the Bishop of Salisbury and afterwards Archdeacon of Berkshire, we do not know, but he was the landscape artist's oldest and closest friend. Fisher performed the marriage ceremony for Constable at St. Martin's-in-the-Fields in 1816; in 1819, the year Constable was made an Associate of the Royal Academy, Fisher bought his chief exhibition picture, the well-known *White Horse* (now in the Frick Collection). Fisher died five years before his friend.

These letters were written at the time of Constable's first great success. In 1821 he had shown the *Hay Wain,* but he did not consent to sell it until 1824, when, taken to Paris, it formed the basis of Constable's fame on the Continent. In 1825 he was one of three English artists—the others were Lawrence and Wilkie—who were asked to show at the exhibition at Lille.

DECLINE OF ART IN ENGLAND

35 Charlotte Street, Fitzroy Square, [London], October 31, 1822

The art will go out; there will be no genuine painting in England in thirty years. This will be owing to *pictures* driven into the empty heads of the junior artists by their *owners,* the Governors of the Institution, etc. . . . In the early ages of the fine arts, the productions were more affecting and sublime, owing to the artists being without human exemplars, they were forced to have recourse to nature; in the later ages, of Raphael and Claude, the productions were more perfect (less uncouth), because the artists could then avail themselves or rather strengthen themselves by *experience* only of what was done to get at nature more securely, but they did not take them at their word, or as the chief objects of imitation. Could you but see the folly and ruin exhibited at the British Gallery, you would go mad. W. Van de Velde, and Gaspar Poussin, and Titian, are made to spawn millions of abortions; and for what are the sublime masters brought to pull aside the lack of their cash? only to serve the purpose of sale . . . It is a shocking scene of folly and venom headed by Lords, etc.

Charlotte Street, [London], December 6, [1822]

I have been to see David's picture (mess) of *The Crowning of Bonaparte and his Empress*. It is 35 ft. by 21. As a picture it does not possess anything of the Language of the art much less of the oratory of Rubens or Paul Veronese; it is below notice as a work of execution. But I still prefer it to West—only because it does not remind me of the *schools*. West is only hanging on by the tail of the Shirt of Carlo Maratti and the tag end of the Roman and Bolognese schools—the last of the Altorum Romanorum, and only the shadow of them. [Compare Morse's opinion of West, p. 278.]

FRESHNESS AND LIGHT

Charlotte Street, [London], November 17, [1824]

I regard all you say, but I do not enter into the notion of varying one's plans to keep the publick in good humour. Subject and

change of weather and effect will always afford variety. What if Van de Velde had quited his sea pieces, or Ruysdal his waterfalls, or Hobima his native woods. Would not the world have lost so many features in art? I know that you wish for no material alteration; but I have to combat from high quarters, even Lawrence, the seeming plausible argument that *subject* makes the picture. Perhaps you think an evening effect or a warm picture might do; perhaps it might start me some new admirers, but I should lose many old ones. Reynolds the Engraver tells me my "freshness" exceeds the *freshness* of any painter that ever lived; for to my Zest of *"Color"* I have added *"light."* Ruysdal and Hobima were *black*. Should any of this be true I must go on. [Compare Boudin, p. 301.]

TO C. R. LESLIE

THE AMERICAN painter Leslie had made Constable's acquaintance soon after his arrival in London in 1811 (to study with Allston and West); but their real friendship did not begin until six years later. Leslie's winning personality, and his great success with the type of humorous genre pictures which he adopted in 1818, made him a popular and powerful figure in the art world of the time. To Constable he was an admiring and helpful friend for twenty years, and the admiration was not altogether one-sided. Leslie's *Memoirs of the Life of John Constable* will always remain our chief source of knowledge of both the painter and the man.

TURNER AND CLAUDE

From my bed, Charlotte Street, January 14, [*1832*]

I remember most of Turner's early works; amongst them was one of singular intricacy and beauty; it was a canal with numerous boats making thousands of beautiful shapes, and I think the most complete work of genius I ever saw. The Claude I well know; grand and solemn, but cold, dull and heavy; a picture of his old age. Claude's exhilaration and light departed from him when he was between fifty and sixty, and he then became a professor of the "higher walks of art," and fell in a great degree into the manner of the painters around him; so difficult is it to be natural, so easy to be superior in our own opinion.

[*1833*]

I have laid by the *Cenotaph* for the present. I am determined not to harass *my mind* and health by scrambling over my canvas as I have too often done. Why should I? I have little to lose and *nothing* to gain. I ought to respect myself for my friends' sake who love me, and my children. It is time, at "fifty-six," to begin, at least, to *know oneself*,—and I do know what I am not . . . [He then speaks of the qualities at which he chiefly aimed in his pictures:] light—dews—breezes—bloom—and freshness; not one of which . . . has yet been perfected on the canvas of any painter in the world.

GAINSBOROUGH [*September, 1834*]

The Gainsborough was down when I was at Petworth; I placed it as it suited me, and I now—even now think of it with tears in my eyes. No feeling of landscape ever equaled it— With particulars he had nothing to do; his object was to deliver a fine sentiment, and he has fully accomplished it; mind, I use no comparisons in my delight in thinking on this lovely canvas; nothing injures one's mind more than such modes of reasoning; no fine things will bear, and want comparisons; every fine thing is unique.

ON LANDSCAPE PAINTING

CONSTABLE APPEARED as a lecturer six times: twice before the Literary and Scientific Society of Hampstead, and four times at the Royal Institution. These lectures were all on landscape painting, and Constable apparently wrote out none of them in full, talking freely from notes. The extracts below are drawn from notes for the lectures at the Royal Institution found among his papers, and published by Leslie.

London, May 26, 1836

I am here on behalf of my own profession, and I trust it is with no intrusive spirit that I now stand before you; but I am anxious that the world should be inclined to look to painters for information on painting. I hope to show that ours is a regularly taught profession; that it is *scientific* as well as *poetic;* that imagination alone

CONSTABLE: The Cenotaph, about 1836

never did, and never can, produce works that are to stand by a comparison with *realities;* and to show by tracing the connecting links in the history of landscape painting that no great painter was ever self-taught.

THE DECLINE OF ART *June 2, 1836*

Claude Lorraine is a painter who carried landscape to perfection, that is to *human perfection* . . . When we speak of the perfection of art, we must recollect what the materials are with which a painter contends with nature. For the light of the sun he has but patent yellow and white lead,—for the darkest shade umber or soot.

The deterioration of art has everywhere proceeded from similar causes, the imitation of preceding styles, with little reference to nature. In Italy [in the eighteenth century] the taste was for the beautiful, but the beautiful in the hands of the mannerists became insipid, and from that descended to the unmeaning . . . But the climax of absurdity to which art may be carried when led away from nature by fashion, may be best seen in the works of Boucher . . . His landscape, of which he evidently was fond, is pastoral; and such pastorality! the pastoral of the opera-house . . .

It is remarkable how nearly, in all things, opposite extremes are allied, and how they succeed each other. The style I have been describing was followed by that which sprang out of the Revolution, when David and his contemporaries exhibited their stern and heartless petrifactions of men and women,—with trees, rocks, tables, and chairs, all equally bound to the ground by a relentless outline, and destitute of chiaroscuro, the soul and medium of art.

PAINTING IS A SCIENCE *June 16, 1836*

It appears to me that pictures have been over-valued; held up by a blind admiration as ideal things, and almost as standards by which nature is to be judged rather than the reverse; and this false estimate has been sanctioned by the extravagant epithets that have been applied to painters, as "the divine," "the inspired," and so forth. Yet in reality, what are the most sublime productions of the pencil but selections of some of the forms of nature, and copies

of a few of her evanescent effects; and this is the result, not of in-spiration, but of long and patient study, under the direction of much good sense . . .

I have endeavored to draw a line between genuine art and man-nerism, but even the greatest painters have never been wholly un-tainted by manner.—Painting is a science, and should be pursued as an inquiry into the laws of nature. Why, then, may not land-scape be considered as a branch of natural philosophy, of which pictures are but experiments?

WASHINGTON ALLSTON

FUSELI AND THE SUBLIME

ALLSTON—HIMSELF a romantic painter, of a difficult and moody character, and the author of "visionary" pictures—quite naturally appreciated Fuseli's eccentric genius. As a youth he had admired Fuseli's *Ghost Scene from Hamlet* in the Charleston Library, and on going to London in 1801 he had met the artist and increased his respect for his work. Asked why he did not keep up Fuseli's acquaintance, Allston replied, "Because I could not stand his profanity."

See Fuseli's own aphorisms, and Blake on Fuseli, p. 259.

[Cambridgeport]

It was a few years ago the fashion with many criticising people (not critics, except those can be called so who make their own

274

ignorance the measure of excellence) to laugh at Fuseli. But Fuseli, even when most extravagant, was not a man to be laughed at; for his very extravagances (even when we felt them as such) had that in them which carried us along with them. All he asked of the spectator was but a particle of imagination, and his wildest freaks would then defy the reason. Only a true genius can do this. But he was far from being always extravagant; he was often sublime, and has left no equal in the visionary; his spectres and witches were born and died with him. As a critic on the art, I know no one so inspiring. Having, as you know, no gallery of the old masters to visit here, I often refresh my memory of them with some of the articles in "Pilkington's Dictionary," and he brings them before me in a way that no other man's words could, he often gives me a distinct apprehension of the style and color of some whose works I have never seen. I often read one or two of his articles before I go into my painting-room; they form indeed almost a regular course at breakfast.

ON COLOR AND IMAGINATION

THIS EXTRACT from the *Lectures on Art* describes Allston's reaction to the paintings he had seen much earlier in the Louvre, in November, 1803, when he went to Paris with Vanderlyn. He was then twenty-five years old and had come from eighteen months in London, where he had known West and Fuseli and had worked in the Royal Academy Schools.

[*Cambridgeport*]

Titian, Tintoret, and Paul Veronese absolutely enchanted me, for they took away all sense of subject. When I stood before *The Peter Martyr, The Miracle of the Slave,* and *The Marriage of Cana,* I thought of nothing but the gorgeous concert of colors, or rather of the indefinite forms (I cannot call them sensations) of pleasure with which they filled the imagination. It was the poetry of color which I felt, procreative in its nature, giving birth to a thousand things which the eye cannot see, and distinct from their cause. I did not, however, stop to analyse my feelings—perhaps at that time I could not have done it. I was content with my pleasure

without seeking the cause. But now I understand it, and think I understand why so many great colorists, especially Tintoret and Paul Veronese, gave so little heed to the ostensible stories of their compositions. In some of them, *The Marriage of Cana,* for instance, there is not the slightest clue given by which the spectator can guess at the subject. They addressed themselves, not to the senses merely, as some have supposed, but rather through them to that region (if I may so speak) of the imagination which is supposed to be under the exclusive dominion of music, to which, by similar excitement they caused to teem with visions that "lap the soul in Elysium." In other words they leave the subject to be made by the spectator, provided he possesses the imaginative faculty; otherwise they will have little more meaning to him than a calico counterpane.

ON STUDY IN EUROPE

ALLSTON'S FRIEND Henry Pickering had written asking advice for a friend of his—also an artist—who was about to leave for study in Europe. The friend was the young Thomas Cole, then twenty-six years old. Allston himself had now been back from London nearly ten years.

For Cole's own opinions, see p. 281.

Boston, November 23, 1827

As you have not mentioned for what part of Europe your friend intended to embark, I suppose you have left it to me to advise on this point. If so, I want to recommend his going first to England, where I would have him remain at least half the time he proposes to remain abroad. The present English school comprises a great body of excellent artists, and many eminent in every branch. At the head of your friend's department he will find Turner, who, take him all in all, has no superior of any age. Turner's *Liber Studiorum* would be a most useful work for him to possess. I venture to say this without having seen it, but coming from *him* I know it must be. There are many other admirable landscape painters whom I could also name, but your friend will hear of them before he has been long in London. I advise this disproportionate stay in England because I think it important that the *first*

TURNER: Junction of Severn and Wye, 1811

bias he receives should be a good one, inasmuch as on this not a little of the future tone of his mind will depend. This bias (in art as well as in manners) is taken from the living, whether we choose it or not; and to impart a true and refined one, together with sound, practical principles, I know no modern school of landscape equally capable with the English; in my judgment it has no living rival; many of them having attained to high excellence, and all knowing, even those who cannot reach it, in what it consists. On quitting England a short time may be spent in France, two or three months in Switzerland, and the remainder of the time in Italy . . .

I would therefore recommend it to your friend to place at the head of his list Claude, Titian, the two Poussins, Salvator Rosa, and Francesco Mola, together with Turner and the best of the modern artists, whom I cannot be supposed as meaning to exclude after what I have already said of the English school. I would have him study them all, and master their principles and examine their masses of light and shadow and color; observe what are the shapes of these, and how they recall and balance each other; and by what lines, whether of light, shadow, or color the eye travels through the pictures.

SAMUEL F. B. MORSE

AMERICAN ARTISTS IN ENGLAND

AFTER HE was graduated from Yale in 1810 Morse was a pupil of Washington Allston, whom he accompanied to London in the following year. There he also studied under Benjamin West, then President of the Royal Academy; and from there he wrote these letters to his parents. Morse returned to America in 1815, became first President of the National Academy of Design in 1826, and in 1839 gave up painting.

For American opinions on contemporary English and Continental art, see Allston, p. 274, and Cole, p. 281.

BENJAMIN WEST *London, March 25, 1812*

As a painter Mr. West can be accused of as few faults as any artist of ancient or modern times. In his studies he has been in-

defatigable, and the result of those studies is a perfect knowledge of the philosophy of his art. There is not a line or a touch in his pictures which he cannot account for on philosophical principles. They are not the productions of accident, but of study.

His principal excellence is considered composition, design, and elegant grouping; and his faults were said to be a hard and harsh outline and bad coloring. These faults he has of late in a great degree amended. His outline is softer and his coloring, in some pictures in which he has attempted truth of color, is not surpassed by any artist now living, and some have even said that Titian himself did not surpass it. [Compare Constable on West, p. 268.]

WASHINGTON ALLSTON *London, March 12, 1814*

It is really a pleasant consideration that [owing to Washington Allston] the palm of painting still rests in America, and is, in all probability, destined to remain with us. All we wish is a taste in the country and a little more wealth . . . In order to create a taste, however, pictures, first-rate pictures, must be introduced into the country, for taste is only acquired by a close study of the merits of the old masters. In Philadelphia I am happy to find they have successfully begun and I wish Americans would unite in the thing, throw aside local prejudices and give their support to one institution. Let it be in Philadelphia, since it is so happily begun there, and let every American feel a pride in supporting that institution; let it be a national not a city institution. Then might the arts be so encouraged that Americans might remain at home and not, as at present, be under the painful necessity of exiling themselves from their country and their friends.

THOMAS COLE

TO ROBERT GILMOR OF BALTIMORE

IN APRIL, 1825, Cole had moved from Philadelphia to New York and set up his studio in the attic of his father's house on Greenwich Street. At this time Cole was already completely absorbed by that interest in romantic landscape which lasted the rest of his life; in July he wrote to Mr. Gilmor

("an early friend and generous patron"): "It would give me great pleasure to see your collection of pictures. I have never yet seen a fine picture of any foreign landscape painter."

On the value of landscape without figures, compare Gainsborough, p. 190.

IN DEFENSE OF LANDSCAPE COMPOSITIONS

New York, December 25th, 1825

I received your letter with pleasure, and must thank you for your opinions respecting the introduction of figures, etc., into pictures . . .

I hope you will pardon me if I make a few remarks on what you have kindly said on compositions. I agree with you cordially about the introduction of water in landscapes: but I think there may be fine pictures without it. I really do not conceive that compositions are so liable to be failures as you suppose, and bring forward an example in Mr. ———. If I am not misinformed, the first pictures which have been produced, both Historical and Landscape, have been compositions. Raphael's pictures, and those of all the great painters, are something more than imitations of nature as they found it . . . If the imagination is shackled, and nothing is described but what we see, seldom will anything truly great be produced either in Painting or Poetry. You say Mr. ——— has failed in his compositions: perhaps the reason may be easily found—that he has painted from himself, instead of recurring to those scenes in nature which, formerly, he imitated with such great success. It follows that the less he studies from nature, the further he departs from it, and loses the beautiful impress, of which you speak with such justice and feeling. But a departure from nature is not a necessary consequence in the painting of compositions: on the contrary, the most lovely and perfect parts of nature may be brought together, and combined in a whole, that shall surpass in beauty and effect any picture painted from a single view. I believe with you, that it is of the greatest importance for a painter always to have his mind upon nature, as the star by which he is to steer to excellence in his art. He who would paint compositions, and not be false, must sit down amidst his sketches, make selections, and combine them, and so have nature for every

object that he paints. This is what I should endeavour to do: and I think you will agree with me, that such a course embraces all the advantage obtained in painting actual views, without the objections.

NOTES FROM HIS JOURNAL

THE FIRST of these entries was written in Paris, where Cole thought it worth while to spend only some ten days! (See Allston's letter of advice, p. 276.) "In consequence of an exhibition of modern works," Cole did not see the old masters. From the entry of 1838 it is not difficult to understand why Cole considered landscape painting superior to all other kinds; for him it *was* "historical" painting.

On the importance of landscape to the romantics, see Runge, p. 247.

FRENCH ROMANTICS *Paris, May, 1831*

I visited the Louvre, but was painfully disappointed at finding that the works of the Old Masters were covered with the production of modern painters. Although I had been informed that the present French artists were low in merit, I did not expect to find them, with little exception, so totally devoid of it. I was disgusted in the beginning with their subjects. Battle, Murder and Death, Venuses and Psyches, the bloody and voluptuous, are the things in which they seem to delight: and these are portrayed in a cold, hard, and often tawdry style, with an almost universal deficiency of chiaroscuro; the whole artificial, labored and theatrical. This is alike applicable to portrait and landscape. In landscape they are poor, in portrait much inferior to the English, and in history cold and affected. In design they are much superior to the English, but in expression false.

Scheffer's pictures are an exception. He has real feeling. A Tempest by him is admirable. In several others he approaches fine color; and in expression and composition he is truly fine.

A ROMANTIC LANDSCAPE *[Catskill, May 22, 1838]*

I am now engaged in painting a picture representing a ruined and solitary tower, standing on a craggy promontory, laved by the unruffled ocean. Rocky islets rise from the sea at various dis-

tances: the line of the horizon is unbroken but by the tower. The spectator is supposed to be looking east just after sunset: the moon is ascending from the ocean like a silvery vapor; around her are lofty clouds still lighted by the sun; and all are reflected in the tranquil waters. On the summit of the cliff around the ruin, and upon the grassy steeps below are sheep and goats, and in the foreground, seated upon some fragments of the ruin, is a lonely shepherd. He appears to be gazing intently at a distant vessel, that lies becalmed on the deep. Sea-birds are flying round the tower, and far off in the dimness below. This picture will not be painted in the most finished style. Still I think it will be poetic. There is a stillness, a loneliness about it that may reach the imagination. The mellow, subdued tone of twilight, the silvery lustre of the moon, the glassy ocean—the mirror of the scene—the ivy-mantled ruin, the distant ship, the solitary shepherd-boy, apparently in dreams of distant lands, and forgetful of approaching night, and of his flocks, yet straggling among the rocks, all these combined must surely, if executed with ordinary skill, produce, in a mind capable of feeling, a pleasing, poetic effect, a sentiment of tranquillity and solitude. This picture will probably remain on my hands. It is not the kind of work to sell. It would appear empty and vague to the multitude. Those who purchase pictures are, many of them, like those who purchase merchandise: they want *quantity,* material —something to show, something palpable—*things* not *thoughts.*

THE DAGUERREOTYPE

I suppose you have read a great deal about the Daguerreotype. If you believe everything the newspapers say (which, by-the-by, would require an enormous bump of marvelousness), you would be led to suppose that the poor craft of painting was knocked in the head by this new machinery for making Nature take her own likeness, and we nothing to do but give up the ghost . . . But I was saying something about Daguerreotype matters—this is the conclusion: that the art of painting is a creative as well as an imitative art, and is in no danger of being superseded by any mechanical contrivance. "What fine chisel did ever yet cut breath?" [Compare Delacroix, p. 233, on photography.]

COLE: The Tower, 1838

HORATIO GREENOUGH

FROM HIS LECTURES ON ART

IN 1851 Horatio Greenough returned to New York from a long residence in Florence. He had first gone abroad in 1825, when he was only twenty, the first American sculptor to study in Rome, and had since practiced his neo-classic art in Italy, with periodic visits to the United States. This trip in 1851 was his last; in 1852 he fell ill, and during the last two months of his life, when he could not work in the studio, he began a series of lectures on art. Two were written and delivered; the rest remained in the form of notes. Besides the two from which we quote, their subjects included "Aesthetics at Washington," "American Architecture," "Burke on the Beautiful," and "An Artist's Creed."

Compare Greenough's ideas on the artist and his schooling with those of Flandrin, p. 242, Géricault, p. 223, and Bouguereau, p. 287.

AGAINST ACADEMIC EDUCATION [*Newport, 1852*]

It seems clear that we are destined to have a school of art. It becomes a matter of importance to decide how the youth who devote themselves to these studies are to acquire the rudiments of imitation, and what influences are to be made to act upon them. This question seemed, at one time, to have been decided. The friends of art in America looked to Europe for an example; and with the natural assumption that experience had made the old world wise, in what relates to the fine arts, determined upon forming Academies, as the more refined nations of the continent have ended by doing. We might as well have proposed a national church establishment . . .

If Europe must furnish a model of artistical tuition, let us go at once to the records of the great age of art in Italy, and we shall there learn that Michael Angelo and Raphael, and their teachers also, were formed without any of the cumbrous machinery and mill-horse discipline of a modern Academy. They were instructed, it is true; they were apprenticed to painters. Instead of passively listening to an experienced proficient merely, they discussed with their fellow students the merits of different works,

the advantages of rival methods, the choice between contradictory authorities. They formed one another. Sympathy warmed them, opposition strengthened, and emulation spurred them on. In these latter days, classes of boys toil through the rudiments under the eye of men who are themselves aspirants for the public favor, and who, deriving no benefit, as masters from their apprentices, from the proficiency of the lads look upon every clever graduate as a stumbling-block in their own way. Hence their system of stupefying discipline, their tying down the pupil to mere manual execution, their silence in regard to principles, their cold reception of all attempts to invent.

EDUCATION IN A DEMOCRACY

We have listened to oft-repeated expression of regret "that from the constitution of our society, and the nature of our institutions, no influences can be brought to bear upon art with the vivifying power of court patronage." We fully and firmly believe that these institutions are more favorable to a natural, healthful growth of art than any hot-bed culture whatever. We cannot—(as did Napoleon)—make, by a few imperial edicts, an army of battle painters, a hierarchy of drum-and-fife glorifiers. Nor can we, in the lifetime of an individual, so stimulate this branch of culture, so unduly and disproportionately endow it, as to make a Walhalla start from a republican soil. The monuments, the pictures, the statues of the republic will represent what the people love and wish for, —not what they can be made to accept, not how much taxation they will bear. We hope, by such slow growth, to avoid the reaction resulting from a morbid development.

BEAUTY AS FUNCTION

I have spoken of embellishment as false beauty. I will briefly develop this view of embellishment. Man is an ideal being; standing, himself inchoate and incomplete, amid the concrete manifestations of Nature, his first observation recognizes defect; his first action is an effort to complete his being. Not gifted, as the brutes, with an instinctive sense of completeness, he stands alone as capable of conative action. He studies himself; he disciplines himself.

Now, his best efforts at organization falling short of the need that is in his heart, and therefore infinite, he has sought to compensate for the defect in his plan by a charm of execution. Tasting sensuously the effect of a rhythm and harmony in God's world, beyond any adaptation of means to ends that his reason could measure and approve, he has sought to perfect his own approximation to the essential by crowning it with a wreath of measured and musical, yet nondemonstrable, adjunct . . . I understand, therefore, by embellishment, The Instinctive Effort Of Infant Civilization To Disguise Its Incompleteness, Even As God's Completeness Is To Infant Science Disguised.

. . . The normal development of beauty is through action to completeness. The invariable development of embellishment and decoration is more embellishment and more decoration. The reductio ad absurdum is palpable enough at last; but where was the first downward step? I maintain that the first downward step was the introduction of the first inorganic, nonfunctional element, whether of shape or color. If I be told that such a system as mine would produce nakedness, I accept the omen. In nakedness I behold the majesty of the essential instead of the trappings of pretension. The agendum is not diminished, it is infinitely extended. We shall have grasped with tiny hands the standard of Christ, and borne it into the academy, when we shall call upon the architect, and sculptor, and painter to seek to be perfect even as our Father is perfect. [Compare Henri, p. 398.]

WILLIAM BOUGUEREAU

ART AND TRADITION

DURING THE last quarter of the nineteenth century Bouguereau and Cabanel were the symbols of official art in France. (Cézanne always spoke of the "Salon of Bouguereau.") Bouguereau exhibited at the official Salon for over fifty years, and he taught at the *Beaux-Arts* for more than twenty-five. It was therefore natural that, in addressing the annual meeting of the five *Académies* which constitute the *Institut de France,* he should have protested against any reform in the curriculum.

On the usefulness of academic discipline, compare the contrasting opinions of Flandrin, p. 242, and Greenough, p. 284; on the relation of art and nature, Bingham, p. 343, and Bellows, p. 461.

IN DEFENSE OF THE ÉCOLE DES BEAUX-ARTS

Paris, October 24, 1885

The first organization of the Institute was distinguished by a prudent separation of its studies into different "academies," and by further subdivision of each academy; a method wise in its conception, happy in its results, and one which tended more and more to accentuate itself. So it was not without regret that I saw the *École des Beaux-Arts* react against this necessity of our time; it wants to free itself from what some consider the narrow prejudices of our forerunners, and, finding that the initial difficulties of studying painting, sculpture, or architecture alone are not enough, it demands of its students proof of their worth in the three arts at once, and further complicates the competition by an examination in history. I fear the mental fatigue that this innovation will cause, and I am seizing this occasion to speak my mind.

I hold that theory should not enter into an artist's elementary

education in so tyrannical a fashion. In the impressionable years of youth it is the eye and the hand that should be exercised. When our pupils know how to draw and to make use of the material processes of their art, when they have chosen the style towards which their taste and talent directs them, they will feel the need of making those special studies which their work demands, and they will make them much more profitably.

One can always acquire the additional knowledge and information that go into the production of a work of art, but—and I insist on this point—no will, no perseverance, no obstinacy during one's later years, can ever make good a lack of practice. And is there any anguish like that of the artist who feels the realization of his dream compromised by the impotence of his execution?

ART AND TRUTH [*1899*]

There is no such thing as symbolic art, social art, religious art, or monumental art; there is only the art of the representation of nature by an artist whose sole aim is to express its truth. Look at the *Venus* of Vienna. Who could doubt that it was done by a great artist? It is enough to see with what love he cut the flesh, with what care he has noted the pressure of the heel on the right thigh and the adorable dimple that it makes. [Compare Rodin, p. 325.]

I am very eclectic, as you see; I accept and respect all schools of painting which have as their basis the sincere study of nature, the search for the true and the beautiful. As for the mystics, the impressionists, the pointillists, etc., I don't see the way they see. That is my only reason for not liking them.

THÉODORE ROUSSEAU

TO CHARLES BLANC

IN 1859, Charles Blanc, progressive critic, art historian, and a director of the *Administration des Beaux-Arts* under Louis Napoleon, founded the *Gazette des Beaux-Arts*. At this time Rousseau had been painting landscapes

for some thirty years, and he and the other painters of the Barbizon school ("the men of 1830"), though recognized professionally, were not yet popular. This letter was written in answer to one of the questionnaires which, as editor, Blanc was in the habit of sending out to important artists and critics.

For other opinions on Ingres and Delacroix, see Redon, p. 359, and Sickert, p. 395.

INGRES VS. DELACROIX [1859]

You persecute me by letter for a parallel between Ingres and Delacroix, and you ask my opinion. It will be that of a landscapist, and no more, and here is the way I see it: When a fine animal dies at the Zoo, the best one can do is to stuff him; he still means something. The elephant at the museum of Natural History is, it seems to me, respectable enough.

With the works of Ingres, one could create a museum analogous to the Museum of Natural History; everything there is respectable. Endowed with the considerable talent that must be granted him and which no one ever questions, one cannot help doing good work; but great work is something different. The gift of personal creation seems to me to have been denied Ingres completely. Still, it is what is important, and if I must tell you the truth, I prefer him who splashes me a little in hitting the water to him who puts a cover on his cistern for fear that the least breath of air will empty it.

Ingres, for me, represents in a feeble degree no more than the beautiful art we have lost.

Need I tell you that I prefer Delacroix with his exaggerations, his mistakes, his visible failures, because he belongs only to himself, because he represents the spirit, the form, the language of his time. He is too sickly and nervous, perhaps, because his art suffers with us, and because in his exaggerated complaints and his resounding triumphs there is always the breath of life, his cry, his suffering, and ours.

We are no longer in the age of the Olympians such as Raphael, Veronese, and Rubens, and the art of Delacroix is as powerful as the voice of Dante's Inferno, the Inferno of our century.

That is why I prefer Delacroix to Ingres, and I am talking here only of the moral aspect of the man, and not of his technique.

. . . Do you understand now that all that my intelligence rejects is in direct ratio to all that my heart has desired, and that the spectacle of the intolerance and the crimes of humanity is as powerful a force in the exercise of my art as the funds of serene contemplation that I have been able to gather together since childhood?

Believe me, everything comes from the universal; one must partake in order to give life. Whatever interest the accidents of time, religion, custom, or history may have given one in the representation of the particular, nothing is worth the understanding of the universal agency of air, the model of the infinite. Nothing can prevent a mileage marker, around which air seems to circulate, from being a grander conception, in a museum, than a storytelling work which lacks this spirit. All the particular, special majesty of a portrait of Louis XIV by LeBrun or Rigaud will be conquered by the humility of a tuft of grass clearly lit by a ray of sun. Good God, what endless talk to say that in art it is better to be honest than clever! But the times belong to the spiteful, and we talk to the mute and the deaf.

JEAN-FRANÇOIS MILLET

TO THÉOPHILE THORÉ

THE REALISTIC, genre character of Millet's peasant pictures, with their symbolic overtones, was naturally sympathetic to the critic Théophile Thoré, who was exiled by Napoleon III for Republican activity. He is best known for his rediscovery of the artistic personality of Vermeer van Delft.

[*1860?*]

In the *Woman Going to Draw Water* I tried to show that she was not a water-carrier, or even a servant, but a woman going to draw water for the house, for soup, for her husband and children; that she should not seem to be carrying any greater or less weight

than the buckets fill; that under the sort of grimace which the weight on her shoulders causes, and the closing of the eyes at the sunlight, one should see a kind of homely goodness. I have avoided (as I always do with horror) anything that might verge on the sentimental. I wanted her to do her work good-naturedly and simply—as if it were a part of her daily labor, the habit of her life. I wanted to show the coolness of the well, and its antique form is meant to suggest that many before her had come there to draw water.

I try not to have things look as if chance had brought them together, but as if they had a necessary bond between them. I want the people I represent to look as if they belonged to their station, and as if their imaginations could not conceive of their ever being anything else. People and things should always be there with an object. I want to put strongly and completely all that is necessary, for I think things weakly said might as well not be said at all, for they are, as it were, deflowered and spoiled—but I profess the greatest horror for uselessness (however brilliant) and filling up. These things can only weaken a picture by distracting the attention towards secondary things.

THE MAN WITH THE HOE

In writing to Alfred Sensier, friend and biographer of both Rousseau and himself, Millet was answering objections similar to those met by Courbet, see p. 296, and Boudin, see p. 300. This picture was the inspiration for Edwin Markham's poem.

[1863?]

The gossip about my *Man With a Hoe* seems to me all very strange, and I am obliged to you for letting me know it, as it furnishes me with another opportunity to wonder at the ideas which people attribute to me. In what club have my critics ever met me? Socialist? Why, I really might answer, like the Auvergnat *commissionaire:* "They say I'm a Saint-Simonist. It isn't true. I don't know what a 'Saint-Simonist' is."

Is it impossible to admit that one can have some sort of idea

in seeing a man devoted to gaining his bread by the sweat of his brow? Some tell me that I deny the charms of the country. I find much more than charms—I find infinite glories. I see as well as they do the little flowers of which Christ said that Solomon, in all his glory, was not arrayed like one of these. I see the halos of dandelions, and the sun, also, which spreads out beyond the world its glory in the clouds. But I see as well, in the plain, the steaming horses at work, and in a rocky place a man, all worn out, whose *"han!"* has been heard since morning, and who tries to straighten himself a moment and breathe. The drama is surrounded by beauty.

It is not my invention. This "cry of the ground" was heard long ago. My critics are men of taste and education, but I cannot put myself in their shoes, and as I have never seen anything but fields since I was born, I try to say as best I can what I saw and felt when I was at work. Those who want to do better have, I'm sure, full chance.

GUSTAVE COURBET

PREFACE TO THE CATALOGUE OF THE
EXHIBITION AT THE PAVILION OF REALISM,
THE WORLD'S FAIR, PARIS, 1855

BECAUSE HE had won a medal at the liberal Salon of 1849 Courbet was luckily exempt from submitting his work to all French Salon juries, otherwise his realistic subjects would have met much opposition. This privilege did not apply to the International Exhibition of 1855. When the special international jury excluded Courbet's important paintings, he withdrew them all and with characteristic self-assurance set up his own one-man show outside the gates of the World's Fair. (Here Delacroix admired his pictures; see above, p. 236.) The experiment was successful, and he repeated it at the 1867 Exposition, when Manet did the same.

The title of "realist" has been imposed upon me, as the men of 1830 had imposed upon them the title of "romantics." Titles have never given a just idea of things; were it otherwise, the work would be superfluous. Without trying to clear up the degree of correctness of a qualification which no one, one must hope, will be asked to understand exactly, I will limit myself to a few words of explanation to cut short any misunderstandings.

I have studied the art of the masters and the art of the moderns, avoiding any preconceived system and without prejudice. I have no more wanted to imitate the former than to copy the latter; nor have I thought of achieving the idle aim of *art for art's sake*. No! I have simply wanted to draw from a thorough knowledge of tradition the reasoned and free sense of my own individuality.

To know in order to do: such has been my thought. To be able to translate the customs, ideas, and appearance of my time as I see them—in a word, to create a living art—this has been my aim.

OPEN LETTER TO A GROUP OF PROSPECTIVE STUDENTS

THIS IS an excellent exposition of what Courbet meant by "realism," with its combination of objectivity and individual interpretation. Having always emphasized the fact that he had never had a master, Courbet could hardly become one himself. On abstract art, see Picasso, p. 420.

PAINTING CANNOT BE TAUGHT *Paris, 1861*

You wish to open a painting studio, where, unhindered, you can continue your artistic education, and you have been so kind as to offer to put it under my direction.

Before giving you any answer, we must reach an understanding concerning this word "direction." I cannot lay myself open to admitting any relationship of teacher and pupil between us . . . I, who believe that every artist must be his own master, cannot think of becoming a teacher.

I cannot teach my art, nor the art of any school, since I deny that art can be taught, or, in other words, maintain that art is completely individual, and that the talent of each artist is but the result

of his own inspiration and his own study of past tradition. I add that, in my opinion, art or talent, for an artist, is merely a means of applying his personal faculties to the ideas and the things of the period in which he lives.

In particular, the art of painting can consist only in the representation of objects visible and tangible to the painter. An epoch can be reproduced only by its own artists. I mean by the artists who have lived in it. I hold that the artists of one century are fundamentally incompetent to represent the things of a past or future century—in other words, to paint the past or the future.

It is in this sense that I deny the existence of an historical art applied to the past. Historical art is by its very nature contemporary.

PAINTING IS REAL, CONCRETE

I hold also that painting is an essentially *concrete* art, and can consist only of the representation of things both *real* and *existing*. It is an altogether physical language, which, for its words, makes use of all visible objects. An *abstract* object, invisible or nonexistent, does not belong to the domain of painting.

Imagination in art consists in finding the most complete expression for an existing thing, but never in imagining or creating this object itself.

The beautiful is in nature, and it is encountered under the most diverse forms of reality. Once it is found it belongs to art, or rather to the artist who discovers it. Once the beautiful is real and visible it contains its own artistic expression. And the artist does not have the right to enlarge upon this expression. He trifles with it at the risk of denaturing, and so weakening, it. Beauty as given by nature is superior to all the conventions of the artist.

Beauty, like truth, is relative to the time when one lives and to the individual who can grasp it. The expression of beauty is in direct ratio to the power of conception the artist has acquired . . .

There can be no schools; there are only painters.

TO M. MAURICE RICHARD, MINISTER
OF FINE ARTS

AFTER THE elections of 1869 the regime of Napoleon III tried to broaden the base of its support. In spite of the fact that Courbet had a police dossier, the Minister of Fine Arts seized the opportunity to bestow upon him the ribbon of the Legion of Honor. This letter was Courbet's reply.

[*1870*]

At the house of my friend Jules Dupré, at l'Isle Adam, I learned of a decree naming me chevalier of the Legion of Honor. This decree, which my well-known opinions on artistic rewards and titles of nobility should have spared me, has been issued without my consent, and you, Your Excellency, thought it your duty to take the initiative . . .

Such methods do you honor, Your Excellency, but allow me to say that they can change neither my attitude nor my decision.

My Republican convictions make me unable to accept a distinction which belongs in essence to a monarchical order. My principles reject this decoration of the Legion of Honor, which, in my absence, you have accorded me.

At no time, under no circumstances, and for no reason would I have accepted it. Much less would I do so today, when betrayals multiply on every side, and the human conscience is saddened by so many selfish recantations. Honor does not lie in a title or a ribbon; it lies in actions and the motives for actions. Respect for oneself and one's ideas is its largest portion. I honor myself by remaining faithful to my lifelong principles; if I betrayed them, I should desert honor to wear its mark.

My feelings as an artist are no less opposed to accepting a reward accorded me by the state. The state is incompetent in matters of art. When it undertakes to reward, it usurps the public taste. Its intervention is altogether demoralizing, disastrous to the artist, whom it deceives concerning his own merit; disastrous to art, which it encloses within official rules, and condemns to the most sterile mediocrity; it would be wisdom for it to abstain. The day the state leaves us free, it will have done its duty towards us.

Permit me then, Your Excellency, to decline the honor you had thought to give me. I am fifty years old, and have always lived free; let me finish my life still free. When I am dead they will have to say of me: He never belonged to any school, to any church, to any institution, to any academy, above all not to any regime, unless it were the regime of liberty.

EUGÈNE FROMENTIN

THE ARTIST AND HIS PUBLIC

TODAY FROMENTIN is better known as a writer and critic-historian than as an artist. But he considered himself chiefly a painter: *Dominique* (published in 1862, but telling a story of twenty years earlier) was written as an account of his youthful romanticism, from which he took refuge in painting; and his famous book of criticism—*Masters of Past Time* (1875)—describes Dutch and Flemish art from the point of view of his own documentary and genre interest as a painter.

These paragraphs are drawn from an address prepared for an audience of artists and amateurs, perhaps the Academy itself, but never delivered. They were written shortly after the exaggerated Philistinism of the regular Salon jury had forced the famous *Salon des Refusés* of 1863 upon a reluctant government. In reading this extremely polite description it is well to bear in mind that Fromentin was himself never a radical artist.

ALL IS SERENE . . . YET DOUBTS PERSIST *Paris, 1864*

The fact that I would like at the moment to establish is this: It appears that an approximately satisfactory equilibrium exists between the artist and his public. From the material point of view, their interests agree; the artists' popularity spreads, propagates, and grows, in the same proportion as their need to produce; both sides have agreed to raise prices; transactions are carried out under such novel conditions that the buyer and the seller are astonished, and it is noteworthy that everyone's self-respect seems to be satisfied. From the spiritual and intellectual point of view, there is no conflict that I know of between the taste of those who appreciate and the imagination of those who create. A reciprocal influence, a

movement of mutual reaction; the common atmosphere that we all breathe, impregnated with the same ideas; the currents of fashion that guide us; and above all a general need to get along with, to understand, and to please one another . . . One can thus say with certainty that our time sincerely loves the arts, and in particular, painting . . .

And yet, gentlemen, do you not find that in this happy state of prosperity, understanding, and fusion of which I have just given you the picture, there is something fundamentally not altogether right?

Don't you see that there is room here for certain doubts? I shall try to describe these doubts.

We complain, we blame, we regret. We should like something better and would ask for something more. We say that good works are rare, and the great no longer exist; that talent grows less in proportion as it multiplies; that as their line increases the blood of strong schools runs thin; that character is frivolous and conscience less austere; that originality is hidden by custom. We are tired of the mediocre, we should prefer the great. And then the growing tide disturbs and dismays; we say that curiosity has its limits, that the most sincere passion for the works of the mind needs a breathing space, and that this periodic flood of six or seven thousand pictures converging every ten months upon the same place and speading over the same public will end by submerging the taste for the beautiful and drowning it in an inevitable weariness.

GOVERNMENT AND LAISSEZ FAIRE

As to the question of whether the government is charged with the duty of directly influencing taste, and the theories of administering souls with which no government I know of ever considered itself invested—I believe I am right in saying that every man of power to whom fate granted a period of enlightenment, from Pericles to our own day, acted in the same spirit: that of *laissez faire,* and of looking upon the harvest of great men who made up the richness of their time as a spontaneous favor from their country

and their age. Their principle was ours: to prepare the ground and to wait. The rest is no one's business, apart from Him who chooses where and when He will cast the mold of a great artist.

EUGÈNE BOUDIN

THE BOURGEOIS IS A PROPER SUBJECT FOR ART

THIS LETTER was written to Boudin's friend, Monsieur Martin, a fellow-townsman of Le Havre, and a member of its art commission. As an immediate predecessor of the impressionists, Boudin defends not only himself but other progressive artists as well: Courbet was at this date already well known, but Monet (whom Boudin had inspired and advised) was just beginning.

See Monet's defense of Manet, p. 311, and, on the subject-matter proper to art, Boulin's contemporaries, Millet, p. 293, and Coubert, p. 296.

September 3, 1868

Your letter arrived just at the moment when I was showing Ribot, Bureau, and another person my little studies of fashionable beach resorts. These gentlemen congratulated me precisely for having dared to put into paint the things and people of our time, and for having found a way of getting the gentlemen in an overcoat and his lady in a raincoat accepted—thanks to the sauce and the seasoning.

This attempt is not new, however, since the Italians and Flemish simply painted the people of their own period, either in interiors or in vast architectural ensembles; it is now making its way, and a number of young painters, chief among whom I would put Monet, find that it is a subject that until now has been too much neglected. The peasants have their painters of predilection: Millet, Jacque, Breton, and this is good; these men carry on sincere and serious work, they partake of the work of the Creator and help Him to make Himself manifest in a manner fruitful for man. This is good; but between ourselves these middle-class men and women, walking on the pier towards the setting sun, have they no right to be fixed on canvas, *to be brought to light?* Between

ourselves, these people coming from their businesses and their offices are often resting after hard work. If there are some parasites among them, aren't there also those who fulfill their tasks? This is a serious, irrefutable argument.

I should not like, under whatever pretext, to condemn myself to paint clothes, but isn't it pitiful to see serious men like Isabey, Meissonier, and so many others, collecting carnival costumes and, under pretext of picturesqueness, dressing up models who most of the time don't know what to do under all their borrowed finery?

The Poitevin [Meissonier] has made his fortune with an old felt hat with a feather and a pair of musketeer's boots that he has painted under all possible pretexts. I should very much like to have one of these gentlemen explain to me the interest such subjects will have in the future, and whether the picturesque character of these canvases will make any impression on our grandchildren. We must not disguise the fact that a painting often owes its title to preservation to its technical perfection. Why else would one hang a Chardin pitcher in a museum? If your commission [of Le Havre] sees things in this light, let it lose no time in buying a Monet, a Ribot, or a Courbet: but it must give up one or the other. For the Lord knows there is no comparison.

I have permitted myself this little digression, my friend, because your good friendship leads you astray: you are worried about me, and you think that I should retrace my steps and make some concessions to the taste of a certain public. [Compare Couture, p. 244.] I have been unhappy long enough, and consequently uncertain enough, to have explored, and sought, and reflected; I have sounded out others enough to know in what their stock consists, and to know what my own is worth. Well, my good friend, I still persist in following my own little road, however untrod it may be, wishing only to walk with a surer and a firmer step, smoothing it a bit if need be. One can find art in anything if one is gifted. And everyone who uses a brush or a pen of necessity thinks himself gifted. It is up to the public to judge, and up to the artist to go forward, and to embrace nature, whether by painting cabbages and cheeses or supernatural and divine beings such as our friend Lemarcais paints so badly.

So I cannot accept your opinion on my bad choice of subjects: on the contrary, I am acquiring more and more taste for it, hoping to broaden this still too narrow genre.

ÉDOUARD MANET

TO THEODORE FANTIN-LATOUR

AFTER THE Salon of 1865, where ridicule was heaped upon his *Olympia* (see Monet's letter below, p. 311) and the *Christ Mocked by the Soldiers* (now in the Chicago Art Institute), Manet went off to Spain to look at the country and the painters who had so much attracted him. Thereafter he had none of his former interest in picturesque Spanish character, but his admiration for Velasquez increased, as recorded here. Fantin-Latour was the painter of *Homage to Delacroix* and *Homage to Manet*.

Madrid, Sunday morning, [*1865*]

How I miss you here, and what a joy it would have been for you to see Velasquez, who, in himself, is worth the trip. The painters of all schools, who surround him here in the museum at Madrid and who are very well represented, all seem like bluffers. He is the painter of painters. He has not surprised me, but he has enchanted me. The full-length portrait in the Louvre is not by him. Only the *Infante* cannot be questioned. There is here an enormous picture, filled with little figures like those in the picture in the Louvre called the *Cavaliers,* but figures of men and women, perhaps better, and above all completely free of restoration. The background, the landscape is by a pupil of Velasquez.

The most astonishing piece of this whole splendid *œuvre,* and perhaps the most astonishing piece of painting that has ever been done, is the picture shown in the catalogue: the portrait of a celebrated actor of the time of Philip IV. The background disappears; air surrounds the man, dressed all in black, and alive. And the *Spinners,* the fine portrait of *Alonso Cano, Las Meninas,* an extraordinary picture too! The philosophers, astonishing works. All the dwarfs; particularly one, seated full-face, with his hands on his hips: a choice picture for a real connoisseur. His magnificent portraits; one would have to enumerate them all, they are all masterpieces. A portrait of *Charles V* by Titian, which has a great reputation that must be deserved and which I would certainly have thought good anywhere else, here seems to me to be made of wood.

And Goya! The most curious master—after the one he imitated too much—in the most servile sense of imitation. But with a great verve nevertheless. There are two fine equestrian portraits by him in the museum; in the manner of Velasquez, but still a good deal inferior. What I have seen of him up to now has not greatly pleased me. In the next few days I am to see a magnificent collection at the Duke of Ossuna's.

TO ANTONIN PROUST

ANTONIN PROUST, fellow-student with Manet in the atelier of Couture, was Minister of Fine Arts in the cabinet of Gambetta. In 1882, the year before Manet's death, when he was already sick, Proust bestowed on him the ribbon of the Legion of Honor.

PAINTING THE SINGLE FIGURE [*1880*]

For three weeks now, your portrait has been at the Salon, badly hung on a cut panel near a door, and criticized still worse. But it is my fate to be vilified, and I accept it philosophically. Nevertheless, my dear friend, you would hardly believe how difficult it is to place a figure alone on a canvas, and to concentrate all the interest on this single and unique figure and still keep it living and real. To paint two figures which get their interest from the duality of the two personalities is child's play in comparison. Ah, the portrait with a hat on, which, one said, was all in blue! Well, I'm still waiting for it; I'll never see it. But after my time they will recognize that I saw and thought with exactness. I remember as if it were yesterday the quick and summary manner in which I treated the glove in the ungloved hand. And when at that instant you said to me, "Please, not a line more," I felt that we were in such perfect accord that I could not resist the impulse to embrace you. Ah, if only later someone does not have the idea of fastening this portrait on a public collection! I have always been horrified by the mania of piling up works of art without leaving space between the frames, the way the latest novelties are put on the shelves of a department store. Well, time will tell. We are in the hands of fate.

CONVERSATION WITH ALEXANDRE CABANEL

CABANEL WAS the embodiment of all that was academic in art—all that Manet opposed. The conversation is reported by Antonin Proust as having taken place the year before Manet's death. For other opinions of Academy training, see Greenough, p. 284, and Bouguereau, p. 287.

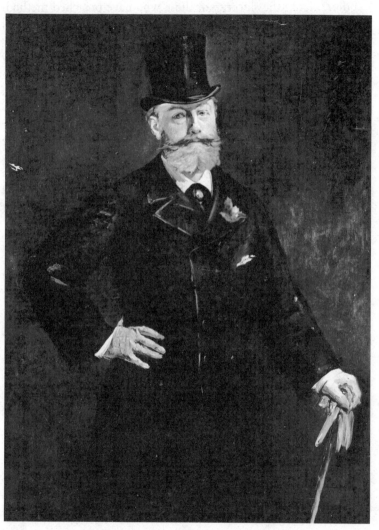

MANET: Portrait of Antonin Proust, 1880

[*Ca. 1882*]

I don't doubt the sincerity of those who have preached methods I find bad. In introducing the ateliers at the *École* [*des Beaux-Arts*] they thought they were doing the right thing; they were mistaken; they didn't see that in installing licensed opticians they not only killed competition, but that these opticians, accustomed to using a certain formula, would put glasses of the same strength on the noses of their pupils. The result has been a succession of the near-sighted and the far-sighted, depending on the distance that their professors saw. Among all the pupils there are some who, once outside and looking with their own eyes, are surprised to see something else than what has been shown them. Those are excommunicated as long as they are unsuccessful; but if they succeed they are claimed for their *alma mater*. Admit, M. Cabanel, that I only speak the truth.

EDGAR DEGAS

FROM HIS NOTEBOOKS AND SAYINGS

AMONG THE impressionists, Degas possessed the keenest wit and the liveliest tongue, although Pissarro was just as reflective about his art (see p. 316). Degas' eyes had been injured in early manhood, and so even before the semi-blindness of his last years he protected them from any strain not directly connected with his painting. He therefore did as little writing as possible, and most of his letters were terse social and business notes. But his just opinions and his *bon mots* were respected and feared by his fellows. The most famous of these sayings were his description of an academic (*pompier*) artist as *"un pompier qui a pris feu"* and his ironic comment on certain dealers: *"Ils nous fusillent, mais ils fouillent nos poches."*

The first of the statements we quote were taken from an early notebook of Degas'; the others are from oral, but reliable, report.

There is courage indeed in launching a frontal attack upon the main structure and the main lines of nature, and cowardice in approaching by facets and details: art is really a battle.

It seems to me that today, if the artist wishes to be serious—to cut out a little original niche for himself, or at least preserve his own innocence of personality—he must once more sink himself in solitude. There is too much talk and gossip; pictures are apparently made, like stock-market prices, by the competition of people eager for profit; in order to do anything at all we need (so to speak) the wit and ideas of our neighbors as much as the businessmen need the funds of others in order to win on the market. All this traffic sharpens our intelligence and falsifies our judgment.

[Undated]

A picture is something which requires as much knavery, trickery, and deceit as the perpetration of a crime. Paint falsely, and then add the accent of nature.

The artist does not draw what he sees, but what he must make others see. Only when he no longer knows what he is doing does the painter do good things.

A picture is first of all a product of the imagination of the artist; it must never be a copy. If then two or three natural accents can be added, obviously no harm is done. The air we see in the paintings of the old masters is never the air we breathe. [Compare Delacroix, p. 230.]

ALFRED SISLEY

AN IMPRESSIONIST'S VIEW

"A corner of nature seen through a temperament": thus Zola, initial defender of the impressionists, defined a work of art. Here, in a letter to an unknown friend, Sisley, one of the most unassuming of the impressionist group, gives us his vision of nature and his method of setting it down. For other personal interpretations of landscape, see Constable, p. 270; Rousseau, p. 290; and Runge, p. 247.

[Undated]

It is a ticklish thing to put down on paper what a painter calls his aesthetic . . .

The aversion to indulgence in theory that Turner felt, I feel too, and I believe it is much easier to talk of masterpieces than to create them—whether with the brush or any other way . . .

As you know, the charm of a picture is many-sided. The subject, the motif, must always be set down in a simple way, easily understood and grasped by the beholder. By the elimination of superfluous detail the spectator should be led along the road that the painter indicates to him, and from the first be made to notice what the artist himself has felt.

Every picture shows a spot with which the artist himself has fallen in love. It is in this—among other things—that the unsurpassed charm of Corot and Jongkind consists.

The animation of the canvas is one of the hardest problems of painting. To give life to the work of art is certainly one of the most necessary tasks of the true artist. Everything must serve this end: form, color, surface. The artist's impression is the life-giving factor, and only this impression can free that of the spectator.

And though the artist must remain master of his craft, the surface, at times raised to the highest pitch of liveliness, should transmit to the beholder the sensation which possessed the artist.

You see that I am in favor of a variation of surface within the same picture. This does not correspond to customary opinion, but I believe it to be correct, particularly when it is a question of rendering a light effect. Because when the sun lets certain parts of a landscape appear soft, it lifts others into sharp relief. These effects of light, which have an almost material expression in nature, must be rendered in material fashion on the canvas.

Objects must be portrayed in their particular context, and they must especially be bathed in light, as is the case in nature. The progress to be realized in the future will consist in this. The means will be the sky (the sky can never be merely a background). Not only does it give the picture depth through its successive planes (for the sky, like the ground, has its planes), but through its form,

and through its relations with the whole effect or with the composition of the picture, it gives it movement . . .

I emphasize this part of a landscape because I would like to make you understand the importance I attach to it.

An indication of this: I always begin a picture with the sky . . .

The painters I like? To mention only contemporaries: Delacroix, Corot, Millet, Rousseau, Courbet, are masters. And finally, all those who loved and had a strong feeling for nature.

CLAUDE MONET

TO THE MINISTER OF FINE ARTS

WRITTEN SEVEN years after Manet's death in 1883, just before Monet's own popularity began, this letter is a symbol of the perpetually renewed struggle of progressive art in the nineteenth and twentieth centuries. At first attacked by everyone but a small group of artists and critics, at length accepted, work that was once anathema was finally enshrined among the classics, to become part of the "tradition." When first shown in 1865 the *Olympia* had been called an offense to both art and morals; now it was accepted for the Luxembourg, and went to the Louvre in 1908.

Paris, February 7, 1890

In the name of a group of subscribers, I have the honor of offering to the nation Édouard Manet's *Olympia*. We are sure of being,

on this occasion, the representatives and spokesmen of a great many artists, writers, and collectors who for many years now have realized how important a place this painter—prematurely taken from his art and his country—must occupy in the history of this century.

The discussions which Manet's pictures aroused, the hostility which they encountered, have now died down. But were the war against him still going on, we should be no less convinced of the importance of Manet's work, and of his decisive triumph. It would be enough—to mention only a few names, formerly despised and rejected but famous today—to recall what happened to such artists as Delacroix, Courbet, Millet, the isolation of their beginnings and their indisputable posthumous glory. But, by the confession of the great majority of those interested in French painting, the role of Édouard Manet was useful and decisive. Not only did he play an important individual part, but he was besides the representative of a great and fruitful evolution.

It therefore has seemed impossible to us that such an *œuvre* should not have its place in our national collections, that the master should not have entrance where his disciples are already admitted. Moreover, we view with alarm the continuous movement of the artistic market, the competition in buying that America gives us, and the departure—so easily foreseen—for another continent of so many works of art which are the joy and glory of France. We have wished to keep here one of Édouard Manet's most characteristic canvases, one in which he appears at the height of his victorious struggle, master of his vision and his art.

. . . Your Excellency, we put the *Olympia* in your hands. It is our desire to see it, in due course, take its place in the Louvre, among the examples of the French school. If the rules forbid its immediate acceptance, if it is objected, in spite of the precedent of Courbet, that ten years have not elapsed since Manet's death, it seems proper that until such date the Luxembourg Museum should receive the *Olympia*. We hope that you will see fit to support this project, to which we have given ourselves, satisfied that we have accomplished a simple act of justice.

TO GUSTAVE GEFFROY

THESE TWO letters to the critic who was Monet's friend and biographer were written towards the end of his life, during the period of his great success. They underline the impressionists' procedure of painting their sensations directly, without (apparent) intellectual construction, and show Monet faithful to it in the midst of the Cézanne-cubist reaction. The *Nymphéas* (now in the Orangerie Museum, Paris), a continuous, low frieze around the walls of a room, is in its rhythm akin to Japanese scroll and screen painting.

THE *Nymphéas* [*1909*]

I was tempted to use the theme of the *Nymphéas* for the decoration of a salon: carried along the walls, its unity enfolding all the panels, it was to produce the illusion of an endless whole, a wave without horizon and without shore; nerves strained by work would relax in its presence, following the reposing example of its stagnant waters, and for him who would live in it, this room would offer an asylum of peaceful meditation in the midst of a flowering aquarium . . .

I have painted for half a century and will soon have passed my sixty-ninth year, but, far from decreasing, my sensitivity has sharpened with age. As long as constant commerce with the outside world can maintain the ardor of my curiosity, and my hand remains the prompt and faithful servant of my perception, I have nothing to fear from old age. I have no other wish than a close fusion with nature, and I desire no other fate than (according to Goethe's precept) to have worked and lived in harmony with her laws. Beside her grandeur, her power, and her immortality, the human creature seems but a miserable atom.

TO PAINT . . . PAINT [*Ca. 1915*]

[I would advise young artists] to paint as they can, as long as they can, without being afraid of painting badly . . . If their painting doesn't improve by itself, it means that nothing can be done —and I wouldn't do anything! . . .

No one is an artist unless he carries his picture in his head before painting it, and is sure of his method and composition. Tech-

MONET: Detail of the "Nymphéas," 1924-1926

niques vary, art stays the same: it is a transposition of nature at once forceful and sensitive. But the new movements, in the full tide of reaction against what they call "the inconstancy of the impressionist image," deny all that in order to construct their doctrine and preach the solidity of unified volume.

Pictures aren't made out of doctrines. Since the appearance of impressionism, the official salons, which used to be brown, have become blue, green, and red . . . But peppermint or chocolate, they are still confections.

CAMILLE PISSARRO

TO LUCIEN PISSARRO

LUCIEN, THE eldest of Camille Pissarro's seven children, had gone to England in 1882 to practice his art and set up a press for fine illustrated editions. There he became associated with the arts and crafts movement of William Morris and Walter Crane, which was part of the general reaction against naturalism that began about 1885. As a stanch impressionist, his father protested against this reaction, and particularly its seeking inspiration in the art and culture of the past. Pissarro had always been sympathetic to socialist ideas; in 1882 Renoir refused to exhibit with him on these grounds, while in 1885 and 1886 he was in close association with the neoimpressionist group of Seurat, Signac (see below, pp. 374 and 376), and the critic Fénéon, who had leanings towards philosophical anarchism.

On the difficulty of "convincing a bourgeois," Pissarro knew whereof he spoke: the eldest of the impressionist group by nearly ten years, older even than Manet, he lived on the thin edge of poverty until the middle nineties, when he was well over sixty.

BOURGEOIS LACK OF TASTE *Osny, December 28, 1883*

The discussion . . . about naturalism is going on everywhere. Both sides exaggerate. It is clear that it is necessary to generalize and not lean on trivial details. But as I see it, the most corrupt art is the sentimental, the art of orange blossoms which makes pale women swoon.

See, then, how stupid the bourgeoisie, the real bourgeoisie have become; step by step they go lower and lower, in a word they are losing all notion of beauty, they are mistaken about everything. Where there is something to admire they shout it down, they disapprove! Where there are stupid sentimentalities from which you want to turn with disgust, they jump with joy or swoon. Everything they have *admired for the last fifty years* is now forgotten, old-fashioned, ridiculous. For years they had to be forcibly prodded from behind, shouted at: This is Delacroix! That's Berlioz! Here is Ingres! etc., etc. And the same thing has held true in literature, in architecture, in science, in medicine, in every branch of human knowledge. They are Zulus with straw-yellow gloves, top hat, and tails. They are like the falling, rolling rock which we must ceaselessly roll back in order to escape being crushed. Hence the sarcasms of Daumier, Gavarni, etc., etc. You are indeed young to want to convince a bourgeois!—English or other!

GAUGUIN'S SYMBOLISM *Paris, April 20, 1891*

I am sending you . . . a review which contains an article on Gauguin by [Albert] Aurier. You will observe how tenuous is the logic of this *littérateur*. According to him, what in the last instance can be dispensed with in a work of art is drawing or painting; only ideas are essential, and those can be indicated by a few symbols. Now I will grant that art is as he says, except that "the few symbols" have to be drawn, after all; moreover, it is also necessary to express ideas in terms of color, hence you have to

have sensations in order to have ideas . . . This gentleman seems to think we are imbeciles!

The Japanese practiced this art as did the Chinese, and their symbols are wonderfully natural, but then they were not Catholics, and Gauguin is a Catholic. I do not criticise Gauguin [in his *Jacob and the Angel*] for having painted a rose background, nor do I object to the two struggling fighters and the Breton peasants in the foreground; what I dislike is that he copped these elements from the Japanese, the Byzantine painters, and others. I criticize him for not applying his synthesis to our modern philosophy, which is absolutely social, anti-authoritarian, and anti-mystical. There is where the problem becomes serious. This is a step backwards; Gauguin is not a seer, he is a schemer who has sensed that the bourgeoisie is moving to the right, recoiling before the great idea of solidarity which sprouts among the people—an instinctive idea, but fecund, the only idea that is permissible! The symbolists also take this line! What do you think? And they must be fought like a disease!

BE MODERN *Rouen, August 19, 1898*

I do not doubt that Morris' books are as beautiful as Gothic art, but it must not be forgotten that the Gothic artists were *inventors,* and we have to perform, not better, which is impossible, but differently and following our own bent. The results will not be immediately evident. Yes, you are right, it is not necessary to be Gothic, but are you doing everything possible not to be? With this in view you would have to disregard friend [Charles] Ricketts, who is of course a charming man, but who from the point of view of *art* seems to stray from the true direction, which is the return to *nature*. For we have to approach nature sincerely, with our own modern sensibilities; imitation or invention is something else again. We have today a general concept inherited from our great modern painters, hence we have a tradition of modern art, and I am for following this tradition while we inflect it in terms of our individual points of view. Look at Degas, Manet, Monet, who are close to us, and at our elders, David, Ingres, Delacroix, Courbet, Corot, the great Corot—did they leave us nothing? Observe that

ıt is a grave error to believe that all mediums of art are not closely tied to their time. Well, then, is this the path of Ricketts? No. It has been my view for a long time that it is not a question of pretty *Italian elegance,* but of using our eyes a bit and disregarding what is in style. Reflect in all sincerity.

SALVATION LIES IN NATURE *Paris, April 26, 1900*

Decidedly, we no longer understand each other. What you tell me about the modern movement, commercialism, etc., has no relation to our conception of art, here at least. You know perfectly well that just as William Morris had some influence on commercial art in England, so here the real artists who seek have had and will have some effect on it. That we cannot prevent stupid vulgarization, even such things as the making of chromos for grocers from figures by Corot . . . is absolutely true. Yes, I know perfectly well that the Greek and the primitive are reactions against commercialism. But right there lies the error. Commercialism can vulgarize these as easily as any other style, hence it's useless. Wouldn't it be better to soak yourself in nature? I don't hold the view that we have been fooling ourselves and rightly should worship the steam engine, with the great majority. No, a thousand times no! We are here to show the way! According to you salvation lies with the primitives, the Italians. According to me this is incorrect. Salva tion lies in nature, now more than ever.

PIERRE-AUGUSTE RENOIR

ON THE IMPORTANCE OF IRREGULARITY
IN THE ARTS

THIS MANIFESTO and proposal was written about 1884, but it was not published. Apart from an introduction to an edition of Cennino Cennini, it is Renoir's only recorded theoretical writing. As far as is known the society never took shape, probably because such formulations were contrary to Renoir's whole approach to his art, as is suggested by his very attempt to give a system to the unsystematic.

[*1884*]

In all the controversies raised daily in matters of art, the capital point to which we are going to draw attention is generally forgotten. We mean irregularity.

Nature abhors a vacuum, say the physicists; they could complete their axiom by saying that she abhors regularity no less.

As a matter of fact, students know that, despite the apparent simplicity of the laws which govern their formation, the works of nature are infinitely varied, whether they are great or small, and to whatever species or family they belong . . .

If one examines the most famous plastic or architectural productions from this point of view, one quickly perceives that the great artists who created them, careful to work in the fashion of that nature whose respectful pupils they did not cease to be, took good care not to violate her fundamental law of irregularity.

One realizes that even works based on geometric principles, such as St. Marco, the little house of Francis I in the Cours la Reine, as well as all the so-called Gothic churches, contain no perfectly straight line, and that the round, square, and oval forms that one finds, which it would have been easy to make exact, never are exact. Thus, without fear of being in error, one can state that all truly artistic production has been conceived and executed in conformity with the principle of irregularity, and, using a neologism which expresses our thought more completely, can say in a word that it has always been the work of an irregularist.

In a period when French art, until the beginning of this century still so filled with penetrating charm and exquisite fantasy, is dying of regularity and dryness, when the mania of false perfection tends to make the engineers blueprint the ideal, we think that it is useful to react against the fatal doctrines which threaten it with extinction, and that it is the duty of all men of sensibility and taste to band themselves together without delay, whatever their repugnance for battle and protest.

CONVERSATION WITH AMBROISE VOLLARD

THESE OPINIONS were recorded by the famous dealer and publisher of illustrated books, the man who gave Cézanne (at the end of his life) and Picasso (at the beginning of his) their first one-man shows in Paris. They are drawn from one of several books of a similar kind, and though they are probably not in Renoir's exact words, they give us his ideas accurately enough.

Contrast Winslow Homer's opinion on outdoor painting, p. 352.

In painting, as in the other arts, there's not a single process, no matter how insignificant, which can be reasonably made into a formula. For instance, I tried long ago to measure out, once and for all, the amount of oil which I put in my color. I simply could not do it. I have to judge the amount necessary with each dip of the brush. The "scientific" artists thought they had discovered a truth once they had learned that the juxtaposition of yellow and blue gives violet shadows. But even when you know that, you still don't know anything. There is something in painting which cannot be explained, and that something is essential. You come to nature with your theories, and she knocks them all flat.

IMPRESSIONISM

[About 1883] I had wrung impressionism dry, and I finally came to the conclusion that I knew neither how to paint nor how to draw. In a word, impressionism was a blind alley, as far as I was concerned . . .

I finally realized that it was too complicated an affair, a kind of painting that made you constantly compromise with yourself. Out of doors there is a greater variety of light than in the studio, where, to all intents and purposes, it is constant; but, for just that reason, light plays too great a part outdoors; you have no time to work out the composition; you can't see what you are doing. I remember a white wall which reflected on my canvas one day while I was painting; I keyed down the color to no purpose— everything I put on was too light; but when I took it back to the studio, the picture looked black . . . If the painter works directly from nature, he ultimately looks for nothing but momentary effects; he does not try to compose, and soon he gets monotonous.

It is not enough for a painter to be a clever craftsman; he must love to "caress" his canvas too.

AUGUSTE RODIN

ON SCULPTURE

THESE OPINIONS—conversations reliably reported by two different biographers—have come down to us undated. They make clear why Rodin never made the distinction between "direct" stone-cutting and modeling that is so important to the modern sculptor, and why he so rarely felt the need to cut the stone himself. For a view of sculpture as the "art of the block," in contrast to Rodin, see Michelangelo, p. 66; for sculpture as relief in space, see Hildebrand, p. 390.

SCULPTURE IS THE ART OF DEPRESSION AND PROTUBERANCE

[Paris, undated]

In sculpture the first . . . principle is that of construction. Construction is the first problem that faces an artist studying his model, whether that model be a human being, animal, tree, or flower. The question arises regarding the model as a whole and regarding it in its separate parts. All form that is to be reproduced ought to be reproduced in its true dimensions, in its complete volume.

And what is this volume? It is the space that an object occupies in the atmosphere. The essential basis of art is to determine that exact space; this is the alpha and omega, this is the general law. To model these volumes in depth is to model in the round, while modeling on the surface is bas-relief. In a reproduction of nature such as a work of art attempts, sculpture in the round approaches reality more closely than does bas-relief.

Today we are constantly working in bas-relief, and that is why our products are so cold and meager. Sculpture in the round alone produces the qualities of life. For instance, to make a bust does not consist in executing the different surfaces and their details one after another, successively making the forehead, the cheeks, the chin, and then the eyes, nose, and mouth. On the contrary, from the first sitting the whole mass must be conceived and constructed in its varying circumferences; that is to say, in each of its profiles . . .

Each profile is actually the outer evidence of the interior mass; each is the perceptible surface of a deep section, like the slices of a melon, so that if one is faithful to the accuracy of these profiles, the reality of the model, instead of being a superficial reproduction, seems to emanate from within. The solidity of the whole, the accuracy of plan, and the veritable life of a work of art, proceed therefrom . . .

This is neither mysterious nor hard to understand. It is thoroughly commonplace, very prosaic. Others may say that art is emotion, inspiration. Those are only phrases, tales with which to amuse the ignorant.

Sculpture is quite simply the art of depression and protuberance. There is no getting away from that.

ART AND NATURE

I grant you that the artist does not see Nature as she appears to the vulgar, because his emotion reveals to him the hidden truths beneath appearances.

But, after all, the only principle in art is to copy what you see. Dealers in aesthetics to the contrary, every other method is fatal. There is no recipe for improving nature.

The only thing is to see.

Oh, doubtless a mediocre man copying nature will never produce a work of art, because he really looks without seeing, and though he may have noted each detail minutely, the result will be flat and without character. But the profession of artist is not meant for the mediocre, and to them the best counsels will never succeed in giving talent.

The artist, on the contrary, sees; that is to say, his eye, grafted on his heart, reads deeply into the bosom of nature.

That is why the artist has only to trust to his eyes.

[Paris, undated]

Is it [the *Venus de' Medici*] not marvelous? Confess that you did not expect to discover so much detail. Just look at the numberless undulations of the hollow which unites the body and the thigh . . . Notice all the voluptuous curvings of the hip . . . And now, here, the adorable dimples along the loins . . . It is truly flesh . . . You would think it molded by caresses! You almost expect, when you touch this body, to find it warm. [Compare Bouguereau on the *Venus* of Vienna, p. 288.]

As paradoxical as it may seem, a great sculptor is as much a colorist as the best painter, or, rather, the best engraver.

He plays so skillfully with all the resources of relief, he blends so well the boldness of light with the modesty of shadow, that his sculptures please one as much as the most charming etchings.

Now color—it is to this remark that I wished to lead—is the

Venus de' Medici (type)

flower of fine modeling. These two qualities always accompany each other, and it is these qualities which give to every masterpiece of the sculptor the radiant appearance of living flesh.

MICHELANGELO AND THE GOTHIC

To sum it up, the greatest genius of modern times has celebrated the epic of shadow, while the ancients celebrated that of light. And if we now seek the spiritual significance of the technique of Michelangelo, as we did that of the Greeks, we shall find that his sculpture expressed restless energy, the will to act without the hope of success—in fine, the martyrdom of the creature tormented by unrealizable aspirations . . .

To tell the truth, Michelangelo does not, as is often contended, hold a unique place in art. He is the culmination of all Gothic thought . . .

He is manifestly the descendant of the image-makers of the thirteenth and fourteenth centuries. You constantly find in the sculpture of the Middle Ages this form of the console to which I called your attention. There you find this same restriction of the chest, these limbs glued to the body, and this attitude of effort. There you find above all a melancholy which regards life as a transitory thing to which we must not cling. [Compare Canova, p. 198, and Epstein, p. 463.]

ADRIANO CECIONI

MACCHIA AND *MACCHIAIOLI*

IN ITALY in the middle of the nineteenth century the rebellion against the academic method and style was represented by a group of artists known as the *Macchiaioli,* who gathered in the Caffè Michelangelo in Florence in the 'fifties. After most of them had fought in the war of independence, they exhibited their works in Florence in 1862. Their nickname *Macchiaioli* comes from *macchia,* a word here meant in the sense of "patch of color."

Though Cecioni (writing in 1884) calls them "impressionists," at the time when the *macchia* flourished they were unacquainted with French impressionism. Rather, they were influenced by Courbet and the Barbizon

group: elsewhere Cecioni says: "The choice is free; the subject, reality; the aim, accuracy."

THE MACCHIAIOLI *August 3, 1884*

All the *macchiaioli,* or *impressionists,* if you like to call then. that, were in agreement with Signorini. Their art consisted not in a research for form but in a mode of rendering the impressions received from reality by using patches of color, or of light and dark; for instance, a single patch of color for the face, another for the hair, a third, say, for the neckerchief, another for the jacket or dress, another for the skirt, others for the hands and feet, and so with the ground and the sky.

The figures scarcely ever exceeded the dimension of fifteen centimeters [six inches], this being the dimension assumed by real persons when viewed at a certain distance—the distance at which the parts of the scene that gave us the impression are seen as masses and not in details. Hence the figure viewed against a white wall or against the sky at sunset or against a sunlit surface was considered as a dark patch on a light patch. In painting the dark patch, moreover, we took into account only its principal and more conspicuous features, such as the head—but without detailing the eyes, nose, and mouth; the hands—without the fingers; the dress—without the folds; first, because in those dimensions such details disappear, secondly, because in the nature of the *macchia* such research had no place, for we cared only to lay down such principles as could serve as a solid basis for an entirely new art. These principles were color, value, and relation [*rapporto*] . . .

It would be impossible to give an idea of the attempts made, especially to render the effects of the sun. We laid pigment upon pigment, but sometimes failed to achieve the value of light. Then we said it depended not on the quantity but on the quality of the pigment and scraped the canvas to try new colors. Yet the desired result failed us . . . You will understand that in that kind of research, the study of form and contour had only a very secondary part or none at all. Outline, properly so called, had not and could not have any part.

MEDARDO ROSSO

THE AIMS OF SCULPTURE

MEDARDO Rosso is the most typical representative of "impressionism" in sculpture. For the interplay of volume and contours he substituted an interplay of light and shadow. Rosso wrote the following in response to an inquiry concerning the relationship between painting and sculpture. Compare the views of Rodin, p. 324, and Hildebrand, p. 390.

What I strive most to achieve in art is to make you forget the material. The sculptor must, by means of a résumé of the impressions received, communicate whatever has struck his sensibility, so that a person beholding his work may experience in its entirety the emotion felt by the artist while he observed nature . . .

When I do a portrait I cannot confine myself to the lineaments of the head, because the head belongs to a body, is situated in an environment exercising an influence upon it, and is part of an ensemble which I do not want to destroy. The impression you produce on me is not the same when I see you standing alone in a garden, when sitting among a group of people in a drawing room, and when walking in the street.

If at first glance the tonality which appeared to be farther off comes forward and then goes back again, the beholder has a very clear perception of a living movement.

I judge that it is impossible to see a horse with its four legs all at once, or to see a man isolated in space like a doll. I feel that this horse and this man belong to an ensemble from which they cannot be separated, to an environment which the artist must take into account.

One must not walk around a statue any more than around a painting, because one does not walk around a shape in order to conceive the impression of it. Nothing is material in space. Art, so conceived, is indivisible. There is not painting on one side and sculpture on the other. What the artist must aim at above all else is this: to produce, by any process whatsoever, a work which by

the life and humanity emanating from it communicates to the beholder whatever the grandiose spectacle of powerful and healthy nature would evoke.

GIOVANNI SEGANTINI

ON ART AND NATURE

SEGANTINI WAS born at Arco, near Trento, attended the Academy at Milan, then lived and worked in the Brianza (Lombardy), at Savognino in the Grisons, and the Maloia Pass in the Engadine. Though imperfectly educated, he liked to write about his art. Among his correspondents were Vittore Grubicy de Dragon, Milanese painter and art critic, who helped make Segantini known; and Anna Radius Zuccari, author, under the nom de plume of Neera, of many novels and short stories.

BEAUTY IN NATURE

I lived a long time with the animals in order to understand their emotions, their sorrows, and their joys. I studied man and his spirit. I studied the rocks, the snow, the glaciers, the great mountain ranges, the blades of grass, and the flowers, asking my soul about their thoughts . . .

Finally I studied the sun's divine light, the cool shades, sweet sunsets, and mysterious nights . . .

Others have painted the Alps as a background, but I paint them for their own sake.

ART OLD AND NEW

The art of the past required the study of the nude, statues, drapery, and the antique, and for this a school was necessary. But nowadays a young artist must study in the fields, in the streets, in the cafés—and there he does study.

REALITY IS NOT ART

The rendering of reality existing and remaining outside of us is not art. It has not and cannot have any value as art. It is not and cannot be anything more than a blind imitation of nature and

therefore a mere material reproduction. Matter must be worked on by the mind to attain lasting form.

AGAINST SKETCHES

As you know, I never make sketches, because if I were to make the sketch I should never paint the picture. Most of the artists who painted a clever sketch seldom painted a picture that was equal to it—if they painted any picture at all—because in the sketch they expressed the spiritual part of their work. I desire my conceptions to be preserved in their virginity in my brain.

THE TEACHING OF ART

As a natural consequence of what I have said again and again on the feeling for art, and on its practical realization, in my opinion the teaching of art is an absurdity. I do not, however, include drawing under this heading. On the contrary, in this most important element I think that a genuine reform is necessary in order to make it harmonize with the character of nature and the needs of art. It should be the means of finding living and perceptible form. Of course, we can be taught to paint as we are taught to play a musical instrument; but as regards painting, this method will produce something that is not art and is harmful to young painters, who had better dispense with it. A conscientious teacher will always strive to teach his pupil his own method of working and consequently of seeing and feeling things. All true artists understand that whatever they have learned from others, in the belief that it was right, is forgotten only with difficulty, so that when they find themselves before free nature they feel that what they learned at school is different, and they find themselves confronted with innumerable obstacles to their work and with perplexing doubts which prevent them from expressing their personality freely and frankly. [Compare Courbet, p. 295, and Bouguereau, p. 287.]

ADOLF MENZEL

TO C. H. ARNOLD

At the time Menzel wrote this letter—he was twenty-one—he was occupied mainly with the production of drawings and lithographs. These were to lead to the illustrations for a book on Frederick the Great, and so to the series of imaginative paintings of Frederick's court for which Menzel is best known. He was not to go to Paris until 1855, when he met Courbet. Compare the opinion of Cole, p. 281, on French art of this period.

Berlin, December 29, 1836

It is our task to achieve in our own time what this phoenix [Duerer] achieved in his. This we shall probably not manage; I believe that the whole present generation of artists (I mean the

332

leaders . . .) are only the forerunners of an epoch that will accomplish it . . . There are many who believe that the [products of the Duesseldorf school] represent the culmination of the art of the present, but I think they are only a temporary stage.

The arts have always produced and carried out only what their own period demanded. When the guiding principle of the human soul was faith, so was it also that of art . . . For this reason I no longer believe that the tendency of our art in this [rational] direction is an error, but that it is the logical result of a reawakened *Zeitgeist,* and what is disturbing and unsatisfying in it stems from its incompleteness. And if art is going to move decisively in this direction, it need not for that reason immediately attain perfection. We shall eventually have those geniuses in whom the spirit of the times will move strongly enough to lend them all the force they need.

The really ingenious and solid materialism of the contemporary Frenchmen (those who represent the school and have in part created it)—Gudin, Roqueplan, Coignet, in some measure Watelet —will produce a revolution here, in which those who believe that to paint coloristically is to paint brilliantly and in cleverly applied strokes will disappear, which can do no harm; and those who are strong enough to last out will certainly proceed the better from there on. And if in certain aesthetic respects the French must be called one-sided, so, and to an equal degree, are we (only towards the other extreme); and I and many others hope that the impress of their work on us will push us out of our own one-sidedness. We should not, and do not, wish to become Frenchmen, but we recognize with respect their many good qualities, and permit them to be a lesson to us.

MAX LIEBERMANN

A CREDO

These lines are drawn from an open confession of artistic faith published by Liebermann in *Kunst und Kuenstler.* If they have a somewhat official character, it is perhaps because after much struggle Liebermann's art,

with its fusion of realism, impressionism, and genre, had become something like the embodiment of approved taste in Germany at the end of the nineteenth century.

Berlin, 1922

It is an uncontested and incontestable axiom of aesthetics that every form, every line, every stroke, must be preceded by an idea; otherwise, though the form may be correct and calligraphically fine, it is not recognizable as artistic, for artistic form is living form, engendered by a creative spirit.

For this reason every artistic form is *per se* idealistic form; to talk of naturalistic form has meaning only when it denotes the form of the medium of expression. Instead of idealistic-naturalistic, we should say, following Schiller's example, naïve and sentimental. For if idealistic form alone exists—i.e., form preceded by idea—there can be no naturalistic form in contrast to it . . .

I am talking of the form of genius, therefore of the form that cannot be learned. So I skip the correct academic form, which can and must be learned, as grammar must be learned.

It is clear that this form is the basis of all pictorial art. But it is much more: it is also its end and its culmination. Without it—to name specific painters—the pictures of Titian and Tintoretto, Rubens and Rembrandt, Goya and Manet would only be Persian carpets. They would be living pictures, but not pictures that live. Because they would have no souls.

It is one of the gravest, and therefore most inexcusable, aesthetic misconceptions to imagine that the more faithfully a painter depicts reality, the less he is a visionary . . .

The more or less faithful depiction of nature is not the criterion by which to judge perception; the decisive factor is the greatness and strength of the artistic personality.

DANTE GABRIEL ROSSETTI

TO HIS BROTHER WILLIAM

The year after the founding of the Pre-Raphaelite Brotherhood (1848), when Rossetti was twenty-two and Hunt twenty-three, they went together to Paris and Belgium. Here, set down with youthful enthusiasm and characteristic Rossettian adjectives, is a contemporary record of the Pre-Raphaelite Brotherhood preference for tight drawing and accurate rendering of detail. (Compare Pforr, p. 248.) Later, William said of these lines that they were "an amusing example of the one-sided and in great part uninformed feeling . . . of the Pre-Raphaelites in their early days," and that his brother later had great admiration for Delacroix and Michelangelo. For other opinions on Delacroix and Ingres, see Théodore Rousseau, p. 289, Cole, p. 281, and Signac, p. 376.

Paris, October 4, 1849

At the Luxembourg there are the following really wonderful pictures—viz., two by Delaroche, two by Robert Fleury, one by Ingres, one by Hesse; others by Scheffer, Granet, etc. are very good. The rest, with a few mediocre exceptions, we considered trash. Delacroix (except two pictures which show a kind of savage genius) is a perfect beast, though almost worshipped here. The school of David got at first frightfully abused for making a stand against him on his appearance. They were quite right, being themselves greatly his superiors, and indeed some of them men who I have no doubt would have done much better in better times.

We ran hurriedly through the Louvre yesterday for the first time. Of course detail is as yet impossible, and indeed, to say the truth, there is monosyllabic current amongst us which enable a P. R. B. to dispense almost entirely with details on the subject. There is however a most wonderful copy of a fresco by Angelico, a tremendous Van Eyck, some mighty things by that real stunner Lionardo, some ineffably poetic Mantegnas (as different as day from night from what we have in England), several wonderful Early Christians whom nobody ever heard of, some tremendous portraits by some Venetian whose name I forget, and a stunning *Francis I* by Titian; Géricault's *Medusa* is also very fine on the whole. We have not yet been through all the rooms. In one there is a ceiling by Ingres which contains some exceedingly good things. This fellow is quite unaccountable. One picture of his in the Luxembourg is unsurpassed for exquisite perfection by anything I have ever seen, and he has others for which I would not give two sous— filthy slosh. I believe we have not yet seen any of Scheffer's best works. Delaroche's Hemicycle in the Beaux-Arts is a marvellous performance . . .

Now for the best. Hunt and I solemnly decided that the most perfect works, taken in toto, that we have seen in our lives, are two pictures by Hippolyte Flandrin (representing Christ's entry into Jerusalem, and His departure to death), in the Church of St. Germain des Prés. Wonderful!! Wonderful!!!

THE CRY OF THE P. R. B., AFTER A CAREFUL EXAMINATION OF
THE CANVASES OF RUBENS, CORREGGIO, ET HOC GENUS OMNE.

Non noi pittore! God of Nature's truth,
If these, not we! Be it not said, when one
Of us goes hence "As these did he hath done;
His feet sought out their footprints from his youth."
Because, dear God! the flesh thou madest smooth
These caked and fretted, that it seemed to run
With ulcers; and the day light of thy sun
They parcelled into blots and glares, uncouth
With stagnant grouts of paint. Men say that these
Had further sight than man's, but that God saw
Their works were good. God that did know them foul!
In such a blindness, blinder than an owl
Leave us! Our sight can reach unto thy seas
And hills; and 'tis enough for tears of awe.

HOLMAN HUNT

PRE-RAPHAELITE AIMS AND METHODS

THIS EXPLANATION of what the Pre-Raphaelite Brotherhood set out to do,
and why, was written some fifty years after the event, when Hunt was over
seventy. He of all the group had remained truest to its original purpose, and
he felt neglected; Rossetti's interwoven life and art had become a legend,
Millais was now a rich and famous academician; Hunt still continued the
struggle. He wrote his book to set the record straight and give himself his
just due in the founding and the history of the movement. The final attack
on foreign influences had its immediate stimulation in the popularity of
French impressionism, which Hunt viewed as the negation of all sound
artistic principles.

Compare the similar views of Franz Pforr, p. 248.

RAPHAEL AND THE PRE-RAPHAELITES

Not alone was the work that we were bent on producing to be
more persistently derived from Nature than any having a dra-
matic significance yet done in the world; not simply were our

productions to establish a more frank study of creation as their initial intention, but the name adopted by us negatived the suspicion of any servile antiquarianism. Pre-Raphaelitism is not Pre-Raphaelism.

Raphael in his prime was an artist of the most independent and daring course as to conventions. He had adopted his principle, it is true, from the store of wisdom gained by long years of toil, experiment, renunciation of used-up thought, and repeated efforts of artists, his immediate predecessors and contemporaries. What had cost Perugino, Fra Bartolommeo, Leonardo da Vinci, and Michael Angelo more years to develop than Raphael lived, he seized in a day—nay, in one single inspection of his precursors' achievements. His rapacity was atoned for by his never-stinted acknowledgments of his indebtedness, and by the reverent and philosophical use in his work of the conquests he had made . . .

There is no need here to trace any failure in Raphael's career; but the prodigality of his productiveness, and his training of many assistants, compelled him to lay down rules and manners of work; and his followers, even before they were left alone, accentuated his poses into postures. They caricatured the turns of his heads and the lines of his limbs, so that figures were drawn in patterns; they twisted companies of men into pyramids, and placed them like pieces on the chess-board of the foreground. The master himself, at the last, was not exempt from furnishing examples of such conventionalities. Whoever were the transgressors, the artists who thus servilely travestied this prince of painters at his prime were Raphaelites. And although certain rare geniuses since then have dared to burst the fetters forged in Raphael's decline, I here venture to repeat, what we said in the days of our youth, that the traditions that went on through the Bolognese Academy, which were introduced at the foundation of all later schools and enforced by Le Brun, Du Fresnoy, Raphael Mengs, and Sir Joshua Reynolds, to our own time were lethal in their influence, tending to stifle the breath of design. The name Pre-Raphaelite excludes the influence of such corrupters of perfection, even though Raphael, by reason of some of his works, be in the list, while it accepts that of his more sincere forerunners.

ART AND MORALITY

Our purpose had not only a newness in its outer form, but also took up in more extended aspiration the principle exemplifying that "Art is Love."

In fact, those who proclaim that art has no connection with morals often condemn our work on the ground of its double purpose. Still let it be said we did not label our pictures with a special appeal as "having a moral," for we knew that a scene of beauty in itself alone gives innocent joy, with unspeakable strength of persuasion to purity and sweetness, and the painter's service in portraying it may be as exalted as that performed when the intent to teach is added thereto.

ART AND NATIONALITY

The doctrine that art has no nationality is much bruited abroad and echoed by the shallow in this day. [See Whistler, p. 351.] It sounds liberal and advanced, but it is altogether false to the precedents of antiquity. The art of all days, from that of the Babylonians to our own, has been characteristically national; to attempt to efface racial distinction in art would have been its destruction. In these days there is still a cardinal difference between the national sentiments of different nations, which can scarcely be confused together without injury to one or the other. The technical qualities of British art have often been unfavourably contrasted with those of modern Continental schools, which have, it must be allowed, justly prided themselves on correctness of form and proportion, and thus have won from casual judgment the reputation of having the best academies of drawing. But mere exactness of proportion is of dubious account; a lay figure is perfectly proportioned, but there is no grace in its form. Sir Joshua Reynolds was not so accurate a draughtsman as David, but in grace he was as Hyperion to a drayman. Yet let us learn correctness; it will not war with beauty; were it so, Greek and Italian marble would not be exquisite; but correctness may be acquired at home. Flaxman, Dyce, and Watts developed their drawing in England, and in them never appeared impurity of taste. Students abroad run the risk of

insidious corruption of idea, and lose shame at corrupted innocence.

Let no sentinel, on our confines, stand aside and allow to pass the derider of national purity, to whom the way has been barred by his great predecessors for so many centuries.

FREDERIC LEIGHTON

TO EDUARD VON STEINLE

IN THESE two letters the arbiter of Victorian art writes to one of the several academic masters with whom he had studied on the Continent in his youth. His expression of literary subject-matter and his desire not to give the "least offence" are typical of his period. On the quality of suggestion in Shakespeare Leighton differed with the romantics, who gave Shakespeare an equal place with the Bible and Dante.

SONGS WITHOUT WORDS

<div style="text-align: center;">2 Orme Square, Bayswater, 30th April, 1861</div>

I have called this picture *Lieder ohne Worte* [*Songs without Words*]. It represents a girl, who is resting by a fountain, and listening to the ripple of the water and the song of a bird. This subject is, of course, quite incomplete without colour, as I have endeavoured, both by colour and by flowing delicate forms, to translate to the eye of the spectator something of the pleasure which the child receives through her ears. This idea lies at the base of the whole thing, and is conveyed to the best of my ability in every detail, so that in the dead photograph one loses exactly half, also the dulling of the eyes, which are dark blue in the picture, gives a look of weakness in the photograph that is not quite pleasant.

The second subject is, as you will know well, the old, ever-new motive of Paolo and Francesca. I endeavoured to put in as much glow and passion as possible without causing the least offence; this picture also would, perhaps, have pleased you in colour. How I should like to show it to you, my dear master! However, you will no doubt send me your candid opinion of the photographs in a few lines, and not spare criticism.

ILLUSTRATION *3rd December 1864*

I must candidly confess I cannot agree about a complete illustration of the Shakespearian plays, those masterpieces already in existence as *exhaustively finished* works of art; it seems to me that in literature only those subjects lend themselves to pictorial representation which stand in the written word more as *suggestion*. Subjects perhaps which are provided in the Bible or in mythology and tradition in great variety, or are not already generally in possession of the minds of the spectators of living plays (e.g. the Greek tragedies). It is for the most part a struggle with the incomparable, already existing *complete*—which is quite intimidating to my capabilities. Do not take this ill, my dear Friend, and do not consider it too great a presumption that I, your pupil, declare so plainly against you where you think so differently.

<div style="text-align: center;">*341*</div>

GEORGE CALEB BINGHAM

ART AND THE IDEAL OF ART

At the close of his life Bingham held the position of Professor of Art at the University of Missouri, and he also taught at Stephens College, Columbia, Missouri. During an illness in Columbia in February, 1879, six months before his death, he prepared an address on "Art, the Ideal of Art, and the Utility of Art" for the University Series of Public Lectures. It was a convincing statement of his own approach to painting; and it revealed his hard-headed refusal to understand either the classical theory of art as an expression of "truth" through the creation of a type, or Ruskin (whom Bingham deigns only to call "the Oxford student") and his moralistic adaptation of this theory. In this Bingham belonged to his time; see Courbet, p. 296, for a similar point of view; but also de la Tour, p. 170.

I cannot believe that the ideal in Art, as is supposed by many, is a specific mental form existing in the mind of the artist more perfect than any prototype in nature, and that to be a great artist he must look within him for a model and close his eyes upon external nature. Such a mental form would be a fixed and determined idea admitting of no variations such as we find in diversified nature and in the works of artists most distinguished in their profession. An artist guided by such a form would necessarily repeat in every work exactly the same lines and the same expression.

BEAUTY IS VARIOUS

To the beautiful belongs an endless variety. It is seen not only in symmetry and elegance of form, in youth and health, but is often quite as fully apparent in decrepit old age. It is found in the cottage of the peasant as well as in the palace of kings. It is seen in all relations, domestic and municipal, of a virtuous people, and in all that harmonizes man with his Creator. The ideal of the great artist, therefore, embraces all of the beautiful which presents itself in form and color, whether characterized by elegance and symmetry or by any quality within the wide and diversified domain of the beautiful.

Mere symmetry of form finds no place in the works of Rem-

brandt, Teniers, Ostade, and others of a kindred school. Their men and women fall immeasurably below that order of beauty which characterizes the sculptures of classic Greece. But they address themselves none the less to our love of the beautiful, and none the less tend to nourish the development and growth of those tastes which prepare us for the enjoyment of that higher life which is to begin when our mortal existence shall end.

ART IS IMITATION

All the thought which in the course of my studies, I have been able to give to the subject, has led me to conclude that the ideal in Art is but the impressions made upon the mind of the artist by the beautiful or Art subjects in external nature, and that our Art power is the ability to receive and retain these impressions so clearly and distinctly as to be able to duplicate them upon our canvas. So far from these impressions thus engraved upon our memory being superior to nature, they are but the creatures of nature, and depend upon her for existence as fully as the image in a mirror depends upon that which is before it. It is true that a work of Art emanating from these impressions may be, and generally is, tinged by some peculiarity belonging to the mind of the artist, just as some mirrors by a slight convex in the surface give reflections which do not exactly accord with the objects before them. Yet any obvious and radical departure from its prototypes in nature will justly condemn it as a work of Art.

GEORGE INNESS

A PROTEST AGAINST HAVING BEEN CALLED AN IMPRESSIONIST

THROUGH HIS objections to the "realist" extremes of the Pre-Raphaelites on the one hand and the impressionists on the other, Inness indirectly defines the quality of "poetic realism" for which he was striving in his own work, and which, unlike French critics, he praises in Courbet. (See Delacroix, p. 231.) The letter was written to "Editor Ledger," editor of a now unidentified newspaper.

Tarpon Springs, Florida, [*1884*]

A copy of your letter has been handed to me in which I find your art editor has classified my work among the "Impressionists." The article is certainly all that I could ask in the way of compliment. I am sorry, however, that either of my works should have been so lacking in the necessary detail that from a legitimate landscape-painter I have come to be classed as a follower of the new fad "Impressionism." As, however, no evil extreme enters the world of mind except as an effort to restore the balance disturbed by some previous extreme, in this instance say Preraphaelism, absurdities frequently prove to be the beginnings of uses ending in a clearer understanding of the legitimate as the rationale of the question involved.

We are all the subjects of impressions, and some of us legitimates seek to convey our impressions to others. In the art of communicating impressions lies the power of generalizing without losing that logical connection of parts to the whole which satisfies the mind.

The elements of this, therefore, are solidity of objects and transparency of shadows in a breathable atmosphere through which we are conscious of spaces and distances. By the rendering of these elements we suggest the invisible side of painting, and the want of that grammar gives to pictures either the flatness of the silhouette or the vulgarity of an over-strained objectivity or the puddling twaddle of Preraphaelism.

Every fad immediately becomes so involved in its application, in the want of understanding of its mental origin, and the great desire of people to label men and things, that one extreme is made to meet with the other in a muddle of unseen life application. And as no one is long what he labels himself, we see realists whose power is in a strong poetic sense as with Corbet [sic]. And Impressionists, who from a desire to give a little objective interest to their pancake of color, seek aid from the weakness of Preraphaelism, as with Monet. Monet made by the power of life through another kind of humbug. For when people tell me that the painter sees nature in the way the Impressionists paint it, I say "Humbug!" from the lie of intent to the lie of ignorance.

Monet induces the humbug of the first form and the stupidity of the second. Through malformed eyes we see imperfectly and are subjects for the optician. Though the normally formed eye sees within degrees of distinctness and without blur, we want for good art sound eyesight. It is well known that we through the eye realize the objective only through the experiences of life. All is flat, and the mind is in no realization of space except its powers are exercised through the sense of feeling. That is, what is objective to us is a response to the universal principle of truth . . .

The first great principle in art is unity representing directness of intent, the second is order representing cause, and the third is realization representing effect.

JAMES A. McNEILL WHISTLER

THE RED RAG

THE RAG which made the Victorian bull of taste see red was Whistler's practice of giving his pictures names that suggested their "abstract" qualities, instead of the usual storytelling titles. He was among the first to formulate openly and to defend the importance of what has now become a consciously accepted quality of art. For later, more radical statements of the same principle, see Maurice Denis, p. 380; Kandinsky, p. 451; and Mondrian, p. 428.

Cheyne Walk, London, May, 1878

Why should not I call my works "symphonies," "arrangements," "harmonies," and "nocturnes"? I know that many good people think my nomenclature funny and myself "eccentric." Yes, "eccentric" is the adjective they find for me.

The vast majority of English folk cannot and will not consider

346

a picture as a picture, apart from any story which it may be supposed to tell.

My picture of a *Harmony in Grey and Gold* is an illustration of my meaning—a snow scene with a single black figure and a lighted tavern. I care nothing for the past, present, or future of the black figure, placed there because the black was wanted at that spot. All that I know is that my combination of grey and gold is the basis of the picture. Now this is precisely what my friends cannot grasp.

They say, "Why not call it *Trotty Veck,* and sell it for a round harmony of golden guineas?"—naïvely acknowledging that, without baptism, there is no . . . market!

But even commercially this stocking of your shop with the goods of another would be indecent—custom alone has made it dignified. Not even the popularity of Dickens should be invoked to lend an adventitious aid to art of another kind from his. I should hold it a vulgar and meretricious trick to excite people about Trotty Veck when, if they really could care for pictorial art at all, they would know that the picture should have its own merit, and not depend upon dramatic, or legendary, or local interest.

As music is the poetry of sound, so is painting the poetry of sight, and the subject-matter has nothing to do with harmony of sound or of colour.

The great musicians knew this. Beethoven and the rest wrote music—simply music; symphony in this key, concerto or sonata in that . . .

Art should be independent of all clap-trap—should stand alone, and appeal to the artistic sense of eye or ear, without confounding this with emotions entirely foreign to it, as devotion, pity, love, patriotism, and the like. All these have no kind of concern with it; and that is why I insist on calling my works "arrangements" and "harmonies."

Take the picture of my mother, exhibited at the Royal Academy as an *Arrangement in Grey and Black*. Now that is what it is. To me it is interesting as a picture of my mother; but what can or ought the public to care about the identity of the portrait?

The imitator is a poor kind of creature. If the man who paints only the tree, or flower, or other surface he sees before him were an

artist, the king of artists would be the photographer. It is for the artist to do something beyond this: in portrait painting to put on canvas something more than the face the model wears for that one day; to paint the man, in short, as well as his features; arrangement of colours to treat a flower as his key, not his model. [Compare Delacroix, p. 233.]

WHISTLER VS. RUSKIN:
ART AND ART CRITICS

ON JULY 2, 1877, John Ruskin wrote in *Fors Clavigera:* "I have seen, and heard, much of cockney impudence before now; but never expected to hear a coxcomb ask two hundred guineas for flinging a pot of paint in the public's face." In November, 1878, Whistler sued Ruskin, onetime defender of the Pre-Raphaelites, for damages for libel. The jury brought in a verdict for the plaintiff, and awarded him damages of one farthing! Here, written one month later, are extracts from Whistler's comments on the proceedings.

Chelsea, December, 1878

Over and over again did the Attorney-General cry out loud, in the agony of his cause, "What is to become of painting if the critics withhold their leash?"

As well might be asked what is to become of mathematics under similar circumstances, were they possible. I maintain that two and two the mathematician would continue to make four, in spite of the whine of the amateur for three, or the cry of the critic for five. We are told that Mr. Ruskin has devoted his long life to art, and as a result—is "Slade Professor" at Oxford. In the same sentence, we have thus his position and its worth. It suffices not, Messieurs! A life passed among pictures makes not a painter—else the policeman in the National Gallery might assert himself. As well allege that he who lives in a library must needs die a poet. Let not Mr. Ruskin flatter himself that more education makes the difference between himself and the policeman when both stand gazing in the Gallery . . .

The Attorney-General said, "There are some people who would do away with critics altogether."

I agree with him, and am of the irrationals he points at—but let me be clearly understood—the *art* critic alone would I extinguish. That writers should destroy writings to the benefit of writing is reasonable. Who but they shall insist upon beauties of literature, and discard the demerits of their brother *littérateurs*? In their turn they will be destroyed by other writers, and the merry game goes on till truth prevail. Shall the painter then—I foresee the question —decide upon painting? Shall *he* be the critic and sole authority? Aggressive as is this supposition, I fear that, in the length of time, his assertion alone has established what even the gentlemen of the quill accept as the canons of art, and recognize as the masterpieces of work.

THE TEN O'CLOCK

ONE DAY Whistler decided to gather together his friends and above all his enemies, and lay down the law. He invited them to a lecture at ten o'clock. With false modesty he began: "It is with great hesitation and much misgiving that I appear before you in the character of The Preacher." He then proceeded to reassert the artist's absolute independence of society, of the public, of the critics, and of his audience. *The Ten O'Clock* had such a *succès de scandale* that Whistler repeated it in March at Oxford and in April at Cambridge.

Contrast Pissarro's ideas on the artist and his contemporary world, p. 318.

London, February 20, 1885

Listen! There never was an artistic period!

There never was an art-loving nation.

And the people questioned not, *and had nothing to say in the matter.*

So Greece was in its splendour, and Art reigned supreme—by force of fact, not by election—and there was no meddling from the outsider . . .

And the Amateur was unknown—and the Dilettante undreamed of! . . .

Nature contains the elements, in colour and form, of all pictures, as the keyboard contains the notes of all music.

But the artist is born to pick, and choose, and group with science,

349

these elements, that the result may be beautiful—as the musician gathers his notes, and forms his chords, until he brings forth from chaos glorious harmony.

To say to the painter, that Nature is to be taken as she is, is to say to the player, that he may sit on the piano.

That Nature is always right, is an assertion, artistically, as untrue, as it is one whose truth is universally taken for granted. Nature is very rarely right, to such an extent even, that it might almost be said that Nature is usually wrong; that is to say, the condition of things that shall bring about the perfection of harmony worthy a picture is rare, and not common at all.

For Art and Joy go together, with bold openness, and high head, and ready hand—fearing nought, and dreading no exposure.

Know, then, all beautiful women, that we are with you. Pay no heed, we pray you, to this outcry of the unbecoming—this last plea for the plain. [Compare Leonardo, p. 55.]

Why this lifting of the brow in deprecation of the present—this pathos in reference to the past?

If Art be rare today, it was seldom heretofore.

It is false, this teaching of decay.

The master stands in no relation to the moment at which he occurs—a monument of isolation—hinting at sadness—having no part in the progress of his fellow men.

He is also no more the product of civilization than is the scientific truth asserted dependent upon the wisdom of a period. The assertion itself requires the *man* to make it. The truth was from the beginning.

So Art is limited to the infinite, and beginning there cannot progress.

ART AND EFFORT [*1885?*]

A picture is finished when all trace of the means used to bring about the end has disappeared.

To say of a picture, as is often said in its praise, that it shows great and earnest labour, is to say that it is incomplete and unfit for view.

Industry in art is a necessity—not a virtue—and any evidence of the same, in the production, is a blemish, not a quality; a proof, not of achievement, but of absolutely insufficient work, for work alone will efface the footsteps of work.

The work of the master reeks not of the sweat of the brow—suggests no effort—and is finished from its beginning.

ART AND NATIONALITY *Paris, August 21, 1886*

Learn then, . . . that there is no such thing as English art. You might as well talk of English Mathematics. Art is Art, and Mathematics is Mathematics.

What you call English Art, is not Art at all, but produce, of which there is, and always has been, and always will be, a plenty, whether the men producing it are dead and called——, (I refer you to your own selection, far be it from me to choose), or alive and called——, whosoever you like as you turn over the Academy catalogue. [Contrast Holman Hunt, p. 339.]

WINSLOW HOMER

PAINTING MUST BE DONE OUTDOORS

A ROMANTIC in temperament and a naturalist in practice, Homer wrote little about his theories or opinions on art. These paragraphs are the most detailed discussion of his ideas we have. They were Homer's answers to a reporter from the *Art Journal*, who made the round of the studios, inter-viewing all manner of artists, most of them now largely forgotten.

Contrast Renoir's opinion on outdoor painting, p. 322.

New York, 1880

I prefer every time a picture composed and painted outdoors. The thing is done without your knowing it. Very much of the work now done in studios should be done in the open air. This

making studies and then taking them home to use them is only half right. You get the composition, but you lose freshness, you miss the subtle and, to the artist, the finer characteristics of the scene itself. I tell you it is impossible to paint an outdoor figure in a studio light with any degree of certainty. Outdoors you have the sky overhead giving one light; then the reflected light from whatever reflects; then the direct light of the sun: so that, in the blending and suffusing of these several luminations, there is no such thing as a line to be seen anywhere. I can tell in a second if an outdoor picture with figures has been painted in a studio. When there is any sunlight in it, the shadows are too positive. Yet you see these faults constantly in pictures in the exhibitions, and you know that they are bad. Nor can they be avoided when such work is done indoors. By the nature of the case the light in a studio must be emphasized at some point or part of the figure; the very fact that there are walls around the painter which shut out the sky shows this.

I wouldn't go across the street to see a Bouguereau. His pictures look false; he does not get the truth of that which he wishes to represent; his light is not outdoor light; his works are waxy and artificial. They are extremely near being frauds. [Comment of the *Art Journal* interviewer: Yet Mr. Homer is the last man in the world to be blind to what are really excellences in a painter like Bouguereau.]

THOMAS EAKINS

DRAWING AND THE STUDY OF ANATOMY

THESE PARAGRAPHS originally appeared as part of an interview in *Scribner's Illustrated Monthly Magazine* for September, 1879, under the title *The Art Schools of Philadelphia*. In it, Eakins, the realist, defended the methods he was using in his teaching, in which he put particular stress upon anatomy and the study of the model. It was for his insistence that his women students, as well as the men, draw from the model that he was later forced to resign his position at the Pennsylvania Academy. Compare Eakins' implied criticisms of usual academic procedure with those of Greenough, p. 284; Bouguereau, p. 287; and Géricault, p. 223.

DRAW WITH THE BRUSH

The brush is a more powerful and rapid tool than the point or stump. Very often, practically, before the student has had time to get his broadest masses of light and shade with either of these, he has forgotten what he is after. Charcoal would do better, but it is clumsy and rubs too easily for the student's work. Still the main thing that the brush secures is the instant grasp of the grand construction of a figure. There are no lines in nature, as was found out long before Fortuny exhibited his detestation of them; there are only form and color. The least important, the most changeable, the most difficult thing to catch about a figure is the outline. The student drawing the outline of that model with a point is confused and lost if the model moves a hair's breadth; already the whole outline has been changed, and you notice how often he has had to rub out and correct; meantime he will get discouraged and disgusted long before he has made any sort of portrait of the man. Moreover, the outline is not the man; the grand construction is. Once that is got, the details follow naturally. And as the tendency of the point or stump is, I think, to reverse this order, I prefer the brush. I don't at all share the old fear that the beauties of color will intoxicate the pupil and cause him to neglect the form. I have never known anything of that kind to happen unless a student fancied he had mastered drawing before he began to paint . . .

The first things to attend to in painting the model are the movement and the general color. The figure must balance, appear solid and of the right weight. The movement once understood, every detail of the action will be an integral part of the main continuous action; and every detail of color auxiliary to the main system of light and shade . . . To these ends, I haven't the slightest hesitation in calling the brush and an immediate use of it, the best possible means.

AGAINST THE STUDY OF CASTS

I don't like a long study of casts, even of the sculptors of the best Greek period. At best, they are only imitations, and an imitation of imitations cannot have so much life as an imitation of nature itself. The Greeks did not study the antique: the *Theseus*

and *Illyssus,* and the draped figures in the Parthenon pediment were modeled from life, undoubtedly. And nature is just as varied and just as beautiful in our day as she was in the time of Phidias.

ANATOMY IS THE GRAMMAR OF ART

About the philosophy of aesthetics, to be sure we do not greatly concern ourselves, but we are considerably concerned about learning how to paint. For anatomy, as such, we care nothing whatever. To draw the human figure it is necessary to know as much as possible about its structure and its movements, its bones and muscles, how they are made, and how they act. You don't suppose we pay much attention to the viscera, or study the functions of the spleen, I trust . . .

If beauty resides in fitness to any extent, what can be more beautiful than this skeleton or the perfection with which means and ends are reciprocally adapted to each other. But no one dissects to quicken his eye for, or his delight in, beauty. He dissects simply to increase his knowledge of how beautiful objects are put together to the end that he may be able to imitate them. Even to refine upon natural beauty—to idealize—one must understand what it is that he is idealizing; otherwise his idealization—I don't like the word, by the way—becomes distortion, and distortion is ugliness. This whole matter of dissection is not art at all, any more than grammar is poetry. It is work, and hard work, disagreeable work. No one, however, needs to be told that enthusiasm for one's end operates to lessen the disagreeableness of his patient working toward attainment of it.

ALBERT PINKHAM RYDER

VISION AND INSPIRATION

It is interesting to compare Ryder's preoccupation with "inspiration," "expression," and "personal style" with Eakins' concern over the transcription of reality. Here is an excellent example of how the artist (in this case a "romantic" out of his time) makes a virtue out of necessity, until at length it becomes an indispensable element of his art.

New York, [after 1900]

The artist should fear to become the slave of detail. He should strive to express his thought and not the surface of it. What avails a storm cloud accurate in form and color if the storm is not therein? A daub of white will serve as a robe to Miranda if one feels the shrinking timidity of the young maiden as the heavens pour down upon her their vials of wrath.

It is the first vision that counts. The artist has only to remain true to his dream and it will possess his work in such a manner that it will resemble the work of no other man—for no two visions are alike, and those who reach the heights have all toiled up the steep mountains by a different route. To each has been revealed a different panorama.

Imitation is not inspiration, and inspiration only can give birth to a work of art. The least of man's original emanation is better than the best of a borrowed thought. In pure perfection of technique, coloring, and composition, the art that already has been achieved may be imitated but never surpassed. Modern art must strike out from the old and assert its individual right to live through Twentieth Century impressionism and interpretation . . .

The canvas I began ten years ago I shall perhaps complete today or tomorrow. It has been ripening under the sunlight of the years that come and go. It is not that a canvas should be worked at. It is a wise artist who knows when to cry "halt" in his composition, but it should be pondered over in his heart and worked out with prayer and fasting.

THE ARTIST NEEDS BUT A ROOF

The artist needs but a roof, a crust of bread, and his easel, and all the rest God gives him in abundance. He must live to paint and not paint to live. He cannot be a good fellow; he is rarely a wealthy man, and upon the pot boiler is inscribed the epitaph of his art.

The artist should not sacrifice his ideals to a landlord and a costly studio. A rain-tight roof, frugal living, a box of colors, and God's sunlight through clear windows keep the soul attuned and the

body vigorous for one's daily work. The artist should once and forever emancipate himself from the bondage of appearance and the unpardonable sin of expending on ignoble aims the precious ointment that should serve only to nourish the lamp burning before the tabernacle of his muse.

1904

ODILON REDON

FROM HIS JOURNAL AND LETTERS

IN DATE of birth Redon belongs to the impressionist generation, but his stylistic affinity is with the end of the century. Huysmans was among the first to notice him; André Mellerio, friend of the symbolists and editor of *L'Estampe Originale,* was his friend and catalogued his graphic work (1913). In 1868 Redon wrote a series of articles for the newspaper *La Gironde;* from 1867 until his death he kept a rather intermittent *Journal;* and a small volume of letters has also been published.

On the propriety of the nude, compare Ammannati, p. 100; Pietro da Cortona, p. 132; and Pacheco, p. 143.

INGRES *April, 1878*

Ingres did not belong to his age; his mind is sterile, the sight of his work, far from increasing our moral force, lets us placidly continue on our bourgeois way of life, in no way affected or changed. His works are not true art; for the value of art lies in its power to increase our moral force or establish its heightening influence . . .

Such is modern work: the least scrawl of Delacroix, of Rembrandt, of Albrecht Duerer makes us start to work and produce; one would say that it is life itself they communicate and transmit to us, and in this lies their ultimate result, their supreme meaning. Whoever acts thus upon others has genius, no matter through what medium he works, whether words, or writing, or even by his own presence . . .

Ingres is an honest and useful disciple of the masters of another age . . . In those false temples, with their great false gods, Ingres, the disciple who follows, is always raised on high. There, graven in golden letters on the marble, are maxims as obstinately hollowed out and as hollow as the following: Drawing is the Probity of Art; words full of meaning for those poor souls who, with a strained manner, enter these sacred groves. What is honesty doing here? Perhaps they mean to indicate the dogma of so-called classic drawing that is taught here. But you are forbidden to study Michelangelo, Rembrandt, and Duerer: they did not practice an honest art. It is dishonest to create and to have genius, and still more dishonest to be a prophet.

NUDES *May 14,* [*1888*]

A painter is not intellectual when, having painted a nude woman, he leaves in our minds the idea that she is going to get dressed again right away.

The intellectual painter shows her to us in a nudity that is reassuring, because she doesn't hide it. Thus, without shame, she remains in an Eden for glances that are not ours, but those of a

cerebral world, an imaginary world created by the painter, where moves and has its being a beauty that never gives birth to impurity, but on the contrary lends to all nudity a pure attraction that does not demean us. The nudes of Puvis de Chavannes never get dressed, nor do many others belonging to the charming gynaeceum of Giorgione and Correggio.

But there is one, in Manet's *Picnic,* who will hurry to dress herself, after her boring ordeal on the cold grass, among those gentlemen without ideals who surround her and talk to her. What are they saying? Nothing innocent, I suspect.

TO ANDRÉ MELLERIO *Peyrelebade [Médoc], August 16, 1898*

I still have in front of me your letter and its embarrassing questions. I cannot answer them completely. What interest have you in knowing if I go to my easel or my stone with ideas of a predetermined concept? For twenty years I have been asked that question. You would not believe how it intrudes upon my reserve; I have never answered it . . .

However, I can confide in you, if you wish, some invincible peculiarities of my nature. Thus, I have a horror of a white sheet of paper. It creates such a disagreeable impression that it makes me sterile, even ridding me of my taste for work (except, of course, when I propose to represent something real, such as a study for a portrait, for example). A sheet of paper so shocks me that as soon as it is on the easel I am forced to scrawl on it with charcoal or pencil, or anything else, and this process gives it life. I believe that any art of suggestion gets much from the reaction of the surface of the medium itself upon the artist. A truly sensitive artist does not find the same image in two different media, because they strike him differently.

MYSTERY AND SUGGESTION

The designation of my drawings by a title is often, so to speak, superfluous. A title is justified only when it is vague and even aims confusedly at the equivocal. My drawings *inspire,* and are not to be defined. They determine nothing. They place us, as does music,

in the ambiguous realm of the undetermined. They are a kind of metaphor . . . [Compare Gauguin, p. 369.]

Imagine varied arabesques or mazes unfolding, not on a plane but in space, with all that the profound and indeterminate margin of the sky would furnish to the mind; imagine the play of their lines projected and combined with the most diverse elements, including that of the human countenance. If this countenance has the particularity of one seen daily in the street, with its immediate fortuitous verity completely real, then you will have the ordinary source and structure of many of my drawings.

There is a kind of drawing which the imagination has liberated from any concern with the details of reality in order to allow it to serve freely for the representation of things conceived . . . No one can deny me the merit of having given the illusion of life to my most unreal creations. My whole originality, therefore, consists in having made improbable beings live humanly according to the laws of the probable, by as far as possible putting the logic of the visible at the service of the invisible.

PAUL CÉZANNE

TO ÉMILE BERNARD

FROM HIS youth Cézanne had always been shy and timid. As he grew older his fear of social contact, of having, as he said, the *grappin* (hook) put upon him, was increased by the cold reception given his art in Paris, and by the ridicule of his fellow citizens of Aix. He had therefore few friends with whom discussion had not ended in dispute. (His continued respect and affection for Pissarro was exceptional.)

In February, 1904, Émile Bernard, landing at Marseille on his way back from Egypt, decided to visit the master whose work he had admired for fifteen years. Cézanne already knew him as the author of an admiring article, and they passed a month together during which their almost daily contact was marred by only one slight misunderstanding. Cézanne took

the young painter under his wing, explained his methods and theories, and tried to cure him of his too "intellectual" tendencies. After Bernard returned to Paris the discussions were continued by letter until just a month before Cézanne's death.

These letters constitute the one body of theory we have from Cézanne's own pen.

POUSSIN FROM NATURE *[Aix-en-Provence, March, 1904]*

As you know, I have often made sketches of male and female bathers which I should have liked to execute on a large scale and from nature; the lack of models has forced me to limit myself to these rough sketches. There were obstacles in my way; for example, how to find the proper setting for my picture, a setting which would not differ much from the one I visualized in my mind; how to gather together the necessary number of people; how to find men and women willing to undress and remain motionless in the poses I had determined. Moreover, there was the difficulty of carrying about a large canvas, and the thousand difficulties of favorable or unfavorable weather, of a suitable spot in which to work, of the supplies necessary for the execution of such a large work. So I was obliged to give up my project of doing Poussin over entirely from nature, and not constructed piece-meal from notes, drawings, and fragments of studies; in short, of painting a living Poussin in the open air, with color and light, instead of one of those works imagined in a studio, where everything has the brown coloring of feeble daylight without reflections from the sky and the sun.

CYLINDER, SPHERE, AND CONE *Aix-en-Provence, April 15, 1904*

May I repeat what I told you here: treat nature by the cylinder, the sphere, the cone, everything in proper perspective so that each side of an object or a plane is directed towards a central point. Lines parallel to the horizon give breadth—that is, a section of nature or, if you prefer, of the spectacle that the Pater Omnipotens Æterne Deus spreads out before our eyes. Lines perpendicular to this horizon give depth. But nature for us men is more depth than surface, whence the need of introducing into our light vibrations, ʳepresented by reds and yellows, a sufficient amount of blue to give the impression of air.

I must tell you that I had another look at the study you made in the lower floor of the studio; it is good. You should, I think, only continue in this way. You have the understanding of what must be done and you will soon turn your back on the Gauguins and the Van Goghs!

TASTE IS THE BEST JUDGE *Aix, May 12, 1904*

I have already told you that I like Redon's talent enormously, and from my heart I agree with his feeling for and admiration of Delacroix. I do not know if my indifferent health will allow me ever to realize my dream of painting his apotheosis.

I am progressing very slowly, for nature reveals herself to me in very complex forms; and the progress needed is incessant. One must see one's model correctly and experience it in the right way; and, furthermore, express oneself forcibly and with distinction.

Taste is the best judge. It is rare. Art only addresses itself to an excessively small number of individuals.

The artist must scorn all judgment that is not based on an intelligent observation of character. He must beware of the literary spirit which so often causes painting to deviate from its true path —the concrete study of nature—to lose itself all too long in intangible speculations.

DO NOT BE AN ART CRITIC *Aix, July 25, 1904*

I am sorry that we cannot be together now, for I want to be right not in theory but in nature. Ingres, in spite of his "estyle" (Aixian pronunciation) and his admirers, is only a very little painter. You know the greatest painters better than I do: the Venetians and the Spaniards.

To achieve progress nature alone counts, and the eye is trained through contact with her. It becomes concentric by looking and working. I mean to say that in an orange, an apple, a bowl, a head, there is a culminating point; and this point is always—in spite of the tremendous effect of light and shade and colorful sensations— the closest to our eye; the edges of the objects recede to a center on our horizon. With a small temperament one can be very much of a painter. One can do good things without being very much of

a harmonist or a colorist. It is sufficient to have a sense of art—and this sense is doubtless the horror of the bourgeois. Therefore institutions, pensions, honors can only be made for cretins, rogues, and rascals. Do not be an art critic, but paint; therein lies salvation.

COLOR, NOT LIGHT *Aix, December 23, 1904*

Yes I approve of your admiration for the strongest of all the Venetians; we are celebrating Tintoretto. Your desire to find a moral, an intellectual point of support in the works, which assuredly we shall never surpass, makes you continually on the *qui vive,* searching incessantly for the way that you dimly apprehend, which will lead you surely to the recognition, before nature, of what your means of expression are; and the day you will have found them, be convinced that you will find also, without effort and before nature, the means employed by the four or five great ones of Venice.

This is true without possible doubt—I am very positive: an optical impression is produced on our organs of sight which makes us classify as light, half-tone, or quarter-tone the surfaces represented by color sensations. (So that light does not exist for the painter.) As long as we are forced to proceed from black to white, the first of these abstractions being like a point of support for the eye as much as for the mind, we are confused, we do not succeed in mastering ourselves, in possessing ourselves. During this period (I am necessarily repeating myself a little) we turn towards the admirable works that have been handed down to us throughout the ages, where we find comfort, a support such as a plank is for the bather.

STUDY NATURE *Aix, [1905], Friday*

If the official salons remain so inferior it is because they only employ more or less widely known methods of production. It would be better to bring more personal feeling, observation, and character.

The Louvre is the book in which we learn to read. We must not, however, be satisfied with retaining the beautiful formulas of our

illustrious predecessors. Let us go forth to study beautiful nature, let us try to free our minds from them, let us strive to express ourselves according to our personal temperaments. Time and reflection, moreover, little by little modify our vision, and at last comprehension comes to us . . .

You will understand me better when we meet again; observation modifies our vision to such an extent that the humble and colossal Pissarro finds his revolutionary theories justified.

Aix, September 21, 1906

Shall I ever reach the goal so eagerly sought and so long pursued? I hope so, but as long as it has not been attained a vague feeling of discomfort persists which will not disappear until I shall have gained the harbor—that is, until I shall have accomplished something more promising than what has gone before, thereby verifying my theories, which, in themselves, are easy to put forth. The only thing that is really difficult is to prove what one believes. So I am going on with my researches . . . I am continually making observations from nature, and I feel that I am making some slight progress. I should like to have you here with me, for my solitude always oppresses me a little; but I am old, ill, and I have sworn to die painting rather than sink into the nasty corruption that threatens old men who allow themselves to be dominated by degrading passions.

TO HIS SON

CÉZANNE, WHO said of himself that he was *"faible dans la vie,"* leaned on the guidance of his son in the practical affairs of life, and most of their correspondence dealt with the problems of day-to-day existence. However, these extracts from two of his last letters complete the story of Cézanne's theoretical discussions with Émile Bernard.

Aix, August 3, 1906

It is unfortunate that I cannot make several specimens of my ideas and sensations; long live the Goncourts, Pissarro, and all those who have the love of color, representative of light and air.

Aix, September 26, 1906

[Camoin] showed me a photograph of a figure by the unfortunate Émile Bernard; we agreed on this point, namely, that he is an intellectual crushed by the memory of the museums, but who does not look at nature enough, and that is the great thing, to make oneself free of the school and indeed of all schools. So that Pissarro was not mistaken, though he went a little too far, when he said that all the necropolises of art should be burned.

Certainly one could make a strange menagerie with all the professionals of art and their kindred spirits.

TO ROGER MARX

ONLY A year before his death, writing to so public a person as the editor of the *Gazette des Beaux-Arts,* Cézanne once more expressed his regret at not having been able to "realize" his artistic vision. Such a feeling is natural to any artist, but it was especially poignant in Cézanne. His frank and emphatic manner of voicing it did much to damage his reputation: long after his death—in good and ill intention—this phrase was repeated without being understood. See, for example, the opinions of W. R. Sickert, p. 394.

Aix, January 23, 1905

I read with interest the lines that you were kind enough to write about me in the two articles in the *Gazette des Beaux-Arts.* Thank you for the favorable opinion that you express on my behalf.

My age and my health will never allow me to realize the dream of art that I have been pursuing all my life. But I shall always be grateful to the public of intelligent amateurs who had—despite my own hesitations—the intuition of what I wanted to attempt for the renewal of my art. To my mind one should not substitute oneself for the past, one has merely to add a new link. With the temperament of a painter and an ideal of art—that is to say, a conception of nature—sufficient powers of expression would have been necessary to be intelligible for man and to occupy a suitable position in the history of art.

PAUL GAUGUIN

TO DANIEL DE MONFREID

Gauguin first went to the South Seas in 1891, returning to Paris two years later. He went again in 1895 and stayed until his death in 1903. Throughout these twelve years the artist de Monfreid was his most faithful correspondent and most useful friend; he looked after Gauguin's interests in Paris, and time and again came to his aid when Gauguin was at the end of his financial rope. The last letter to de Monfreid was written a month before Gauguin died.

Tahiti, October, 1897

I can see that you are in a productive vein; and of sculpture! Admit, now, that it's either very amusing and quite easy, or very difficult if one wishes to express oneself a bit mysteriously—in

parables—to search for forms. What your friend, the little sculptor from the South, would call *deforming*. Keep the Persians, the Cambodians, and a bit of the Egyptians always in mind. The great error is the Greek, however beautiful it may be. I am going to give you a bit of technical advice, do with it as you like. Mix a lot of fine sand with your clay. It will make many useful difficulties for you and will keep you from seeing the surface and from falling into the atrocious trickiness of the Beaux-Arts school. A clever twist of the thumb, a sleek modeling of the meeting of cheek and nostril—that is their ideal. And then sculpture allows lumps but never holes. A hole is necessary to the human ear, but not to the ear of God. He sees and hears, perceives all without the help of the senses, which exist only to be tangible to man. Suggest that.

August, 1901

I have always said, or at least thought, that literary poetry in a painter is something special, and is neither illustration nor the translation of writing by form. In painting one must search rather for suggestion than for description, as is done in music. Sometimes people accuse me of being incomprehensible only because they look for an explicative side to my pictures which is not there. [Compare Redon, p. 361.]

TO ANDRÉ FONTAINAS

In January, 1899, the critic Fontainas had written a review in the *Mercure de France* of Gauguin's exhibition at the Vollard Gallery, which included the large painting *Whence Do We Come? What Are We? Where Are We Going?* (now in the Boston Museum), which Gauguin had done in 1898. Gauguin objected to the literary interpretation given his picture, and sent Fontainas this explanation of his method and purpose. In describing his equally famous *Spirit of the Dead Watching* Gauguin also insisted that the picture had given birth to its own title. Gauguin entrusted Fontainas with the posthumous publication of his *Intimate Journals* (*Avant et Après*).

Tahiti, March, 1899

The idol is not there [in *Whence Do We Come . . . ?*] as a literary symbol but as a statue, yet perhaps less of a statue than

369

the animal figures, less animal also, combining my dream before my cabin with all nature, dominating our primitive soul, the unearthly consolation of our sufferings to the extent that they are vague and incomprehensible before the mystery of our origin and of our future.

And all this sings with sadness in my soul and in my design while I paint and dream at the same time with no tangible allegory within my reach—owing, perhaps, to a lack of literary education.

Awakening with my work finished, I ask myself: "Whence do we come? What are we? Where are we going?" A thought which has no longer anything to do with the canvas, expressed in words quite apart on the wall which surrounds it. Not a title but a signature.

You see, although I understand very well the value of words—abstract and concrete—in the dictionary, I no longer grasp them in painting. I have tried to interpret my vision in an appropriate décor without recourse to literary means and with all the simplicity the medium permits: a difficult job. You may say that I have failed, but do not reproach me for having tried, nor should you advise me to change my goal, at one with other ideas already accepted, consecrated. Puvis de Chavannes is the perfect example. Of course Puvis overwhelms me with his talent and experience, which I lack; I admire him as much as you do, and more, but for entirely different reasons (and—don't be annoyed—with more understanding). Each of us belongs to his own period.

The government is right not to give me an order for a decoration for a public building which might clash with the ideas of the majority, and it would be even more reprehensible for me to accept it, since I should have no alternative but to cheat or lie to myself . . .

After fifteen years of struggle we are beginning to free ourselves from the influence of the Academy, from all this confusion of formulas, apart from which there has been no hope of salvation, honor, or money . . .

Now the danger is past. Yes, we are free, and yet I see still another danger flickering on the horizon; I want to discuss it with

GAUGUIN: Whence do we come? What are we? Where are we going? 1898

you. This long and boring letter has been written with only that in view. Criticism of today, when it is serious, intelligent, full of good intentions, tends to impose on us a method of thinking and dreaming which might become another bondage. Preoccupied with what concerns it particularly, its own field, literature, it will lose sight of what concerns us, painting. If that is true, I shall be impertinent enough to quote Mallarmé: "A critic is someone who meddles with something that is none of his business." [Compare Whistler, p. 348.]

FROM HIS *INTIMATE JOURNALS*

DURING HIS second stay in the Pacific, while alone in Tahiti and the Marquesas, Gauguin set down his thoughts on various subjects: love, morals, colonial administration, other artists, his own painting. He insisted on the informality of these notes—reiterating, "This is not a book"—and that quality was preserved when, as *Avant et Après,* they were published after his death. They are much closer to his style of writing and thinking than the earlier *Noa Noa,* which underwent considerable editorial alteration. Some of the notes are dated, most of them are not; but they were all written during the last few years of Gauguin's life.

It is well for young men to have a model, but let them draw the curtain over it while they are painting. It is better to paint from memory, for thus your work will be your own; your sensation, your intelligence, and your soul will triumph over the eye of the amateur. When you want to count the hairs on a donkey, discover how many he has on each ear and determine the place of each, you go to the stable.

SEEK HARMONY

Who tells you that you ought to seek contrast in colors?

What is sweeter to an artist than to make perceptible in a bunch of roses the tint of each one? Although two flowers resemble each other, can they ever be leaf by leaf the same?

Seek for harmony and not contrast, for what accords, not for what clashes. It is the eye of ignorance that assigns a fixed and unchangeable color to every object; beware of this stumbling-block.

Practice painting an object in conjunction with, or shadowed by —that is to say, close to or half behind—other objects of similar or different colors. In this way you will please by your variety and your truthfulness—your own. Go from dark to light, from light to dark. The eye seeks to refresh itself through your work; give it food for enjoyment, not dejection. It is only the sign-painter who should copy the work of others. If you reproduce what another has done you are nothing but a maker of patchwork; you blunt your sensibility and immobilize your coloring. Let everything about you breathe the calm and peace of the soul. Also avoid motion in a pose. Each of your figures ought to be in a static position . . .

Study the silhouette of every object; distinctness of outline is the attribute of the hand that is not enfeebled by any hesitation of the will.

Why embellish things gratuitously and of set purpose? By this means the true flavor of each person, flower, man, or tree disappears; everything is effaced in the same note of prettiness that nauseates the connoisseur. This does not mean that you must banish the graceful subject, but that it is preferable to render it just as you see it rather than to pour your color and your design into the mold of a theory prepared in advance in your brain.

Do not finish your work too much. An impression is not sufficiently durable for its first freshness to survive a belated search for infinite detail; in this way you let the lava grow cool and turn boiling blood into a stone. Though it were a ruby, fling it far from you. [Compare Delacroix, p. 234.]

IMPRESSIONISM

The impressionists study color exclusively, but without freedom, always shackled by the need of probability. For them the ideal landscape, created from many different entities, does not exist. They look and perceive harmoniously, but without aim. Their edifice rests upon no solid base and ignores the nature of the sensation perceived by means of color. They heed only the eye and neglect the mysterious centers of thought, so falling into merely

373

scientific reasoning. When they speak of their art, what is it? A purely superficial thing, full of affectations and only material. In it thought does not exist.

A critic at my house sees some paintings. Greatly perturbed, he asks for my drawings. My drawings? Never! They are my letters, my secrets. The public man—the private man.

GEORGES SEURAT

TO MAURICE BEAUBOURG

IN ARRIVING at his own style, Seurat studied both the technique of older masters and the color theories of scientists (such as Chevreul, Rood, Charles Henry, and David Sutter) who were concerned with color in its application to art and industry. Here Seurat presents his adaptation of the theory of the simultaneous contrasts of color, tone, and line which was the basis

of his carefully calculated method of painting. Jules Christophe, a mutual friend, had just published a book on Seurat. This letter was written to correct what Seurat felt were errors that had crept into Christophe's rendering of his ideas. To another friend Seurat wrote: "They see poetry in what I have done. No, I apply my method, and that is all there is to it."

Compare Signac's exposition of the contributions of "neoimpressionism," p. 377.

AESTHETIC *August 28,* [*1890*]

Art is harmony.

Harmony is the analogy of contrary and of similar elements of tone, of color, and of line, conditioned by the dominant key, and under the influence of a particular light, in gay, calm, or sad combinations.

The contraries are:

For tone: a more luminous, or lighter, shade against a darker.

For color: the complementaries, i.e., a certain red opposed to its complementary, etc. (red-green, orange-blue, yellow-violet).

For line: those making a right angle.

Gaiety of tone is given by the dominance of light; of color, by the dominance of warm colors; of line, by the dominance of lines above the horizontal.

Calm of tone is given by an equivalence of light and dark; of color, by an equivalence of warm and cold; and of line, by horizontals.

Sadness of tone is given by the dominance of dark; of color, by the dominance of cold colors; and of line, by downward directions.

TECHNIQUE

Taking for granted the phenomena of the duration of the light impression upon the retina:

A synthesis follows as a result. The means of expression is the optical mixture of tones and colors (both of local colors and of the illuminating color—sun, oil lamp, gas lamp, etc.); i.e., a mixture of the lights and their reactions (shadows) according to the laws of contrast, sequence, and irradiation.

The frame is in a harmony contrasted to that of the tones, the colors, and the lines of the picture.

PAUL SIGNAC

THE COLOR CONTRIBUTIONS OF DELACROIX, THE IMPRESSIONISTS, AND THE NEOIMPRESSIONISTS

SIGNAC HAD first met Seurat at the *Salon des Indépendents* of 1884, and for the next seven years they worked together to develop the art and theory of "neoimpressionism." Signac had personally consulted with Chevreul and collaborated with Charles Henry, and, unlike Seurat, he was always eager to expound his ideas. Compare Seurat's summary.

AIM

Delacroix
Impressionism
Neoimpressionism

To give color its greatest possible brilliance.

MEANS

Delacroix

1. A palette made up of both pure colors and reduced colors.
2. Mixture (of colors) on the palette, and optical mixture.
3. Cross-hatching.
4. Methodical and scientific technique.

Impressionism

1. A palette composed solely of pure colors, approximating those of the solar spectrum.
2. Mixture (of colors) on the palette, and optical mixture.
3. Brush strokes of comma-like or swept-over form.
4. A technique depending on instinct and the inspiration of the moment.

Neoimpressionism

1. The same palette as impressionism.
2. Optical mixture (of colors).
3. Divided brush strokes.
4. Methodical and scientific technique.

RESULTS

Delacroix

Through the rejection of all flat color-tones, and thanks to shading, contrast, and optical mixture, he succeeds in creating from the partially incomplete elements at his disposal a maximum brilliance whose harmony is insured by the systematic application of the laws governing color.

377

Impressionism By making up his palette of pure colors only, the impressionist obtains a much more luminous and intensely colored result than Delacroix; but he reduces its brilliance by a muddy mixture of pigments, and he limits its harmony by an intermittent and irregular application of the laws governing color.

Neoimpressionism By the elimination of all muddy mixtures, by the exclusive use of the optical mixture of pure colors, by a methodical divisionism and a strict observation of the scientific theory of colors, the neoimpressionist insures a maximum of luminosity, of color intensity, and of harmony —a result that had never yet been obtained.

MAURICE DENIS

A DEFINITION OF SYMBOLISM

IN 1888, Paul Sérusier, back in Paris after having by chance met and talked with Gauguin in Brittany, transmitted to his fellow-students at the *Académie Julian* his interpretation of the older man's ideas. Sérusier gathered about him a group known as the *Nabis* which included, among others, Denis, Bonnard, Vuillard, and later Maillol. Their style was variously called symbolist (like the contemporary literature), synthetist, or neotraditionist. It was the ideas of this group that Denis, then aged twenty, expressed in his article, written at the request of Lugné-Poë, who in 1893, with Camille Mauclair and Édouard Vuillard, was to found the famous *Théâtre de l'Oeuvre.*

Remember that a picture—before being a battle horse, a nude woman, or some anecdote—is essentially a plane surface covered with colors assembled in a certain order.

I am seeking a *painting* definition of that simple word "nature," the word which is both the label and the definition of the theory of art most generally accepted by our dying century.

Is it perhaps: the totality of our optical sensations? But, not to mention the disturbance natural to the modern eye, who is not aware of the power mental habits have over our vision? . . . With unexceptionable scientific method, M. Signac can prove to you the absolute necessity of his chromatic perceptions. While M. Bouguereau, if the corrections he gives his students are sincere, is altogether persuaded that he is copying "nature." . . . [See p. 288.]

Our period is literary to the marrow; it refines upon minutiae and is avid of complexity. Do you suppose that Botticelli wanted to put into his *Spring* all the sickly delicacy and precious sentimentality that we have read into it? . . . In every period of decadence, the plastic arts fall into literary affectation and naturalistic negation . . .

All the sentiment of a work of art comes unconsciously, or nearly so, from the state of the artist's soul. "He who wishes to paint Christ's story must live with Christ," said Fra Angelico. This is a truism . . .

The emotion—bitter or sweet, or "literary" as the painters say —springs from the canvas itself, a plane surface coated with colors. There is no need to interpose the memory of any former sensation (such as that of a subject derived from nature).

A Byzantine Christ is a symbol; the Jesus of the modern painter, even in the most correctly drawn turban, is merely literary. In the one, the form is expressive; in the other, an imitation of nature wishes to be so.

Once more I see the *Gioconda*. What voluptuousness in the happy convention that has driven out the false and annoying life of wax figures, lighting, and atmosphere that others try to achieve. The blue arabesques of the background with their penetrating and

caressive rhythm are an enchanting accompaniment to the orange-colored theme—akin to the seduction of the violins in the overture to *Tannhäuser* . . .

The neotraditionist begins to achieve some definitive syntheses. Everything is contained in the beauty of the work itself.

VINCENT VAN GOGH

TO HIS BROTHER THEO

VINCENT VAN GOGH once told his brother Theo that both of them together had painted his pictures, and that Theo should think of himself not as an art dealer, but as an artist. It was certainly true that without Theo to look after him—feed him and clothe him, buy his paints and canvases, and watch over him when he was sick—Vincent's creation would have been impossible. The three volumes of Vincent's letters to his brother cover the whole of his life as an artist. All the quotations here are drawn from letters written between the time Vincent left Paris, after discovering impressionism and Japanese prints, and his first fit of madness when Gauguin was staying with him. They represent what was probably the happiest year of his short life, when, in his first intoxication with the sun of the *Midi,* Vincent was putting all his vitality into a tremendous rush of production.

For similar opinions on the use of non-naturalistic color, see Gauguin, p. 373.

Arles, 1888

Is it not emotion, the sincerity of one's feeling for nature, that draws us, and if the emotions are sometimes so strong that one works without knowing one works, when sometimes the strokes come with a sequence and a coherence like words in a speech or a letter, then one must remember that it has not always been so, and that in the time to come there will again be heavy days, empty of inspiration.

So one must strike while the iron is hot, and put the forged bars on one side.

Arles, 1888

You talk of the emptiness you feel everywhere; it is just that very thing that I feel myself.

Taking if you like the time in which we live as a great and true renaissance of art, the worm-eaten official tradition still alive but really impotent and inactive, the new painters alone, poor, treated like madmen and because of this treatment actually becoming so at least as far as their social life is concerned.

THE MARRYING OF FORM AND COLOR *Arles, 1888*

Why does one not hold to what one has, like the doctors and the engineers; once a thing is discovered and invented they retain the knowledge; in these wretched Fine Arts everything is forgotten, nothing is kept.

Millet gave the synthesis of the peasant, and now, yes, there is Lhermitte, certainly there are a few others, Meunier . . . Then have we in general learned now to see the peasant? No, hardly anyone knows how to knock one off.

Is the fault really not a little with Paris and the Parisians, changeable and faithless as the sea?

Well, you have damn good reason to say: Let us go quietly on our way, working for ourselves. You know, whatever this sacrosanct impressionism may be, all the same I wish I could paint things that the generation before, Delacroix, Millet, Rousseau, Diaz, Monticelli, Isabey, Décamps, Dupré, Jongkind, Ziem, Israels, Meunier, a heap of others, Corot, Jacque, etc., could understand.

Ah, Manet has been very, very near it, and Courbet, the marrying of form and color. I would very much like to hold my tongue for ten years, and do nothing but studies, then do one or two pictures of figures. The old plan, so much urged, is so seldom put in practice.

SYMBOLIC PORTRAITS: SYMBOLIC COLOR *Arles, 1888*

What a mistake Parisians make in not having a palate for crude things, for Monticellis, for clay! But there, one must not lose heart because Utopia is not coming true. It is only that what I learned in Paris is leaving me, and that I am returning to the ideas I had in the country before I knew the impressionists. And I should not be surprised if the impressionists soon find fault with my way of working, for it has been fertilized by the ideas of Delacroix rather

than by theirs. Because, instead of trying to reproduce exactly what I have before my eyes, I use color more arbitrarily so as to express myself forcibly. Well, let that be as far as theory goes, but I am going to give you an example of what I mean.

I should like to paint the portrait of an artist friend, a man who dreams great dreams, who works as the nightingale sings, because it is his nature. He'll be a fair man. I want to put into the picture my appreciation, the love that I have for him. So I paint him as he is, as faithfully as I can, to begin with.

But the picture is not finished yet. To finish it I am now going to be the arbitrary colorist. I exaggerate the fairness of the hair, I come even to orange tones, chromes, and pale lemon yellow.

Beyond the head, instead of painting the ordinary wall of the mean room, I paint infinity, a plain background of the richest, intensest blue that I can contrive, and by this simple combination of the bright head against the rich blue background, I get a mysterious effect, like a star in the depths of an azure sky.

Arles, 1888

In the end, it is to be feared that as soon as the new painting is appreciated, the painters will go soft.

But anyway, this much is positive, it is not we of the present time who are decadent. Gauguin and Bernard talk now of "painting like children"—I would rather have that than "painting like decadents." How is it that people see something decadent in impressionism? It is very much the reverse.

TO EXPRESS HOPE BY SOME STAR *Arles, 1888*

If, defrauded of the power to create physically, a man tries to create thoughts in place of children, he is still part of humanity.

And in a picture I want to say something comforting as music is comforting. I want to paint men and women with that something of the eternal which the halo used to symbolize, and which we seek to give by the actual radiance and vibration of our colorings . . .

Ah! portraiture, portraiture with the thought, the soul of the model in it, that is what I think must come.

Arles, 1888

So I am always between two currents of thought, first the material difficulties, turning round and round and round to make a living; and second, the study of color. I am always in hope of making a discovery there, to express the love of two lovers by a marriage of two complementary colors, their mingling and their opposition, the mysterious vibrations of kindred tones. To express the thought of a brow by the radiance of a light tone against a somber background.

To express hope by some star, the eagerness of a soul by a sunset radiance. Certainly there is nothing in that of stereoscopic realism, but is it not something that actually exists?

JAPANESE ART *Arles, 1888*

If we study Japanese art, you see a man who is undoubtedly wise, philosophic, and intelligent, who spends his time how? In studying the distance between the earth and the moon? No. In studying the policy of Bismarck? No. He studies a single blade of grass.

But this blade of grass leads him to draw every plant and then the seasons, the wide aspects of the countryside, then animals, then the human figure. So he passes his life, and life is too short to do the whole . . .

And you cannot study Japanese art, it seems to me, without becoming much gayer and happier, and we must return to nature in spite of our education and our work in a world of convention.

LEARN A LITTLE TO BE PRIMITIVE *Arles, 1888*

And so what Rembrandt has alone or almost alone among painters, that tenderness in the gaze which we see whether it's in the *Pilgrims of Emmaus,* or in the *Jewish Bride,* or in some such strange angelic figure as the picture you have had the luck to see —that heartbroken tenderness, that glimpse of a superhuman infinite that there seems so natural, in many places you come upon it in Shakespeare. And then portraits grave or gay, like the *Six* and like the *Traveler,* and like the *Saskia*—he is full of them, above all.

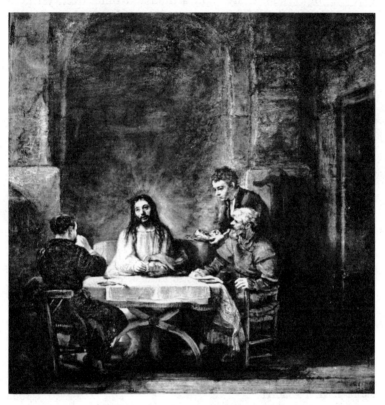

REMBRANDT: Christ at Emmaus, 1648

When I think of the impressionists and of all the problems of art nowadays, what lessons there are for us in that very thing! And so the idea came to me from what I have just been reading that the impressionists are right a thousand times over, yet even then they must consider much and often if it follows from that that they have the right or the duty to take justice into their own hands.

If they dare to call themselves primitives, certainly they would do well to learn a little to be primitives as men before pronouncing the word "primitive" as a title, which would give them a right to anything whatsoever. But as for those who may be the cause of the impressionists' ill fortune—well, they are in pretty serious case, even though they make a jest of it.

JAMES ENSOR

SELECTIONS FROM HIS WRITINGS

As HE was forced to paint for himself, so Ensor wrote for himself. And, as in his pictures, he expresses himself in a violent and sarcastic language often difficult to understand, and even more difficult to translate. In its deliberate affront to sensibility, and on occasion to reason, is wrapped that combination of profound pessimism and bitter pride induced by a hard and lonely life.

For the expression of another artistic recluse, see the letters of Ryder, p. 356.

FROM LINE TO LIGHT *1882*

Vision changes while it observes. The first, vulgar vision is that of the simple, dry line, without any attempt at color. In the second stage the more practiced eye distinguishes delicacies of tone and value; this stage is ahead, less understood by the common eye. The third is that in which the artist sees the multiple subtlety and play of light, its planes, its attractions and directions. These progressive discoveries so modify the primitive vision that line suffers and becomes secondary. This vision will be little understood. It requires long observation and attentive study. The vulgar will see

nothing but chaos, disorder, and incorrectness. Thus art has evolved from Gothic line through the color and movement of the Renaissance to reach modern light.

REASON IS THE ENEMY OF ART [*Ca. 1915*]

Let us put our claims on the table, fully and philosophically, and if they seem to have a dangerous odor of pride, so much the better.

Definite and proven results:

My unceasing investigations, today crowned with glory, aroused the enmity of my snail-like followers, continually passed on the road . . . Thirty years ago, long before Vuillard, Bonnard, van Gogh, and the luminists, I pointed the way to all the modern discoveries, all the influence of light and freeing of vision.

A vision that was sensitive and clear, not understood by the French impressionists, who remained superficial daubers suffused with traditional recipes. Manet and Monet certainly reveal some sensations—and how obtuse! But their uniform effort hardly foreshadows decisive discoveries.

Let us condemn the dry and repugnant attempts of the pointillists, already lost to light and to art. They apply their pointillism coldly, methodically, and without feeling; and in their correct and frigid lines they achieve only one of the aspects of light, that of vibration, without arriving at its form. Their too limited method prohibits further investigation. An art of cold calculation and narrow observation, already far surpassed in vibration.

O Victory! the field of observation grows infinite, and sight, freed and sensitive to beauty, always changes, and perceives with the same acuity the effects or lines dominated by form or light . . .

. . . Narrow minds demand old beginnings, identical continuations. The painter must repeat his little works, and all else is condemned. These poor creatures demand that adorable fantasy, roseate flower of heaven, be severely banished from the artistic program . . .

Yes, before me the painter did not heed his vision.

HANS VON MARÉES

TO CONRAD FIEDLER

SOME FIFTEEN years before this letter was written Marées, in Rome for the first time, unsure of his own artistic powers, and in financial difficulties, had suffered a period of profound melancholy brought on by the overwhelming impression of the old masters and the antique and the necessity for the unity of life and style. Fiedler, a lawyer by profession, but chiefly an amateur of the arts, had rescued him and assured his existence.

On the artist as a "human being" see Pissarro, p. 318; and on his reconciliation to his own powers, see Cézanne, p. 367.

DEFINITION OF AN ARTIST *Rome, January 29, 1882*

I would call that man a born artist whose soul nature has from the very beginning endowed with an ideal, and for whom this ideal replaces the truth; he believes in it without reservation, and his life's task will be to realize it completely for himself, and to set it forth for the contemplation of others. This word "ideal" is one of those which is easily misunderstood; for the plastic artist it consists first of all in the fact that for him everything he sees has an inexhaustible fullness and value. His mind and spirit are early fixed in this direction, and the qualities necessary to it—reflection, urge to copy, manual dexterity, etc.—also develop soon . . .

From the beginning I felt within myself the existence of a standard by which I could shape my own judgment—and, strictly speaking, its shaping has been my life's main task. For even the gifted can accomplish nothing without a matured judgment. "And he saw that it was good": this, in the end, is what the artist must be able to say, even if, being only human, he can only say it conditionally. That he remains a human being is what makes it so hard for him to be an artist, and yet the one is impossible without the other. Nor can he escape the necessity of becoming a complete, and in so far as possible a purified, human being. I know no other way to acquire that direct, ingenuous attitude towards nature which

we point to as one of the finest gifts of childhood; nor any other way of finding a means of-expression intelligible to all. (An easy accessibility is always one of the finest qualities of a work of art.) . . .

The balance between warm susceptibility to impressions and cool judgment, between which the artist continually swings to and fro, can only be found in self-conquest and subsequent self-control. The happiest and proudest artist will be he who most easily achieves renunciation. I mean renunciation in the highest sense of the word —that which lies in not exhibiting one's talent and knowledge, and using them only in so far as they are relevant. Because it will prove to be a fact that a mere excess of artistic power will not make the solution of even the simplest artistic problem easy; for a perfect solution even the most extraordinary powers will hardly suffice . . .

He who desires what he can in no way accomplish does not give brilliant proof of his intelligence. The artist has grasped the most that is attainable when he has really accomplished all that lies within his power. I believe this to be very rare, and find that the essential cause always lies in purely human, moral reasons. There is no question but that external circumstances also play a great part. But for this very reason I say that the artist must lift himself above all external circumstance, even above himself. For, last but not least, he must in his works achieve a bold and un-hampered resolution that denies all pain and trouble, or at least hides them from the eyes of the world.

ADOLF VON HILDEBRAND

THE PROBLEM OF FORM

HILDEBRAND, A friend of Marées and Fiedler, belonged to the Munich group. His work and theories influenced his own pupils, while his book, *The Problem of Form,* was better known among critics and aestheticians than among artists. Yet his views were in accord with the general currents of his time: consideration of form for its own sake; a preference for archaic styles;

the substitution of parallel planes in space for modeling in the round. For opposing points of view, see the opinions of Cellini, p. 89; Rodin, p. 323; and Rosso, p. 329.

SPACE FROM SUCCESSIVE SILHOUETTES *Munich, 1893*

It has been pointed out [that] the artist, with his problem of making a unitary picture out of his complicated ideas of the three-dimensional, is compelled to separate clearly the two-dimensional appearance of the object from the general subjective idea of depth. Thus he arrives at a simple idea of volume as a plane continuing into the distance. To make this manner of presentation quite clear, think of two planes of glass standing parallel, and between them a figure whose position is such that its outer points touch them. The figure then occupies a space of uniform depth measurement and its members are all arranged within this depth. When the figure, now, is seen from the front through the glass, it becomes unified into a unitary pictorial surface, and, furthermore, the perception of its volume, of itself quite a complicated perception, is now made uncommonly easy through the conception of so simple a volume as the total space here presented. The figure lives, we may say, in one layer of uniform depth . . .

By this sort of arrangement the object resolves itself into a layer of a certain uniform thickness. The total volume of a picture will then consist, according to the objects represented, of a greater or lesser number of such imaginary layers arranged one behind the other, yet all together uniting into one appearance having one uniform depth measurement. So the artist divides and groups his ideas of space and form, which consisted originally in a complex of innumerable kinesthetic ideas, until there results a simple visual impression stimulating a strong idea of depth, which the resting eye is able to take in, without kinesthetic sensations or movements.

CONCEPT OF RELIEF

This common mode of artistic imagination as above developed is no other than the concept of relief so prominent in Greek art. This concept of relief defines the relation of two-dimensional im-

pressions to three-dimensional. It gives us a specific way of viewing nature; it is a mold in which the artist casts the form of nature. In all ages this mode of perception has resulted from the artist's insight into the unchangeable laws of art. Its absence means a deficiency in one's artistic relation to nature, an incapacity to understand this relation and develop it consistently. The thousand-fold judgments and movements of our observation find in this mode of presentation their stability and clearness. It is an essential to all artistic form, be it in a landscape or in the portrayal of a head. In this way the visual content is universally arranged, bound together, and put in repose . . .

It is only thus that [the artist's] work attains a uniform standard of measurement. The more clearly this is felt, the more unified and satisfactory is the impression. This unity is, indeed, the Problem of Form in Art, and the value of a work of art is determined by the degree of such unity it attains.

FERDINAND HODLER

PARALLELISM

IN THIS statement Hodler set forth the reasoned basis of the decorative and symbolic "parallelism" that pervaded all his painting, but that was particularly strong in the works done between 1895 and 1910. Together with a lecture given in 1897 upon the invitation of the University of Freiburg, it constitutes his whole theoretical writing.

[Ca. 1900]

I call parallelism any kind of repetition.

When I feel most strongly the charm of things in nature, there is always an impression of unity.

If my way leads into a pine wood where the trees reach high

392

into heaven, I see the trunks that stand to the right and to the left of me as countless columns. One and the same vertical line, repeated many times, surrounds me. Now, if these trunks should be clearly outlined on an unbroken dark background, if they should stand out against the deep blue of the sky, the reason for this impression of unity is parallelism. The many upright lines have the effect of a single grand vertical or of a plane surface . . .

A tree always produces the same form of leaf and fruit. When Tolstoy, in *What Is Art?* says that two leaves of the same tree are never exactly alike, one might more correctly answer that nothing looks more like a maple leaf than the leaf of the maple . . .

I must also point out that in nearly all the examples I have just given, the repetition of color enhances that of form. The petals of a flower, as well as the leaves of a tree, are generally of the same color.

Now we also recognize the same principle of order in the structure of animal and human bodies in the symmetry of the right and left halves . . .

Let us then sum up: Parallelism can be pointed out in the different parts of a single object, looked at alone; it is even more obvious when one puts several objects of the same kind next to each other.

Now if we compare our own lives and customs with these appearances in nature, we shall be astonished to find the same principle repeated . . .

When an important event is being celebrated, the people face and move in the same direction. These are parallels following each other . . .

If a few people who have come together for the same purpose sit around a table, we can understand them as parallels making up a unity, like the petals of a flower.

When we are happy we do not like to hear a discordant voice that disturbs our joy.

Proverbially, it is said: Birds of a feather flock together.

In all these examples parallelism, or the principle of repetition, can be pointed out. And this parallelism of experience is, in expression, translated into the formal parallelism which we have already discussed . . .

If an object is pleasant, repetition will increase its charm; if it

expresses sorrow or pain, then repetition will intensify its melancholy. On the contrary, any subject that is peculiar or unpleasant will be made unbearable by repetition. So repetition always acts to increase intensity . . .

Since the time that this principle of harmony was employed by the primitives, it has been visually lost, and so forgotten. One strove for the charm of variety, and so achieved the destruction of unity . . .

Variety is just as much an element of beauty as parallelism, provided that one does not exaggerate it. For the structure of our eye itself demands that we introduce some variety into any absolutely unified object . . .

To be simple is not always as easy as it seems . . .

The work of art will bring to light a new order inherent in things, and this will be: the idea of unity.

WALTER RICHARD SICKERT

FROM HIS WRITINGS ON ART

SICKERT WAS among those English painters who based their art upon a union of French impressionism with the British tradition of genre realism, and who, following Whistler and Wilde, were equally at home in France and in England. A man of the theater as well as a painter, Sickert was also a prolific writer on art and, in this role, often the friendly enemy of Roger Fry and Clive Bell. Sickert wrote the first of these pieces in reaction against the enthusiastic introduction into England of French postimpressionist works at Brighton in the summer of 1910 and at the famous Grafton Gallery exhibition in the winter of 1910-1911.

For other—and very different—opinions on Ingres, see Rousseau, p. 289, and Redon, p. 359.

CÉZANNE *London, 1911*

History must needs describe Cézanne as *un grand raté,* an incomplete giant. But nothing can prevent his masterpieces from taking rank . . .

Cézanne was fated, as his passion was immense, to be immensely neglected, immensely misunderstood, and now, I think, immensely

overrated. Two causes I suspect have been at work in the reputation his work now enjoys: I mean causes, after all acknowledgment is made of a certain greatness in his talent. The moral weight of his single-hearted and unceasing effort, of his tragic love for his art, has made itself felt. In some mysterious way, indeed, this gigantic sincerity impresses, and holds, even those who have not the slightest knowledge of what were his qualities, of what he was driving at, of what he achieved, or of where he failed.

DRAWING *London, August, 1916*

All draftsmen do two things in succession. First they draw, and then, sometimes, generally one may say, they upholster their drawings. This upholstery corresponds to padding in literature, and may be very skillfully and beautifully done, as it may be poorly done. Among Rembrandt's etchings the *Boys Bathing* is pure drawing with no upholstery. There is not in it a line which is not alive. The *Burgomaster Six,* on the other hand, is a drawing that has been upholstered to death, skillfully, industriously, tenderly upholstered, if you will, but upholstered to death. If Rembrandt had known how to stay his hand, when the plate was at its most expressive, we should have had a masterpiece instead of a laborious work. I may say these things about Rembrandt. *Je suis très bien avec Rembrandt.* The shade of Rembrandt is not like the standardized *ancien-jeune.* He does not consider criticism "disloyal." He is no longer a vested interest.

INGRES *London, June, 1922*

In Ingres we come to the modern who proves the oneness of past and present, . . . the modern who was not the sketcher, but the painter of pictures. At the age of twenty-five he had painted the portrait of Mme. Rivière, one of the great paintings of the world. So slack, so sentimental, so impatient have we become that the mere momentary contemplation of such intellectual wealth, such patience, such ingenuity is to us a greater fatigue than were to him their constant exercise. He humiliates and crushes us, and drives us to a defense consisting of theories of negation. "We have got past that," we say, holding out empty hands . . .

INGRES: Portrait of Mme Rivière, 1805

For all this the path of classic effort is neither a hidden nor mysterious one. It moves from careful step to careful step, and cumulates by what is little more than sublimated common sense. Since a suave and beautiful execution must needs be slow, careful, and laborious, and since the life to be suggested by the work is in its essence fleeting, it is clear that the execution of a picture and the impression received from nature must be separated. The part that is played in the work of Ingres by painting from nature is a small one. Some painted studies we have, but few. He must have felt how heavy-handed was the brush charged with its sticky burden, compared to the point . . .

. . . In what does the painting by Ingres differ from a plate of color photography? First in this, that all dross, external to what has interested the painter, has been fired out. Then that each line and each volume has been subtly and unconsciously extended here and contracted there, as the narrator is swayed by his passion, his rhetoric. The drawing has become a living thing with a life, with a debit and credit of its own. What it has borrowed here, it may, or may not, as it pleases, pay back there. And further, the following compromise has, from the necessity of the case, to be set up, and it, the very compromise itself, is the creation of the beauty of color in a picture. Nature having the range of all colors, plus the range from light to shade, can set this double range against the painter's single range of color, in a uniform light. So the great painters of the world have in their traditional cunning hit upon the plan of attenuating, as they cannot but do, the light and shade of their pictures, and paying us back by drenching each tone with as much of the wine of color as it will hold, without contradicting the light and shade.

ROBERT HENRI

THE ART SPIRIT

THE OLDEST member of the famous "Eight" who showed together in 1908, and in a sense their champion and defender, Henri was for twenty-five years a successful and influential teacher, opposed to the academic, and helpful in training such younger realists as George Bellows. Here he gives expression to two of the fundamentals of his art: his interest in the direct painting tradition of Hals, Velasquez, and Manet; and his interest in embodying the quality and human meaning of everyday things.

Contrast his views with the later "pure painting" attitude of his onetime associate in the "Eight," John Sloan, p. 401.

BEAUTY IN FUNCTION

I love the tools made for mechanics. I stop at the windows of hardware stores. If I could only find an excuse to buy many more

of them than I have already bought on the mere pretense that I might have use for them! They are so beautiful, so simple and plain and straight to their meaning. There is no "art" about them, they have not been *made* beautiful, they *are* beautiful.

Someone has defined a work of art as a "thing beautifully done." I like it better if we cut away the adverb and preserve the word "done," and let it stand alone in its fullest meaning. Things are not done beautifully. The beauty is an integral part of their being done.

HUMAN FEELING

Because we are saturated with life, because we are human, our strongest motive is life, humanity; and the stronger the motive back of a line the stronger, and therefore the more beautiful, the line will be.

Critics have written that Renoir was not interested in the people he painted, was only interested in color and form, that the who or what of the model was totally negligible to him. Yet one has only to look at those little children he painted, the one bending over his writing, the two little girls at the piano, to cite instances; and it will be apparent that Renoir had not only a great interest in human character, in human feeling, but had also a great love for the people he painted.

He needed new inventions in technique, in color and form to express what he felt about life. His feeling was so great that his search was directed, and the result is as we have seen—great rhythms in form and color.

NATIONALISM

In a great many writings and in much conversation I have noted a tendency to consider the paintings of a man who has never been abroad more American than those of a man who has been abroad. One may as well say that Benjamin Franklin left his American spirit in Philadelphia when he went to Europe.

It is quite possible for a man to live all his life in California and paint as a disciple of the Barbizon school and for another to spend

RENOIR: Two Girls at the Piano, 1892

most of his life in the forest of Fontainebleau and show his Californian birth from beginning to end.

After all, the error rests in the mistaken idea that the subject of a painting is the object painted. [Compare Holman Hunt, p. 339.]

ART IS THE ATTAINMENT OF A STATE OF FEELING

The object of painting a picture is not to make a picture—however unreasonable this may sound. The picture, if a picture results, is a by-product and may be useful, valuable, interesting as a sign of what has passed. The object, which is back of every true work of art, is *the attainment of a state of being,* a state of high functioning, a more than ordinary moment of existence. In such moments activity is inevitable, and whether this activity is with brush, pen, chisel, or tongue, its result is but a by-product of the state, a trace, the footprint of the state.

These results, however crude, become dear to the artist who made them because they are records of states of being which he has enjoyed and which he would regain. They are likewise interesting to others because they are to some extent readable and reveal the possibilities of greater existence.

JOHN SLOAN

THE GIST OF ART

THESE EXTRACTS from Sloan's book represent his interests as a teacher and his concern with the problems of pure painting that have occupied his later years. He has come a long way from the city subjects, and the picturesque, color-pattern character of his early painting as a member of the famous "Ash Can" school.

For another expression of the primacy of drawing, see Ingres, p. 216.

PAINTING IS DRAWING

Painting is drawing, with the additional means of color. Painting without drawing is just "coloriness," color excitement. To think of color for color's sake is like thinking of sound for sound's sake.

Who ever heard of a musician who was passionately fond of B flat? Color is like music. The palette is an instrument that can be orchestrated to build form.

I am interested in the use of colored tones to build solids and as an added means to composition. The great painters separated form and color as a means to realization. They did it by underpainting the form in semi-neutral colors and bringing that sculptured low relief into plastic existence by superimposed color glazes.

A painting may be a thing, the sculpture of a thing, or it may also have color texture. The painting that has only color has nothing, the painting that has only sculpture has a great deal . . .

I think of a good painting as being a colored low relief with no air pockets. First there is the formative under-substance, the shape of the form that the blind man knows through the sense of touch. This is made with the neutral half-tones that carry the sculpture of the form. Clench your fist and bear down on it with the other hand. That solidness, that bulk, must be created on the canvas. It should be sculptured, not modeled. It may be done with two or three tones, or with three hundred.

You can't see the separation of form and color in nature, it is a mental concept . . . I harp on this idea because I believe it to be the root principle of form realization. No doubt it is the main reason for the special vitality of the Renaissance masters. Their color is beautiful not only because it is harmonious, but because it is significant.

Most pictures painted within the last seventy-five years were made "directly" with opaque oil paint. In other words the artist was painting form and color at the same time. Good pictures have been painted in this way, but none of them have the plastic realization that can be obtained when form and color are painted separately.

HENRI ROUSSEAU

TO ANDRE DUPONT, ART CRITIC

ON MARCH 11, 1910, just six months before his death, Rousseau wrote to the poet Guillaume Apollinaire that he had just sent off his big picture, *The Dream,* to the Independents' exhibition. "Everyone likes it," he wrote. But evidently M. Dupont, who had reviewed the exhibition, did not understand it, and Rousseau wished to give him the proper explanation. The artist does not mention that the woman "in question" was Yadwigha, with whom he was desperately in love, and who spurned his offers of marriage.

Paris, April 1, 1910

I am answering your kind letter immediately in order to explain to you the reason why the sofa in question is included [in my picture *The Dream*]. The woman sleeping on the sofa dreams that she is transported into the forest, hearing the music of the snake charmer's instrument. This explains why the sofa is in the picture . . . I thank you for your kind appreciation; if I have kept my naïveté, it is because M. Gérome, who was professor at the *École des Beaux-Arts,* and M. Clément, director of the *École des Beaux-Arts* at Lyon, always told me to keep it. So in the future you will no longer find it astonishing. And I was also told that I did not belong to this century. You must realize that I cannot now change the manner that I have acquired with such stubborn labor. I end this note by thanking you in advance for the article you will write about me. Please accept my best wishes, and a hearty and cordial handshake.

HENRI ROUSSEAU: The Dream, 1910

ANTOINE BOURDELLE

ON SCULPTURE

THESE OPINIONS of Bourdelle have been selected from his conversation, his criticisms given while teaching at the atelier of the *Grande Chaumière,* and an early unpublished manuscript—all as recorded by his biographer, Gaston Varenne.

On Michelangelo, see Canova, p. 198; Maillol, p. 406; and Epstein, p. 463.

ARCHAISM *Paris, 1910*

Those who dislike my work—and they are many—have told me that it is archaic. They told me that as a punishment.

They thought that archaism was something dead, belonging to a far-off fabulous time. But archaism is eternal and living.

Each archaic synthesis is a born enemy of the lie, of all the *trompe l'œil* art which changes stones into corpses. The archaic is neither naïve nor outmoded. It is the art that has penetrated and is at one with the universe, that is both the most eternal and the most human. All narrow minds, frightened by the sublime nakedness of truth, find it rude and worn because it is too far above their understanding.

Life itself has been my school.

MICHELANGELO

One can find no attitudes more admirably composed than the *Thinker* and the *Moses*—in the first, one of man's noblest actions; in the second, an almost divine expression.

And yet one must have the courage to say . . . that though these two works are the issue of great minds, they belong to the world of the theater and the mode of literature, and no longer partake of the laws of sculpture.

Their superb mimicry holds a whole world of decadence; they open an era of art built upon gesture, forgetting the original, the sovereign law of beauty that replaces the mimicry of gesture by the sublime emotion of just construction. We should return to this original truth.

I hold Romanesque art to be the purest, the most direct, and the most enlightened plastic expression of Christian constructive and decorative thought.

In a Romanesque church I feel myself caught and held by the mathematical principles of truth. Romanesque construction is at once vision and calculation; within the laws of this art the initiated can build their faith upon the solid foundations of reason . . .

Romanesque art is organic and logical; it is the living temple conceived in universal form. In this cradle of the absolute was rocked our French genius and spirit.

ARISTIDE MAILLOL

CONVERSATIONS WITH JUDITH CLADEL

THE VIEWS of Maillol on art are recorded for us only through interviews and conversations. These paragraphs are drawn from the record of his opinions and reminiscences set down by Judith Cladel—also the biographer and scribe of the last years of Rodin's life.

On sculpture seen from many sides, compare Cellini, p. 89; on Michelangelo compare the opinions of Rodin, p. 327.

MICHELANGELO

The particular does not interest me; I find meaning only in a general idea. In Michelangelo one is carried away by the idea of power, the whole singleminded concept he imposed on himself. The *Slaves* and the *Medici Tombs* are sculpture made to be seen only from one side. For me, sculpture means the block; my figure of *France* has more than twenty different sides. When I enlarged it only four were left, and I had to rework it . . .

I have a weakness for Egyptian sculpture: its figures are sculptured gods, sculptured ideas. Very different in expression, Hindu sculpture is based on very similar assumptions . . . The oriental peoples are much more artistic than we. When nations

grow old, their art grows complicated and soft. We should try to return to our youth, to work naïvely; this is what I seek, and it is why I have had such success, because our century has tried to return to the primitive. I work as if no art had ever been made, before me, as if I had never learned anything. I am the first man to do sculpture.

AFRICAN SCULPTURE

But one must be modern, one must adapt oneself to one's own time. Gauguin made a mistake when he imitated Negro sculpture. He should have done his sculpture in the same way as his painting, by drawing from nature, while instead he made women with large heads and little legs. He had two different ideas, one in painting, and another in sculpture; so he was a double nature. At the beginning of my career it was said that I was influenced by his reliefs in wood. That is a legend. I did make use of his style, but only in painting.

Negro art contains more ideas than Greek art. Its strange inventiveness of form is astonishing, and its imagination and extraordinary sense of decoration are difficult to explain. We dare not take such liberties; but the Negroes have succeeded. We are too much the subjects of our own past . . . Those who do Negro art in this country are wrong. We are in France; in the country of Ronsard, La Fontaine, and Racine. What connection is there between this country and these men, and Negro sculpture? An artist can only create in accordance with the character of his people and his time . . . But it is difficult to explain such things.

When Picasso does pure painting he is a great artist. When he paints as a cubist, putting one tone next to another, the arrangement of planes is fine and the result very strong. But those who imitate him achieve nothing worth while.

IMMOBILITY IN SCULPTURE

For my taste, sculpture should have as little movement as possible. It should not fall, and gesture, and grimace, and if one depicts movement, grimaces come too easily. Rodin himself remains

quiet; he puts movement into his rendering of muscles, but the whole remains quiet and calm. The more immobile Egyptian statues are, the more it seems as if they would move . . . One expects to see the Sphinx get up. Hindu sculptors made statues with ten arms, but they are not agitated, they have the serenity of that which does not move. On the other hand, I dislike the fugitive lines of the *Roman Gladiator* . . . Immobility of the body does not mean immobility of the flesh: in my model for the monument to Cézanne the whole figure is quiet, but there are several movements in the torso.

DONATELLO AND DELLA QUERCIA

I do not like Donatello. In his own way, he displeases me as much as Praxiteles. When Bourdelle and I saw much of each other I used to like him. Today I prefer the Virgins in our baroque churches. Donatello's art does not come out of nature, it belongs to the studio. He exaggerates to make it lifelike. His weeping children grimace frightfully. One can express sorrow by calm features, but not by a twisted face and a distended mouth. Art should give pleasure . . . When movement is excessive it is frozen: it no longer represents life. The immobility that the artist creates is not at all that of the photograph. A work of art contains latent life, possibility of movement; a grimace made eternal does not represent life. One always talks of Donatello, but never of della Quercia. Yet della Quercia invented Michelangelo's style before Michelangelo.

HENRI-MATISSE

NOTES OF A PAINTER

THE *Notes d'un Peintre* from which these extracts are taken were first published in *La Grande Revue,* on Christmas Day, 1908. "They remain the most complete and authoritative statement by Matisse thus far published." When they were written Matisse was at the height of his style as a *Fauve* painter: *La Joie de Vivre* had been completed the previous year; *La Danse* and *La Musique* were produced in the following two years.

EXPRESSION *Paris, 1908*

What I am after, above all, is expression. Sometimes it has been conceded that I have a certain technical ability but that, my ambi-

tion being limited, I am unable to proceed beyond a purely visual satisfaction such as can be procured from the mere sight of a picture. But the purpose of a painter must not be conceived as separate from his pictorial means, and these pictorial means must be the more complete (I do not mean complicated) the deeper is his thought. I am unable to distinguish between the feeling I have for life and my way of expressing it.

COMPOSITION

Expression, to my way of thinking, does not consist of the passion mirrored upon a human face or betrayed by a violent gesture. The whole arrangement of my picture is expressive. The place occupied by figures or objects, the empty spaces around them, the proportions—everything plays a part. Composition is the art of arranging in a decorative manner the various elements at the painter's disposal for the expression of his feelings. In a picture every part will be visible and will play the role conferred upon it, be it principal or secondary. All that is not useful in the picture is detrimental . . .

Composition, the aim of which is expression, alters itself according to the surface to be covered. If I take a sheet of paper of given dimensions I will jot down a drawing which will have a necessary relation to its format—I would not repeat this drawing on another sheet of different dimensions, for instance on a rectangular sheet, if the first one happened to be square. And if I had to repeat it on a sheet of the same shape but ten times larger I would not limit myself to enlarging it: a drawing must have a power of expansion which can bring to life the space which surrounds it.

LIMITATIONS OF SPONTANEITY

Both harmonies and dissonances of color can produce very pleasurable effects. Often when I settle down to work I begin by noting my immediate and superficial color sensations. Some years ago this first result was often enough for me—but today if I were satisfied with this my picture would remain incomplete. I would have put down the passing sensations of a moment; they would not completely define my feelings, and the next day I might not

recognize what they meant. I want to reach that state of condensation of sensations which constitutes a picture. Perhaps I might be satisfied momentarily with a work finished at one sitting, but I would soon get bored looking at it; therefore, I prefer to continue working on it so that later I may recognize it as a work of my mind . . .

Supposing I want to paint the body of a woman: first of all I endow it with grace and charm, but I know that something more than that is necessary. I try to condense the meaning of this body by drawing its essential lines. The charm will then become less apparent at first glance, but in the long run it will begin to emanate from the new image. This image at the same time will be enriched by a wider meaning, a more comprehensively human one, while the charm, being less apparent, will not be its only characteristic. It will be merely one element in the general conception of the figure. [Compare Bernini, p. 134.]

COLOR COMPOSITION

If upon a white canvas I jot down some sensations of blue, of green, of red—every new brush stroke diminishes the importance of the preceding ones. Suppose I set out to paint an interior: I have before me a cupboard; it gives me a sensation of bright red —and I put down a red which satisfies me; immediately a relation is established between this red and the white of the canvas. If I put a green near the red, if I paint in a yellow floor, there must still be between this green, this yellow, and the white of the canvas a relation that will be satisfactory to me. But these several tones mutually weaken one another. It is necessary, therefore, that the various elements that I use be so balanced that they do not destroy one another . . .

I am forced to transpose until finally my picture may seem completely changed when, after successive modifications, the red has succeeded the green as the dominant color. I cannot copy nature in a servile way, I must interpret nature and submit it to the spirit of the picture—when I have found the relationship of all the tones the result must be a living harmony of tones, a harmony not unlike that of a musical composition.

For me all is in the conception—I must have a clear vision of the whole composition from the very beginning.

COLOR AS EXPRESSION

The chief aim of color should be to serve expression as well as possible. I put down my colors without a preconceived plan. If at the first step and perhaps without my being conscious of it one tone has particularly pleased me, more often than not when the picture is finished I will notice that I have respected this tone while I have progressively altered and transformed the others. I discover the quality of colors in a purely instinctive way. To paint an autumn landscape I will not try to remember what colors suit this season, I will only be inspired by the sensation that the season gives me; the icy clearness of the sour blue sky will express the season just as well as the tonalities of the leaves. My sensation itself may vary, the autumn may be soft and warm like a protracted summer or quite cool with a cold sky and lemon yellow trees that give a chilly impression and announce winter.

My choice of colors does not rest on any scientific theory; it is based on observation, on feeling, on the very nature of each experience. Inspired by certain pages of Delacroix, Signac is preoccupied by complementary colors, and the theoretical knowledge of them will lead him to use a certain tone in a certain place. [See p. 376.] I, on the other hand, merely try to find a color that will fit my sensation. There is an impelling proportion of tones that can induce me to change the shape of a figure or to transform my composition. Until I have achieved this proportion in all the parts of the composition I strive towards it and keep on working. Then a moment comes when every part has found its definite relationship, and from then on it would be impossible for me to add a stroke to my picture without having to paint it all over again.

SUBJECT-MATTER

What interests me most is neither still life nor landscape but the human figure. It is through it that I best succeed in expressing the nearly religious feeling that I have towards life. I do not insist upon the details of the face. I do not care to repeat them with

anatomical exactness. Though I happen to have an Italian model whose appearance at first suggests nothing but a purely animal existence, yet I succeed in picking out among the lines of his face those which suggest that deep gravity which persists in every human being. A work of art must carry in itself its complete significance and impose it upon the beholder even before he can identify the subject-matter. When I see the Giotto frescoes at Padua I do not trouble to recognize which scene of the life of Christ I have before me, but I perceive instantly the sentiment which radiates from it and which is instinct in the composition in every line and color. The title will only serve to confirm my impression.

TRANQUILLITY

What I dream of is an art of balance, of purity and serenity devoid of troubling or depressing subject-matter, an art which might be for every mental worker, be he businessman or writer, like an appeasing influence, like a mental soother, something like a good armchair in which to rest from physical fatigue.

GEORGES ROUAULT

I AM A BELIEVER AND A CONFORMIST

GEORGES ROUAULT is perhaps the most important religious painter of this century. Here he recalls the period of 1900 to 1910 when, as a member of the *Fauve* group opposed to the art of the Academy, he was developing his own personal style.

On art as "arabesque," see Redon, p. 361, and compare the views of Rouault's fellow-*Fauve*, Matisse, p. 409; on academic art, see also Manet, p. 306.

Paris, 1937

Art of the people, you have lived far from the Academy, will you ever come to life again? The School was not dead, but had so little strength, and did not know where to turn nor whom to heed.

414

Copying nature had not freed it from its badly adjusted Ingrist snobbism; it accused others of being up-to-the-minute moderns oversensitive to a success they had not sought. A confused period, in which no strong style appeared, and in his heart each thought how sweet and good it would be to taste the success he denied his neighbor. In both camps an occasional heroic exception, who took care not to be too much in evidence, since each one was engaged in drawing his secret plans, making his own way, and, though divided within himself, trying to play the bully. The dream we dreamed in our youth of faithfulness to a rigid ideal, an ideal a little too lofty and a little too great for our gifts—who can say he has wholeheartedly pursued it?

Often pagans, with their eyes wide open, do not see very clearly. How they have dinned their decorative art into our ears! There is no such thing as decorative art, but only art, intimate, heroic, or epic. We are far removed from the great fresco painters of the past, beside whom we often appear so small, but in every well-found work there will always be an arabesque of rhythm—which will not prevent fine and subtle relationships of texture. There has been confusion. One imagined one was returning to simplicity, while in truth one had achieved poverty: Everyone painted "decorations."

I am a believer and a conformist. Anyone can revolt; it is more difficult silently to obey our own interior promptings, and to spend our lives finding sincere and fitting means of expression for our temperaments and our gifts—if we have any. I do not say "neither God, nor Master," only in the end to substitute myself for the God I have excommunicated . . .

Is it not better to be a Chardin, or even much less, than a pale and unhappy reflection of the great Florentine?

To equal Angelico it is not enough to pray before painting; nor will belief in spiritual means alone produce viable work; first a strong and lively inclination is necessary.

Degas will always be in bad odor for having said "the fine arts must be discouraged."

PABLO PICASSO

AN INTERVIEW

PICASSO HAS been the most prolific artist of the twentieth century. He has, besides, written poetry; but he has never, with his own hand, written anything on art. He has, however, granted two interviews for publication. "The following statement was made in Spanish to Marius de Zayas. Picasso approved de Zayas' manuscript before it was translated into English and published in *The Arts,* New York, May, 1923, under the title *Picasso Speaks.*" At the time he made the statement, Picasso was painting in the manner generally known as his "classic period."

DO NOT SEEK—FIND! *Paris, 1923*

In my opinion to search means nothing in painting. To find is the thing. Nobody is interested in following a man who, with

his eyes fixed on the ground, spends his life looking for the pocket-book that fortune should put in his path . . .

Among the several sins that I have been accused of committing, none is more false than the one that I have, as the principal objective in my work, the spirit of research. When I paint my object is to show what I have found and not what I am looking for. In art intentions are not sufficient and, as we say in Spanish, love must be proved by facts and not by reasons . . .

The idea of research has often made painting go astray, and made the artist lose himself in mental lucubrations. Perhaps this has been the principal fault of modern art. The spirit of research has poisoned those who have not fully understood all the positive and conclusive elements in modern art and has made them attempt to paint the invisible and, therefore, the unpaintable.

They speak of naturalism in opposition to modern painting. I would like to know if anyone has ever seen a natural work of art. Nature and art, being two different things, cannot be the same thing. Through art we express our conception of what nature is not.

Velasquez left us his idea of the people of his epoch. Undoubtedly they were different from what he painted them, but we cannot conceive a Philip IV in any other way than the one Velasquez painted . . .

And from the point of view of art there are no concrete or abstract forms, but only forms which are more or less convincing lies. That those lies are necessary to our mental selves is beyond any doubt, as it is through them that we form our aesthetic point of view of life.

Cubism is no different from any other school of painting. The same principles and the same elements are common to all. The fact that for a long time cubism has not been understood and that even today there are people who cannot see anything in it, means nothing. I do not read English, an English book is a blank book to me. This does not mean that the English language does not exist, and why should I blame anybody else but myself if I cannot understand what I know nothing about?

ART DOES NOT EVOLVE

I also often hear the word "evolution." Repeatedly I am asked to explain how my painting evolved. To me there is no past or future in art. If a work of art cannot live always in the present it must not be considered at all. The art of the Greeks, of the Egyptians, of the great painters who lived in other times, is not an art of the past; perhaps it is more alive today than it ever was. Art does not evolve by itself, the ideas of people change and with them their mode of expression. When I hear people speak of the evolution of an artist, it seems to me that they are considering him standing between two mirrors that face each other and re-produce his image an infinite number of times, and that they contemplate the successive images of one mirror as his past, and the images of the other mirror as his future, while his real image is taken as his present. They do not consider that they all are the same images in different planes . . .

The several manners I have used in my art must not be con-sidered as an evolution, or as steps towards an unknown ideal of painting . . . When I have found something to express, I have done it without thinking of the past or of the future. I do not believe I have used radically different elements in the different manners I have used in painting. If the subjects I have wanted to express have suggested different ways of expression I have never hesitated to adopt them. I have never made trials nor experiments. Whenever I had something to say I have said it in the manner in which I have felt it ought to be said. Different motives inevitably require different methods of expression.

CUBISM

Many think that cubism is an art of transition, an experiment which is to bring ulterior results. Those who think that way have not understood it. Cubism is not either a seed or a fetus, but an art dealing primarily with forms, and when a form is realized it is there to live its own life . . . If cubism is an art of transition I am sure that the only thing that will come out of it is another form of cubism.

Mathematics, trigonometry, chemistry, psychoanalysis, music,

and what not have been related to cubism to give it an easier interpretation. All this has been pure literature, not to say nonsense, which brought bad results, blinding people with theories.

Cubism has kept itself within the limits and limitations of painting, never pretending to go beyond it.

A CONVERSATION

"CHRISTIAN ZERVOS [editor of *Cahiers d'Art*] put down these remarks of Picasso immediately after a conversation with him at Boisgeloup, his country place, in 1935. When Zervos wanted to show Picasso his notes Picasso replied: 'You don't need to show them to me. The essential thing in our period of weak morale is to create enthusiasm. How many people have actually read Homer? All the same the whole world talks of him. In this way the Homeric legend is created. A legend in this sense provokes a valuable stimulus. Enthusiasm is what we need most, we and the younger generation.'

"Zervos reports, however, that Picasso did actually go over the notes and approved them informally."

Paris, 1935

It is my misfortune—and probably my delight—to use things as my passions tell me. What a miserable fate for a painter who adores blondes to have to stop himself putting them into a picture because they don't go with the basket of fruit! How awful for a painter who loathes apples to have to use them all the time because they go so well with the cloth. I put all the things I like into my pictures. The things—so much the worse for them; they just have to put up with it.

A PICTURE IS A SUM OF DESTRUCTIONS

In the old days pictures went forward towards completion by stages. Every day brought something new. A picture used to be a sum of additions. In my case a picture is a sum of destructions. I do a picture—then I destroy it. In the end, though, nothing is lost: the red I took away from one place turns up somewhere else.

It would be very interesting to preserve photographically, not the stages, but the metamorphoses of a picture. Possibly one might

then discover the path followed by the brain in materializing a dream. But there is one very odd thing—to notice that basically a picture doesn't change, that the first "vision" remains almost intact, in spite of appearances. I often ponder on a light and a dark when I have put them into a picture; I try hard to break them up by interpolating a color that will create a different effect. When the work is photographed, I note that what I put in to correct my first vision has disappeared, and that, after all, the photographic image corresponds with my first vision before the transformation I insisted on. [Compare Matisse, p. 410.]

THERE IS NO ABSTRACT ART

There is no abstract art. You must always start with something. Afterwards you can remove all traces of reality. There's no danger then, anyway, because the idea of the object will have left an indelible mark. It is what started the artist off, excited his ideas, and stirred up his emotions. Ideas and emotions will in the end be prisoners in his work . . . [Compare Courbet, p. 296.]

In my Dinard pictures and my Pourville pictures I expressed very much the same vision. However, you yourself have noticed how different the atmosphere of those painted in Brittany is from those painted in Normandy, because you recognized the light of the Dieppe cliffs. I didn't copy this light nor did I pay it any special attention. I was simply soaked in it. My eyes saw it and my subconscious registered what they saw: my hand fixed the impression. One cannot go against nature . . . We may allow ourselves certain liberties, but only in details.

Nor is there any "figurative" and "non-figurative" art. Everything appears to us in the guise of a "figure." Even in metaphysics ideas are expressed by means of symbolic "figures" . . . See how ridiculous it is, then, to think of painting without "figuration."

THE PAINTER UNLOADS HIS FEELINGS

When we invented cubism we had no intention whatever of inventing cubism. We wanted simply to express what was in us. Not one of us drew up a plan of campaign, and our friends, the poets, followed our efforts attentively, but they never dictated to

us. Young painters today often draw up a program to follow, and apply themselves like diligent students to performing their tasks.

The painter goes through states of fullness and evacuation. That is the whole secret of art. I go for a walk in the forest of Fontainebleau. I get "green" indigestion. I must get rid of this sensation into a picture. Green rules it. A painter paints to unload himself of feelings and visions. People seize on painting to cover up their nakedness. They get what they can wherever they can. In the end I don't believe they get anything at all. They've simply cut a coat to the measure of their own ignorance. They make everything, from God to a picture, in their own image. That is why the picture-hook is the ruination of a painting—a painting which has always had a certain significance, at least as much as the man who did it. As soon as it is bought and hung on a wall, it takes on quite a different kind of significance, and the painting is done for.

ART IS NOT MADE TO BE UNDERSTOOD

Everyone wants to understand art. Why not try to understand the song of a bird? Why does one love the night, flowers, everything around one, without trying to understand them? But in the case of a painting people have to understand. If only they would realize above all that an artist works of necessity, that he himself is only a trifling bit of the world, and that no more importance should be attached to him than to plenty of other things which please us in the world, though we can't explain them. People who try to explain pictures are usually barking up the wrong tree.

GEORGES BRAQUE

REFLECTIONS ON PAINTING

GEORGES BRAQUE is to be counted alongside Picasso as one of the founders of cubism and for nearly forty years its most faithful adherent. But though he has practiced an analytic and calculated style of painting with eminent success, Braque has only rarely written down the logic of his ideas. These terse paragraphs appeared in one of the short-lived "little reviews" that

were a characteristic manifestation of the intellectual liveliness of the groups of painters who, in the Paris of the twenties and thirties, were continually forming and re-forming their artistic alignments.

Paris, 1917

In art, progress does not consist in extension, but in the knowledge of limits.

Limitaton of means determines style, engenders new form, and gives impulse to creation.

Limited means often constitute the charm and force of primitive painting. Extension, on the contrary, leads the arts to decadence.

New means, new subjects.

The subject is not the object, it is a new unity, a lyricism which grows completely from the means.

The painter thinks in terms of form and color.

The goal is not to be concerned with the *reconstitution* of an anecdotal fact, but with *constitution* of a pictorial fact.

Painting is a method of representation.

One must not imitate what one wants to create.

One does not imitate appearances; the appearance is the result.

To be pure imitation, painting must forget appearance.

To work from nature is to improvise.

One must beware of a formula *good for everything,* that will serve to interpret the other arts as well as reality, and that instead of creating will only produce a style, or rather a stylization.

The arts which achieve their effect through purity have never been arts that were good for everything. Greek sculpture (among others), with its decadence, teaches us this.

The senses deform, the mind forms. Work to perfect the mind. There is no certitude but in what the mind conceives.

The painter who wished to make a circle would only draw a curve. Its appearance might satisfy him, but he would doubt it. The compass would give him certitude. The pasted papers [*papiers collés*] in my drawings also gave me a certitude.

Trompe l'œil is due to an *anecdotal chance* which succeeds be-
The pasted papers, the imitation woods—and other elements of

a similar kind—which I used in some of my drawings, also succeed through the simplicity of the facts; this has caused them to be confused with *trompe l'œil,* of which they are the exact opposite. They are also simple facts, but are *created by the mind,* and are one of the justifications for a new form in space.

Nobility grows out of contained emotion.

Emotion should not be rendered by an excited trembling; it can neither be added on nor be imitated. It is the seed, the work is the flower.

I like the rule that corrects the emotion.

FERNAND LÉGER

THE NEW REALISM

THIS TALK was given at the Museum of Modern Art at the time of Léger's first visit to New York, in 1935. Its ideas reflect the problems of the *querelle du réalisme* (i.e., the "reality" or the lack of it possessed by abstract art) then

being carried on in Paris by those advanced painters who were at the same time concerned with giving their art a significant and convincing "subject-matter."

On the content of abstract art, compare the opinions of Mondrian, p. 428, and Kandinsky, p. 449.

December, 1935

During the past fifty years the entire effort of artists has consisted of a struggle to free themselves from certain old bonds.

In painting, the strongest restraint has been that of subject matter upon composition, imposed by the Italian Renaissance.

This effort towards freedom began with the impressionists and has continued to express itself until our own day.

The impressionists freed color—we have carried their attempt forward and have freed form and design.

Subject-matter being at last done for, we were free. In 1919 the painting *La Ville* was executed in pure color. It resulted, according to qualified writers on art, in the birth of a world-wide publicity.

This freedom expresses itself ceaselessly in every sense.

It is, therefore, possible to assert the following: that color has a reality in itself, a life of its own; that a geometric form has also a reality in itself, independent and plastic.

Hence, composed works of art are known as "abstract," with these two values reunited.

They are not "abstract," since they are composed of real values: colors and geometric forms. There is no abstraction.

"What does that represent?" has no meaning. For example: With a brutal lighting of the fingernail of a woman—a modern fingernail, well manicured, very brilliant, shining—I make a movie on a very large scale. I project it enlarged a hundredfold, and I call it—"Fragment of a Planet, Photographed in January, 1934." Everybody admires my planet. Or I call it "abstract form." Everybody either admires it or criticizes it. Finally I tell the truth—what you have just seen is the nail of the little finger of the woman sitting next to you.

Naturally, the audience leaves, vexed and dissatisfied, because of having been fooled, but I am sure that hereafter those people

Léger: The City, 1919

won't ask any more of me and won't repeat that ridiculous question: "What does that represent?"

There was never any question in plastic art, in poetry, in music, of representing anything. It is a matter of making something beautiful, moving, or dramatic—this is by no means the same thing.

If I isolate a tree in a landscape, if I approach that tree, I see that its bark has an interesting design and a plastic form; that its branches have dynamic violence which ought to be observed; that its leaves are decorative. Locked up in "subject-matter," these elements are not "set in value." It is here that the "new realism" finds itself, and also behind scientific microscopes, behind astronomical research which brings us every day new forms that we can use in the movies and in our paintings.

Commonplace objects, objects turned out in a series, are often more beautiful in proportion than many things called beautiful and given a badge of honor.

PIET MONDRIAN

FIGURATIVE ART AND NON-FIGURATIVE ART

IN 1917 Piet Mondrian was among the founders of the Leyden group of *de Stijl*. From then on, during his residence in Holland, and later in Paris and New York, to his death in 1944, Mondrian was not only one of the most important and influential of abstract painters, but a leading theorist of abstraction. His published works include many articles in *de Stijl* magazine, the manifesto *Neoplasticism* (Paris, 1920), and other articles in French and in English translation; including work as yet unpublished, his writings total nearly one hundred thousand words.

NEOPLASTICISM *Paris, 1932*

All painting—the painting of the past as well as of the present —shows us that its essential plastic means are only line and color.

Although these means, when composed, inevitably produce forms, these forms are not at all the essential plastic means of art.

For art they exist only as a secondary or auxiliary means of expression, and not as a method of achieving a particular form.

Although the art of the past expressed itself through particular form, it transformed its appearance of "visual reality" by representing it in a more universal fashion.

It increased the tension of line and the purity of color, and sought to transform the plasticity of nature into a plane surface. Towards the end, it had already tried to free line and color from natural appearance.

The new art has continued and culminated the art of the past in such a way that the new painting, by employing "neutral," or universal forms, expresses itself only through the relationships of line and color.

While in the art of the past these relationships are veiled by the particular form, in the new art they are made clear through the use of neutral or universal forms.

Because these forms become more and more neutral as they approach a state of universality, neoplasticism uses only a single neutral form: the rectangular area in varying dimensions.

Since this form, when composed, completely annihilates itself for lack of contrasting forms, line and color are completely freed.

REPRESENTATION *Paris, 1933*

The artistic efficacy of a work is determined not only by its artistic value, but also by the character of the figural representation: subject, natural or abstract forms.

Although the artistic value may be identical in every true work of art, eternal and independent of the figural representation, the latter is of such importance that it completely determines the expression of this artistic value. Being changeable, the figural representation constantly transforms the purely artistic expression; with the passage of time the artistic capacity constantly makes use of new forms, or creates them. In this reciprocal action we must therefore distinguish two values: the artistic value, and the value of the means of expression.

It is therefore clear that for the modern mentality, a work which has the appearance of a machine or a technical product increases

its artistic efficacy by its more exact forms, its lack of classic or romantic lyricism, etc. However, it is the artistic value which determines to what extent this new "representation" is annihilated and transformed into a work of art.

PLASTIC ART AND PURE-PLASTIC ART *1937*

The laws which in the culture of art have become more and more determinate are the great hidden laws of nature which art establishes in its own fashion. It is necessary to stress the fact that these laws are more or less hidden behind the superficial aspect of nature. Abstract art is therefore opposed to a natural representation of things. But it *is not opposed to nature,* as is generally thought. It is opposed to the raw primitive animal nature of man, but it is one with true human nature. First and foremost there is the fundamental law of dynamic equilibrium which is opposed to the static equilibrium necessitated by the particular form.

The important task of all art is to destroy the static equilibrium by establishing a dynamic one. Non-figurative art demands an attempt of what is a consequence of this task, the destruction of particular form and the construction of a rhythm of mutual relations, of mutual forms, or free lines . . . In order that art . . . should not represent relations with the natural aspect of things, the law of the *denaturalization of matter* is of fundamental importance. In painting, the primary color that is as pure as possible realizes this abstraction of natural color.

The fact that people generally prefer figurative art (which creates and finds its continuation in abstract art) can be explained by the dominating force of the individual inclination in human nature. From this inclination arises all the opposition to art which is purely abstract.

[Non-figurative art] shows that "art" is not the expression of the appearance of reality such as we see it, nor of the life which we live, but that it is the expression of true reality and true life . . . indefinable but realizable in plastics. Thus we must carefully distinguish between two kinds of reality, one which has an individual character, and one which has a universal appearance . . .

It is, however, wrong to think that the non-figurative artist finds

impressions and emotions received from the outside useless, and regards it even as necessary to fight against them . . .

It is equally wrong to think that the non-figurative artist creates through "the pure intention of his mechanical process," that he makes "calculated abstractions," and that he wishes to "suppress sentiment not only in himself but in the spectator." . . . That which is regarded as a system is nothing but constant obedience to the laws of pure plastics, to necessity, which art demands from him. It is thus clear that he has not become a mechanic, but that the progress of science, of technique, of machinery, of life as a whole, has only made him into a living machine, capable of realizing in a pure manner the essence of art.

OSSIP ZADKINE

THE POETIC CLIMATE OF ART

Zadkine is an outstanding representative of those artists of the School of Paris whose work cannot be dogmatically classified. Stemming from the cubist-abstract tradition in his form, he nevertheless insists upon the "poetry" (both in vision and in subject-matter) of his sculpture.

AIMS OF THE ARTIST *New York, 1944*

Whatever the apparent aim of the artist, he is called upon first to move the spectator, after having been himself struck by a design or color composition, which may or may not have a relation to natural objects. His predilections, his preferences, crystallize afterwards in the choice of means to interpret those natural objects; these means are always, obligingly, of imaginary essence. For the artist soon discovers that however daring his researches are, his "found" forms are, his faculties will not escape the "permitted," and that there are no undiscovered forms to bring to light, but *only* some forms which, until his researches, have remained in temporary obscurity. Whether it be Masaccio, Giotto, Greco, Cézanne, or Picasso, each had to "fashion" the natural appearance of objects and their forms, and give them a quality of an imaginary world.

POETIC CLIMATE

In my own researches and findings I have always insisted on plastic and sculptural values, and also on what I call a poetic climate. The object, whether it is a book, a bottle, or a human body, once it is visualized and expressed by means of clay, stone, or wood, ceases to be a document and becomes an animated object in stone, wood, or bronze, and lives its independent life of wooden, bronze, or granite object. These animated, independent objects are meant to vibrate through their plastic and poetic symbolism.

ART SCHOOLS

Art school training is not obligatory; it is only conditional. There exists a world of elementary knowledge which art school education can supply; but the highest stages of initiation are a matter of awareness in the adept.

I proceed with pupils by teaching them to "see" the object, to read its natural aspect, and then try to initiate them in the plastic and sculptural meaning of the given naturalistic object. The "final" state consists in clarifying for the pupil the existence, the plastic life, of any invented object, liberated of its documentary specifisms.

These notions are *par excellence* illustrated in most of the works found in the museums. There is no higher delight than a visit to the Louvre or Athens museums to contemplate the Apollos of the sixth century B.C.

Only in the presence of these magnificent objects from antiquity does one realize that there is no past in art, but only an exciting present illuminated with the wise smile of the past.

NATIONALISM IN ART

I do not believe that art must develop on national lines, but I am convinced that there never was and never will be an international art. There is and was French, German, Italian, and Flemish art. But I deny those specific definitions so fashionable with adepts of fascism which make of every country an hermetic cell from which all foreign artists are excluded. The presence of Leonardo and so many other Italian artists in sixteenth-century France has not prevented that epoch from being profoundly French . . .

In every country where he chooses to live the artist is called upon to fulfill a social function by merely painting pictures or carving statues. Whether consciously or not, he reflects in his works every social intonation of the society in which he lives: the more or less tangible participation is a question of inner individual necessity. The profound religious consciousness of Rouault and the bitter poisonous cartoons of Daumier do not prevent them from representing French art, both fifty years ago and at the present time.

MARC CHAGALL

A RECORDED INTERVIEW

PUBLISHED AFTER he had been in America for some three years, the interview from which these extracts are taken is Chagall's clearest statement to date on his art, with its folk subject-matter and its supposedly presurrealist character. In addition to articles on his travels, and reminiscences, Chagall has written an autobiography, *Ma Vie* (1931).

ANECDOTE AND FANTASY *New York, 1944*

There is nothing anecdotal in my pictures—no fairy tales—no literature in the sense of folk-legend associations. Maurice Denis [see p. 380] described the paintings of the synthetists in France about 1899 as plane surfaces "covered with colors arranged in a

certain order." To the cubists a painting was a plane surface covered with form-elements in a certain order. For me a picture is a plane surface covered with representations of objects—beasts, birds, or humans—in a certain order in which anecdotal illustrational logic has no importance. The visual effectiveness of the painted composition comes first. Every extra-structural consideration is secondary.

I am against the terms "fantasy" and "symbolism" in themselves. All our interior world is reality—and that perhaps more so than our apparent world. To call everything that appears illogical, "fantasy," fairy tale, or chimera would be practically to admit not understanding nature.

Impressionism and cubism were relatively easy to understand, because they only proposed a single aspect of an object to our consideration—its relations of light and shade, or its geometrical relationships. But one aspect of an object is not enough to constitute the entire subject-matter of art. An object's aspects are multifarious.

I am not a reactionary from cubism. I have admired the great cubists and have profited from cubism . . . [But] to me cubism seemed to limit pictorial expression unduly. To persist in that I felt was to impoverish one's vocabulary. If the employment of forms not as bare of associations as those the cubists used was to produce "literary painting," I was ready to accept the blame for doing so.

PLASTIC VALUES AND POETIC VALUES

In painting, the images of a woman or of a cow have different values of plasticity—but not different poetic values. As far as literature goes, I feel myself more "abstract" than Mondrian or Kandinsky in my use of pictorial elements. "Abstract" not in the sense that my painting does not recall reality. Such abstract painting in my opinion is more ornamental and decorative, and always restricted in range. What I mean by "abstract" is something which comes to life spontaneously through a gamut of contrasts, plastic at the same time as psychic, and pervades both the picture and the eye of the spectator with conceptions of new and unfamiliar elements . . .

The fact that I made use of cows, milkmaids, roosters, and provincial Russian architecture as my source forms is because they are part of the environment from which I spring and which undoubtedly left the deepest impression on my visual memory of any experiences I have known. Every painter is born somewhere. And even though he may later return to the influences of other atmospheres, a certain essence—a certain "aroma"—of his birthplace clings to his work. But do not misunderstand me: the important thing here is not "subject" in the sense pictorial "subjects" were painted by the old academicians. The vital mark these early influences leave is, as it were, on the handwriting of the artist.

UMBERTO BOCCIONI

FUTURIST MANIFESTOES

UNLIKE CUBISM, from which they in part derived, futurist painting and sculpture began their career with an alliance to a literary movement and a full-blown program written by the artists themselves. Futurism as such was proclaimed by Marinetti's manifesto of 1909. Its artistic battle cry was issued in Milan the following year, and it became more generally known with the translation and expansion of its manifestoes at the time of the futurist exhibition in Paris in 1912. Written by Boccioni, these manifestoes were also signed by Carra, Russolo, Balla, and Severini.

Compare Picasso's discussion of cubism, p. 418.

MANIFESTO OF THE FUTURIST PAINTERS *February 11, 1910*

To the young artists of Italy!

We want to fight relentlessly against the fanatical, irresponsible, and snobbish religion of the past, which is nourished by the baneful existence of museums. We rebel against the groveling admiration for old canvases, old statues, old objects, and against the enthusiasm for everything moth-eaten, dirty, time-worn, and we regard as unjust and criminal the usual disdain for everything young, new, and pulsating with life . . .

Only that art is viable which finds its elements in the surrounding environment. As our ancestors drew the matter of their art

from the religious atmosphere weighing upon their souls, so we must draw inspiration from the tangible miracles of contemporary life, from the iron network of speed enveloping the earth, from the transatlantic liners, the Dreadnoughts, the marvelous flights furrowing the skies, the darksome audacities of underwater navigators, the spasmodic struggle for the conquest of the unknown . . .

Here are our peremptory conclusions:

By our enthusiastic adherence to futurism we propose:

1. To destroy the cult of the past, the obsession with the antique, the pedantry and formalism of the academies.
2. To despise utterly every form of imitation.
3. To extol every form of originality, however audacious, however violent.
4. To draw courage and pride from the facile reproach of madness, with which innovators are lashed and gagged.
5. To consider art critics useless or harmful.
6. To rebel against the tyranny of the words "harmony" and "good taste," overelastic expressions with which the works of Rembrandt and Goya could easily be demolished.
7. To sweep from the field of art all motifs and subjects that have already been exploited.
8. To render and glorify the life of today, unceasingly and violently transformed by victorious science.

TECHNICAL MANIFESTO OF FUTURIST PAINTING *April 11, 1910*

Our craving for truth can no longer be satisfied by traditional *form* and *color*!

Action, in our works, will no longer be an arrested moment of universal dynamism. It will be, simply, dynamic sensation itself.

Everything moves, everything runs, everything turns swiftly. The figure in front of us never is still, but ceaselessly appears and disappears. Owing to the persistence of images on the retina, objects in motion are multiplied and distorted, following one another like waves through space. Thus a galloping horse has not four legs: it has twenty, and their movements are triangular.

In art, everything is conventional. The truths of yesterday are downright lies today.

We again affirm that a portrait, to be a work of art, neither must nor may resemble the sitter and that the painter has within himself the landscapes he wishes to produce. To depict a figure one must not paint that figure; one must paint its atmosphere . . .

The sixteen persons traveling with you in a streetcar are one, ten, four, three. They sit still and they move. They come and go; they bounce into the street, are devoured by a sunlit patch, then return to their seats in front of you, persistent symbols of universal vibration. Sometimes on the cheek of the person we are talking to we see a horse passing far away. Our bodies enter into the seats; the streetcar that is passing enters into the houses, and the houses in turn hurl themselves onto the streetcar and merge with it.

Painters have always shown us things and persons in front of us. We shall place the spectator at the center of the picture . . .

Our pictorial sensations cannot be whispered. We sing them and shout them in our canvases, which ring with deafening and triumphal fanfares.

Your eyes, accustomed to semi-darkness, will open on the most radiant visions of light. The shadows that we shall paint will be more luminous than the lights of our predecessors, and our pictures, compared to those stored in the museums, will look like the most dazzling daylight near the darkest night.

Hence we are naturally led to conclude that no painting may exist without divisionism. Divisionism, however, is not, in our view, a technical device that one can learn and apply methodically. Divisionism, with the modern painter, must be an inborn complementarism, which we regard as part of our essence and ordained by fate.

FUTURIST INNOVATIONS *February, 1912*

Futurist painting contains three new pictorial concepts:
1. The solution of the problem of volumes in the picture, for we oppose the liquefaction of objects which is a fatal consequence of impressionistic vision.

2. The translation of objects according to the *lines of force* which characterize them, by means of which an absolutely new plastic dynamism is achieved.

3. The third, which is a natural consequence of the first two points, is the rendition of the emotional atmosphere of the picture, which is a hitherto unknown source of pictorial lyricism.

GINO SEVERINI

ART AND IMITATION

SEVERINI, AFTER passing through an impressionist period, became one of the original members of the futurist group. Like others who went through this evolution, he later developed a more conservative style inspired by the neatness, precision, and solidity of the antique and the early Renaissance.

Severini has written *Du Cubisme au Classicisme* (1921) and *Ragionamenti sulle Arti Figurative* (1936).

DISTORTION AND CONSTRUCTION

Distortion is the correction of nature according to one's sensibility. It bears no relation whatever to construction, whose starting point is quite opposite. The aesthetics of distortion informs works ranging from ordinary cartoons and caricatures to the works of Daumier, when sustained by talent. When thus sustained, distortion may deceive the inexperienced as to its sensorial essence, but it remains an inferior art, nonetheless.

ART AND SCIENCE

One of the main causes of our artistic decline lies beyond doubt in the separation of art and science. Art is nothing but humanized science.

PERCEIVED AND INTELLECTUAL ART

Philosophers and aestheticians may offer elegant and profound definitions of art and beauty, but for the painter they are all summed up in this phrase: To create a harmony.

At all times two paths have offered themselves to the artist for realizing this harmony: some artists have tried to achieve it through the imitation of nature's appearances by the aesthetics of empiricism and sensibility; others have secured it through a reconstruction of the universe by the aesthetics of number and intellect.

As one or the other of these two approaches has triumphed, we have had good periods of art and periods of barbarism and decadence. The latter are always characterized by an exaltation of instinct and sensibility. The periods admired by us, on the contrary, owe their greatness to the intellectual approach and to the aesthetics of number.

PAINTING IS LIKE MUSIC

An art which does not obey fixed and inviolable laws is to true art what a noise is to a musical sound. To paint without being acquainted with these fixed and very severe laws is tantamount to composing a symphony without knowing harmonic relations and the rules of counterpoint.

Music is but a living application of mathematics. In painting, as in every constructive art, the problem is posed in the same manner. To the painter numbers become magnitudes and color tones; to the musician, notes and sound tones.

GIORGIO DE CHIRICO

METAPHYSICAL ART

GIORGIO DE CHIRICO was born in Greece of Italian parents, and has lived in France and Italy. His "metaphysical painting," which he later abandoned, must be counted among the most original and influential of twentieth-century styles. De Chirico has written poetry, stories, a novel (*Hebdomeros*), and several books and articles on painting.

MYSTERY AND CREATION *Paris, 1913*

To become truly immortal a work of art must escape all human limits: logic and common sense will only interfere. But once these barriers are broken, it will enter the regions of childhood vision and dream.

Profound statements must be drawn by the artist from the most secret recesses of his being; there no murmuring torrent, no bird song, no rustle of leaves can distract him.

What I hear is valueless; only what I see is living, and when I close my eyes my vision is even more powerful.

It is most important that we should rid art of all that it has contained of *recognizable material* to date; all familiar subjects, all

439

traditional ideas, all popular symbols must be banished forthwith. More important still, we must hold enormous faith in ourselves: it is essential that the revelation we receive, the conception of an image which embraces a certain thing, which has no sense in itself, which has no subject, which means *absolutely nothing* from the logical point of view—I repeat, it is essential that such a revelation or conception should speak so strongly in us, evoke such agony or joy, that we feel compelled to paint, compelled by an impulse even more urgent than the hungry desperation which drives a man to tearing at a piece of bread like a savage beast.

I remember one vivid winter's day at Versailles. Silence and calm reigned supreme. Everything gazed at me with mysterious, questioning eyes. And then I realized that every corner of the palace, every column, every window possessed a spirit, an impenetrable soul . . . At that moment I grew aware of the mystery which urges men to create certain strange forms. And the creation appeared more extraordinary than the creators.

METAPHYSICAL ART *1919*

Everything has two aspects: the current aspect, which we see nearly always and which ordinary men see, and the ghostly and metaphysical aspect, which only rare individuals may see in moments of clairvoyance and metaphysical abstraction.

A work of art must narrate something that does not appear within its outline. The objects and figures represented in it must likewise poetically tell you of something that is far away from them and also of what their shapes materially hide from us. A certain dog painted by Courbet is like the story of a poetic and romantic hunt.

THE SENSE OF ARCHITECTURE *1920*

Among the many senses that modern painters have lost, we must number the sense of architecture. The edifice accompanying the human figure, whether alone or in a group, whether in a scene from life or in an historical drama, was a great concern of the ancients. They applied themselves to it with loving and severe spirit, studying and perfecting the laws of perspective. A landscape

enclosed in the arch of a portico or in the square or rectangle of a window acquires a greater metaphysical value, because it is solidified and isolated from the surrounding space. Architecture completes nature. It marks an advance of human intellect in the field of metaphysical discoveries.

PAUL KLEE

NOTES FROM HIS DIARY

WHEN THESE notes were written, Paul Klee was less than twenty-five. Born near Berne, he had studied at the Academy in Munich and had spent the year 1901 in travel through Italy, where the weight of tradition induced doubt of his own artistic powers. (See Marées, p. 388.) It was in this mood that

he returned to Berne and to that characteristic process of introspection which these notes reflect. In 1906 he went to live in Munich, where in 1912 he joined in the *Blaue Reiter* group.

BEGIN WITH THE SPECIFIC INSTANCE *Berne, April, 1902*

A month has now elapsed since my trip to Italy. A review of my professional affairs is not too encouraging, and I do not know why, but I am nevertheless still hopeful. Perhaps because criticism of my work, although almost totally destructive, now means something to me, whereas previously my self-deception admitted nothing.

But by way of consolation: it is valueless to paint premature things, what counts is to be a personality, or at least to become one. The domination of life is one of the basic conditions of productive expression. For me this is surely the case; when I am depressed I am unable even to think about it—and this holds true for painting, sculpture, tragedy, or music. But I believe that pictures alone will abundantly fill out this one life . . .

I have to disappoint at first. I am expected to do things a clever fellow could easily fake. But my consolation must be that I am much more handicapped by the sincerity of my intentions than by any lack of talent or ability. I have a feeling that sooner or later I shall arrive at something legitimate, only I must begin, not with hypotheses, but with specific instances, no matter how minute. If I then succeed in distinguishing a clear structure, I get more from it than from a lofty imaginary construction. And the typical will automatically follow from a series of examples.

THE MICROCOSM *June, 1902*

It is a great difficulty and great necessity to have to start with the smallest. I want to be as though new-born, knowing nothing, absolutely nothing, about Europe; ignoring poets and fashions, to be almost primitive. Then I want to do something very modest; to work out by myself a tiny, formal motive, one that my pencil will be able to hold without any technique. One favorable moment is enough. The little thing is easily and concisely set down. It's already done! It was a tiny but real affair, and someday, through

the repetition of such small but original deeds, there will come one work upon which I can really build.

The naked body is an altogether suitable object. In art classes I have gradually learned something of it from every angle. But now I will no more project some plan of it: I will proceed so that all its essentials, even those hidden by optical perspective, will appear upon the paper. And thus a little uncontested personal property has already been discovered, a style has been created.

STUDY ARCHITECTURE *December, 1903*

When, in Italy, I learned to understand architectural monuments I had at once to chalk up a remarkable advance in knowledge. Though they serve a practical purpose, the principles of art are more clearly expressed in them than in other works of art. Their easily recognizable structure, their exact organism, makes possible a more fundamental education than all the "head- nude- and composition-studies." Even the dullest will understand that the obvious commensurability of parts, to each other and to the whole, corresponds to the hidden numerical proportions that exist in other artificial and natural organisms. It is clear that these figures are not cold and dead, but full of the breath of life; and the importance of measurement as an aid to study and creation becomes evident.

FROM A LETTER

Formerly it frequently happened to me that when questioned regarding a picture I simply did not know what it represented. I had not seen the subject, so to say. Now I have also included the content so that I know most of the time what is represented. But this only supports my experience that what matters in the ultimate end is the abstract meaning or harmonization.

ART AND SCIENCE

IN 1920 Klee became professor at the *Bauhaus* Academy in Weimar, and he moved with the *Bauhaus* to Dessau in 1926. These paragraphs come from the *Bauhaus* prospectus of 1929. They should be compared with the ideas

of Klee's colleague, Kandinsky (p. 449), and with the ideas of Mondrian on contemporary subject-matter (p. 427).

[*Dessau, 1929*]

We construct and construct, and yet intuition still has its uses. Without it we can do a lot, but not everything. One may work for a long time, do different things, many things, important things, but not everything.

When intuition is joined to exact research it speeds the progress of exact research . . .

Art, too, has been given sufficient room for exact investigation, and for some time the gates leading to it have been open. What had already been done for music by the end of the eighteenth century has at last been begun for the pictorial arts. Mathematics and physics furnished the means in the form of rules to be followed and to be broken. In the beginning it is wholesome to be concerned with the functions and to disregard the finished form. Studies in algebra, in geometry, in mechanics characterize teaching directed towards the essential and the functional, in contrast to the apparent. One learns to look behind the façade, to grasp the root of things. One learns to recognize the undercurrents, the antecedents of the visible. One learns to dig down, to uncover, to find the cause, to analyze.

FRANZ MARC

APHORISMS

IN 1911 with Kandinsky, and then Klee in Munich, Franz Marc founded the group known as the *Blaue Reiter* and helped create an "expressionist" art based upon the discoveries in form of the *Fauves* and the cubists. These selections from his *Aphorisms* parallel the short five years—part of them spent as a soldier—during which Marc painted in his own mature style. Why throughout that period he concentrated upon pictures of animals is further explained in one sentence from a letter to his wife written at the front in April, 1915, less than a year before his death: "The impure men and women who surrounded me (and particularly the men), did not arouse any of my real feelings; while the natural feeling for life possessed by animals set in vibration everything good in me."

LET THE WORLD SPEAK FOR ITSELF *Munich, 1911-12*

Is there any more mysterious idea for an artist than the conception of how nature is mirrored in the eyes of an animal? How does a horse see the world, or an eagle, or a doe, or a dog? . . .

What relation has a doe to our picture of the world? Does it make any logical, or even artistic, sense, to paint the doe as it appears to our perspective vision, or in cubistic form because we feel the world cubistically? It feels it as a doe, and its landscape must also be "doe" . . . I can paint a picture: the roe; Pisanello has painted such. I can, however, also wish to paint a picture: "the roe feels." How infinitely sharper an intellect must the painter have, in order to paint this! The Egyptians have done it. The rose; Manet has painted that. Who has painted the flowering rose? The Indians . . .

There is little abstract art today, and what there is is stammering and imperfect. It is an attempt to let the world speak for itself, instead of reporting the speech of minds excited by their picture of the world. The Greek, the Gothic, and the Renaissance artist set forth the world the way he saw it, felt it, and wished to have it; man wished above all to be nourished by art; he achieved his desire but sacrificed everything else to this one aim: to construct homunculus, to substitute knowledge for strength and skill for spirit. The ape aped his creator. He learned to put art itself to the ends of trade . . .

Only today can art be metaphysical, and it will continue to be so. Art will free itself from the needs and desires of men. We will no longer paint a forest or a horse as we please or as they seem to us, but *as they really are.*

FOLK ART

The people itself (and I do not mean the "masses") has always given art its essential style. The artist merely clarifies and fulfills the will of the people. But when the people does not know what it wants, or, worst of all, wants nothing, . . . then its artists, driven to seeking their own forms, remain isolated, and become martyrs . . .

Folk art—that is, the feeling of people for artistic form—can arise again only when the whole jumble of worn-out art concepts of the nineteenth century has been wiped from the memory of generations.

ART OF THE FUTURE [*At the front, near Verdun*], *1915*

The day is not far distant on which Europeans—the few Europeans who will still remain—will suddenly become painfully aware of their lack of formal concepts. Then will these unhappy people bewail their wretched state and become seekers after form. They will not seek the new form in the past, in the outward world, or in the stylized appearances of nature, but they will build up their form from within themselves, in the light of their new knowledge that turned the old world fable into a world form, and the old world view into a world insight.

The art of the future will give form to our scientific convictions; this is our religion and our truth, and it is profound and weighty enough to produce the greatest style and the greatest revaluation of form that the world has ever seen.

Today, instead of using the laws of nature as a means of artistic expression, we pose the religious problems of a new content. The art of our time will surely have profound analogies with the art of primitive periods long past, without, of course, the formalistic similarities now senselessly sought by many archaistic artists. And our time will just as surely be followed in some distant, ripe, late European future by another period of cool maturity, which in its turn will again set up its own formal laws and traditions.

MAX BECKMANN

ON HIS PAINTING

WHEN BECKMANN spoke these lines—on the occasion of an exhibition of modern German art in London—he had been living in exile in Holland for nearly two years. The expressionist style of his painting, and his factual reporting of the terrible scenes he had witnessed in the trenches during World War I, had caused him to be placed among those "degenerate" artists officially banned by the Nazi government. It was in this setting that Beckmann spoke of his relation to political life.

London, July, 1938

Painting is a very difficult thing. It absorbs the whole man, body and soul—thus I have passed blindly many things which belong to real and political life . . .

What I want to show in my work is the idea which hides itself behind so-called reality. I am seeking for the bridge which leads

447

from the visible to the invisible, like the famous cabalist who once said: "If you wish to get hold of the invisible you must penetrate as deeply as possible into the visible." . . .

What helps me most in this task is the penetration of space. Height, width, and depth are the three phenomena which I must transfer into one plane to form the abstract surface of the picture, and thus to protect myself from the infinity of space. My figures come and go, suggested by fortune or misfortune. I try to divest them of their apparently accidental quality.

One of my problems is to find the ego, which has only one form, and is immortal—to find it in animals and men, in the heaven and in the hell which together form the world in which we live . . .

The uniform application of a principle of form is what rules me in the imaginative alteration of an object. One thing is sure—we have to transform the three-dimensional world of objects into the two-dimensional world of the canvas.

If the canvas is filled only with a two-dimensional conception of space, we shall have applied art, or ornament. Certainly this may give us pleasure, though I myself find it boring as it does not give me enough visual sensation. To transform three into two dimensions is for me an experience full of magic in which I glimpse for a moment that fourth dimension which my whole being is seeking . . .

Color, as the strange and magnificent expression of the inscrutable expression of eternity, is beautiful and important to me as a painter; I use it to enrich the canvas and to probe more deeply into the object. Color also decided, to a certain extent, my spiritual outlook, but it is subordinated to life and, above all, to the treatment of form. Too much emphasis on color at the expense of form and space would make a double manifestation of itself on the canvas, and this would verge on craft work. Pure colors and broken tones must be used together, because they are the complements of each other.

WASSILY KANDINSKY

THE ART OF SPIRITUAL HARMONY

THOUGH HE was born in Russia, when these lines were written Kandinsky had been painting in Munich (and for a brief period in Paris) for more than a decade. In 1911, a year after the publication of this book, he was to complete his first abstract picture—perhaps the first that had ever been painted—and our quotation shows his thought moving in that direction. The same year Kandinsky and Franz Marc founded the *Blaue Reiter* group and later published a manifesto of the same name. In 1914 Kandinsky returned to Russia.

[Munich, 1910]

Pure artistic composition has two elements:

1. The composition of the whole picture.
2. The creation of the various forms which, by standing in different relationships to each other, decide the composition of the whole. Many objects have to be considered in the light of the whole, and so ordered as to suit this whole. Singly they will have little meaning, being of importance only in so far as they help the general effect. These single objects must be fashioned in one way only; and this, not because they have to serve as building material for the whole composition.

So the abstract idea is creeping into art, although, only yesterday it was scorned and obscured by purely material ideals. Its gradual advance is natural enough, for in proportion as the organic form falls into the background, the abstract ideal achieves greater prominence.

But the organic form possesses, all the same, an inner harmony of its own, which may be either the same as that of its abstract parallel (thus producing a simple combination of two elements) or totally different (in which case the combination may be unavoidably discordant). However diminished in importance the organic form may be, its inner note will always be heard; and for this reason the choice of material objects is an important one. The spiritual accord of the organic with the abstract element may

strengthen the appeal of the latter (as much by contrast as by similarity) or may destroy it.

Think of a rhomboidal composition, made up of a number of human figures. The artist asks himself: Are these human figures an absolute necessity to the composition, or should they be replaced by other forms, and that without affecting the fundamental harmony of the whole? If the answer is "Yes," we have a case in which the material appeal directly weakens the abstract appeal. The human form must either be replaced by another object which, whether by similarity or by contrast, will strengthen the abstract appeal, or it must remain a purely non-material symbol . . .

The impressions we receive, which often appear merely chaotic, consist of three elements: the impression of the color of the object, its form, and of its combined color and form, i.e., of the object itself.

At this point the individuality of the artist comes to the front and disposes, as he wills, these three elements. *It is clear, therefore, that the choice of object (i.e., of one of the elements in the harmony of form) must be decided only by a corresponding vibration in the human soul* . . .

The more abstract is form, the more clear and direct is its appeal. In any composition the material side may be more or less omitted in proportion as the forms used are more or less material, and for them substituted pure abstractions, or largely dematerialized objects . . .

Must we then abandon utterly all material objects and paint solely in abstractions? The problem of harmonizing the appeal of the material and the non-material shows us the answer to this question. As every word spoken rouses an inner vibration, so likewise does every object represented. To deprive oneself of this possibility is to limit one's power of expression. That is, at any rate, the case at present. But besides this answer to the question, there is another, and one which art can always employ to any question beginning with "must": There is no "must" in art, because art is free.

LINE AND FISH

IN THE quarter century between this and the preceding quotation, Kandinsky had returned to Russia (1914), become a professor at the University in Moscow, gone again to Germany (1921), taught at the Bauhaus, and in 1934 gone to Paris to live. Throughout that time he had been evolving the abstract, somewhat mystical art which this quotation reflects.

For related theories on abstract painting and sculpture, see Mondrian, p. 426.

Paris, March, 1935

Approaching it in one way, I see no essential difference between a line one calls "abstract" and a fish.

But rather an essential likeness.

This isolated line and the isolated fish alike are living beings with forces peculiar to them, though latent. They are forces of expression for these beings and of impression on human beings, because each has an impressive "look" which manifests itself by its expression.

But the voice of these latent forces is faint and limited. It is the environment of the line and the fish that brings about a miracle: the latent forces awaken, the expression becomes radiant, the impression profound. Instead of a low voice one hears a choir. The latent forces have become dynamic.

The environment is the composition.

The composition is the organized sum of the interior functions (expressions) of every part of the work.

But approaching it in another way, there is an essential difference between a line and a fish.

And that is that the fish can swim, eat, and be eaten. It has, then, capacities of which the line is deprived.

These capacities of the fish are necessary extras for the fish itself and for the kitchen, but not for painting. And so, not being necessary, they are superfluous.

That is why I like the line better than the fish—at least in my painting.

KASIMIR MALEVICH

SUPREMATISM: THE NON-OBJECTIVE WORLD

IN 1913 in Moscow Malevich created suprematism by exhibiting a picture of a black square on a white ground. In so doing he was the first painter to make of painting "a system of absolutely pure geometrical abstraction." Shortly after 1920 abstract art began to be officially discouraged in Russia, and suprematism, like constructivism (see below), suffered; but its influence was felt in Germany during the following decade. In 1927 the *Bauhaus* published Malevich's explanation of his theories under the title of *The Non-Objective World*.

1914

The rectangular picture-plane indicates the starting point of suprematism: a new realism of color conceived as non-objective creation.

The forms of suprematist art live like all the living forms of nature. This is a new plastic realism, plastic precisely because the realism of hills, sky, and water is missing. Every real form is a world. And any plastic surface is more alive than a (drawn or painted) face from which stare a pair of eyes and a smile.

1927

By suprematism, I mean the supremacy of pure feeling in the pictorial arts.

From the suprematist point of view, the appearances of natural objects are in themselves meaningless; the essential thing is feeling —in itself and completely independent of the context in which it has been evoked.

Academic naturalism, the naturalism of the impressionists, of Cézannism, of cubism, etc., are all so to speak nothing but dialectic methods, which in themselves in no way determine the true value of the work of art.

The representation of an object, in itself (the objectivity as the aim of the representation), is something that has nothing to do

with art, although the use of representation in a work of art does not rule out the possibility of its being of a high artistic order.

For the suprematist, therefore, the proper means is the one that provides the fullest expression of pure feeling and ignores the habitually accepted object. The object in itself is meaningless to him; and the ideas of the conscious mind are worthless. Feeling is the decisive factor . . . and thus art arrives at non-objective representation—at suprematism.

When in 1913, in a desperate attempt to rid art of the ballast of objectivity, I took refuge in the form of the square, and exhibited a picture that represented nothing more than a black square on a white field, the critics—and with them society—sighed, "All that we loved has been lost. We are in a desert. Before us stands a black square on a white ground." . . .

But the desert is filled with the spirit of non-objective feeling, which penetrates everything.

I too was filled with a sort of shyness and fear, as I was called to leave "the world of will and idea" in which I had lived and created, and in whose reality I had believed. But the happy liberating touch of non-objectivity drew me out into the "desert" where only feeling is real, . . . and so feeling became the content of my life. It was no "empty square" I had exhibited but the feeling of non-objectivity.

I perceived that the "thing" and the "idea" were taken to be equivalents of feeling, and understood the lie of the world of will and idea. Is the milk bottle the symbol of milk?

Suprematism is the rediscovery of that pure art which in the course of time, and by an accretion of "things," had been lost to sight.

NAHUM GABO AND ANTOINE PEVSNER

FROM THE CONSTRUCTIVIST MANIFESTO

IN 1917 the two brothers Gabo and Pevsner returned from Norway to Moscow. There they joined the constructivist movement, led by Tatlin, and began to do abstract constructions which they exhibited in the big Constructivist Exhibition of 1920—the same year in which they published their manifesto. In 1932, when they joined the Paris group of *Abstraction-Création,* this manifesto was partially reprinted in translation in the first catalogue of the new association.

For other statements on abstract art, compare Mondrian, p. 426.

Moscow, 1920

The "fundamental bases of art" must rest on solid ground: real life.

In fact (actuality) space and time are the two elements which exclusively fill real life (reality).

Therefore, if art wishes to grasp real life, it must, likewise, be based on these two fundamental elements.

To realize our creative life in terms of space and time: such is the unique aim of our creative art.

We hold our sextant in our hand, our eyes look straight before them, our minds are stretched like a bow, and we shape our work as the world its creation, the engineer his bridge, the mathematician his formulas of a planetary orbit . . .

We know that every object has its own individuality. Table, chair, lamp, book, telephone, house—each of them constitutes a world in itself, a world having its own rhythm and its own planetary orbit . . .

We deny volume as an expression of space. Space can be as little measured by a volume as a liquid by a linear measure. What can space be if not impenetrable depth? Depth is the unique form by which space can be expressed. We reject physical mass as an element of plasticity. Every engineer knows that the force of re-

sistance and the inertia of an object do not depend upon its mass. One example suffices: railroad tracks.

Nevertheless, plasticians preserve the prejudice according to which mass and volume are inseparable.

We have freed ourselves from the age-old errors of the Egyptians, according to whom the basic element of art could only be a static rhythm.

We announce that the elements of art have their basis in a dynamic rhythm.

ERIC GILL

THE PRIESTHOOD OF CRAFTSMANSHIP

THE ESSAY from which these extracts are taken first appeared in *Blackfriars* magazine almost at the time of Eric Gill's death. It is therefore in a sense a summation of all his thinking on the relation, or rather the essential oneness, of art and religion, and on the revival of craftsmanship in the sense and tradition of William Morris. The trend of his thinking can also be understood from the titles he gave to two earlier collections of his essays: *Art and Prudence* (1928) and *Beauty Looks After Herself* (1933).

The Incarnation may be said to have for its object the drawing of men from misery to happiness. Being the act of God It is the greatest of all rhetorical acts and therefore the greatest of all works of art . . .

But the word "art," in spite of the obsequious worship which the modern world gives to the works of painters and sculptors and musicians, is not a holy word in these days. Art, the word, which primarily means skill and thus human skill in doing and making, has, in literary circles and among the upper classes, come to mean only the fine arts, and the fine arts have ceased to be rhetorical and are now exclusively aesthetic; they aim only to give pleasure. Hence, however cultivated we may be and however refined our pleasures, we do not associate the word with holiness, or holiness with art. If we associate holiness with art at all it is only with that lowest form of art, the "holy picture," the cheap mass-produced reproductions we distribute as pious gestures. But art, "high art," the sort we put in museums and picture galleries, has become a pleasure thing; it is put there to amuse. Eat, drink, and be merry for tomorrow we die, and the utmost endeavor of our educators is to see to it that our merriment shall be "high class." If we put a painting of a Madonna in our art gallery, it is not because the painter has succeeded in conveying a specially clear view of her significance, but simply because he has succeeded in making a specially pleasing arrangement of materials. A Raphael Madonna! But it is as "Raphael" that we honor it and not as a Madonna; for Raphael is, or was until recently, held by the pundits to be particularly good at making pleasing arrangements, and we are no longer concerned with meanings . . .

In proclaiming the essentially evangelical nature of all human works we are not suggesting that the whole world ought to turn itself into one great "church furniture" shop. The contrary would be nearer the truth, we ought rather to abolish church furniture shops altogether; for just as prayer almost ceases to be prayer when we know that we are praying, so "church" art ceases to be suitable for churches. The point is that human works should

be holy, for holiness is properly their criterion, and holiness is not simply that which is so called . . .

It should be noted that I am not claiming a special loftiness for a small class of special persons for, in a normal society, one, that is to say, composed of responsible persons, responsible for what they do and for what they make, "the artist is not a special kind of man, but every man is a special kind of artist." There is not such hard distinction between what is useful physically and what is useful mentally . . . Art as a virtue of the practical intelligence is the well-making of what is needed—whether it be drain-pipes or paintings and sculptures and musical symphonies of the highest religious import—and science is that which enables us to deal faithfully with technique. As art is the handmaid of religion, so science is the handmaid of art. [Through the full realization of these facts] we should avoid the absurdity of machine-made ornamentation and the indecency of sprawling wens like London; and painters and sculptors, who, under our present financier-run tyranny, are compelled to be simply mountebanks or lap-dogs, and their works a sort of hot-house flowers, would again find themselves in normal employment as members of a building-gang.

Art is a rhetorical activity—this is easily understood when we think of books and dramatic plays, of poetry and music, or pictures and sculptures. And if we realize that there is no dividing line between these things and the works of blacksmiths and navvies, we shall see how all things work together for good, and that is to say, for God.

What is a work of art? A word made flesh. That is the truth, in the clearest sense of the text. A word, that which emanates from the mind. Made flesh; a thing, a thing seen, a thing known, the immeasurable translated into terms of the measurable. From the highest to the lowest that is the substance of works of art. And it is a rhetorical activity; for whether by the ministry of angels or of saints or by the ministry of common workmen, gravers or gravediggers, we are all led heavenwards.

EDWARD WADSWORTH

ON ENGLISH ART AND ABSTRACTION

IN 1933 Wadsworth, Paul Nash, and other English artists tending towards abstraction formed a group they called *Unit One*. It was to serve as "an expression of a truly contemporary spirit," and to combat the "unconscious beauties of the English school" and the "lack of structural purpose" among English artists. Wadsworth set down these opinions in answer to a questionnaire the group sent to its members.

On "English" art, compare Hogarth, p. 180; Holman Hunt, p. 339; and Whistler, p. 351.

London, 1933

A picture is no longer a window out of which one sees an attractive little bit of nature; nor is it a means of demonstrating the personal sentiments of the artist: it is itself, it is an object: a new unity expanding the idea of the term "beauty."

In the best periods, the painter does not paint what he sees but what he knows *is*. A reality must be evoked—not an illusion.

The impressionists took the mote out of the eye, and the beam must be taken out of the spirit.

The imitation, in painting, of the visual forms of machinery is as ridiculous as the imitation of any other forms, but the disciplined lyricism of the machine can suggest themes of form, line, or movement on equal, though more limited, terms with nature.

A picture is primarily the animation of an inert plane surface by a spatial rhythm of forms and colors. It may subsequently contain symbols representing persons or landscapes, but in the first instance the color will be determined by the character of the shapes. The determining character may also, as in the case of the Virgin's cloak, be of a literary quality.

I prefer to use the most direct means: the simplest forms and colors (preponderance of black, white, red, and blue) to avoid the equivocal. Color, relative to forms concerned, must be pure —not necessarily bright. It must be functional. One does not want

a sauce—not even a good sauce—to conceal the poorness of the meat. The color must contain the Form.

The spirit of our epoch is one of synthesis and construction, and any work of art which does not express this spirit does not belong spiritually to our age.

The quality most characteristic of English expression has always been an insistence on workmanship or technique rather than on design—a meticulousness about *how* a thing is said rather than *what* is said—a preoccupation with the material rather than the spiritual. (Everyone fill in here, please, his own list of exceptions.)

The artists of this country have added—from time to time—their contribution to the ideography of occidental painting, and they will continue to do so if they combine their craftsmanship with a more universal point of view of what they want to say. The production of healthy works of energetic thought and feeling has not ceased in this country. But one does not speak of "English" mathematics or "English" tennis.

GEORGE BELLOWS

ANSWERS TO FIVE QUESTIONS

BELLOWS THE "realist," pupil of Henri (see p. 398), was asked these questions by a group of students who wanted to know the principles by which they should proceed. The answers were found among Bellows' papers after his death and published as a preface for a book of his paintings. They have something of the vigor of his art.

[Undated]

What is good drawing?

This question depends on the definition of what is a work of art. If we consider that a work of art is the finest, deepest, most significant expression of a rare personality, it follows that any

plastic invention or creative molding of form which succeeds in giving life to this expression is good drawing. It may have mechanical and spiritual shortcomings coincident with even the greatest of people, but it will still remain good drawing.

What is good painting?

This question is a development of the first and is answered equally in the first statement . . . In fact, I am sure that no line can be drawn between [the two words] as manifested in pictures.

How does subject-matter relate to art?

A work of art is both independent of and dependent on a subject: independent in that all objective or subjective sensations, anything in fact, which has the power to hold or receive human attention, may be the subject of a work of art; dependent, in the sense of the necessity, whether realized or not, of a point of departure, a kernel, a unit established, around which the creative imagination builds or weaves itself. The name given to a thing is *not* the subject, it is only a convenient label. Any subject is inexhaustible.

How is nature related to art?

In English the word "nature" is used with several distinct and opposite meanings . . . In its broadest, and, I imagine, most scientific, meaning all things that are are nature . . . Its distinctly opposite and popular meaning is its use in distinguishing between the natural and the artificial, or art, or between the spontaneous phenomena, as we know them, and man's arrangement of natural forces. A third, and still more ambiguous, meaning connects the word with law. We speak of following the "laws of nature." Therefore the school dictum of following nature is a foolish criterion and a meaningless phrase. Anything is right only as it answers to the need for which it was ordered . . .

The ideal artist is he who knows everything, feels everything, experiences everything, and retains his experience in a spirit of wonder and feeds upon it with creative lust. He is therefore best able to select and order the components best suited to fulfill any given desire. The ideal artist is the superman. He uses every possible power, spirit, emotion conscious or unconscious to arrive at his ends.

Of what importance is art to society?

All civilization and culture are the results of the creative imagination or artist quality in man. The artist is the man who makes life more interesting or beautiful, more understandable or mysterious, or probably, in the best sense, more wonderful. His trade is to deal with illimitable experience. It is therefore only of importance for the artist to discover whether he be an artist, and it is for society to discover what return it can make to its artists.

JACOB EPSTEIN

ON SCULPTURE AND SCULPTORS

FOR MANY years one of the most controversial figures in modern art, Epstein has also been one of the most explosive and voluble. When attacked he has defended himself stoutly, much in the manner of Whistler (also an American resident in London), though with more bluntness. These opinions are drawn from his two books, *The Sculptor Speaks* (1931) and *Let There Be Sculpture* (1940).

SELF-EVALUATION *London, 1940*

It is naturally difficult to assess one's place in the period one lives in—perhaps it is impossible. It is a process similar to painting one's own portrait, or rather to working on a portrait in the round, a really difficult undertaking. The artist usually dramatizes himself, and that is why few self-portraits bear the imprint of truth. My outstanding merit in my own eyes is that I believe myself to be a return in sculpture to the human outlook, without in any way sinking back into the flabby sentimentalizing, or the merely decorative, that went before. From the cubists onwards, sculpture has tended to become more and more abstract, whether the shape it took was that of the clearness and hardness of machinery or soft and spongy forms as in Hans Arp, or a combination of both. I fail to see, also, how the use of novel materials helps, such as glass, tin, strips of lead, stainless steel, and aluminum. The use of these materials might add novel and pleasing effects in connection

with architecture, but it adds nothing to the essential meanings of sculpture, which remain fundamental. The spirit is neglected for detail, for ways and means.

NUDES

The continual harping on the nude for its own sake has been overdone, and a rest from the nude might do sculpture good. Draped figures, as in Gothic work, might as an alternative today seem as novel as the apotheosis of the nude after Gothic . . . The main charge against my work is that it has no "formal relations." By "formal relations" the critic means that my forms and their juxtaposition were just accidental. This I consider sheer nonsense. Because an artist chooses to put certain abstract forms together does not mean that he has succeeded in creating a better design than mine, whose forms are taken from a study of nature. To construct and relate natural forms may call for a greater sensibility and a more subtle understanding of design than the use of abstract formulae.

CARVING VS. MODELING *London, 1931*

There is apparently something romantic about the idea of the statue imprisoned in the block of stone, man wrestling with nature. Michelangelo himself has written a poem about the subject, but he was a modeler as well as a carver. According to the modern view Rodin stands nowhere. He is patronized as a modeler of talent, even of genius, but merely as a modeler. As a matter of fact nearly all the great sculptors of the Renaissance were modelers as well. Verrocchio is almost entirely a modeler, Donatello modeled many of his most important works. Personally I find the whole discussion entirely futile and beside the point. It is the result that matters, after all. Of the two, modeling, it could be argued logically, and this is said as a logical argument only, seems to me to be the more genuinely creative. It is the creating of something out of nothing. An actual building up and getting to grips with the material. In carving the suggestion for the form of the work often comes from the shape of the block. In fact, inspiration is always modified by the material, there is no complete freedom,

while in modeling the artist is entirely unfettered by anything save the technical difficulties of his own chosen subject. As I see sculpture it must not be rigid. It must quiver with life, while carving often leads a man to neglect the flow and rhythm of life. Take the case of the *Sick Child*.

Twenty years ago I would have simplified the hair of the child into what critics call "true sculptural form," while today I find a rhythm in the hair of each individual head that I must capture.

DONATELLO AND MICHELANGELO

There is a very great difference between genuine vitality and the forced dramatic element of baroque. Michelangelo is called the father of baroque, but there is no trace of that restlessness in his work. He is very much an unwilling father. Baroque came into being through pygmies trying to follow a giant. Michelangelo was too remote to have any followers of note. Donatello, who had perhaps greater contact with life, was the safer man to follow as a *chef d'école* and did produce many remarkable followers. The artist who possesses genuine strength will not need, whatever subject he is treating, to descend to restless theatricality. It is interesting to compare Bourdelle's large equestrian statue with the *Colleoni* and the *Gattamelata*. At first sight the Bourdelle may appear grand and impressive, but it is very forced and hollow. The Donatello and the Verrocchio produce a thrill in a far more subtle manner. They do not make a parade of their strength. It is held in reserve, so that the effect is not exhausted at a first glance. They are full of vitality, but they have at the same time that repose that is so essential in a work of art and that gives one a feeling of finality. The baroque artist has to exaggerate in order to produce an effect. He has continually to seek the aid of fancy dress, to clothe his sitters in a toga, to lend them a dignity which the work itself should give. [Compare Canova, p. 198; and Rodin, p. 327.]

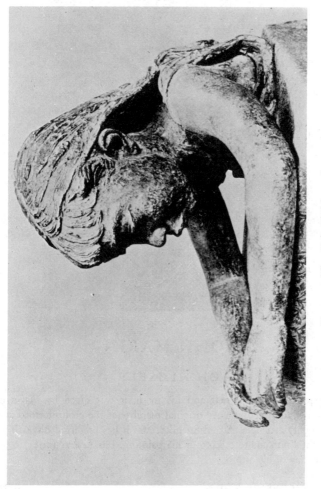

EPSTEIN: The Sick Child, 1928

JOHN MARIN

ON HIMSELF

THIS DESCRIPTION of himself and his methods was given by Marin only reluctantly and by request. An original member of the group formed at *291* by the highly articulate Alfred Stieglitz, Marin has preferred discussing his extra-artistic pursuits to talking of his painting. His *Letters* (1931) contain little mention of his art.

THE COLLECTIVE OF TODAY *1928*

 To lay off for a while, which is not too difficult, to ponder over, to think on, to vision, what I have done, am doing, am to do, what I have seen, am seeing, am to see, in, of, and on this world about

me in which I am living, that impels the doing of my do—that's more difficult.

And too what others are doing. For the trend of the doing from the seeing must certainly bear out a sort of collective of today.

For the worker to carry on, to express his today, with the old instruments, the old tools, is inexcusable, unless he is thoroughly alive to the relationships of things and works in relationships. Then he can express his today in any material, preserving that material's relationship; as the relationship of two electric bulbs of different strengths can be the same as the relationship of two pieces of lead of different weights.

THE FLAT PLANE AND THE BLESSED EQUILIBRIUM

To get to my picture, or to come back, I must for myself insist that when finished, that is when all the parts are in place and are working, that now it has become an object and will therefore have its boundaries as definite as that the prow, the stern, the sides and bottom bound a boat.

And that this my picture must not make one feel that it bursts its boundaries. The framing cannot remedy. That would be a delusion and I would have it that nothing must cut my picture off from its finalities. And too, I am not to be destructive within. I can have things that clash. I can have a jolly good fight going on. There is always a fight going on where there are living things. But I must be able to control this fight at will with a Blessed Equilibrium.

Speaking of destruction, again, I feel that I am not to destroy this flat working surface (that focus plan of expression) that exists for all workers in all mediums. That on my flat plane I can superimpose, build up onto, can poke holes into—by George, I am not to convey the feel that it's bent out of its own individual flatness.

ELEMENTAL FORMS AND HORSE SENSE

Too it comes to me a something in which I am curiously interested. I refer to Weight Balances. As my body exerts a downward pressure on the floor, the floor in turn exerts an upward pressure on my body.

Too the pressure of the air against my body, my body against the air, all this I have to recognize when building the picture.

Seems to me the true artist must perforce go from time to time to the elemental big forms—Sky, Sea, Mountain, Plain—and those things pertaining thereto, to sort of re-true himself up, to recharge the battery. For these big forms have everything. But to express these, you have to love these, to be a part of these in sympathy . . .

And now, after looking over my scribblings on various pieces of paper, I think that what I have put down is about what I have wanted to say, the gist of it anyway. My present-day creed, which may show different facets on the morrow.

Toward the logic, the horse sense of the matter, I have tried to lean. I may have failed, but, my friend, I am forced to pit my horse sense against yours, otherwise there'd be no race, no fun.

MARSDEN HARTLEY

ART—AND THE PERSONAL LIFE

THIS is an anti-expressionist plea by an artist usually called "expressionist." But Hartley formed this opinion neither suddenly nor casually. More than ten years before he had argued the "Importance of Being Dada" because, he said, "it is the newest and most admirable reclaimer of art in that it offers at last a release for the expression of natural sensibilities." Now he had changed his mind.

Hartley's polished essays on painters, writers, and vaudevillians were gathered together in a volume entitled *Adventures in the Arts* (1921).

I have come to the conclusion that it is better to have two colors in bright relation to each other than to have a vast confusion of emotional exuberance in the guise of ecstatic fullness or poetical revelation—both of which qualities have, generally speaking, long since become second-rate experience.

I have lived the life of the imagination, but at too great an expense. I do not admire the irrationality of the imaginative life. I have, if I may say so, made the intellectual grade. I have made the complete return to nature, and nature is, as we all know, primarily an intellectual idea. I am satisfied that painting also is, like nature, an intellectual idea, and that the laws of nature as presented to the mind through the eye—and the eye is the painter's first and last vehicle—are the means of transport to the real mode of thought: the only legitimate source of aesthetic experience for the intelligent painter . . .

I am not at all sure that the time isn't entirely out of joint for the so-called art of painting, and I am certain that very few persons, comparatively speaking, have achieved the real experience of the eye either as spectator or performer. Modern art must of necessity remain in the state of experimental research if it is to have any significance at all. Painters must paint for their own edification and pleasure, and what they have to say, not what they are impelled to feel, is what will interest those who are interested in them. The thought of the time is the emotion of the time.

FOR INTELLECTUAL EXPERIMENT

It is not the idiosyncrasy of an artist that creates the working formula, it is the rational reasoning in him that furnishes the material to build on. Red, for example, is a color that almost any ordinary eye is familiar with—but in general when an ordinary painter sees it he sees it as isolated experience—with the result that his presentation of red lives its life alone, where it is placed, because it has not been modified to the tones around it—and modification is as good a name as any for the true art of painting color as we think of it today . . . Real color is in a condition of neglect

at the present time because monochrome has been the fashion for the last fifteen or twenty years . . . Cubism is largely responsible for this because it is primarily derived from sculptural concepts and found little need for color in itself. When a group feeling is revived once again, such as held sway among the impressionists, color will come into its logical own. And it is timely enough to see that for purposes of outdoor painting, impressionism is in need of revival.

EDWARD HOPPER

NOTES ON PAINTING

HOPPER COMPOSED the notes from which these selections are drawn as a preface to the catalogue of the one-man show given him in 1933 by the Museum of Modern Art. They represent the opinions of an artist whose pictures are often valued for their transcription of a subjective mood, but who considers himself an uncompromising realist. They constitute all that Hopper has ever written on his painting.

For further opinions on art and nationality see Holman Hunt, p. 339; Whistler, p. 351; and Wadsworth, p. 459.

PAINTING IS A RECORD OF EMOTION *1933*

My aim in painting has always been the most exact transcription possible of my most intimate impressions of nature. If this end is unattainable, so, it can be said, is perfection in any other ideal of painting or in any other of man's activities . . .

I have tried to present my sensations in what is the most congenial and impressive form possible for me. The technical obstacles of painting perhaps dictate this form. It derives also from the limitations of personality. Of such may be the simplifications that I have attempted.

I find, in working, always the disturbing intrusion of elements not a part of my most interested vision, and the inevitable obliteration and replacement of this vision by the work itself as it proceeds. The struggle to prevent this decay is, I think, the common lot of all painters to whom the invention of arbitrary forms has lesser interest.

I believe that the great painters, with their intellect as master, have attempted to force this unwilling medium of paint and canvas into a record of their emotions. I find any digression from this large aim leads me to boredom.

NATIONALITY IN ART

The question of the value of nationality in art is perhaps unsolvable. In general it can be said that a nation's art is greatest when it most reflects the character of its people. French art seems to prove this.

The Romans were not an aesthetically sensitive people, nor did Greece's intellectual domination over them destroy their racial character, but who is to say that they might not have produced a more original and vital art without this domination. One might draw a not too far-fetched parallel between France and our land . . .

If an apprenticeship to a master has been necessary, I think we have served it. Any further relation of such a character can only mean humiliation to us. After all, we are not French and never can be, and any attempt to be so is to deny our inheritance and to try to impose upon ourselves a character that can be nothing but a veneer upon the surface.

THE MODERN IS NOT THE NEW

In its limited sense, modern art would seem to concern itself only with the technical innovations of the period. In its larger and to me irrevocable sense it is the art of all time; of definite personalities that remain forever modern by the fundamental truth that is in them. It makes Molière at his greatest as new as Ibsen, or Giotto as modern as Cézanne.

Just what technical discoveries can do to assist interpretive power is not clear. It is true that the impressionists perhaps gave a more faithful representation of nature through their discoveries in out-of-door painting, but that they increased their stature as artists by so doing is controversial. It might here be noted that Thomas Eakins in the nineteenth century used the methods of the seven-

teenth, and is one of the few painters of the last generation to be accepted by contemporary thought in this country.

If the technical innovations of the impressionists led merely to a more accurate representation of nature, it was perhaps of not much value in enlarging their powers of expression. There may come or perhaps has come a time when no further progress in truthful representation is possible. There are those who say that such a point has been reached and attempt to substitute a more and more simplified and decorative calligraphy. This direction is sterile and without hope to those who wish to give painting a richer and more human meaning and a wider scope.

CHARLES SHEELER

SENSIBILITY AND ORDER

THIS BRIEF credo was written for the catalogue of the Forum Exhibition of American Painting, in 1916. Coming three years after the Armory Show, it presented the advanced tendencies of the day—artists under the influence of cubist and *Fauve* painting—backed by the prestige of Robert Henri's name in a foreword. This was written before Sheeler's art became so completely allied with his interest in photography.

1916

I venture to define art as the perception through our sensibilities, more or less guided by intellect, of universal order and its expression in terms more directly appealing to some particular phase of our sensibilities . . .

And I here add "less rather than more," for I believe that human intellect is far less profound than human sensibility; that every thought is the mere shadow of some emotion which casts it.

Plastic art I feel to be the perception of order in the *visual* world (this point I do not insist upon), and its expression in purely plastic terms (this point I absolutely insist upon). So that whatever problem may be at any time any particular artist's point of departure for creative aesthetic endeavor, or whatever may be his means of solving his particular problem, there remains but one test of the

aesthetic value of a work of plastic art, but one approach to its understanding and appreciation, but one way in which it can communicate its most profound significance. Once this has been established, the observer will no longer be disturbed that at one time the artist may be interested in the relation of straight lines to curved, at another in the relation of yellow to blue, or at another in the surface of brass to that of wood. One-, two-, and three-dimensional space, color, light and dark, dynamic power, gravitation or magnetic forces, the frictional resistance of surfaces and their absorptive qualities, all qualities capable of visual communication, are material for the plastic artist; and he is free to use as many or as few as at the moment concern him. To oppose or relate these so as to communicate his sensations of some particular manifestation of cosmic order—this I believe to be the business of the artist.

DIEGO RIVERA

THE REVOLUTION IN PAINTING

RIVERA STUDIED in Spain, France, and Italy from 1910 to 1921 and for a time worked within the cubist tradition. But his later fresco style and subject-matter—Mexican revolutionary history—has, with Orozco's work, come to be considered characteristic of Mexico. Throughout his career Rivera has been constantly involved in Mexican and world politics and has expressed that interest in his art.

ART AND THE PROLETARIAT *January, 1929*

A few years ago before the Great War, I often discussed the role which art would assume once the power of the State was in the hands of the working class. After the Mexican Revolution, my revolutionary confrères—then living in Paris—thought that if they gave modern art of the highest quality to the masses this art would immediately become popular through its instant acceptance by the proletariat. I was never able to share this point of view,

because I always knew that the physical senses are susceptible not only to education and development, but to atrophy and desuetude; and also that the "aesthetic sense" can only be reached through the physical senses themselves. I had also observed the indubitable fact that among the proletariat—exploited and oppressed by the bourgeoisie—the workman, ever burdened with his daily labor, could cultivate his taste only in contact with the worst and the vilest portion of bourgeois art which reached him in cheap chromos and the illustrated papers. And this bad taste in turn stamps all of the industrial production which his salary commands—public expositions being difficult of access for him because he is at work day in and day out.

Popular art produced by the people for the people has been almost wiped out by this kind of industrial production of the worst aesthetic quality throughout the world. And I also believed that a popular peasant art could not achieve an effective substitute in modern industrial production of fabrics, utensils, illustrated books, and so forth.

ART AS A SOCIAL INSTRUMENT

Only the work of art itself can raise the standard of taste. Art has always been employed by the different social classes who hold the balance of power as one instrument of domination—hence, as a political instrument. One can analyze epoch after epoch—from the stone age to our own day—and see that there is no form of art which does not also play an essential political role. For that reason, whenever a people have revolted in search of their fundamental rights, they have always produced revolutionary artists: Giotto and his pupils, Gruenewald, Bosch, Breughel the elder, Michelangelo, Rembrandt, Tintoretto, Callot, Chardin, Goya, Courbet, Daumier, the Mexican engraver Posadas, and numerous other masters. What is it then that we really need? An art extremely pure, precise, profoundly human, and clarified as to its purpose.

An art with revolution as its subject: because the principal interest in the worker's life has to be touched first. It is necessary that he find aesthetic satisfaction and the highest pleasure appareled in the essential interest of his life.

REVOLUTIONARY ART

I have therefore arrived at the clearest and firmest conviction that it is necessary to create that kind of art. Is it necessary therefore to discard all our ultra-modern technical means, necessary to deny the classic tradition of our métier? Not at all. It would have been as foolish to believe that in order to construct a grain elevator, a bridge, or to install a communal co-operative, one should not use the materials and methods of construction achieved by the industrial technique of the bourgeoisie. It is on the contrary the duty of the revolutionary artist to employ his ultra-modern technique and to allow his classic education (if he had one) to affect him subconsciously. And there is absolutely no reason to be frightened because the subject is so essential. On the contrary, precisely because the subject is admitted as a prime necessity, the artist is absolutely free to create a thoroughly plastic form of art. The subject is to the painter what the rails are to a locomotive. He cannot do without it. In fact, when he refuses to seek or accept a subject, his own plastic methods and his own aesthetic theories become his subject instead. And even if he escapes them, he himself becomes the subject of his work. He becomes nothing but an illustrator of his own state of mind, and in trying to liberate himself he falls into the worst form of slavery. That is the cause of all the boredom which emanates from so many of the large expositions of modern art, a fact testified to again and again by the most different temperaments. That is the deception practiced under the name of "Pure Art," two new resounding words which attest to nothing more in the work of talented men.

JOSÉ CLEMENTE OROZCO

ON HIS ART

THESE TWO explanations of Orozco's attitude in art were written while he was working in the United States (1927-1934). In each case he is referring to his style of monumental fresco painting, which, along with Rivera's art, set a new style in Mexico and had great influence in the United States.

IDEA VS. STORY *1934*

In every painting, as in any other work of art, there is always an IDEA, never a STORY. The idea is the point of departure, the first cause of the plastic construction, and it is present all the time as energy creating matter. The stories and other literary associations exist only in the mind of the spectator, the painting acting as the stimulus.

There are as many literary associations as spectators. One of them, when looking at a picture representing a scene of war, for example, may start thinking of murder, another of pacifism, another of anatomy, another of history, and so on. Consequently to write a story, and to say that it is actually TOLD by a painting, is wrong and untrue. Now the ORGANIC IDEA of every painting, even the worst in the world, is extremely obvious to the average spectator with normal mind and normal sight. The artist cannot possibly hide it. It might be a poor, superfluous, and ridiculous idea or a great and significant one.

But the important point regarding these frescoes [of Baker Library, Dartmouth College] is not only the quality of the idea that initiates and organizes the whole structure, it is also the fact that it is an AMERICAN idea developed into American forms, American feeling, and, as a consequence, into American style.

It is unnecessary to speak about TRADITION. Certainly we have to fall in line and learn our lesson from the Master. If there is another way it has not been discovered yet. It seems that the line of Culture is continuous, without short cuts, unbroken from the unknown Beginning to the unknown End. But we are proud to say now: this is no imitation, this is our OWN effort, to the limit of our own strength and experience, in all sincerity and spontaneity.

NEW WORLD, NEW PEOPLES, AND NEW ART *January, 1929*

The art of the New World cannot take root in the old traditions of the Old World nor in the aboriginal traditions represented by the remains of our ancient Indian peoples. Although the art of all races and of all times has a common value—human, universal—

each new cycle must work for itself, must create, must yield its own production—its individual share to the common good.

To go solicitously to Europe, bent on poking about its ruins in order to import them and servilely to copy them, is no greater error than is the looting of the indigenous remains of the New World with the object of copying with equal servility its ruins or its present folk-lore. However picturesque and interesting these may be, however productive and useful ethnology may find them, they cannot furnish a point of departure for the New Creation. To lean upon the art of the aborigines, whether it be of antiquity or of the present day, is a sure indication of impotence and of cowardice, in fact, of fraud.

If new races have appeared upon the lands of the New World, such races have the unavoidable duty to produce a New Art in a new spiritual and physical medium. Any other road is plain cowardice.

Already, the architecture of Manhattan is a new value, something that has nothing to do with Egyptian pyramids, with the Paris Opera, with the Giralda of Seville, or with Saint Sofia, any more than it has to do with the Maya palaces of Chichen-Itza or with the "pueblos" of Arizona.

Imagine the New York Stock Exchange in a French Cathedral. Imagine the brokers all rigged out like Indian chieftains, with head feathers or with Mexican sombreros. The architecture of Manhattan is the first step. Painting and sculpture must certainly follow as inevitable second steps.

The highest, the most logical, the purest and strongest form of painting is the mural. In this form alone, is it one with the other arts—with all the others.

It is, too, the most disinterested form, for it cannot be made a matter of private gain; it cannot be hidden away for the benefit of a certain privileged few.

It is for the people. It is for ALL.

SOURCES

Unless otherwise indicated, selections from all titles not given in English have been translated by the editors. Where translations have been used, an edition of the original text is given in parentheses. For further bibliography on the earlier sections, the reader is referred to Schlosser, DIE KUNSTLITERATUR, page references to which are indicated thus: (Sch. p. . . .).

ALBANI: C. C. Malvasia, *Felsina pittrice,* Bologna, 1841, II, p. 163. (Sch. p. 543)

ALBERTI: L. B. Alberti, *Kleinere Kunsttheoretische Schriften,* Vienna, 1877, *passim.* (Collated with *De pictura,* Basel, 1540.) (Sch. p. 111)

ALLSTON: Jared B. Flagg, *The Life and Letters of Washington Allston,* New York, 1892, pp. 39-40, 55-56, 203-06.

AMMANNATI: F. Baldinucci, *Notizie de professori del disegno,* Florence, 1864, II, p. 396.—G. Gaye, *Carteggio inedito d'artisti,* Florence, 1839–1840, III, p. 578.

ARMENINI: G. B. Armenini, *Dei veri precetti della pittura,* Pisa, 1823, I, pp. 55, 67-68, 103-04, 120, 212-13. (Sch. p. 384)

BARRY: James Barry, *The Works of Sir James Barry, Esq.,* London, 1809, pp. 80-81, 215, 243-45.

BECKMANN: Max Beckmann, *On My Painting,* New York, 1941, *passim.*

BELLOWS: G. Bellows, *The Paintings of George Bellows,* New York, 1929, pp. viii-xi.

BERNINI: L. Lalanne, "Journal du Voyage du Cavalier Bernin," *Gazette des Beaux-Arts,* Paris, 1877, I, pp. 186, 200, II, p. 176; 1879, I, p. 286, II, p. 275; 1880, I, pp. 382-84, 387; 1884, I, p. 452.

BINGHAM: Albert Christ-Janer, *George Caleb Bingham,* New York, 1940, pp. 120-21, 125-26.

BLAKE: William Blake, *The Writings of William Blake,* ed. Geoffrey Keynes, London, 1925, II, pp. 300-01; III, pp. 5-7, 24-25, 27, 38, 72, 91-92.

BOCCIONI: Umberto Boccioni, *Opera completa,* Foligno, 1927, p. 185 ff.

BOSSI: Giuseppe Bossi, "Saggio di ricerche intorno all'armonia cromatica," *Memorie dell' I. R. Istituto Veneto del Regno Lombardo Veneto,* Milan, 1821, II.

BOUDIN: Jean-Aubry, *Boudin, d'après des documents inédits,* Paris, 1922 pp. 70-71.

BOUGUEREAU: Marius Vachon, *W. Bouguereau,* Paris, 1900, pp. 109-10, 132, 140.

BOURDELLE: Gaston Varenne, *Bourdelle par lui-même,* Paris, 1937, pp. 46, 56, 64.

BRAQUE: Georges Braque, "Pensées et réflexions sur l'art," *Nord-Sud,* X, Dec. 1917, pp. 3-5.

CANOVA: V. Malamani, *Canova,* Milan, 1911, pp. 141-54.—F. Boyer, "Autour de Canova et de Napoléon," *Revue des études italiennes,* II, no. 3, July–Sept. 1937.—G. Bottari and S. Ticozzi, *Raccolta di lettere sulla pittura, scultura, ed architettura,* Milan, 1822–1825, VIII, pp. 203-06.—M. Missirini, *Della vita di Antonio Canova,* Prato, 1824, p. 316 ff.

CARDUCHO: V. Carducho, *Diálogos de la pintura,* Madrid, 1865, pp. 126-27, 131, 159, 206.

CARRACCI: C. C. Malvasia, *Felsina pittrice,* Bologna, 1841, I, pp. 286-70.

CECIONI: Adriano Cecioni, *Scritti e ricordi,* Florence, 1905.

CELLINI: Benvenuto Cellini, *I trattati dell'oreficeria e della scultura,* Florence, 1857, pp. 216-18, 272-75.—Benvenuto Cellini, *Memoirs,* tr. A. Macdonnell, London, 1910, bk. VII, ch. V. (Sch. p. 356)

CENNINI: C. Cennini, *Il libro dell'arte,* ed. D. V. Thompson, New Haven, 1932. C. Cennini, *The Craftsman's Handbook,* tr. D. V. Thompson, New Haven, 1933, pp. 16, 36, 48, 49. (Sch. p. 78)

CÉZANNE: Emile Bernard, *Sur Paul Cézanne,* Paris, 1925, p. 99.—Paul Cézanne, *Letters,* ed. John Rewald, London, 1941, Letters nos. 167, 168, 169, 171, 175, 180, 183, 188, 195, 197.

CHASSÉRIAU: Valbert Chevillard, *Théodore Chassériau,* Paris, 1893, pp. 42-46.

CHARDIN: E. & J. Goncourt, *L'art au XVIII^e siècle,* Paris, n.d., I, pp. 130-32.

CHIRICO, DE: Giorgio de Chirico, "Mystery and Creation," *London Bulletin,* no. 6, Oct. 1938, p. 14.—G. de Chirico, "Sull'arte metafisica," *Valori Plastici,* I, no. 4-5, April–May 1919, pp. 15-17.—G. de Chirico, "Il senso architettonico nella pittura antica," *Valori Plastici,* II, no. 5-6, May–June 1929, pp. 59-61.

CHAGALL: J. J. Sweeney, "Marc Chagall: An Interview," *Partisan Review,* XI, no. 1, 1944, pp. 88-93.

COLE: Thomas Cole, *The Course of Empire, The Voyage of Life, and Other Pictures . . . with Selections from His Letters,* New York, 1853, pp. 93-94, 125-26, 263-64, 303-04.

Conca: M. Missirini, *Memorie per servire alla storia della Romana Accademia di S. Luca,* Rome, 1823, pp. 214-19.

Constable: C. R. Leslie, *Memoirs of the Life of John Constable, R. A.,* ed. The Hon. Andrew Shirley, London, 1936, pp. 275, 289, 298, 316, 390, 393, 402.

Corot: Etienne Moreau-Nélaton, *Corot raconté par lui-même,* Paris, 1924, I, pp. 25, 66, 105, 125-26.

Cortona, Pietro da: Odomenigico Lelonotti da Fanano e Britio Prenetteri (anagrams of Gio. Domenico Ottonelli e Pietro Berrettini), *Trattato della pittura e scultura, uso ed abuso loro,* Florence, 1652, pp. 40, 118, 177, 205. (Sch. p. 545)

Courbet: Charles Léger, *Courbet,* Paris, 1929, pp. 61, 86-88, 153-55.

Couture: Thomas Couture, *Conversations on Art Methods* (Méthode et entretiens d'atelier, Paris, 1868), tr. S. E. Stewart, New York, 1879, pp. 10-11, 209, 219-20.

Coypel: Henry Jouin, *Conférences de l'académie royale de peinture et de sculpture,* Paris, 1883, pp. 277-78, 285, 296.

David: J. David, *Le peintre Louis David,* Paris, 1880, pp. 149-50, 353-54, 572-77.—J. B. Delecluze, *Louis David, son école et son temps,* Paris, 1855, pp. 62, 209, 226.

David d'Angers: Henry Jouin, *David d'Angers, sa vie, son œuvre,* Paris, 1878, II, pp. 372-73, 390, 403-04.

Degas: Etienne Charles, "Les Mots de Degas," *La Renaissance de l'art français,* no. 2, April 1918, pp. 3-7.

Delacroix: Eugène Delacroix, *Journal of Eugène Delacroix,* tr. Walter Pach, New York, 1937, *passim.* (*Journal d'Eugène Delacroix,* ed. André Joubin, 3 vols., Paris, 1932.)

Denis: Maurice Denis, *Théories: 1870–1910,* Paris, 1930, pp. 1-13.

Duerer: W. M. Conway, *The Literary Remains of Albrecht Duerer,* Cambridge, 1889, pp. 48, 171, 179, 231, 250-51; corrected and emended by Erwin Panofsky. (Lange und Fuhse, *Duerer's schriftlicher Nachlass,* Halle, 1893. (Sch. p. 241)

Eakins: William C. Brownell, "The Art Schools of Philadelphia," *Scribner's Monthly Illustrated Magazine,* XVIII, no. 5, Sept. 1879, pp. 737-50.

Ensor: James Ensor, *Les écrits de James Ensor,* Brussels, 1921, pp. 22-28, 95.

Epstein: Jacob Epstein, *Let There Be Sculpture,* New York, 1940, pp. 211-12.—Jacob Epstein, *The Sculptor Speaks,* London, 1931, pp. 60-61, 85-86, 109-10.

FALCONET: Etienne Falconet, *Oeuvres,* Paris, 1808, III, pp. 3-5, 16-17, 24.

FILARETE: A. A. Filarete, *Tractat ueber die Baukunst,* ed. W. von Oettingen, Vienna, 1896, pp. 619-23, 627, 643 (with Italian text). (Sch. p. 119)

FLANDRIN: Henri Delaborde, *Lettres et pensées de Hippolyte Flandrin,* Paris, 1865, pp. 490-92.

FROMENTIN: Louis Gonse, *Eugène Fromentin, peintre et écrivain,* Paris, 1881, pp. 119-20.

FUSELI: John Knowles, *The Life and Writings of Henry Fuseli,* London, 1831, III, *passim.*

GABO & PEVSNER: Nahum Gabo and Antoine Pevsner, *Realistic Manifesto,* Moscow, 1920; (tr. and abridged, *Abstraction-création,* no. 1, 1932, p. 27).

GAINSBOROUGH: W. I. Whitley, *Thomas Gainsborough,* London, 1915, pp. 20-21, 379-80.

GAUGUIN: Paul Gauguin, *Lettres de Paul Gauguin à Georges-Daniel de Monfreid,* Paris, 1918, p. 89.—Paul Gauguin, *Letters to Ambroise Vollard and André Fontainas,* ed. John Rewald, San Francisco, 1943, pp. 23-24.—Paul Gauguin, *The Intimate Journals of Paul Gauguin,* tr. Van Wyck Brooks, New York, 1936, pp. 71-75, 92-93, 132-34.

GÉRICAULT: Charles Clément, *Théodore Géricault, étude biographique et critique,* 3rd ed., Paris, 1879, pp. 108-09, 200-03, 242-49.

GHIBERTI: L. Ghiberti, *Denkwuerdigkeiten (I commentarii),* ed. J. von Schlosser, Berlin, 1912, I, pp. 4, 35-36, 48-49, 61-62. (Sch. p. 91)

GILL: Eric Gill, "Last Essays," *Art,* London, 1942, pp. 9-20.

GIRODET: P. A. Coupin, *Oeuvres posthumes de Girodet-Trioson, suivies de sa correspondance,* Paris, 1829, II, pp. 400, 280-81.

GOGH, VAN: Vincent van Gogh, Further Letters of Vincent van Gogh to His Brother, London, 1929, Letters nos. 504, 514, 519, 520, 527, 531, 542, 597.

GOYA: A. de Beruete y Moret, *Goya grabador,* Madrid, 1918, pp. 29-30.

GREENOUGH: H. T. Tuckerman, *A Memorial of Horatio Greenough, Consisting of a Memoir, Selections from His Writings, and Tributes to His Genius,* New York, 1853, pp. 110-16, 132-36.

HARTLEY: Marsden Hartley, "Art—and the Personal Life," *Creative Art,* II, no. 6, June 1928, pp. 31-34.

HENRI: Robert Henri, *The Art Spirit,* Philadelphia, 1923, pp. 48-49, 108, 126, 159.

HILDEBRAND, VON: Adolf von Hildebrand, *The Problem of Form,* New York, 1932, pp. 80-84.

HILLIARD: Philip Norman, "Nicholas Hilliard's Treatise Concerning the Arte of Limning," *Walpole Society*, 1911–1912, I, pp. 15-16, 18, 22, 28-29.

HODLER: Bender, *Die Kunst Ferdinand Hodler's*, Zurich, 1923–1941, I, pp. 215-28.

HOGARTH: John Ireland, *Hogarth Illustrated*, 2nd ed., London, 1793–1798, III, pp. 26-31.—William Hogarth, *The Analysis of Beauty*, London, 1753, Introduction.

HOMER: *Art Journal*, VI, 1880, pp. 107-08.

HOPPER: Museum of Modern Art, *Edward Hopper*, New York, 1933, pp. 17-18.

HUNT: W. H. Hunt, *Pre-Raphaelitism and the Pre-Raphaelite Brotherhood*, New York, 1905, I, pp. 135-37; II, pp. 465-66.

INGRES: Walter Pach, *Ingres*, New York, 1939, *passim*. (Delaborde, *Ingres, sa vie, ses travaux, sa doctrine*, Paris, 1890.)

INNESS: George Inness, *The Life, Art and Letters of George Inness, by George Inness, Jr.*, New York, 1917, pp. 168-73.

KANDINSKY: Wassily Kandinsky, *The Art of Spiritual Harmony*, tr. M. T. H. Sadler, Boston, 1914.—Wassily Kandinsky, "Line and Fish," *Axis*, no. 2, April 1935, p. 6.

KLEE: Paul Zahn, *Paul Klee*, Potsdam, 1920, pp. 26-28.—San Francisco Museum of Art, *Paul Klee Memorial Exhibition*, San Francisco, 1941.—Museum of Modern Art, *Bauhaus: 1919–1928*, New York, 1938, p. 172.

LA TOUR: Albert Besnard, *La Tour; la vie et l'œuvre de l'artiste*, Paris, 1928, pp. 65, 79, 85.

LAWRENCE: D. E. Williams, *The Life and Correspondence of Sir Thomas Lawrence*, London, 1870, pp. 149-50, 230-32.

LE BRUN: Charles Le Brun, *Conference Upon Expression*, tr. John Smith, London, 1701, *passim*. (Paris, 1667.) (Sch. p. 555)

LÉGER: Fernand Léger, "The New Realism," *Art Front*, II, Dec. 1935, p. 10.

LEIGHTON: Frederic I. Leighton, Baron Leighton of Stratton, *The Life, Letters, and Work of Frederic Leighton*, ed. by Mrs. Russell Barrington, London, 1906, II, pp. 63, 113.

LEONARDO DA VINCI: Leonardo da Vinci, *Das Buch der Malerei*, ed. H. Ludwig, Wien, 1882, *passim*.—Leonardo da Vinci, *The Literary Works*, ed. and trans. J. P. Richter, New York-London, 1939, *passim* (with original text).—E. MacCurdy, *The Notebooks of Leonardo da Vinci*, New York, 1939, *passim*.

LIEBERMANN: "Ein Credo," *Kunst und Kuenstler,* XX, July 1922, pp. 335-38.

LOMAZZO: G. P. Lomazzo, *Trattato dell'arte della pittura, scultura, ed architettura,* Milan, 1585, I, ch. 1; III, ch. 8; VI, ch. 4. (Sch. p. 359)

LOMBARD: G. Gaye, *Carteggio inedito d'artisti,* Florence, 1839–1840, III, 173-78. (Sch. p. 261)

MAILLOL: Judith Cladel, *Aristide Maillol,* Paris, 1937, pp. 128-35.

MALEVICH: P. Westheim, *Kuenstlerbekenntnisse,* Berlin, n.d., p. 355.— Kasimir Malevich, *Die gegenstandlose Welt* (Bauhausbuecher, 11), Munich, 1927, pp. 65-66, 72.

MANET: Etienne Moreau-Nélaton, *Manet raconté par lui-même,* Paris, 1926, I, pp. 71-72.—Antonin Proust, *Edouard Manet,* Paris, 1913, pp. 102-03, 124-25.

MARC: Franz Marc, *Briefe, Aufzeichnungen und Aphorismen,* Berlin, 1920, pp. 121-30.

MARÉES, VON: Julius Meier-Graefe, *Hans von Marées,* Leipzig, 1910, III, p. 234 ff.

MARIN: John Marin, *The Letters of John Marin,* New York, 1931, *passim.*

MATISSE: Museum of Modern Art, *Henri Matisse,* ed. Alfred H. Barr, New York, 1931, pp. 29-36. (*La Grande Revue,* Paris, Dec. 25, 1908.)

MENGS: A. R. Mengs, *Opere, corrette ed aumentate da C. Fea,* Rome, 1787.

MENZEL: A. von Menzel, *Briefe,* Berlin, 1914, p. 12 ff.

MICHELANGELO: J. A. Symonds, *The Sonnets of Michael Angelo and Campanella,* London, 1878, p. 35.—J. E. Taylor, *Michelangelo considered as a philosophic poet,* London, 1852, p. 107.—N. A. Robb, *Neo-Platonism of the Italian Renaissance,* London, 1935, p. 262.—H. W. Longfellow, *The Complete Poetical Works,* Boston and New York, 1922, p. 835. The originals may be found in C. Frey, *Die Dichtungen der Michelagniolo Buonarroti,* Berlin, 1897, pp. 7, 99, 201 and 236.— M. Buonarroti, *A Record of His Life as Told in His Own Letters,* ed., R. W. Carden, London, 1913, pp. 194-201, 250-52.—Francisco de Hollanda, *Four Dialogues on Painting,* tr. A. F. G. Bell, London, 1928, pp. 11-13, 15-18, 20, 60, 69, 72.

MILLET: Alfred Sensier, *Jean-François Millet,* tr. Helena de Kay, Boston, 1881, pp. 141-42, 157-58. (Paris, 1881.)

MONDRIAN: Piet Mondrian, "Neo-Plasticism," *Abstraction-création,* no. 1, 1932, p. 25; no. 2, 1933, p. 31.—P. Mondrian, "Figurative and Non-Figurative Art," *Circle,* London, 1937, pp. 41-56.

MONET: Gustave Geffroy, *Claude Monet,* II, pp. 146, 166.

MORSE: E. L. Morse, *Samuel F. B. Morse: Letters & Journals,* New York, 1914, I, pp. 68, 122.

OROZCO: José C. Orozco, *The Orozco Frescoes at Dartmouth,* Hanover, 1934.—Orozco, "New World, New Races, and New Art," *Creative Art,* IV, no. 1, Jan. 1929, pp. 65, 66.

OVERBECK: Margaret Howitt, *Friedrich Overbeck,* Freiburg, 1886.

PACHECO: F. Pacheco, *Arte de la pintura,* Madrid, 1866, pp. 118-21.

PALOMINO: A. A. Palomino de Castro y Velasco, *El museo pictorico y escala optica,* Madrid, 1715-24.

PFORR: F. H. Lehr, *Die Bluetezeit Romantischer Bildkunst,* Marburg, 1924, pp. 269-71.

PICASSO: Museum of Modern Art, *Picasso,* New York, 1939, pp. 9-20. ("Conversation avec Picasso," *Cahiers d'Art,* Paris, 1935, x, no. 10, pp. 173-78.)

PIERO DELLA FRANCESCA: Petrus Pictor Burgensis, *De prospectiva pingendi,* ed. C. Winterberg, Strassburg, 1899, I, pp. 1, 31-32 (with orginal text).

PISSARRO: Camille Pissarro, *Letters to His Son Lucien,* ed. John Rewald, New York, 1943, pp. 49-50, 163-64, 328-29, 340-41.

PONTORMO: G. Bottari, *Raccolta di lettere sulla pittura, scultura, ed architettura,* Rome, 1754-1773, I, pp. 15-17.

POUSSIN: Nicolas Poussin, *Correspondance de Nicolas Poussin,* ed. Ch. Jouanny, Paris, 1911, Letters 147, 156.—G. P. Bellori, *Le vite de' pittori, scultori, ed architetti moderni,* Rome, 1672, pp. 460-62.

PRUD'HON: Charles Clément, *Prud'hon, sa vie, ses œuvres, et sa correspondance,* Paris, 1872, pp. 127, 178-80.

RAPHAEL: V. Golzio, *Raffaello nei documenti,* Città del Vaticano, 1936, pp. 30-31, 82 ff.

REDON: Odilon Redon, *A soi-même; journal (1867-1915); notes sur la vie, l'art et les artistes,* Paris, 1922, pp. 29-30, 91-92, 140.—O. Redon, *Lettres de Odilon Redon, 1878-1916, publiées par sa famille, avec une préface de Marius-Ary Leblond,* Paris, 1923, p. 33.

RENI, GUIDO: G. P. Bellori, *Le Vite dei pittori, scultori, ed architetti moderni,* Rome, 1672, p. 6.

RENOIR: Lionello Venturi, *Les archives de l'impressionisme,* Paris, 1939, I, pp. 127-29.—Ambroise Vollard, *Renoir, an Intimate Record,* New York, 1930, pp. 116, 118-19, 129.

REYNOLDS: Joshua Reynolds, *The Works of Sir Joshua Reynolds,* London, 1798, II, pp. 229-34; III, notes x, LIV.

RIDOLFI: C. Ridolfi, *Delle maraviglie dell'arte*, Venice, 1648, I, p. 227.

RIVERA: Diego Rivera, "The Revolution in Painting," *Creative Art*, IV, 1929, pp. 28-30.

RODIN: Judith Cladel, *Rodin, The Man and His Art, with leaves from his notebook*, tr. S. K. Star, New York, 1917, pp. 107-08.—Auguste Rodin, *Art*, tr. Romilly Fedden (from French of Paul Gsell), Boston, 1912, pp. 32, 55, 61, 215-17. (Paris, 1911.)

ROSSETTI: W. M. Rossetti, *Dante Gabriel Rossetti; His Family Letters*, London, 1895, II, pp. 61-62.

ROSSO: E. Claris, "De l'impressionisme en sculpture," *Nouvelle revue*, Paris, 1901, X, pp. 321-26.

ROUAULT: Lionello Venturi, *Rouault*, New York, 1942, pp. 19-20.— Georges Rouault, "Climat pictural," *La Renaissance*, XX, no. 10-12, Oct. 1937, pp. 3-4.

ROUSSEAU, HENRI: H. Rousseau, *Les soirées de Paris*, III, no. 20, Jan. 15, 1933.

ROUSSEAU, THÉODORE: Alfred Sensier, *Souvenirs sur Théodore Rousseau*, Paris, 1872, pp. 242-44.

RUBENS: *Correspondance de Pierre-Paul Rubens*, ed. Ch. Ruelans, Antwerp, 1887, II, pp. 286-87.—Roger de Piles, *Cours de peinture par principes*, Paris, 1708, pp. 139-48.

RUNGE: H. Uhde-Bernays, *Kuenstlerbriefe ueber Kunst*, Dresden, 1926, pp. 399-401.

RYDER: F. F. Sherman, *Albert Pinkham Ryder*, New York, 1920, pp. 21-22, 36-38.

SACCHI: C. C. Malvasia, *Felsina pittrice*, Bologna, 1841, p. 179. (Sch. p. 543)

SEBASTIANO DEL PIOMBO: V. Golzio, Raffaello nei documenti, Città del Vaticano, 1936, p. 71.

SEGANTINI: Giovanni Segantini, *Scritti e lettere*, Turin, 1910.

SEURAT: Gustave Coquiot, *Seurat*, Paris, ca. 1924, pp. 232-33.

SEVERINI: Gino Severini, *Du Cubisme au Classicisme*, Paris, 1921.—G. Severini, *Ragionamenti sulle arti figurative*, Milan, 1936.

SHEELER: Forum Exhibition, Catalogue, New York, 1916, no paging.

SICKERT: Robert Emmons, *The Life and Opinions of Walter Richard Sickert*, London, 1941, pp. 157, 199-200, 275-77.

SIGNAC: Paul Signac, *De Delacroix au néo-impressionisme*, Paris, 1921 (1899), pp. 87-88.

SISLEY: Paul Westheim, *Kuenstlerbekenntnisse*, Berlin, n.d., pp. 30-31.

SLOAN: John Sloan, *The Gist of Art*, New York, 1939, pp. 53, 109-12, 189.

TINTORETTO: C. Ridofi, *Delle maraviglie dell'arte,* Venice, 1648, II, p. 58-59.

TITIAN: C. Ridolfi, *Delle maraviglie dell'arte,* Venice, 1648, I, p. 189.

VASARI: Louisa L. Maclehose, *Vasari on Technique,* London, 1907, pp. 210-19.—Giorgio Vasari, *The Lives of the Painters, Sculptors, and Architects,* tr. A. B. Hinds, London, 1927, I, p. 205; II, pp. 151-55; IV, pp. 108, 141. (Vasari-Milanesi, *Le Vite,* 9 vols., Florence, 1906.)

VERONESE: P. Caliari, *Paolo Veronese, sua vita e sue opere,* Rome, 1888, pp. 102-05. (Sch. p. 357)

WADSWORTH: Unit One, London, 1933, pp. 94-99.

WATTEAU: E. & J. Goncourt, *L'Art au XVIII^e siècle,* Paris, n.d., I, p. 40.

WHISTLER: J. A. McN. Whistler, *The Gentle Art of Making Enemies,* New York, 1893, pp. 26-30, 126-28, 139, 141-43, 153-55.

ZADKINE: Written for this book.

ZUCCARI: G. Bottari, *Raccolta di lettere sulla pittura, scultura, ed architettura,* Rome, 1754-1773, VI, pp. 118, 135. (Sch. p. 358)

ACKNOWLEDGMENTS

The editors of this anthology and Pantheon Books Inc. wish to express their gratitude to all the publishers who have kindly granted reprint permissions. Every effort has been made to ascertain the copyright owners, but in spite of our best efforts present circumstances have in some cases made communication impossible. We therefore tender our apologies to anyone whose rights may appear to have been overlooked.

For quotations from:
Mrs. Russell Barrington: "The Life, Letters, and Work of Frederic Leighton."

John Sloan: "The Gist of Art," *to The American Artists Group, Inc., New York.*

George Inness, Jr.: "The Life, Art, and Letters of George Inness."—Rodin: "The Man and His Art," with leaves from his notebook, compiled by Judith Cladel and tr. by S. K. Star, *to D. Appleton-Century Company, Inc., New York.*

"The Painting of George Bellows," *to Mrs. George Bellows, New York.*

Jean-Aubrey: "Boudin, d'après des documents inédits," *to Bernheim-Jeune, New York.*

Max Beckmann: "On My Painting," *to the Buchholz Gallery, New York.*

Umberto Boccioni: "Opera Completa," *to F. Campitelli, Foligno.*

"Letters of Paul Cézanne," ed. by John Rewald.—Franz Marc: "Briefe, Aufzeichnungen und Aphorismen," *to Bruno Cassirer, London.*

Michelangelo Buonarroti: "A Record of His Life as Told in His Own Letters," ed. by R. W. Carden.—"Further Letters of Vincent Van Gogh to His Brother."—Wassily Kandinsky: "The Art of Spiritual Harmony," *to Constable and Company, Ltd., London.*

489

Charles Léger: "Courbet."—"Lettres de Paul Gauguin à Georges-Daniel de Monfreid," *to Les Editions G. Crès et Cie., Paris.*

"The Journal of Eugène Delacroix," ed. by Walter Pach, copyright by Covici, Friede, Inc., *to Crown Publishers, New York.*

Eric Gill: "Last Essays," *to Devin-Adair Co., New York.*

A. Christ-Janer: "George Caleb Bingham," *to Dodd, Mead and Company, Inc., New York.*

Lionello Venturi: "Les Archives de l'Impressionisme," *to Durand-Ruel and Company, New York.*

Benvenuto Cellini: "Memoirs," tr. by A. Macdonnell.—Louise Maclehose: "Vasari On Technique."—Giorgio Vasari: "The Lives of the Painters, Sculptors, and Architects," tr. by A. B. Hinds, *to E. P. Dutton, Inc., New York.*

Robert Emmons: "The Life and Opinions of Walter Richard Sickert," *to Robert Emmons, Esq., Boston.*

Gaston Varenne: "Bourdelle par lui-même," *to E. Fasquelle et Cie., Paris.*

Paul Gauguin: "Letters to Ambroise Vollard and André Fontainas," *to the Grabhorn Press, San Francisco.*

Judith Cladel: "Aristide Maillol," *to Editions Bernard Grasset, Paris.*

Walter Pach: "Ingres," *to Harper and Brothers, New York.*

Jacob Epstein: "The Sculptor Speaks," *to W. Heinemann, Ltd., London.*

Ambroise Vollard: "Renoir," *to Alfred A. Knopf, New York.*

"The Intimate Journals of Paul Gauguin," tr. by Van Wyck Brooks, *to Liveright Publishing Corporation, New York.*

W. H. Hunt: "Pre-Raphaelitism and the Pre-Raphaelite Brotherhood," *to The Macmillan Company, New York.*

"The Letters of John Marin," *to John Marin, Cliffside, New Jersey.*

C. R. Leslie: "Memoirs of the Life of John Constable, R.A.," *to The Medici Society, London.*

Julius Meier-Graefe: "Hans von Marées," *to Mrs. Julius Meier-Graefe, New York.*

Gustave Coquiot: "Seurat," *to Albin Michel et Cie., Paris.*

"The Letters and Journals of Samuel F. B. Morse," *to Miss Leila L. Morse, New York.*

W. T. Whitley: "Thomas Gainsborough," *to John Murray, London.*

"The Bauhaus: 1919–1928."—"Edward Hopper."—"Henri Matisse," ed. by Alfred H. Barr, Jr.—"Picasso," ed. by Alfred H. Barr, Jr., *to The Museum of Modern Art, New York.*

"The Writings of William Blake," ed. by Geoffrey Keynes, *to the None-such Press, London.*

Robert Henri: "The Art Spirit," *to Miss Violet Organ, New York.*

Francisco de Hollanda: "Four Dialogues on Painting," tr. by A. F. G. Bell.—Leonardo da Vinci: "The Literary Works," ed. and tr. by J. P. Richter, *to The Oxford University Press, Oxford, England.*

J. J. Sweeney: "Marc Chagall: An Interview," *to Partisan Review, New York.*

Jacob Epstein: "Let There Be Sculpture," *to G. P. Putnam's Sons, New York.*

Ewald Bender: "Die Kunst Ferdinand Hodler's," *to A. Rascher, Zurich, Switzerland.*

"The Notebooks of Leonardo da Vinci," ed. by E. MacCurdy, *to Reynal & Hitchcock, New York.*

"Paul Klee Memorial Exhibition," *to the San Francisco Museum of Art, San Francisco, California.*

Jared B. Flagg: "The Life and Letters of Washington Allston," *to Charles Scribner's Sons, New York.*

F. F. Sherman: "Albert Pinkham Ryder," *to Mrs. F. F. Sherman, Cannondale, Connecticut.*

Adolf von Hildebrand: "The Problem of Form," *to G. E. Stechert & Company, New York.*

Lionello Venturi: "Rouault," *to E. Weyhe, New York.*

C. Cennini: "The Craftsman's Handbook," tr. by D. V. Thompson.—C. Cennini: "Il Libro dell'arte," ed. by D. V. Thompson, *to the Yale University Press, New Haven, Connecticut.*

INDEX

Believing that an index of subjects, which would have contained such headings as color, composition, line, etc., which are mentioned on every other page of this book, would have been too cumbersome to be useful, the editors have confined this index to proper names. Cross-references to similar and contrasting opinions on important topics have been introduced into the body of the book, in the hope that the reader will be led to fruitful comparison and judgment.

Page numbers in bold refer to the artist's own writing.

493